當代設計與民俗信仰一起策展
Curating Daxi ✦ The development of Daxidaxi festival

桃園市立大溪木藝生態博物館
Daxi Wood Art Ecomuseum, Taoyuan

VERSE
Books

大溪大禧 DAXI DAXI

當代設計與民俗信仰一起策展
Curating Daxi ✦ The development of Daxidaxi festival

目次
Content

Chapter 4　「大溪大禧」指揮中心

走在慶典文化復興的路上

文 —— 桃園市立大溪木藝生態博物館

桃園大溪有深厚的文化底蘊，二百多年來的城鎮發展，有著大溪人積極投入公共事務的熱情和能量，為民間與政府共同經營地方打造了堅實的基礎。桃園市立大溪木藝生態博物館的成立，期望透過公立博物館的設置、生態博物館的經營精神，宣示桃園市政府和民眾一同經營地方的決心，與民眾共同保存、傳承、守護文化資產。

大溪豐富的人文生態景觀之中，日治時期開始辦理迄今的大溪普濟堂關聖帝君聖誕慶典，也就是大溪人所說的「迎六月廿四」，凝聚了大溪歷史、產業及文化的精華，登錄為桃園市第一個市定民俗，十分具地方性和代表性。木博館進入大溪當時，這個傳承百年的慶典文化，正面臨逐年參與人力不足、大眾對廟會文化的負面印象，以及外部藝陣加入擾亂大溪子弟社純樸精神等隱憂，故積極展開慶典文化田調普查工作，重新梳理這項慶典文化的在地知識及從籌備到遶境過程的精彩人、事、物及故事，並訂立「讓大溪人重新看見自己的魅力，找回認同與榮耀」，及「讓更多人認識並加入慶典文化復興」的目標，成為「大溪大禧」發展的基礎。

藉由本書的出版，整理及分享木博館與策展團隊策畫「大溪大禧」的發展過程，看見從促進慶典文化保存及發展的關懷切入，如何結合設計力的加入，喚醒大家對鄉土的熱愛、對慶典文化的熱情，號召眾人一起走在慶典文化復興的路上，並成為具國際性的臺灣文化節慶。

桃園市立大溪木藝生態博物館
桃園市立大溪木藝生態博物館成立於 2015 年 1 月 1 日、同年 3 月 28 日開館，為桃園市第一座公立博物館，以生態博物館精神和博物館方法推動地域經營，展現大溪生活文化的多元精采。

On the way of the revival of the festival culture

Daxi Wood Art Ecomuseum, Taoyuan

Daxi carries a cultural heritage that runs deep and wide. For over two centuries, the people of Daxi have been actively involved in public affairs, investing themselves with passion and solidarity, and forging a solid partnership for the community and government to work together to develop the area. The Taoyuan City Daxi Wood Art Ecomuseum program aims to achieve that through the establishment of a public museum that acknowledges the spirit of an ecomuseum. It also symbolizes the determination of the Taoyuan City Government and the public to work together to preserve, pass on, and protect cultural assets.

Among the rich cultural and ecological landscape of Daxi, the Daxi Puji Temple Guan Sheng Dijun anniversary ritual, or "June 24 Reception" as the people of Daxi call it, has been in the works since the Japanese colonial period. The event converges the history, industry, and cultural essence of Daxi, and has been registered as the first city-designated folk art festival in Taoyuan City for its iconic regional significance. When the Daxi Wood Art Ecomuseum, Taoyuan was first opened in Daxi, the one hundred year old celebration was facing a shortage of participants year after year; its temple events also suffering from negative public impression. There were also worries about other temple performing troupes joining in, and muddying the pure spirit of the Daxi community. Therefore, we have conducted field surveys of the culture of the temple celebrations to inventory the local knowledge of this culture and document the wonderful people, events, and stories – ranging from the preparation to the formal procession - thus setting the goal of "allowing the people of Daxi to experience the charm of their hometown again and to recover their sense of identity and honor" and "allowing more people to know and join the revival of the culture of the festival." These became the base of "Daxidaxi."

In preparing for the publication of this book, the Wood Art Ecomuseum and its curatorial team have compiled and presented the development process of "Daxidaxi " from the perspective of the care, promotion, the preservation and development of temple ritual celebration culture. It's time to leverage the power of design to inspire love for the homeland, the passion for temple celebration culture, and motivate people to walk together on the road of reviving temple celebration culture, fashioning it into an internationally renowned cultural festival of Taiwan.

Daxi Wood Art Ecological Museum

Daxi Wood Art Ecological Museum (WE Museum) was established on January 1, 2015 and opened on March 28 of the same year. It is the first public museum in Taoyuan City. The WE Museum promotes regional management with the spirit of the ecomuseum and museum methods to show the diversity and deepth lifestyle and culture of Daxi.

帶我回大溪！

文 ―― 詹偉雄 | 社會觀察家

從多年以前，臺灣開啟地方創生的浪潮以來，外來者與原生地的拉鋸，一直是個顯要的議題。

如果沒有外部力量或資源（不論是政府投入的經費，還是熱心田野工作者）的介入，地方顯然無法自沈沒與消失的主旋律中抽身；而如果光倚賴靈光一現的外部力量，那麼當計畫的時程到期、工作者氣力放盡之後，地方仍會從焰火的絢爛片刻，落回漫漫長夜的現實中。

地方創生 2.0 的主要習題，也是最幽微的思考面向，便不再是一股腦地保存或復舊，蓋上一大堆的社區文物館來典藏、紀錄、復刻那些消逝中的傳統，而是思索如何重新連結傳統與現在的當代住民生活的意義關聯，創造一叢叢新的紐帶，讓傳統能給予現代人面向未來生命的某些意義感，使即將消失的（過往）得以久留，幫即刻空虛的（現實）得以充填，這個工作說起來看似簡易，但投入過地方工作的人都知道它非常困難，不只需要體力和毅力，而且還要一點文化人類學的情懷，才能在漫長的田野實踐歲月中獲得一些創造性的收穫，同時在自身的生命裡獲得一些長進的成就感。

已經進行五年（其中因疫情關係中斷一年）的桃園「大溪大禧」文化節慶活動，是一系列 2.0 的嘗試中，非常新鮮、活潑而且具有創造性的案例。每一年的農曆六月二十四日，是關公這位民間神祇的壽誕，這是「祭」的起因；在大溪老鎮的商業發跡歷史裡，重義守諾的關聖帝君（在地人尊稱為「聖帝公」）不只象徵著生活世界裡的守護神，而是更具體地體現著所有人進行商買買賣時的上位人倫價值，因此，每一年週而復始的遶境慶典，便是這個人文傳統儀式化的強調與顯現。但是，隨著現代性為臺灣各個城鎮帶來的穿透與解組，這個祭典隨著大溪人口外移、商業凋落、觀光服務業崛起，不免逐漸形式化，而不再具備著昔日能牢固城鎮精神意志的力量。

桃園市政府投入資源，由衍序規劃設計的總策展人劉真蓉和眾多夥伴們攜手創造的「大溪大禧」，是一個讓昔日祭典生命重新復活的地方毛細孔工程。在過去這幾年，不論是在烈日當頭的酷暑還是大雨傾盆的午後，「大溪大禧」不僅吸引在地居民和社頭的高度投入，也吸引了像我這樣的台北住民的參與。在高溫下，噴灑著滿身的熱汗，捲入將軍們碩大身形的遊街陣形，吸吮沿街商家供桌上浮蕩的縷縷香煙，不由自主地也進入這個小鎮的歷史敘事之中，原來樟腦、木器和茶葉各自有各自的演義故事，而廟前廣場俯瞰大漢溪的視野，建構著河階地上不同開墾

期的自然空間。當然，這個工程絕非容易，聽著真蓉說過，從面對地方的各種質疑與消極對待，團隊可是做了非常多的努力，才一步步建立起信任與主動的合作情誼，而過程中的關鍵，就記錄在這本書裡，套用她的說法，不只是有一種熱愛、投入的思維與內在基因（我一直以為：真蓉對任何神祇和祭典都有一種附身的原始癡迷），還必須有「方法」（methodology），是這種客觀性，讓諸事諸為能包容萬物，找得到最大公約數，而又不失義理的中心。

海德格在現代人愈來愈偏向科技中心主義的上個世紀初，提出了「天、地、人、神」的一種現象學世界觀——天，意味著自然韻律；地，代表岩石和水流、植物和動物，蘊養眾生；神，是隱而不顯的神性律令，顯現而入於當前；人，則是「終有一死者」（die Sterblichen），人因為體察到終將一死，而能感受到身邊世界裡的天、地、神，進而定奪人在此世的終極意義，從失去世界到重新擁有世界。

「大溪大禧」每年那幾天的活動，都讓我不斷咀嚼海德格對我這般暮年者的提點，這都得感謝衍序和年輕世代的工作者，能把握到活動裡未必說得清楚的神聖性，把它當作生命的一塊血肉和靈魂而非一件工作來看待。

或可這麼說：當我們每次離開大溪，大溪卻已常駐在我們心中某個角落了。

詹偉雄

1961 年生於臺中縣豐原鎮，臺大新聞研究所碩士。九〇年代在《天下》雜誌做過財經記者、達一廣告擔任創意總監、參與博客來網路書店創辦，1999 年參與《數位時代》雜誌創辦，擔任總編輯，隨後陸續參與學文創志業與《ShoppingDesign》、《短篇小說》等雜誌之創辦，兼及文化與社會變遷研究、旅行、寫作。

Wei-hsiung Chan

Born in 1961 in Taichung, Taiwan, Wei-Hsiung Chan holds a master's degree in Journalism from National Taiwan University. In the early 1990s, Chan was a journalist focusing on the hi-tech industry, and creative director at an advertising firm, and co-founded the largest online bookstore in Taiwan, "Books.com.tw." He also co-founded the Internet trend magazine "Business Next" in 1999, serving as Editor-in-Chief, was one of the founding members.., and has participated in the launch of magazines, such as Shopping Design, Short Fiction,etc. He is now a full-time researcher and writer of cultural and social change in Taiwan society.

Take me back to Daxi!

Wei-Hsiung Chan | Social Observer

Since the start of the placemaking movement many years ago here in Taiwan, the tension between outsiders and the local community has surfaced as a concern.

Local communities will not be able to fight their inevitable decline without outside intervention or resources (be it government funding or enthusiastic fieldworkers). If we rely on the ingenuity of outside forces, the place would eventually fall back into decline after the revitalization project expires and workers run out of momentum.

The main theme of Local Revitalization 2.0, and also the most subtle direction of thinking, is no longer about preserving or reviving the old, building numerous community heritage museums to collect, document and restore the fading traditions; but rather, to think about how to reconnect the traditions in a meaningful way with contemporary life, to create a series of new ties, so that the traditions can give some meaning to modern people when they face the future. The job to preserve the vanishing tradition (past), and helping to fill the immediate void (reality), may seem easy, but anyone who has been involved in placemaking project knows that it is very challenging. It requires more than just physical strength and perseverance, but also a touch of cultural anthropology for continued inspiration, and at the same time enjoy a sense of accomplishment in one's own life.

The "Daxidaxi" festival, now in its fifth year (with a one-year interruption due to the COVID-19 pandemic), is a very fresh and creative example of Revitalization 2.0 attempts. Every year on the 24th day of the 6th month of the lunar calendar, the birthday of Holy Emperor Guan, a folk deity, is the reason for the "ritual celebration." In the history of the commercial development of Daxi Old Town, Guan Sheng Dijun, who is a god of righteousness and loyalty, comes to symbolize the guardian god in the mortal world, and embodies more specifically the moral values of all people engaged in business and trade. Therefore, this ritual held in the form of a religious procession year after year, is the manifestation of this tradition. However, with the prevalence and associated disorganization of modernity in Taiwan's towns, this festival has grown more "formularized" as the population of Daxi went on an exodus; commerce has declined, and the tourism industry has risen, and it no longer has the power to strengthen the spiritual will of the town that it once had.

The Taoyuan City Government has invested resources in the creation of Daxidaxi, in the attempt to revive ancient folk rituals through placemaking, led by Tammy Liu of BIAS Architects & Associates and many partners. Over the past few years, whether in the scorching heat or the late afternoon pouring rain, "Daxidaxi" has managed to experience high levels of participation from locals and performing formations, but also

people from outside Daxi, like myself from Taipei. Under the scorching heat, with sweat pouring like rain, we are swept into the street procession interspersed by the gigantic figures of the generals, based in the wispy smoke wafting from the incense on the worship tables of the merchants along the street, I could not help but be immersed in the historical narrative of this small town. It turns out that camphor, woodwork and tea have their own stories of evolution, and the view from the square in front of the temple overlooking the Dahan River constructs the natural space of different reclamation periods on the river terrace terrain. Of course, Daxidaxi is definitely not an easy undertaking, and I have heard Tammy comment that the team has worked hard to build trust and engage the locals' cooperation. The key to the process is recorded in this book. In her words, it is not only a passionate, committed mindset and innate DNA (I have always thought that Tammy has a primal obsession with any gods and rituals), but also a "methodology," a vision to achieve consensus without losing the focus on what is right.

In early last century, as modern men grew more technocentric, Heidegger proposed a phenomenological worldview of "heaven, earth, man and God". Heaven means the rhythm of nature; earth represents the rocks and water, plants and animals, which nourish all beings; God is the hidden but unseen divine order, which manifests His omnipresence; and man is the "mortality of life" (die Sterblichen). By recognizing our eventual mortality, we can feel the heaven, earth, and God in the world around us, and furthermore, we can seize the ultimate meaning of our life in this world, from losing the world to regaining the world.

Daxidaxi is an annual celebration that keeps me deliberating on Heidegger's advice to people like me as I advance in age. Thanks to the work of BIAS and the young generation, I was able to enjoy the sanctity of the event, which is not always clear, and see it as a piece of life and soul rather than merely a work.

It can be said that every time we leave Daxi, Daxi is already firmly implanted somewhere in our hearts.

一趟關於文化紀錄的奇幻旅程

文 —— 劉真蓉｜總策展人、衍序規劃設計顧問有限公司 總監

「你老家在大溪哪邊？」曾有一位在地的長輩這樣問我。
「其實我不是大溪人，但是我很愛大溪，她讓我真正認識了天地⋯⋯」聽到這個美麗的誤會，我也很感動地回答。

大溪大禧從一開始至五年後的今天，其中經歷無數歷程，我的心境與意念也轉換了非常多次。原以為「空間整合」就可以創造一個慶典，其實還不得要領，謝謝大溪引領我們進入「文化整合」的境地，學習聆聽，換位思考。最感動我的不只設計本身，是眾人共創與相信的意念。感謝在大溪發生的一切，這裡有度、有量、有空間可以學習，也得到肯定。

「大溪大禧」是一趟奇幻旅程，是生命中最意外卻最感動的篇章。祂連結了我追本溯源又開放的心，一步一步打破界線，精神無遠弗屆，所有設計與儀式的轉換，都為了要讓文化深化與這個世代對話。

感謝安排取經旅程、運籌帷幄的普濟堂關聖帝君小哥哥；謝謝衍序的夥伴，芷瑄、咨穎、婷嵐、子瑜、心汶、禹之⋯⋯等等，與一路上始終微笑相伴的包包、老神在在的小子。謝謝史上心臟最強、理想最高的業主——桃園市立大溪木藝生態博物館；謝謝林志峰老師提醒著以設計作為策展的原動力，謝謝使命必達的創作者與設計師們；謝謝大溪普濟堂、民俗技藝協會與社頭們、與城市中的好朋友們，待衍序如自己人。

這個故事還在書寫，寫的是現代臺灣文化圖譜，記錄的有大溪還有你，關照的是我們的心，與腳下的這一片土地。

衍序規劃設計 BIAS Architects & Associates
透過設計推衍這個時代「一些思緒、一點秩序」，取名衍序規劃設計。
團隊包含以價值先行思考的建築師、策展人、設計師與策略規劃師，一群想得到就做得到的夥伴，以議題研究的方式，嘗試「建築 × 策展 × 設計 × 文化」跨領域的可能性，實踐設計導入文化，期許每一個作品都有其時代意義。
作品歷程
臺灣節慶國際化的「大溪大禧 Daxidaxi」，2018~2022，總策展與規劃設計
臺灣文化展會「2019 臺灣文博會 — Culture on the move」，總策展規劃設計
城市品牌策展「2020 臺灣設計展 — Check in Hsinchu」，總策展規劃設計
臺北夜間城市藝術季「台北白晝之夜」，2016、2017，規劃設計
對標永續發展目標的「鼓勵好室 Green House」，2018~2019，總策展規劃設計

A fantastic journey about the cultural record

Tammy Liu | Chief Curator, Director, BIAS Architects and Associates

"Where is your hometown in Daxi?" I was once asked this by a local elder.
"In fact, I am not from Daxi, but I love Daxi very much...it has helped me get to know the heavens and the earth" I was touched to hear this beautiful misunderstanding.

From the beginning to today, five years later, Daxidaxi has gone through countless experiences, and my mind and perceptions have changed many times. I thought that "spatial integration" would be enough to create a festival celebration, but in fact I was still not able to understand it. I thank Daxi for leading us into the realm of "cultural integration," learning to listen and think differently. I am thankful for everything that happened at Daxi, where there is tolerance for experimentation, and space to learn and be affirmed.

Daxidaxi is a fantastic journey, the most unexpected and touching chapter in my life. Holy Emperor Guan connects me to the origin I seek with an open heart, breaking down the boundaries step by step, with a boundless spirit. All the design and ritual transformations are aimed at deepening the cultural dialogue with this generation.

Thank you to Guan Sheng Dijun of Puji Temple for making the trip possible. Thank you to my partners at BIAS Architects & Associates, Chih-Hsuan, Peter, Ting-Lan, Tzu-Yu, Hsin-Wen, Yu-Chih, etc... Thank you to the always-smiling Bao Bao with his calm and collected composure at all times. Our appreciation to the management team with their staunch support, the Daxi Wood Art Ecomuseum. A big thank you to Mr. Chih-Feng Lin for reminding us to use design as the driving force for curating the exhibition. Thank you to the creators and designers who are committed to the mission. Thank you to the Daxi Puji Temple, the Folk Art Association, the Shetou organizations, as well as the people of Daxi for treating BIAS as one of their own.

This story is still being written, and it is a map of modern Taiwanese culture. It is a record of Daxi and you. It is about our hearts and the land under our feet.

BIAS Architects & Associates

BIAS aims at expanding the public realm. It does so by refusing to surrender to any apparent lack of possibilities for the case. BIAS team consists of professional curators, designers, and architects with international background. While integrating research and projective thinking, BIAS strongly relies on interdisciplinary work across the fields of architecture, curating, design, social, and culture studies. We devoted ourselves to infuse design with culture, with the hope that any new work of ours can enrich the contemporary life.

Representative works

A modern religious Festival in which contemporary design joins folk beliefs, "Daxidaxi," 2018-2022 (Chief curators)
An expo that launched Taiwan's cultural movement, "Creative Expo Taiwan — Culture on the move," 2019 (Chief curators)
A design Expo that turned urban spaces into exhibition venues, "Taiwan Design Expo — Check in Hsinchu," 2020 (Chief curators)
An urban art festival that turned Taipei City into a night museum, "Nuit Blanche Taipei," 2016-2017 (Curators)
A pavilion showing the sustainability of agriculture and human life, "Greenhouse as a Home," 2018-2019. (Chief curators)

策一個大溪，尋原鄉起點

Curating Daxi: The Search for "Home"

一座老城，是一座開放式的博物館，廟口就像是接待大廳。

每個地方的大廟，都是在地的心靈信仰中心。從廟口開始，就能看見臺灣城市的凝聚力；可以穿越時間，將不同世代的人連結在同一個信念上；從廟口，閉上眼睛，感受到人與人、人與神的連結，祈求上天保佑地方；睜開眼睛，看見由信仰帶來的文化縱深、民俗藝術、食物薈萃、生活儀式，讓人有無比的勇氣，踏上每一次對原鄉樣貌的探尋。

來到大溪，從大漢溪岸邊的廟口為起點，開始了解街屋牌樓的成形。遙想城市中百工百業與衰史，穿越市場，看到與食衣住行緊密連結的市街。將時間調到這一百年來每年農曆六月廿四日──因為關聖帝君的生日，這座城市就像是開啟了另一個時間表，信仰與城市日常相互交織出了密集的劇本：在地居民會以自身本業的專長，互相幫助、傳授經驗、提供資源，將這個已成為大溪人集體記憶的慶典，從神明誕辰前的一個月起始，一步一步再現。為神慶生的慶典，拉近人與人的距離，人與土地的關係，人與故鄉的情懷。

一切就是從這個碼表按下，整理臺灣原鄉記憶，從土地切入設計，策一個大溪。

An old city is an open museum, and the entrance of the temple is the reception area.

In every town the great temples are the center of local spiritual beliefs. From the entrance of the temple, one can put tabs on the cohesiveness of Taiwan's cities; the temples connect people of different generations throughout time with the same belief. When you're in the temple, close your eyes, feel the connection between the folks, the people and between the people and their gods, as they pray to heaven to bless the place. When you open your eyes, you can sense the cultural depth, folk art, authentic local food and the rituals of life inspired by faith, which inspires you with the courage to embark on every quest for the appearance of the hometown.

When arriving at Daxi, start from the temple on the bank of the Dahan River, and begin to explore the history behind the formation of shophouses, to reflect on the history of the rise and fall of trade and industry in the city; walk through the market, and see the city streets that underpin all of life's necessities. Set the time to the 24th day of the 6th month of the lunar calendar every year for the past millennium - for the birthday of Guan Sheng Dijun. The cityscape feels like it's stepped out from another era in time for the birthday of Guan Sheng Dijun, when faith and the city's daily life are interwoven in an ancient script. The residents help each other with what they could contribute, pass on their experience, and provide resources to recreate this celebration that has become a collective memory of the people of Daxi, starting from the month before the Guan Sheng Dijun's birthday. The celebration of the god's birthday draws people closer to each other, to the land, and to their hometown.

With the press of the stopwatch, let us walk down the memory lane of small-town Taiwan, from land to design, and curate the tapestry of Daxi.

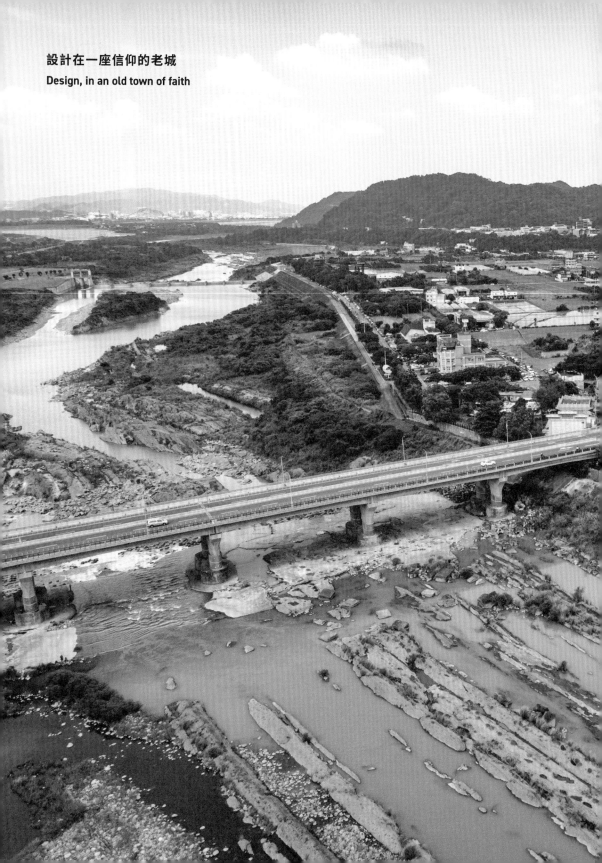

設計在一座信仰的老城
Design, in an old town of faith

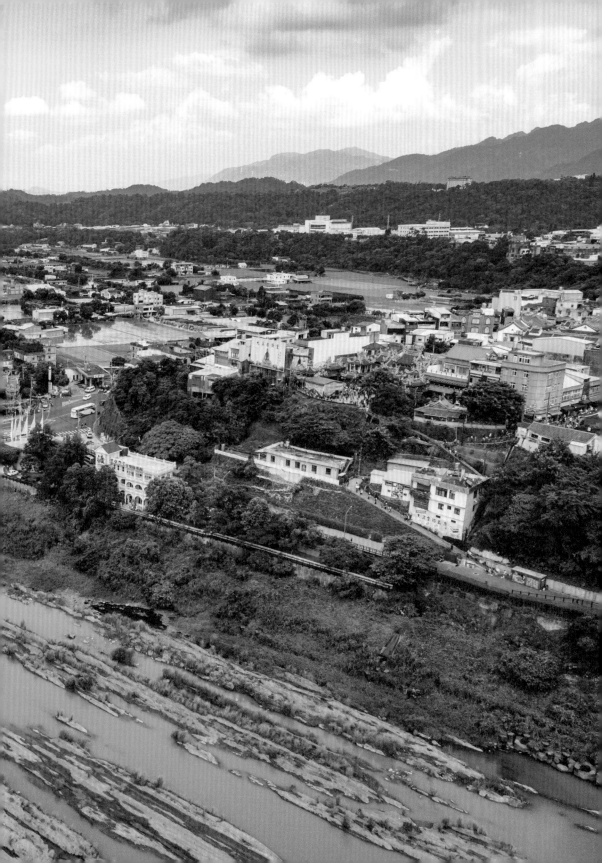

用 10 個臺灣原鄉關鍵字認識大溪

Get to know Daxi with 10 key words representing small-town Taiwan

(1)｜大料崁

清治乾隆以後，文獻上曾出現的大溪舊稱有大龜崁、大姑陷、大料崁、大科崁等，皆為同一語音的漢字表記，清代大料崁僅指稱大料崁溪東側的部分，故亦稱為河東，日治時期1920 年改名為大溪沿用至今，今日大溪區行政管轄範圍橫跨大料崁溪（今大漢溪）東西兩側。

什麼是臺灣文化的樣貌？我們在大溪彷彿看見一座臺灣城市生活的縮影。

為了讓臺灣城鎮的文化記憶更清晰，關於「大溪大禧」的策畫，源頭從對「原鄉」的記憶開始挖掘，建立大眾在參與慶典活動本身之外，了解所經歷的所有環境與動態，都是沈浸在一種臺灣城市的樣態。

原鄉，代表著每個人對故鄉印象的認同感，是在地域場景中找到熟悉的符碼、是與成長經驗相通的人際關係、也是代代相傳的生活儀式。隨著時代推進，現代人對土地的連結與情感漸漸消失，屬於臺灣的生活樣貌在資訊洪流中漸漸面目不清。然而在桃園有一座老城，古名大枓崁 (1)，在山河的庇蔭下，這裡的人技藝非凡，人與人的濃厚情感連結，處處都還保留著對臺灣土地「原鄉」的記憶，「大溪大禧」的故事就是從這一座名叫「大溪」的城鎮，發掘原鄉記憶訴說起。

10 組「原鄉」的關鍵字，勾勒出土地的樣貌、劃出疆界、記錄群眾生活與文化意識、信仰與慶典。

(1) | Da Ke Kan

After the Qing Dynasty, Daxi was referenced in the literature in several of its old monikers, such as Da Gui Kan, Da Gu Xian, Da Ke Kan, etc., all of which are Chinese characters with the same phonetic notation. During the Qing Dynasty, Da Ke Kan (Tuā-khoo-khàm) referred merely to the eastern part of Da Ke Kan River, so it was also called Hedong (East side of the river). The name was changed to Daxi in 1920 during the Japanese colonial period and is still in use today. Today, the administrative jurisdiction of Daxi District straddles the east and west sides of Da Ke Kan River (now Dahan Creek).

What is the authentic "look" of Taiwanese culture? One can see the life of a Taiwanese community encapsulated in Daxi.

In order to capture the cultural memory of Taiwan's townships, the planning of "Daxidaxi" starts from the memory of the "hometown," and builds up the public's understanding that all the environment and dynamics they experience are interspersed in a type of Taiwan community outside the religious celebration itself.

What we call "hometown" is defined by one's identification with their place of origin, a familiar "code" of local scenes, a human relationship imbued with the experience of growing up, and a ritual of life passed down from generation to generation. As time progresses, modern people's connection and emotion to the land begins to fade, and the community experience of Taiwan becomes murky in the flood of information. However, there is an old city in Taoyuan, which was once called Da Ke Kan [1] (Tuā-khoo-khàm in Taiwanese Hokkien) in ancient times. Shielded by the mountains and rivers, the people here cultivated extraordinary skills and strong emotional ties with each other, and the memory of the authentic "hometown" of Taiwan is still preserved here. The story of "Daxidaxi" is thus told from this city called "Daxi," where the memory of hometown is explored.

The following are the 10 key words that we define as part of a place that is a "hometown". Through these we can outline the land, define boundaries, and document the lives of the people and their cultural awareness, beliefs and celebrations.

❶ 景觀

1. 一個地區由地貌及人文構成，放眼所見的環境與景象。

2.【大溪】因大漢溪侵蝕形成河階地形的大溪地區，放眼望去可見分為三層的河階，第一層是靠近河流的平原區，主要發展農業；第二層稍高，為倚山而建大溪老城區，可見百年廟宇「大溪普濟堂」佇立，周邊是熱鬧的商貿老街、居民生活的街道巷弄，還有綠樹成蔭的公園綠廊以及一系列日式木造建築的博物館群；第三層則是近山地區，有豐富的山林物產。

Landscape

1. The environment and scenery of an area composed of landforms and humanities as far as the eye can see.

2. [Daxi] The Daxi area, formed by the gradual erosion of the Dahan River, is divided into three terraced river terrains. Tier one is the plain area near the river, which is primarily used for agriculture; the second level, slightly higher in elevation, is the old town of Daxi, which is built alongside a mountain. This is where the century-old temple "Daxi Puji Temple" stands, surrounded by the lively old trade streets, the streets and alleys where the residents live, the tree-lined green corridor of the park, and a throng of museums modeled after Japanese wooden buidlings. Tier three is the hilly areas surrounding the town, which is rich in mountain and forest products.

❷ 地域

1. 一個地區由地理特徵或行政區域劃定的領域、疆界，具有歸屬感。

2.【大溪】位於桃園市中央偏東近山地區的大溪，舊稱「大嵙崁」，1920 年以後稱為大溪。以大漢溪為界，在地人習慣分為河東與河西。河東包含河階上緊鄰大漢溪的老城區與月眉平原，以及近山的三層、頭寮、內柵等區域，河西則包含中庄、埔頂、南興、員樹林等區域。

Region

1. An area defined by geographical features or administrative areas, administrative boundaries, with a sense of belonging.

2. [Daxi] Located in the central eastern part of Taoyuan City near the mountains, Daxi was formerly known as "Da Ke Kan (Tu-khoo-khàm)" and has been called Daxi since 1920. With the Dahan River as the natural boundary, the local people began to divide the land into Hedong (East side of the river) and Hesi (West side of the river). The eastern part of the river includes the old town area and the Yuemei Plain on the river level adjacent to the Dahan River, as well as the areas near the mountains such as Sanceng, Touliao, and Neizha, while the western part of the river cover Zhongzhuang, Puding, and Nanxing.

③ 城鎮

1. 地區中人口集中且工商業較為發達的區域。

2.【大溪】 大溪在清光緒年間，發展為淡水河系上游興盛的內陸河港，桃竹苗地區的各類產品經由此轉運，河港周邊則成為人口聚集、商業繁榮的城鎮。日治時期（1912 年）隨著「市區改正」都市計畫的街道拓寬整治及立面整建，將主要街道上的建築改建為牌樓立面，其融合西式建築語彙與中式、日式吉祥圖樣特色，成為大溪彼時繁華榮景的象徵。

Towns

1. Areas of the region where the population is concentrated and where commerce and industry are more developed.

2. [Daxi] During the Guangxu reign of the Qing Dynasty, Daxi grew into a thriving inland river port in the upper reaches of the Tamsui River system, through which various products from the Taoyuan/Hsinchu/Miaoli region were transshipped and traded, and as a result, the area around the river port began to thrive with people gathering to engage in business activities. During the Japanese colonial era (1912), the main street was widened and converted into a shophouse façade as part of the "Urban Reform" plan, characterized by Western architectural elements and Chinese- and Japanese- inspired patterns of auspices. It has become a symbol of the prosperity and glory of Daxi at that time.

④ 市場

1. 一個地區居民日常進行貨物買賣、商品交易的場所。

2.【大溪】 在清光緒年間即是大漢溪河港旁重要商業市場的大溪和平老街，藉著周邊近山物產豐富及港口轉運優勢，成為樟腦、茶業、木材、煤礦及日用品等商品的集散地，各類商號店舖林立，至今仍是大溪最熱鬧的街道之一。

Market

1. A place where the people of an area buy and sell goods and trade commodities on a daily basis.

2. [Daxi] During the Qing Dynasty, Heping Old Street served as an important commercial market beside the Dahan River port. With abundant produce from the surrounding mountains and its geographical vantage point as a port transshipment hub, Heping Old Street became a flourishing distribution center for goods, such as camphor, tea, timber, coal and daily necessities. Many shops and stores of various kinds started to pop up and grow, and it remains the busiest street in Daxi to this day.

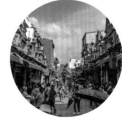

⑤ 工藝

1. 具地區特色，將原材料或半成品加工成產品的工作、方法、技術或手藝。

2.【大溪】 藉著河港成為周邊地區重要木材集散地的大溪，自清代便吸引許多優秀的木工匠師來此定居。隨著城市擴展與商業發達，木工匠師協助建造商店、帆船、家宅、製作家具及生活木器，為大溪的木藝產業扎下日漸興盛的根基。

Craft

1. The work, method, technique or art of processing raw materials or semi-finished products into merchandise, rich with regional characteristics.

2. [Daxi] Blessed with a river port, Daxi became an important lumber distribution center for the surrounding area, attracting many talented carpenters and wood craftspeople to settle here since the Qing Dynasty. As the town expanded and commerce developed, woodworkers helped build stores, sailboats, homes, furniture and household woodenware, laying the foundations for a thriving wood art industry here in Daxi.

⑥ 信仰中心

1. 一個地區奉祀神明、進行宗教儀式的主要場所。

2.【大溪】 臺灣聚落生活中，廟口便是每座城市藝術、教育、生活匯集的地方。普濟堂原本是地方私人信仰的鸞堂，因短短幾年間屢顯神威，地方仕紳們便決定發起建廟。後來因為有捐糧、藥籤等貼近日常需求的服務內容，使普濟堂逐漸成為大溪重要的信仰中心之一。

Faith Center

1. The main place where the gods are worshipped, and religious ceremonies are performed in a region.

2. [Daxi] In traditional Taiwanese settlements, the temple entrance is the place where art, education, and life converge. Puji Temple was originally a local private Luantang (Phoenix Hall). Because of the supernatural power of the Phoenix Hall in answering prayers, the local gentry decided to build the temple. Later on, as provisions of food and medicinal prescriptions poured in, Puji Temple gradually became one of the important centers of faith in Daxi.

❼ 信仰

1. 對某種思想或宗教極為信服和敬慕，或對一位人、一個物、一件事或一種概念的堅信不疑。

2.【大溪】關聖帝君因為其「重承諾」、「守信義」的精神，所以被封為商業之神，大溪普濟堂的關聖帝君曾為至九份挖礦的礦工點金脈、保佑外出子弟平安等事蹟，逐漸成為大溪人重要的神明信仰，成為大溪人口中的「聖帝公」、「聖帝公祖」。

Faith

1. A deep conviction and admiration for an idea or religion, or a deeply-held belief in a person, object, event, or concept.

2. [Daxi] Because of his spirit of "commitment" and "integrity," Guan Sheng Dijun is often regarded as the god of commerce. Guan Sheng Dijun of Daxi Puji Temple once showed the location of gold veins to miners who went to Jiufen to mine, and he offered protection and safety to those studying or working away from home. Over time, he became a guardian saint for the people of Daxi, becoming what locals called "Shengdi Gong" or "Shengdi Gongzu".

❽ 慶典

1. 一個區域因信仰或習俗文化，在固定或不固定的日期內，約定俗成、世代相傳隆重盛大的慶祝典禮儀式。

2.【大溪】每年農曆六月廿四日是關聖帝君聖誕，慶典與遶境儀式是大溪全城的年度盛事，從農曆六月初一啟動籌備會，展開近一個月的籌備過程，並於農曆六月廿三、廿四日舉行為期兩天的慶典及遶境儀式，俗稱「大溪大拜拜」或「迎六月廿四」。

Festival Celebrations

1. A grand ceremony celebrated in a region on a fixed or irregular date due to beliefs or customs and culture, and passed down from generation to generation.

2. [Daxi] June 24th on the Lunar Calendar marks the birthday of Guan Sheng Dijun. The festival and parade are a highly-anticipated annual event for the whole of Daxi. The preparatory meeting starts on the first day of the sixth month of the lunar calendar, and a two-day festival and parade is held on the 23rd and 24th day of the sixth month of the lunar calendar, which is commonly known as "Daxi's Great Worship" (Daxi Da Baibai) or " June 24 Reception."

❾ 社區

1. 一群共享共同價值觀、文化、生活利益的人群聚集組成的共同體，其居住生活在同一區域，有時亦稱為「社群」。

2.【大溪】保持著對大溪的地方認同，以及感謝神明庇佑的心意，大溪人依照不同的職業性、地域性、興趣愛好，陸續組織數十個「社頭」，共同參與聖誕慶典的遶境活動。漸漸形成敬天惜緣、互助傳承的社頭人精神，以身體力行的方式回饋生活的這片土地。

Community

1. A group of people who share common values, culture, and interests in life, and who live in the same area.

2. [Daxi] In order to acknowledge the identity of Daxi, and to express appreciation to the gods for their blessings, the people of Daxi have organized dozens of "Shetou" organizations according to different occupations, regions, and hobbies to participate in the annual temple procession. Gradually the spirit of the Shetou grows and develops within the group, through their activities of honoring the gods, of expressing gratitude for the gifts received from the heavens, of helping each other and of giving back to the land that they live on.

❿ 飲食

1. 在特定時節、儀式中吃喝的食物，或吃喝相關的文化及作為。

2.【大溪】在河階平原的肥沃土地上，大溪從 18 世紀便開始發展稻作產業，伴隨著鄰近產地的河運與市鎮興起，稻作逐漸成為地方產業主力，因此大溪生活中也充滿米食的身影：一年的初始與結尾都少不了有祈福意義的米糕與發糕，隨著歲時節令，還有元宵節的平安龜、七夕的車輪粿、中秋的月光餅等大溪特有的傳統米食。

Food culture

1. Food and drinks consumed during specific times and rituals, or food and drink related costums and behaviors.

2. [Daxi] In the fertile land of the river terrace, agriculture grew into the community business staple in Daxi since the 18th century. With the rise of river transportation and formation of towns in the neighboring production areas, rice farming has gradually become the community mainstay, and as a result, the food culture in Daxi often revolves around food made with rice: rice pudding and steamed sponge cake, symbolize the prayer for good fortune, which is essential at the beginning and end of the year, and during the festivals of the year. There are also traditional rice foods unique to Daxi, such as the Pingan Turtle Cake for the Lantern Festival, the Chelun Cake for the Chinese Valentine's(Qixi), and the moon cake for the Mid-Autumn Festival.

一個以信仰連結生活文化之城
A city of living culture, connected by faith

大溪，一座被翠綠群山包圍的山城，依附著一條水量豐沛的大河而生。

(1)｜林本源家族
清領時期因經營米業、鹽業致富的商業望族，為臺灣五大家族之一。十九世紀初遷居大溪帶動地方產業發產，後來又遷居板橋，又稱「板橋林家」。

古稱「大嵙崁」的這個城鎮，始於清朝中葉開發臺灣內山的時空，林本源家族 **(1)** 也在清末投入開墾北臺灣山地。原本在新莊發展的林家為躲避漳泉械鬥 **(2)**，評估大嵙崁這個地方，擁有河港要地與便利於山林產業發展的雙重優勢，在十九世紀初決定移居大嵙崁，於此開墾土地、經營農事、運輸從商、建立家業，也從唐山禮聘木作匠師，在大嵙崁溪邊蓋起牆高壁厚的林宅「通議第」，其他居民沿著通議第周邊造屋、做生意，形成大溪老城區現今的街區雛形。

(2)｜漳泉械鬥
漳州人與泉州人是來自中國福建的兩大閩南語族群。漳泉械鬥發生在 18 世紀中到十九世紀末的臺灣，是因族群不同而產生的武裝衝突。

隨著 1860 年舊稱滬尾的淡水開港通商，上游的大嵙崁也進入航運興盛的時代。從同治十年（1872 年）《淡水廳志》中記載的「街擺渡，往來新莊，上通大嵙崁三坑仔，下達淡水港」文字間，可以想見大嵙崁當時的榮景。這個北臺灣重要的內陸河港航運發達，當時已有雙向航道讓帆船上通下行，便利往返於大嵙崁與大稻埕碼頭之間。大嵙崁城中，山林物產與各種日用品的買賣交換興盛，商業、農業、煤礦業、建築等相關行業人才交流頻繁，來自世界各國的洋行與本地的商號就高達三、四百家。

繁榮的城市交易塑造了大溪地方的仕紳望族，在大溪，仕紳階級一直是建設地方的重要角色。從林本源家族於清末開始開墾大溪，直至日治時期，大嵙崁有許多經商有成的仕紳，一同參與地方的公共政策與建設，如：簡、呂、江、李、黃、王等大家族。這些仕紳響應政府的政策，一起投資或捐款，投入輕便鐵道、電力等基礎建設及學校教育，一起推行大溪城市和生活的現代化。大正七年（1918 年）配合日治時

(3)｜市區改正計畫

「市區改正計畫」是局部性的都市改造措施，為「都市計畫」的前身。以寬敞筆直的道路、圓環、公園等公共設施，取代臺灣以往道路曲折狹窄，且衛生環境不佳的空間。

(4)｜社頭

大溪參與遶境的迎神團體稱為「社頭」，在臺灣其他地區常稱為「軒社」、「陣頭」，是由在地人自發組成的業餘陣頭組織，有著傳統傳習的精神。

期的「市區改正計畫 **(3)**」，仕紳家族配合拓寬道路的政策，共同設置亭仔腳（騎樓）供公眾通行及便利各家戶店面交易，許多家族更聘請匠師，為家屋設計獨具巧思的牌樓新門面；不僅採用當時流行的紅磚建材與洗石子工法，更以剪黏與泥塑點綴祥獸花果等多樣裝飾，此後大溪牌樓成為最具特色的街道景色。

串起所有大溪人的「迎六月廿四」

擁有學養與家業的仕紳家族，在大溪也同時是推廣地方文化教育，建立地方信仰中心的推手。

信仰可以凝聚民心，而地方宮廟往往不只是宗教祭儀的中心，還是地方議事、捐助勸善的公共場所。舉凡大溪福仁宮、大溪齋明寺、大溪普濟堂，都是地方仕紳發起建廟的宗教場所。其中大溪普濟堂發展於日治時期大嵙崁經濟鼎盛時期，當時仕紳家族有感於關聖帝君的照顧與指引，而在普濟堂提供各種貼近居民生活需求的服務作為回饋，使得普濟堂很快成為城市中重要的信仰中心。

為了感謝關聖帝君庇佑，仕紳們積極籌募資金興起遶境，也帶動大溪全城一起加入酬神行列。從礦業、木器業、農業到商業等，各行各業都紛紛組織「社頭 **(4)**」參與農曆六月廿四日的關聖帝君聖誕慶典遶境。隨著信仰人數越來越多，許多以廟宇、區域性、或是因相同興趣的人也組成社頭共同參與。單是日治時期，就陸續成立了二十個社頭，並發展出帶有各自特色的藝陣 **(5)**，而這樣的人、事、物，因為信仰而傳續至今。

圖 Figure｜1

為農曆六月廿四日大溪普濟堂關聖帝君聖誕遶境盛況。可看見自日治時期保留至今的牌樓立面。

The image on the right is the birthday celebrations of Guan Sheng Dijun on the 24th day of the 6th lunar month. The facades of the shophouses have been preserved since the Japanese colonial period.

大溪現今共有 31 個社頭，長期的文化積累讓社頭成員以這個身分為傲，作為地方重要的社群組織，積極參與大溪的公共事務，努力傳承地方文化、技藝與精神。大溪人將關聖帝君聖誕慶典視為大溪的第二個過年，慣稱「迎六月廿四」。每年農曆六月一到，平日裡有各自工作與生活的社頭人們，會放下一切投入慶典的密集籌備，與社員們練習藝陣技藝。遶境前的夜晚，大溪各處廟埕、空地、廣場上甚至馬路邊，都聚集著揮汗夜練的社頭們以及前來應援看熱鬧的鄰里鄉親，此情此景，百年如一日。

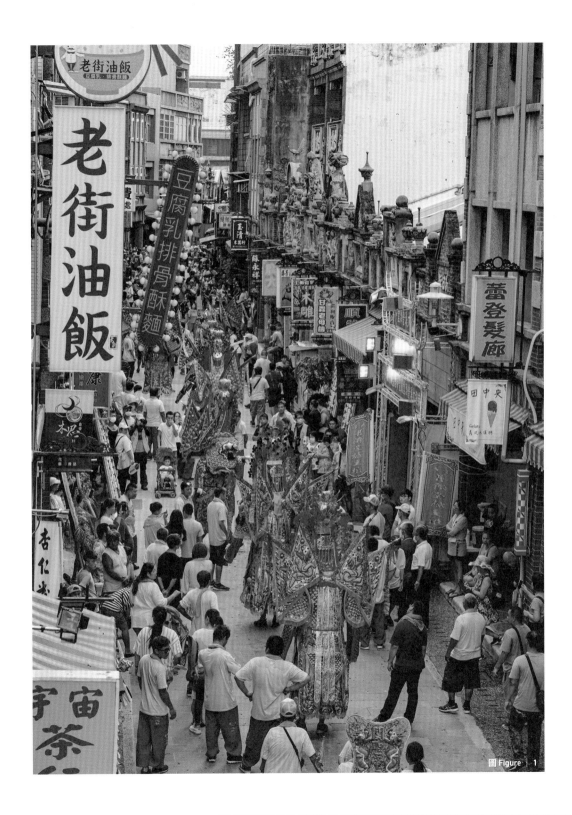

圖 Figure｜1

(5)｜藝陣

藝陣是藝閣與陣頭的併稱，為迎神賽會場合中具有強烈表演性的各式陣頭。大溪社頭會依照職業與特性，製作大型道具與服裝，推出特色藝陣酬謝神明。

隨著慶典時間越來越近，大溪人們開始向親友預告慶典將至。街道上各種慶典食物、祭祀糕餅香氣四溢，層層疊加著對慶典期待的氛圍。遶境當週，帶著各方好貨的夜市展開，讓大溪的夜晚也熱鬧起來。直至農曆六月廿四日慶典當天，喧嘩熱鬧的氛圍瞬間達到高峰，街道上充滿等著看熱鬧的居民、一起來共襄盛舉的親朋好友、大溪人細心準備著迎接神明與福氣的香案，以及慰勞遶境隊伍的鹹甜點心。

「迎六月廿四」的慶典期間，大溪人彷彿遵守和關聖帝君的約定，每年回到出生、成長的小鎮，一起為慶典付出、感謝神明的庇佑，共享一整個月的期待氛圍。信仰成為大溪生活文化的一部份，而凝聚著這座城市的，便是人們堅持百年的心意。

如果大溪是一座博物館？

時空背景不斷變化之下，一座老城的繁盛樣貌，包括生活風貌、產業，信仰文化及工藝，都需面臨傳承再創的課題，然而大溪卻有其獨特的運轉方式。

(6)｜香案

放置香爐、燭臺、祭品以祭奉或迎接神明的桌子。

關於食物，雖然農村生活式微、產業轉型，遶境沿路仍有虔誠居民，數十年不間斷擺出香案 **(6)**，奉上滿滿心意的供品、米食點心與涼水，迎接遶境隊伍及聖帝公到來。

圖 Figure｜2

大溪人們會在家屋前設置香案，迎接遶境隊伍與關聖帝君神尊。

The people of Daxi would prepare the incense for welcoming the procession team and Guan Sheng Dijun.

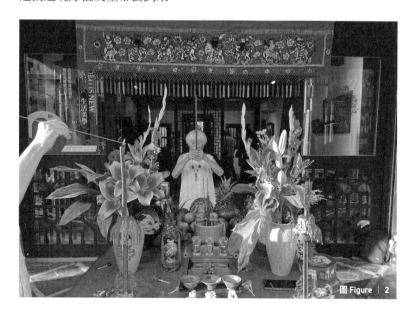

圖 Figure｜2

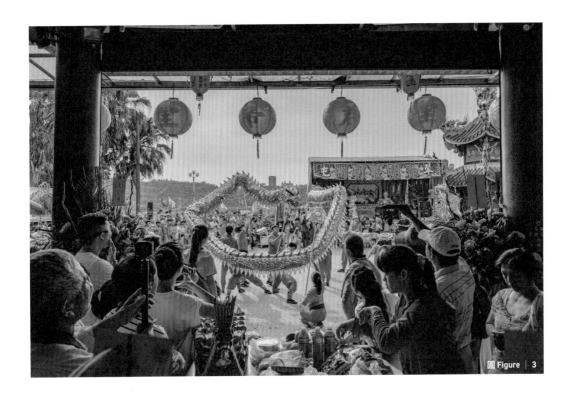

圖 Figure | 3

圖 Figure | 3

農曆六月廿四日，眾人圍
在大溪普濟堂廟埕，觀看
傳統酬神戲與陣頭拜廟。

On the 24th day of the
6th lunar month, people
gathered at Daxi Puji
Temple to watch the
traditional performance
and the worshiping of the
formations.

關於工藝，當傳統工藝不再是生活所必需，大溪的木藝匠師將精緻的
手工藝，持續運用在日常生活木器及家具製作，讓職人精神與故事得
以傳承。

關於市況，隨著河運及輕便鐵道衰退，物產轉運集散的優勢不再，
大溪人仍共同維護著老城區與集市，昔日榮景的象徵成為今日城市魅
力，以觀光敘事持續展現。

關於信仰，當傳統信仰文化逐漸式微，大溪人仍然每一年守護關聖帝
君聖誕遶境，從社頭到全城鎮讓信仰延續。

當傳統生活方式，依然是大溪的日常，大溪是不是就像一座博物館？

如果大溪是一座博物館？

Daxi, a town surrounded by lush green mountains, was born alongside a large river with abundant water.

The ancient name of this town is "Da Ke Kan," which started in the mid-Qing Dynasty, when the inner mountains of Taiwan are developing. In order to flee the armed conflicts between Zhangzhou and Quanzhou groups**(1)**, the Lin Ben Yuan family **(2)**, who was also involved in the reclamation of the mountains of Northern Taiwan in the late Qing Dynasty and originally settled in Xinzhuang, assessed their future in Da Ke Kan, which boasted a major river and port, and development strengths for land cultivation and forestry. Following a careful evaluation, the family settled in Da Ke Kan during the early 19th century. In the area, the family cultivated land, farmed, and engaged in transport and commerce, and business flourished. Skilled woodworkers were hired from Mainland China to build a high walled forest house called "Tongyidi" (通議第) along the Da Ke Kan River. Other residents built houses and businesses along the perimeter of the Tongyidi, forming the present-day prototype of the old town area of Daxi.

With the opening of the port of Tamsui, formerly known as Huwei, to commerce in 1860, Da Ke Kan, which sits on the upper reaches of the Tamsui River, also entered an era of prosperous trade. From the text of "Gazetteer of Tamsui Sub-Prefecture" in 1872, we can imagine the glory of Da Ke Kan at that time, which reads, "The ferry leads to Xinzhuang, up to Sankengzai in Da Ke Kan and down to Tamsui Port." This important inland river port in Northern Taiwan was well developed, and at that time there was a two-way channel for sailing ships to travel up and down the river, making it convenient to travel between Da Ke Kan and Dadaocheng. In the town of Da Ke Kan, the trade and exchange of mountain and forest products and various daily necessities multiplied, and there were frequent exchanges of talents in commerce, agriculture, coal mining, construction, and other related industries, and as many as 300 to 400 foreign firms and local businesses from all over the world were established here.

The prosperous trade helped shape the local gentry and influential families in Daxi, who played an important role in building up Daxi. Here in this town, the gentry class played an important role in developing the place. From the late Qing Dynasty when the Lin Ben Yuan family started to cultivate Daxi, until the Japanese colonial period, many successful businesses in Da Ke Kan participated in the public policy development of the area, such as Chien, Lu, Chiang, Li, Huang, Wang and other prominent families. In response to the government's policy, some of the gentry invested or donated money to infrastructure services, such as light railways, electricity, and school education to modernize life in Daxi. During the 7th year of the Taisho era (1918), when the Urban Improvement Plan **(3)** was implemented during the Japanese colonial era took place, prominent

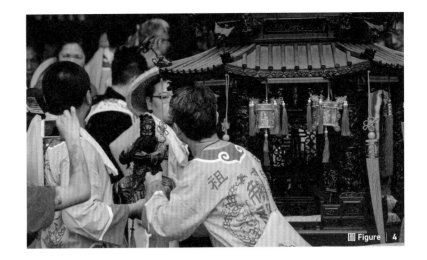

local families joined road widening projects and set up shophouses for public access and store trading. Many families even hired skilled craftsmen to design new and ingenious facades for their shophouses. Not only did they use the then-popular red brick materials and washed-finish techniques, they also decorated their houses with various motifs such as auspicious animals and, flowres and fruits by cutting and gluing clay sculptures, transforming the Daxi shophouses into the most distinctive street scenery that we know today.

"June 24 Reception" for all the People of Daxi

The local gentry and their prominent families, with their education and business ties, were also the driving force behind the promotion of local culture and education and the establishment of a local faith center in Daxi.

(4) | Shetou

The group that takes part in the procession is called "Shetou" in Daxi, while it is commonly called "Xuanshe" or "Zhentou " in other areas of Taiwan. It is an amateur group formed by local people of their own volution. It is hosted to pass down the heritage and practices.

Faith can unite the people. Local temples are often the centers for religious rituals, and public places for discussing local public matters, as well as hosting donation drives. For example, Daxi Furen Temple, Daxi Zhai Ming Temple, and Daxi Puji Temple; all were religious places constructed at the behest of local gentry. Among them, Daxi Puji Temple was developed during the economic heyday of Da Ke Kan. In return for the care and guidance of Guan Sheng Dijun, the local gentry provided a variety of services closely linked to the needs of the residents at Puji Temple, which soon became an important center of faith in the city.

In order to thank Guan Sheng Dijun for his blessing, the gentry actively raised funds for the processions, and led the whole city of Daxi to join the parade to pay tribute to the god. From mining, woodworking, agriculture, and commerce, various industries organized "Shetou" **(4)** organizations to participate in the

圖 Figure | 5

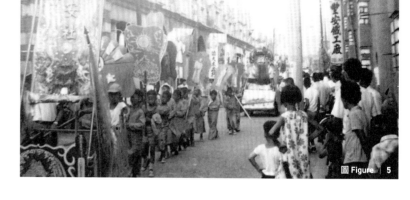

圖 Figure | 5

圖 Figure | 5

1960 年代，和平老街上觀
看遶境的人潮洶湧。
照片提供：邱垂正

A crowd of people wthing
the procession on Heping
old street in 1960.
Photo credit:
Chui-Zheng, Qiu

(5) | Art formation

A procession formation with
highly performative quality.
In Daxi Shetou societies
will make large-scale props
and costumes according
to their occupations and
characteristics, and launch
special art formations to
reward the gods.

birthday celebrations of Guan Sheng Dijun on the 24th day of the 6th lunar month. As the number of believers grew, many temples, regions, or people with similar interests also formed Shetou groups to partake in the program. During the Japanese rule period alone, twenty Shetou societies were established in succession, and they developed their own art formations **(5)** with their own characteristics. This heritage has been passed on through the practice of faith to this day.

There are now 31 Shetou groups in Daxi, and the long-standing cultural accumulation has made the Shetou proud of their status as important local community organisations, actively participating in Daxi's public affairs and striving to pass on the local culture, skills and spirit to the next generation. The people of Daxi consider the Guan Sheng Dijun Birthday Celebration the second Lunar New Year in Daxi, or "June 24 Reception" for short. On the first day of the sixth month of the lunar calendar, each member in the Shetou, who leads their own life in general, would drop everything and devote themselves to the intensive preparations for the festival, contributing their arts and crafts along with their peers. On the night before the parade, numerous Shetou groups practice at night to perfect their presentation throughout local temple squares, open spaces, and even on the roadside, and neighbors come to support and join the fun.

As the time for the festival draws closer, people in Daxi begin to notify their friends and relatives that the festival is coming. The streets are filled with the aroma of festival foods and cakes, adding to the festive mood. During the week of the temple procession, the night market is also bustling with all kinds of activities, turning the evenings in Daxi into memorable parties. On the 24th of June on the Lunar Calendar, the day of the celebration, the mood soon climaxes. The streets are filled with residents waiting to see the procession, friends and relatives come to join the festivities, and the people of Daxi carefully prepare the

(6) | **Incense table**

A table on which incense burners, candlesticks, and offerings are placed to worship or greet the gods.

incense **(6)** for welcoming the gods and blessings, as well as the sweet and savory snacks to regale the parade team.

During the "June 24" celebration every year, Daxi locals return to the town where they were born and raised, per their promise kept to Guan Sheng Dijun, share a month-long atmosphere of anticipation, in which they work together for the celebration, and thank the gods for their blessings. Faith has become the fabric of the culture of Daxi life, and what unites this town is this millennial goodwill of the people.

What if Daxi were a museum?

In the changing context brought about by the ebbs and flows of time, the prosperity of an old city, including its lifestyle, industries, beliefs, culture and craftsmanship, everything needs to be recreated, but Daxi has its own unique way of conveyance and operation.

Despite the decline of rural life and the transformation of industries, there are still devout residents along the procession route who have insisted on setting up incense in dedication for decades, offering heartfelt offerings, rice snacks and cold water to welcome the procession team and Guan Sheng Dijun.

Regarding craftsmanship, even though traditional craftsmanship is no longer a necessity in life, Daxi's woodworkers continue to apply their exquisite craftsmanship to everyday woodworking and furniture making, allowing the spirit and stories of the craftsmen to be passed on for generations to come.

With the decline of river transportation and light railways, the advantages of transshipment and distribution of goods are no longer available. However, the people of Daxi still work together to maintain the old town and marketplace, and the symbols of the past glory have become the charm of the city today, which continues to be expressed in the tourism narrative.

Regarding faith, while traditional faith culture culture has gradually declined, the people of Daxi still observe Guansheng Dijun's Birthday Procession every year, keeping the faith alive from Shetou groups to the whole city.

When the traditional way of life is still very much a part of the daily fabric of life of Daxi, is Daxi like a museum?

What if Daxi were a museum?

一座保存「生鮮文化」的博物館

A Museum That Preserves "Fresh Culture"

無論是自然環境，還是在地的生活與信仰文化，這些特質的融合，讓大溪成為一座獨特的老城。想更加認識大溪，不可不提在地的「大溪木藝生態博物館」（以下簡稱「木博館」）；不只是一棟保存文物的建築，專注貫徹「生態博物館」精神，將大溪的地方知識分門整理，不僅是保存，更強調靈活應用，再延伸創造更多的分享與體驗，以多元的營運方式，串起人們與大溪歷史、文物、生活文化與信仰的緊密關係。無論身在大溪何處，這裡的一草一木、歷史建築、還是大溪人的文化記憶、正在發生的日常……都是鮮活又富有生命力的館藏。整座城市的過去、現在與未來，任你體會、擷取與感受，甚至歡迎你成為參與、創造歷史的一份子。

The eclectic of natural environment, local life and faith culture give Daxi its unique identity. To know more about Daxi, one must call attention to the local " Daxi Wood Art Ecomuseum" (hereinafter referred to as "Wood Art Ecomuseum" or "museum"). The museum is much more than a building for housing and preserving cultural relics; it's also a an architecture that upholds the spirit of an "ecomuseum," as it curates nuggets of knowledge of Daxi from different aspects: it preserves, it emphasizes a versatile application, and extends the knowledge to create more community sharing and experiences, so that Daxi's history, cultural relics, living culture and faith can be woven to resonate with people through diversified approaches. No matter where you are in Daxi, every grass, tree, historical building, or cultural memory of the people of Daxi, and the daily life that is happening here...they all serve as the vivid collection of the Wood Art Ecomuseum. The past, present, and future of Daxi are yours to experience and feel, and you are even welcome to be a part of the creation of history.

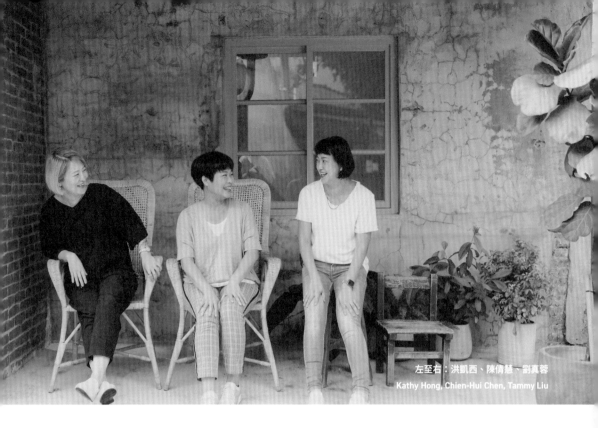

左至右：洪凱西、陳倩慧、劉真蓉
Kathy Hong, Chien-Hui Chen, Tammy Liu

陳倩慧 Chien-Hui Chen

新竹人，自 2012 年起參與推動成立木博館，並於 2015 年開館時擔任第一任館長至今。過去對信仰沒有特別記憶，卻在來大溪之後被這裡的遶境文化及社頭子弟精神深深感動。

A native of Hsinchu, she has participated in the establishment of the Taoyuan City Daxi Wood Art Ecomuseum since 2012 and has served as its director since then. At first, she didn't have any particular memory of faith, but after coming to Daxi she was deeply touched by the procession culture and the spirit of the Shetou community in Daxi.

劉真蓉 Tammy Liu

豐原人，衍序規劃設計顧問有限公司共同創辦人。小時看著阿嬤的拜拜行事曆，即是她對宗教最深刻的記憶之一。認為「大溪大禧」是一個設計師鍛鍊技藝的武場，同時也是讓地方展現自己的主場。

Tammy hails from Fengyuan in Taichung and is the co-founder of BIAS Architects. One of her most profound memories of religion, is reading her grandma's temple worship calendar as a child. She believes that "Daxidaxi " is the best training ground for designers to hone their skills, and also a place for them to express themselves.

洪凱西 Kathy Hong

本名洪家琪，現任雲門文化藝術基金會執行總監。兒時在左營長大，對信仰活動記憶最深的是爬刀梯的橋段。覺得「大溪大禧」是一個很好的橋樑，牽起在地人也牽起外地人，互相分享交流地方文化魅力。

Her real name is Chia-Chi Hong, and she is currently the Executive Director of the Cloud Gate Culture and Arts Foundation. Growing up in Zuoying, Kaohsiung, she vividly remembers the "climbing a ladder made of knifes" ritual during temple processions. Kathy thinks "Daxidaxi" serves as a good bridge for local people and foreigners to share and exchange the character of local folk culture.

博物館裡的全城慶典
City-wide celebration
in the Daxi Wood Art Ecomuseum

經過多年整理，木博館為「探索大溪文化」提供了由簡入深的途徑。打破靜態展現文物的制式，拓寬在地知識文化的體驗，創造地方與外界參與的平台⋯⋯致力將整個大溪打開，「木博館讓全大溪都變成一座鮮活博物館。」究竟如何做到？本篇請到木博館長陳倩慧、「大溪大禧」總策展人劉真蓉，同時也邀請到臺灣許多重要藝文活動之推手的雲門文化基金會執行總監洪凱西參與對談。透過博物館學操作、策展與設計力介入推動文化保存、地方慶典的復興，甚至到文化活動的體驗推廣與行銷⋯⋯等不同層面，來一探究竟木博館的獨特，與「大溪大禧」的多面影響力。

After many years of compilation and consolidation, the Museum provides a way to "explore Daxi culture" from the surface to the deep. By transcending the conventional static displays of cultural relics, broadening the experience of local knowledge and culture, and creating a platform for local and external participation... we are committed to opening up all of Daxi. "The Wood Art Ecomuseum has been transformed into a living museum for all of Daxi. " How was this achieved? In this article, we invited Chien-Hui Chen, the director of the Wood Art Ecomuseum, and Tammy Liu, the chief curator of "Daxidaxi", as well as the Executive Director of the Cloud Gate Culture and Arts Foundation, Kathy Hong, who is the driving force behind many important art and cultural events in Taiwan, to participate in the conversation. We will explore the unique character of the Museum and the multifaceted influence of "Daxidaxi," covering museum operations, curatorial and design interventions for cultural preservation, the revitalization of local festivals, and the promotion and marketing of cultural events.

Q：首先請三位和我們介紹一下自己的工作內容。

陳倩慧（以下簡稱館長） ｜我的工作其實跟一般人想像的館長蠻不一樣的；因為任職於一個地方型博物館，經營的是「地方」，所以我會常接觸的是地方居民，還有地方的生活文化。我們是從第一線的角度談「地方生活、文化，怎麼被看見？」這件事。

木博館是個活的博物館，它不會只是做靜態的歷史研究、古物典藏與展示。我們在做的是地方知識、文化的發掘，這些內容很多是在地居民累積下來的。由於人的長期經營，跟這個地方的風土與環境互動形成自己的生活樣貌，且持續產生有機的變化。木博館強調怎麼發掘這些具地方特色的文化，然後讓地方成為主角，看見自己的價值。就博物館的角度來講，這是在生活中進行活的保存、發展，絕對不是進到博物館裡變成靜態展示，那就像是「死了的文化」。所以你問我木博館在做什麼，<u>我想我是在推動由地方參與經營的一種運作模式的博物館，是培力居民自己當主角及經營自己生活文化的地域博物館。</u>

洪凱西（以下簡稱凱西） ｜因為表演藝術是個團隊的行業。我本身不是創作者，我的工作簡單來說，其實是在<u>協助創作者所創造的藝術，所以會從過程中協助他們創作。創作完成之後，再來思考可以怎麼跟社會溝通。</u>我本人始終相信藝術可以改變些什麼，不管是用潛移默化，或者是當頭棒喝的方式。

Q. First of all, please tell us a little bit about your work.

Chen Chien-Hui (Hereinafter referred to as "Director"): My job as a museum director is quite different from what people perceive it to be. Since I work in a regional museum, "communities" are the mainstay of my work, and I often come into contact with local residents, their life and culture. Which is why we are exploring "ways to ensure the visibility of local life and culture" from a front-line perspective.

The Wood Art Ecomuseum is a "living" museum that focuses on more than the static historical research process and the display of antique collections. What we are committed to is the discovery of local knowledges and cultures, many of which are accumulated over the years by local residents. The systematic management of people is defined by the interaction between local customs and culture, which gives rise to a distinct lifestyle, which continues to produce organic changes. The Ecomuseum emphasizes discovering the culture with local characteristics, and let the locality become the protagonist of its own story, its own value statement. From the museum's point of view, this is a daily preservation and development experience of something that is alive, and it's distinct from a static display in a museum, which is like a "dead culture". Therefore, if you ask me what I am responsible for as a director of Wood Art Ecomuseum, <u>I'd say that I am promoting a museum that encourages local participation, a regional museum where the residents themselves are the protagonists, who celebrate their own living culture.</u>

劉真蓉（以下簡稱真蓉）｜我的工作內容主要是在策展，城市就是展場。由於我是空間背景出身，我常覺得我在策劃的就是「這個空間與其應該發生的事」，很像在創造什麼，但這並非無中生有。「空間」就像是介質，但不限於「空間」，也可能是地方人文風土，人們熟悉的共同記憶與某些情懷，這些值得保存延續的事物，將他們整合起來，長出其樣貌，或許它可能長成一座橋、一本書、一個展覽，或是「大溪大禧」維大力、平安符、一系列儀式、甚至是一場遶境……這些對我來說沒有一定的界線，各種形式的「整合」與「平衡」，就是我與團隊的主要工作。

Q：想問館長何謂「生態博物館」？為何木博館以「生態博物館」為定位？

館長｜關於木博館，我會說，這個博物館並不是政府成立了一個博物館，而是整個大溪一起成立了博物館。

生態博物館其實在國外已經推動許久，2012-2014 年在討論大溪警察宿舍群修復再利用的功能定位時，我們認為生態博物館是個很適合大溪的運作方式。進入這裡的街區生活及廟會慶典之後，讓我很感動；大溪人會跟公司請三天假只為了回鄉為關聖帝君慶生，下班自發夜練、人力不夠還會互相協助……不只這樣，大溪人很會說故事，跟他們聊天會發現「哇！任何一個故事都好精彩」，但他們只是把從阿公阿嬤流傳下來、累積逾百年的大小事分享給我，無論是房子、照片或是物件，本身就很有歷史文化感，而且他們真的就生活在老街區及格局特別的老建築裡。

Kathy Hong (Hereinafter referred to as "Kathy"): Performing arts functions as a team. I am not a creator myself; my job, simply put, is to help the creators in their creation experience. After the work is done, I think about how I can communicate the character of the finished item with society. I always believe that art can effect change, whether it's by subliminal influence or by a head-on approach.

Tammy Liu (Hereinafter referred to as "Tammy"): Curation makes up the lion's share of my work, and the city is the exhibition space. Since I come from a background of spatial design and planning, I often feel that what I am curating is "this space and what should happen to it." It's very much like creating something, but it's not making something out of nothing. "Space" is like a medium, but it is not limited to "space," it can also be manifested in the local culture and customs, the shared memories and certain feelings that people are familiar with, and these things are worth preserving and continuing, plus an integrative process into their own distinctive narrative. This may come in the form of a bridge, a book, an exhibition, or a "Daxidaxi" Vitali, a peace charm, a series of rituals, or even a religious procession... There are no boundaries to me, and the "integration" and "balance" in various forms is what my team and I are mainly involved in.

Q. My question to the director is what is an "Ecomuseum"? Why is the Wood Art Ecomuseum positioned as an "eco museum"?

Director: I would say that this museum is not a museum set up by the government, but a museum set up by all the people of Daxi together.

那時我便覺得，這裡如果有博物館，那一定就是在居民的生活場域裡面。

當時其中一個任務，是先把這些日治時期的廳舍及職員宿舍都登錄歷史建築並完成修復，它們是這個城鎮的一部分，但不是大溪的全部，很多精彩的東西都在生活街區裡，不可能只經營宿舍群，少了任何一部份都不完整。對居民來說，「歷史建築到底要不要保留？」他們會持肯定答案。但，「留下之後要做什麼？」才是重點。如果只是延伸經營咖啡店或餐廳，他們只會覺得這跟自己無關。我們希望這些事跟在地人有所關聯，所以我們覺得這些宿舍群的經營跟大溪的街區生活，應該要一起看。

一開始木博館成立的想法，就是我們是「夥伴」，不是「上對下」的關係。包括在地的街角館、社頭組織、木器行與博物館的宿舍群……大家都是這個網絡裡的一份子，每個人有不同分工，扮演自己的角色，一起共創，加起來就是一個能讓人看見大溪魅力的強大網絡啊！雖然一開始這裡的人不太了解「生態」的意涵，<u>因為他們所認知的博物館一直都是在一棟建築裡的。</u>木博館要做的，就是

In fact, there have long been examples of ecomuseums overseas, with a celebrated history. From 2012 to 2014, when considering the restoration and reuse of the old Daxi police quarters, we had affirmed Daxi is perfect for an ecomuseum locale. After getting immersed in the local life and temple festivals, I was deeply moved by the fact that the people of Daxi would take three days off from work just to go back to their hometown to celebrate the birthday of Guan Sheng Dijun. They would practice at night of their own volition after work, and they would pitch in when there was not enough people around... Not only that, the people of Daxi are excellent storytellers. When you talk to them, you will be overwhelmed, and they surely have really captivating stories to tell!

However, they are just sharing with me the things that have been passed down from their elders for over a hundred years. Whether it is houses, photos or objects, a sense of history and culture is always there, and they really exist in the old neighborhoods and old buildings with special layouts.

At that time, I thought, if there were to be a museum here, it must be integrated with the living area of the residents.

One of the tasks of that time was to first document and repair all the halls and staff quarters from the Japanese colonial period as historical buildings in a registry. They are an integral part of the town, but do not encompass all Daxi has to offer. There are many wonderful things happening in the local communities, and it is impossible to deliver them in a mere dormitory complex, as it is not complete when any part of the puzzle is missing. For residents, the particular question - "should we preserve

慢慢地把大溪價值及自明性建立起來，工作重點可能是陪伴居民整理自己的空間及找出經營特色，或是一個像「大溪大禧」這樣的活動，慢慢把大溪推廣出去。博物館希望成為「把想要一起為大溪努力的人連起來的平台」，以此願景努力經營，讓這裡更好。

在木博館正式成立前，我們已有了「街角館」的想法；當時想說，豐富精采的大溪就在街區裡，我們想在街區裡找出想分享故事的人和空間，只要他願意成為一個館，他即是博物館。不同館不同主題，各有特色，每個館都可以做自己想做的主題，分享與展現他自己的故事與生活樣貌。大溪最特別的就是你看見的都不是電影場景，大家都在這個活的場景裡真實活著，說出來的故事就是大溪在地的故事，大家都是博物館的一份子。

Q：「大溪大禧」為何說是博物館學實踐的一種方式？獲得了什麼樣的效益？

館長｜地方博物館在談的是博物館如何做地方知識文化的保存、發展、推廣……等這類的事。一個地方的知識文化即是寶物，要怎麼讓這些寶物被看見，這些寶物已經傳承百年依舊活著，那我就沒必要把這些活的東西放進博物館，變成只是個靜態的物件在館內陳列。我希望讓大家在這個活動現場，去認識這些事，策劃「大溪大禧」就是透過與設計的結合，為這些「活著的文化資產」開創出能讓更多人參與的管道。

一開始看大溪遶境時，我只能當個觀眾在旁邊看陣頭經過。我們就在想「如果可以創造一種途徑，讓人不僅是觀眾，也可以一起成

historic buildings or not?" - would always be met with an affirmative answer. But, "What should we do with it?" is the key point. If it's just an extension of a coffee shop or a restaurant, they will feel that it bears no relevance. We want these things to be relevant to the local people, so we think that the operation of these dormitory complexes and the life of the neighborhood in Daxi should be seen holistically.

The idea behind the establishment of the Museum was that we are "partners", instead of a "top-down" hierarchical relationship. The network includes local corner shops, Shetou organizations, woodcraft workshops and the dormitory complex of the Ecomuseum... everyone is a part of this network. Each person has a different responsibility and role to take and play, and together, we can jointly create a powerful network that can proudly present the delight of Daxi on an international stage! Although the people here didn't quite understand the meaning of "ecosystem" at first, since their concept of a museum was a stereotypical museum building. What the Ecomuseum is trying to do, is to slowly build up the values and self-awareness of Daxi. The focus may include support of the residents to organize their own space, and formulate the highlights and features of the space, or an event like "Daxidaxi" to patiently promote Daxi. The museum hopes to become "a platform to connect people who want to work together for Daxi," and to carry this vision and strive to make this a better place.

Before the official establishment of the Ecomuseum, we already had the idea of a "corner museum"; we wanted to encapsulate the rich and wonderful context of Daxi in the neighborhood, and we wanted to find people

為一份子」的方式。例如像是 2022 年企劃的「正氣步」，或周邊商品的販售，來推廣大溪的「迎六月廿四」。同時，這一年我們也開創很多的街角館據點協助販售周邊商品，這也是很好的嘗試。每個街角館都變成協助推廣的一份子，而人們透過買商品，也成為投入這個文化的一份子。許多地方媽媽熱購「大溪大禧」繪本，說要把這個故事回去分享給孩子，聽了很開心！

真蓉｜發現很多購買繪本的都是大溪在地人呢！甚至是在臺北聖興天后宮，在關聖帝君生日那陣子，供桌上居然放著一本繪本（還是普濟堂與帝君的跨頁）！聽說另一間也出現繪本的廟宇是在桃園市！達到了很棒的宣傳效果，也把觀眾的範圍打開了。

館長｜「大溪大禧」最核心的就是讓大溪的慶典知識與文化透過設計的方式傳遞，以創新開放的方式產生影響力，吸引更多人一起開創，讓更多人都可以成為文化傳播的一份子，也就是多元參與，而且不分年齡。今年有個點讓我印象深刻，由小學生組成的將軍、舞龍、舞獅遶境隊伍「小社頭聯盟」，因為疫情一直都不能訓練，原本一直以為他們可能今年無法參與，沒想到後來發現家長們都願意簽署同意書讓孩子來參加，讓人感受到大溪人來參與「大溪大禧」的光榮感。

雖然實際的經濟效益我們並沒有認真去統計，但有收到一些迴響：例如參與合作的維大力給予銷售頗佳的回饋，也聽到很多店家說有客人一口氣購買好幾個正氣包與繪本。不只是大人，很多孩子甚至指名要家長幫忙

and spaces in the neighborhood who wanted to share their stories; as long as they are willing to become a museum, they are a museum. Different museums have different themes, each with their own characteristics, and each museum can curate its own theme and showcase its own story and life. The most special thing about Daxi is that what you see is not a movie scene, but a live scene in which everyone is actually living and telling the story of Daxi, therefore everyone is a part of the museum.

Q. Why is "Daxidaxi" an approach to the practice of museology? What kind of benefits have been achieved?

Director: Local museums are dedicated to preserving, developing, and promoting local knowledge and culture. The knowledge and culture of a place is the treasure; ensuring visibility of these treasures is the focal point. Some of these "treasures" have been passed down for a hundred years and are still alive, so there is no need for me to put these living things into the museum and downgrade them into mere static objects to be displayed in the museum. I hope to help people know these things at this event, and through the combination of design and planning, "Daxidaxi" aims to create a channel for more people to be involved with this "living cultural assets" initiative.

At the beginning, when I saw the annual Daxi religious procession, I could only be a spectator and watch the parade formation pass by. We thought, "What if we could create a way for people to not only be spectators, but also to be a part of it? For example, people were active in the "Holy Generals Steps" (Cheng Chi Bu) project in 2022, the sale of merchandise and memorabilia to promote the "Welcome June 24" in Daxi.

買正氣包與貼紙，家長即便驚嘆價格，但設計實在太討喜，忍不住買了下去。

Q：2015 年至今，木博館有什麼特別難忘的挑戰嗎？

館長｜頭幾年比較辛苦的是，我們是用一個新的方法來為這些傳統的事物做轉譯及推廣，可是要與在地的老人家溝通與對接是很不容易的，他們覺得用原來的方法就可以做到，而且也不太聽懂我們在講什麼。不過事情總會有個開始，有幾個老人家願意用比較開放的胸懷，他開始聽懂我們想說的，但發現自己不行，於是帶著社裡的年輕人來跟你一起合作，溝通平台終於在被質疑了近三年之後，漸漸出現。

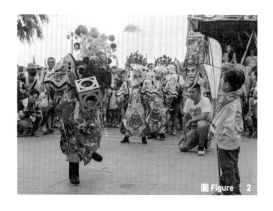

圖 Figure 2

「迎六月廿四」能夠持續這麼久，是因為地方人們在意傳承的問題，過程中他們也體會到，木博館很認真的面對信仰傳承這個問題而且用了一種新的方法，也逐漸影響年輕人開始慢慢用這樣的方法去推動。他們以前不懂保存文物，現在學會把倉庫裡的物件分類保存，為社內或是生活裡的文物做記錄。起初好像不懂我們，可是後來發現木博館真的

This year, we also created many corner stalls to help sell memorabilia products, which is also a constructive experiment. Each corner stall has become a part of the promotion experience, and people have become part of the culture by buying the products. Many local moms are buying picture books, saying that they want to share the story with their children, which I am very delighted to hear!

Tammy: I found that many of the people buying picture books are locals from Daxi! There was even the pop-up picture book on the altar at a Mazu Temple in Taipei on the birthday of Guan Sheng Dijun (even the cross-page of Pu Ji Temple and Guan Sheng Dijun)! I heard that another temple that launched picture books was located in Taoyuan City! It was a great promotion and helped expand the horizons of our audience!

Director: The core objective of "Daxidaxi " is to allow the knowledge and culture of Daxi to be conveyed through design, to generate influence in an innovative and open manner, and to attract more people to co-create, so that more people can become part of the cultural transmission process; that is, diverse participation regardless of age. I was also impressed by one thing this year, the "Little Shetou League", which was participated by elementary school students portraying generals, dragon dancers, and lion dancers. I didn't think training was possible due to the pandemic, and assumed they might be absent from the event this year. I was pleasantly surprised to find that parents were willing to sign consent forms for their children to participate in the event, which reflected the sense of pride that came from being part of the activity.

Even though we have not yet figured out the actual economic benefits reaped, we have

還蠻認真的想要去懂他們了，就像「大溪大禧」，也讓他們相信說，這是透過大家一起努力的成果。

Q：木博館未來想要做什麼樣的嘗試與企劃嗎？

館長｜就「大溪大禧」來說，我覺得可以再延伸「慶典與食衣住行」的各種面向。把這些面向串連，也或許會帶動店家服務品質的提升。另外就是希望將「吃辦桌」這件事重新回到生活裡；以往回鄉拜拜號召親朋好友來吃辦桌是很鮮明的記憶，近年已經鮮少。在連續劇《神之鄉》裡也有演到這樣的片段，在農曆六月廿四日這天會遶境也會辦桌，準備很多的料理、擺桌，親戚朋友都會回來吃飯……「拜拜辦桌」的復興可能不容易，但希望之後也能用不同的方法讓更多人感受到早期大溪人這個重要的生活記憶。

Q：想問真蓉，在你的角度來看，木博館的特別之處？

真蓉｜我覺得木博館很特別，因為他不是真的有棟建築，反而是一開始就告訴你，這個

received positive feedback already: for example, we have received encouragement from our partner, Vitali, the beverage maker, about the great sales figures. We also learned that many customers are lining up to purchase Cheng Chi Bags and picture books. Besides interests among adults, many children also asked their parents to pick up the Cheng Chi bags and stickers for them. The price of the bag was over the budget for many parents, but the design was simply too appealing for them to pass up.

Q. Has the Wood Art Ecomuseum encountered any particular challenge since its debut in 2015?

Director: Admittedly the first few years were a bit hard. We adopted a new method to translate and promote the traditional cultural elements, but communicating and engaging with local elders was still difficult. They felt they could do it the conventional way, and they didn't really understand what we are trying to achieve. But to start something you need to take the first step, and a few elders were willing to embrace the idea with an open mind, and began to understand what we wanted to convey. They found that little could be achieved when they did this on their own, so they brought several youth in the community to work with us, and a

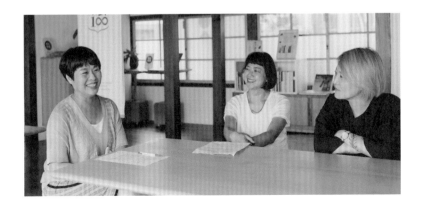

城市就是一個博物館，每個城市人都是館員，這件事很生動。我是學空間的，當這個城市也代表其文化本身，對我來說是非常迷人的。而且這個博物館並沒有館藏，它不是要特別收藏什麼，而是城市正在發生與存在的人事物即是文化，你的所聽所見，都是真實的故事，而且每天都有變化。不僅在保存，同時也在與人互動交流，以及達到教育意義，這些同時都在大溪木博館內並存，我還沒有過這樣的體驗，非常特別。

Q：承上題，「大溪大禧」與妳經手過的專案有什麼不同？挑戰又是什麼？

真蓉｜目前大概累積了五年多，老實說每年幾乎都有不一樣的挑戰。大溪特別的是她的地域性強烈，所以「大溪大禧」的登場，要凸顯這個城市的個性與身份，希望透過「一個穿越當代設計以及民俗信仰的城市祭典」的目標來做努力。

除了努力地生出「大溪大禧」這個嶄新的名稱，搭配延伸的也必須是以當代設計的元素加入。並且必須實際讓人們想要進入這座城市，讓大家看到她的信仰特色，也看到這裡的各種生活樣貌與文化，就像走進一個真實的博物館，所見所現都是這座城市重要的基底，而不只是舉辦一場廟會然後就此結束。

當然，執行跟真正參與有著不同挑戰；一開始對這裡的人來說，這些想法太創新了，光是要先說服不同領域和背景的業主們，就超級困難。業主除了木博館，還包含民俗技藝協會 (1)、三十多個社頭，以及廟宇（普濟堂）的主委、總幹事……你必須帶著簡報一一和

communication platform finally emerged after nearly three years.

The reason why the "June 24 Reception" event has lasted so long is that the locals are concerned about the issue with heritage, and in the process, they have come to realize that the Ecomuseum is very serious about addressing these concerns and adopted a new approach, which has positively influenced the youth to resonate with this approach. They previously did not know how to preserve artifacts, but now they have learned to classify and preserve the objects in the warehouse, and make records of the artifacts in the Shetou organization or in their lives. At first, it seemed that they did not understand us, but later they found that the Ecomuseum was really serious about understanding them, just like the "Daxidaxi" event, and even convinced them that this was the result of our joint efforts.

Q. What kind of projects do you want to do in the future?

Director: In the context of "Daxidaxi ", I think we can further extend the various aspects of the relationship between "celebration and food, clothing, living and transportation". By linking these aspects, we may be able to improve the service quality of stores. In addition, I hope to bring back the event of "streetside banquets" (Bando) to life; the vivid memory of friends and relatives joining a Bando banquet after a worship ritual has grown rare in recent years. In the TV drama series, "The Summer Temple Fair," is a scene in which a streetside banquet is set up on the 24th day of the 6th lunar month, and many dishes are prepared, with many relatives and friends joining in the feast... It may not be easy to revitalize the streetside banquet after a worship ritual, but I hope that in the future, different

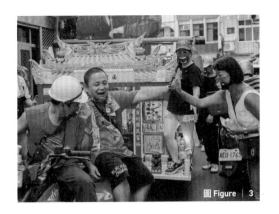

圖 Figure | 3

他們拜會、說明，讓在地人知道，這個計畫並不是為了自己，而是為了推廣這座城市與「迎六月廿四」的文化，是為了大溪人。你得要去了解大溪的三十多個社頭，真正認識他們的背景，才有辦法向這些社頭人，提出希望一起參與一個嶄新遠境的想法，雙方開始進入比較可以交流與理解彼此的階段，並且一起達成。

再來，設計介入與藝術性的顧及也是挑戰。設計不希望只是做表面，設計師參與時必須要對大溪有著足夠的了解，透過各式各樣的思考與設計方式，與在地人的生活樣貌能夠真正結合，做出巧妙的轉譯，這並不容易。同時還必須兼顧藝術性；我們一直在思考，包含「怎樣融入當代設計？」，「大溪如何展現新的祭典形式設計？」或是「從表演藝術來看，它該是什麼樣的秀？」等層面，再去思考有什麼不同的藝術家或是老師們能代表、參與及詮釋臺灣傳統文化。我們希望透過一個更大的展演舞台企劃（包含後面章節將提到的「神嬉舞夜」），來看見在地傳統藝術與創新的整合與展現，不只是表演藝術，也在展現在地文化祭典的設計新語彙。

approaches can be adopted to help more people revisit this vital tradition celebrated in Daxi's earliest days.

Q. My next question is for Tammy. From your point of view, what is special about the Daxi Wood Art Ecomuseum?

Tammy: The Ecomuseum is very special in that it is not really a singular building, but it tells you from the get-go that the city is a museum and everyone in the city is a curator. I have a background in spatial design and planning, and the way this town embraces its culture fascinates me. This museum does not have a collection: it is not about housing specific collectibles. However, the people and events that are happening and existing in the city are part of the fabric of local culture; what you hear and see are real stories, and changes happen every day, not only in the focus on preservation, but also in the engagement with people to achieve educational significance, all of these coexist in harmony at the same time in the Daxi Wood Art Ecomuseum. I have not experienced such a special and profound experience before.

Q. So to elaborate further on the above, what is the difference between "Daxidaxi " and previous projects you worked on? What are the challenges?

Tammy: The event has been held continuously for more than five years now. To be honest, every year presents a different challenge. The special thing about Daxi is its strong regional root, so for "Daxidaxi," which helps highlight the city's character and identity; we hope to achieve this through the goal of "A modern religious Festival in which contemporary design joins folk beliefs."

所以，並非找來設計師或是藝術家來大溪創作就行，「平衡設計」即是我控制的重點之一；參與過的創作者，例如同根生樂團、柯智豪老師，或是造型設計師李育昇，甚至是為關聖帝君打造新形象的廖小子，他們常說來大溪之後，回去獲得更多反饋，他們即把這些獲得繼續帶入創作中，漸漸深根，發展地更完整。他們在「大溪大禧」的創作不一定是他們平時的作風，但是這些創作就是他們融入後的成果。廖俊裕（廖小子）之前並沒有繪製過這類的 IP，但他卻創造出了一個非常討喜的角色，甚至創造出帝君周邊的裝備與其他角色；在我這邊，就是讓他們去創作，但時時去衡量這些元素是否與整體達成平衡，並適時調整。

而這兩年最難的，則是怎麼驅動這個城市裡的人，讓他們與設計一起表現、參與，甚至一起跟我們創造出更多精彩的內容，展現更多他們與這座城市真實的部分，累積出更多精彩的片段，使其不會消失。

Q：在操作「大溪大禧」時，透過各種富記憶點及趣味的溝通方式，打開各種時間與空間的限制，讓人對活動印象深刻，能不能和我們談談這些操作背後的想法與概念？

真蓉｜「打開」這個字眼有點大，我們的訴求就是要讓大眾能夠理解，所以你沒辦法用太高大上的語彙，因此「打開」就變得非常重要，不只是單究空間、時間，基本上它就代表著我們透過層層的轉譯方式，來重新引導人們參與。

In addition to coming up with a new name, "Daxidaxi," while ensuring that the extension must also acknowledges contemporary design elements, we must actually inspire people to want to visit the city, allow them to immerse in the character of its faith culture, as well as the various aspects of life and culture here. It can be likened to a visit to a real museum, and what visitors see is the important foundation of the city, and that it will continue to resonate after the temple has concluded.

Of course, the implementation process presents a different challenge to the actual participation; the ideas were so innovative to the people here at the beginning that it was immensely challenging to convince the stakeholders of different backgrounds. In addition to the Wood Art Ecomuseum, the stakeholders also include the Folk Art Association [1], more than 30 Shetou, and the chairman and directors of temples (Pu Ji Temple). You have to bring a presentation slide to meet them one by one and explain to them, so that the local people would learn that this project is not about self-serving interests, but for promoting the city and the culture of " June 24 Reception," and for the people of Daxi. You have to get to know more than 30 Shetou in Daxi and really know their backgrounds before you can put forward to them the idea of participating in a brand-new procession parade together, so that both sides can start to communicate with each other constructively, and reach a consensus.

Another challenge lies in the incorporation of design intervention and artistic value. The design shouldn't be superficial; designers must have sufficient understanding of Daxi, through a variety of thought processes and design approaches, and the local people's lifestyle can be truly integrated, to make an adept translation,

空間即是現場，讓大溪這個現場表現這裡的城市記憶是很重要的；我們很希望帶大家回到這裡，好好認識與看見它的生活樣貌。每個現場會展現出什麼表現與畫面，我們都有所想像，並且設法實現它。當這步規劃達成之後，接下來我們希望將這些畫面與片段輸出，於是企劃了第二現場：關公Online——也就是線上化，讓無法來親身參與的人們，也能有機會（無論是否與現場同時）參與這場盛事。插畫家廖國成協助我們繪製出大溪的地圖，網站設計黑洞為我們製作出了好用又具互動感的官方網站。因為疫情這個機緣，催生了這個想法，讓參與遠境真的打破現場限制，甚至還能在線上求籤，真正地無遠弗屆了。除了Online，我們透過與通訊軟體line的合作，開啟了城市探索的互動遊戲。透過「大溪大禧」來造訪大溪的人們，藉由這款遊戲的帶領，你可以和不同在地店家互動，甚至獲得獎勵，城市裡的生活學能很輕鬆的在遊戲當中汲取。透過這些方式，人們可以將現場記錄在線上，也可以讓人在線上看到跨越時間性的紀錄，從空間到時間的突破，也就把城市記憶打開，散播出去了。

除了前面說的之外，另一個不可不談的即是「行銷」，它就是一種很重要的打開。並非每個人都了解什麼是「大溪大禧」與這裡的文化，但是透過各種不同的轉譯，就能夠讓更多的大眾了解。每個人從當中看到一個有趣的點，無論是跟著跳正氣步或是買正氣包，他就可能分享出去讓更多人認識「大溪大禧」。每個人都能用自己的方式去傳播，這就是最大的打開，也是讓這個文化永續傳承下去的重要力量。

which is far from simple. At the same time, we have been thinking about "how to incorporate contemporary design? or "Ways to enable Daxi to present a new form of festival design," or "putting out the kind of shows that references the viewpoint of performing arts." We are looking for the kind of artists or experts who can represent, participate in, and interpret traditional Taiwanese culture. We hope that through a larger stage project (including the " Danceing with Gods"（神嬉舞夜）to be mentioned in the next chapter), we can witness the acoustic integration and presentation of local traditional arts and innovation, not only in terms of performing arts, but also in terms of the design of a new vocabulary of local cultural festivals.

Therefore, it is not just a matter of finding designers or artists to create in Daxi, but the aim for "balanced design" is one of the key points under my management. The creators who have participated in the project, such as the A Root Orchestra, Mr. Blaire Ko, or stylist Yu-Sheng Lee, or even Chun-yu Liao (@Godkidlla), who created a new image for Guan Sheng Dijun, often say that after they came to Daxi, they received more feedback, which they continue to bring into their work. Overtime, they have grown more entrenched and blossomed in their endeavors. Their creations in "Daxidaxi" are not necessarily their usual repertoire, but these creations are the result of their blending and integration. Godkidlla had never illustrated this kind of IP before, but he created a very likable character, and even created the equipment and other characters around Guan Sheng Dijun; on my side, I give them free reign to create, but I always measure whether these elements are in balance with the whole and make adjustments accordingly.

Q：「大溪大禧」其實是促進在地城市祭典的品牌化與國際化，這件事為何重要？

真蓉 │ 對我來講，「大溪大禧」的重點固然是行銷大溪，但它背後真正的核心價值，其實是臺灣原鄉城市與文化的塑造與展現。大溪有好山好水的環境，有自己獨有的信仰中心與生活文化，這些人事物非常具體且清楚，因為清楚，別人得以有所投射。我們希望的就是有越來越多的人與城市可以有這樣的投射，讓這樣的事情在不同城市都可能產生。

「大溪大禧」可以說是一種文化品牌的建立，而且是經由在地文化底蘊層層轉化而產生的原型（Prototype），當這個品牌帶動觀光，透過這樣的層層串連，讓更多人注意到地方的價值與文化魅力。

「國際化」很難舉出具體規則或方式去推動，或許先從「成為自己」開始，找出與長出每個地方自己的樣子。很想問凱西，妳覺得怎麼樣的特質會吸引國外人士想參與？

凱西 │ 「大溪大禧」本身已是一個聲勢很大的品牌，你可以繼續加入不同的內容，但不需要刻意去做「聯名」，不需要借重別的資源，來讓自己建立的品牌更加豐厚壯大。因為這裡的文化性已經夠豐厚了，各種娛樂節目絕對可以帶來不同的有趣體驗，但核心還是在地獨特的文化底蘊。

我自己倒是想談談時間性，因為真正農曆六月廿四日遶境的日子如果在平日，一般人就很難來參加。對於在地的受眾，他們可以透過提前在週末辦的「大溪大禧」開幕式來參

The most difficult thing over these two years is how to inspire the people in this city, so that they can express, participate and even create more exciting content with us, showing more of their real part with this city, accumulating more exciting pieces so that it will not disappear.

Q. As "Daxidaxi" went on, we adopted various methods to evoke the memories and fun-filled communication approaches, to dissolve the traditional constraints of time and space, making it possible for visitors to experience Daxi beyond those constraints. Can you talk to us about the ideas and concepts behind these operations?

Tammy: The word "dissolve" is a bit far-reaching. We simply want to appeal to the public, and that rules out long, cumbersome vocabulary. Therefore, "dissolution" becomes very critical, and it's not just about space and time. In a nutshell, it means we inspire public participation through multidimensional interpretation.

Space is the site, and it is important to allow the site of Daxi to encapsulate the memory of the city. We have imagined what expressions and images will appear in each scene, and we have tried to realize them. Afterwards, we wanted to export these images and clips, so we planned a second site: DaxiDaxi Online, meaning that it's gone viral, so that people who could not come to the event in person could enjoy it by participating virtually (whether or not they were there at the same time). Illustrator Kuo-Cheng Liao helped us draw the map of Daxi, and web designer Black Hole helped us to create a useful and interactive official website. This idea was borne of pandemic prevention measures, and procession parade participation has really transcended physical constraints, and even the ability to ask for fortune-telling sticks online,

與，但對國際人士來說，只要他們想來就不會是問題，反而是讓這個活動慢慢加入更多不同的東西。像剛剛妳們提到在地社頭，我就很有興趣，想去拜訪看看，跟他們聊天喝茶聽故事，變成較深度的旅行與走讀。我期待每次來都有驚喜，或是可以體驗新事物，但我不會知道那個是什麼，直到你們生出來，才有驚喜感啊！

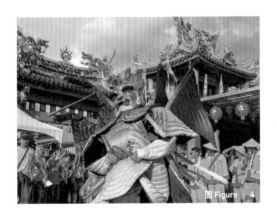

圖 Figure│4

以外國人的視角來看，這樣的活動很神祕、有趣，因為這個宗教是他們不熟悉的，但當中有很多的美學，不管是穿的，建築物本身與儀式性，都很有吸引力。更可貴的在於，一個地方慶典沒有很偏限的受眾，而是真的能吸引大眾（for all），我想這代表你們想的其實都有做到。

Q：有什麼令凱西難忘的文化活動與節慶嗎？

凱西│因為職業的關係，我大部分參與的是藝術或音樂相關的慶典，有個讓我印象深刻的，是在澳洲南部的塔斯馬尼亞，當地每年六月有個名為 Dark Mofo（暗黑藝術節）的活動。由於南半球六月是寒冬，那裡又靠近南極，黑夜因此比白天長，大部分都在黑暗中。Dark

which is truly amazing. In addition to the online format, we have started an interactive game of an urban exploration adventure through a partnership with LINE, an instant messaging app. People who visit Daxi through "Daxidaxi" can interact with different local stores and even pick up rewards through the game. The learning of life in Daxi can be easily drawn from the game. In this way, people can experience the scene online and offline, transcending space and time constraints, and opening up the city's memory and disseminate it.

In addition to the above, another important thing to talk about is "marketing," which is a very important aspect of "the launch". Not everyone understands what "Daxidaxi" and its culture is, but through various translations, it can be accessible to a wider public. Everyone sees something interesting from it, whether it is dancing with the Cheng Chi Formation or buying a Ching Chi Bag, may share it to let more people know about "Daxidaxi". Everyone can spread the word in their own way, and this is the greatest way to "open up" the site, and an important catalyst to keep this culture alive.

Q. Why is it important to promote the branding and internationalization of local city festivals and celebrations, such as through "Daxidaxi"?

Tammy: To me, the focus of "Daxidaxi" is certainly to market Daxi's sights and sounds, but the real core value behind it is actually the shaping and presentation of Taiwan's indigenous city and culture. Daxi is blessed with a beautiful natural environment, its own unique faith center and living culture, and these people and things are very specific and clear. It is precisely because it's clear that others can project it. What we hope is that this projection

Mofo 為期十天，整座城市都會有很多的藝術表演活動，全城都會點上火把與紅色的燈，散發出一種黑暗與邪惡的感覺，火和黑與紅即是主要元素，黑暗又讓人聯想到邪惡、鬼怪啊……等等，最後一天他們還會燒掉一個很大的裝置藝術（一隻狼），完成這個儀式感。

訪客在黑暗又詭異的氛圍中能參與各種體驗；包括有神秘氛圍的餐會（而且是請知名餐廳或品牌聯手登場），各種演出、市集……甚至會故意到表演快開始前，才通知觀眾在何處集合與演出，Dark Mofo 透過販售各種有趣的體驗，讓人在充滿神秘感的城市中探索。不只口碑累積豐碩，連當地人也非常買單。

真蓉｜這些活動通常都會把周邊交通、建設與設施等細節籌備好，給予訪客一個完整的體驗感。而且他們也會針對不同服務收費，讓我聯想到 Museum Night（博物館之夜）(2)，這個活動也是標榜打開博物館，創造更多活動與民眾交流，如果把這樣的概念放在大溪，讓各種單位一起來參與，感覺非常適合。

Q：行銷絕對是很重要的一環，時代不同，推廣藝文活動的挑戰會有不一樣嗎？

凱西｜現在因為社會碎片化，每個人的專注力都變得很短暫，可能才走到門口，短短幾步，已經忘記剛剛想到什麼了。所以，現在要讓大家知道一件事，得要花更多力氣跟錢，非常困難。你得讓他有非常特別的體驗，人都是用體驗來記憶的，靠著記憶的累積，讓人持續想回去那個現場，刷新的體驗感，接著人們便會將其傳播出去。

圖 Figure｜5

can be replicated in more people and cities, so that this kind of success can happen in different cities.

"Daxidaxi" can be described as a kind of cultural branding, and it is a prototype created through the transformation of the local cultural heritage layer by layer. When this branding strategy results in thriving tourism activities, linkages derived from such layers will allow more people to appreciate the value and cultural charm of the place.

It's hard to devise specific rules or ways to promote "internationalization," but maybe we should start by "becoming ourselves" and finding and growing our own identity in each place. I would like to ask Kathy, what do you think are the qualities that inspire foreign visitors to participate in the activity?

Kathy: "Daxidaxi" is already a powerful brand in its own right, and you can continue to add different content, but you don't need to deliberately do "crossover co-branding" or leverage other resources to reinforce your brand identity. Because the cultural aspect of the place is already rich enough, and the various entertainment programs can definitely lead to

剛剛真蓉在說她帶兒子去看了一個舞團的表演，他看了怕怕的，可能下一次便不敢進去，因為他的體驗差。體驗不好，你要他再次成為你的顧客，是更加困難的，所以找人來很難，如果大家問我「大溪大禧」如何，我說還好，大家就會覺得「那好像也不用去了吧？」只有讓他體驗非常美好，才有效益。讓體驗過的人幫你做傳播，效益才會擴大。

different and compelling experiences, but the core is the unique cultural heritage of the place.

I would like to talk about the timing myself, because if the actual traditional June 24 procession were held on a weekday, and it would be very difficult for the general public to come and participate. For local audiences, they can participate through the Daxidaxi opening ceremony, which is held on the weekend, but for international visitors, it's not a problem if they want to come. It's a matter of slowly adding more variety to the event. For example, the local Shetou organizations are of particular interest to me. I want to visit them, talk to them, engage with them, and listen to their stories; this will become a more in-depth experience. I expect to be surprised every time I come, or to experience something new, but I won't know what that is until you guys come up with it!

From a foreigner's point of view, such an event is interesting in its mythical appeal, since it's a religion they are not familiar with, but there is a lot of aesthetics in it, whether it's the dress, the building itself and the rituals, it's all very attractive. What is even more valuable is that a local celebration does not have a limited audience, but really appeals to all, which I take it to mean that what you want is actually achieved.

Q. What are the most unforgettable cultural events and festivals you've experienced?

Kathy: My career has led me to participate in mostly art or music-related festivals. One that really impressed me was in Tasmania in southern Australia. There is an annual event in June called Dark Mofo. Since June is a cold winter in the southern hemisphere and it is near the Antarctic, the night is longer than the day and darkness

makes up most of the day. Dark Mofo lasts for 10 days, with many art performances throughout the city, and the whole city is lit with torches and red lights, giving off a feel of darkness and evil, with fire, black and red being the main elements, and darkness reminding people of evil, ghosts, etc. On the last day, They will also burn a large installation art (in the form of a wolf) to complete the ritual.

Visitors can participate in a variety of experiences in a dark and eerie ambience, including mysterious atmospheric dinners (catered by famous restaurants or brands), various performances, markets...the hosts even deliberately put off notifying of the meeting place and the performance until the program is about to start. The event has grown in its celebrity, and wide acceptance of the locals.

Tammy: These events are usually well-prepared. The host pays painstaking attention to traffic, infrastructure service and facilities, to allow visitors to immerse in the experience. It reminds me of Museum Night **(2)**, which also aims to open up the museums and create more activities to engage with the public. It would be very appropriate to apply such a concept in Daxi, so that all kinds of organizations can come together and participate.

Q. Marketing is definitely an important part of the process. Will the challenges of promoting arts and cultural activities be different in different times?

Kathy: Nowadays, due to the fragmentation of society, everyone's attention span has become very short, and they may just have walked out to the door and forget what they have just thought of in mere seconds ago. So, it's very difficult to tell people about a certain matter or experience that requires the investment of more effort and money. You have to give people a very special experience. Memory comes from experiences, and with the accumulation of memory, people keep wanting to go back to that scene and refresh their sense with that new experience. Only then will people help spread the word.

Just now, Tammy was saying that she took her son to see a dance troupe performance, and he was so scared that he might not dare to go in next time because he had a bad experience. If his experience is not good, it will be difficult to make him a repeat customer. So, it is very difficult to attract people to come. If people ask me how Daxidaxi is like, and I replied so-so, then people will think that it is not worth going, right? The only way to be effective is to let experiences be profoundly enjoyable. Let the people who have experienced it help you spread the word, and effects and benefits will expand.

註解

(1)｜民俗技藝協會
「桃園市大溪區社團民俗技藝協會」由各社頭代表組織而成，共同解決各種問題與衝突。

(2)｜博物館之夜
歐洲各國博物館共同響應，在同一天延長開館時間，並透過夜間尋寶、博物館探險、音樂會、光雕秀等活動，陪大家在博物館徹夜狂歡。

圖說

1｜在大溪街道巷弄中，到處都是願意跟你分享很多故事的耆老。

2｜「小社頭聯盟」一起參與傳統遶境。在大溪普濟堂廟埕前，大溪國小的小將軍正在進行拜廟動作。

3｜2022年「與神同巡」中，總策展人劉真蓉（右）與途中的興安社打招呼。

4｜2018年，由服裝設計師陳劭彥為農友團雷神童仔設計的新裝登場。

5｜「大溪大禧」打造全城市的慶典氛圍，讓所有人都能沈浸其中。

Notes

(1)｜Folk Art Association
 "Taoyuan City Daxi District Association of Folk Art" is organized by representatives of various Shetou organizations to partner up and address various conflicts)

(2)｜Museum Night
Museums in Europe would extend the opening hours on the same day. With activities such as night treasure hunts, museum adventures, concerts, light sculpture shows, etc., the museums would accompany the public to revel all night.

Figure

1｜In the streets and alleys of Daxi, there are many elders who are willing to share stories.

2｜Little Shetou League joins the traditional procession. The little generals of Daxi Elementary School are worshiping in front of Daxi Puji Temple.

3｜In 2022, chief curator Tammy Liu greeted Xing'an Society during the "Patrol with Gods."

4｜In 2018, the new outfit for the Leishen Holy Child of Nongyou Tuan was designed by Shao-Yen Chen.

5｜During "Daxidaxi", there is a city-wide festival vibe, allowing everyone to immerse themselves in it.

什麼是「生態博物館」
What is an "Ecomuseum"

若是訪問大溪人，或是博物館館員，「怎麼認識木博館？」很可能得到的答案不止一種。2015 年 1 月 1 日博物館行政組織正式成立，木博館員們因此來到大溪，一起共學、日復一日感受大溪城鎮的作息，藉由種種行動，一步一步建立地方文化永續的動能。

你可曾想像過一座博物館，裡面的收藏每一分每一秒都在變化？甚至，這些收藏能夠自己和觀眾對話、交流，產生新的想法？而觀眾的參與也重新詮釋了收藏？……聽起來像是電影情節，卻很可能是一種容易理解大溪木藝「生態博物館」精神的說法。

和大溪人一起詮釋大溪

2015 年 3 月 28 日木博館，活動宣傳海報以「大溪，我們的博物館誕生」為主題，說明了木博館與居民的關係。而特別設計的博物館全區地圖，匯集了大溪地景上歷經百年發展保存的珍貴資源，地圖中看見母親之河大漢溪流過、老城區的街道與建築、及分布在三層河階臺地上的人文地景，雖然 2015 年開館時，木博館自己修復及開放的場館只有壹號館及武德殿二棟館舍，卻吸引更多在地人一起看著地圖，暢想未來如何串連大溪的街屋及地景，宣示以整個大溪作為空間場域，與大溪人一起詮釋大溪，如此開啟以「我們（WE）」作為生態博物館精神的操作方式。

木博館的創立，是透過與在地民眾由下而上的倡議形成。生態博物館緣起於法國，原創論述相當複雜，經營模式也有實踐上的難題，博物館學家呂理政老師說：「法國起源的生態博物館，經過多年的

(1)
出自《2019 大溪學論壇【地方社群共學的實踐】論壇手冊》中，由呂理政老師撰文之〈實踐居民參與共學行動的博物館──大溪木藝生態博物館共學架構芻議〉

實踐，既然沒有成功發展成為一種廣為接受的博物館類型（Museum type），還不如將生態博物館視為一種博物館運作思維模式（way of thinking）。」**(1)**

博物館經營地方的運作策略是什麼呢？

一般定義博物館的基本功能，包含典藏、研究、展示、教育推廣，以及近年越趨強調的公共服務與社會連結。木博館館長提到，大溪城鎮的人文風貌、自然環境，與從其間衍生的生活方式，都是木博館的鮮活館藏。在此前提下，木博館在大溪做了哪些博物館的事情呢？

首先，以「文化場域」的塑造，作為這座城市博物館體驗的基底：城鎮中橫跨清代、日治，以至近現代歷史的建築群被修復、整理及開放，它們自身便展示著城鎮的發展脈絡，與見證臺灣歷史作用在城鎮的痕跡。今天看到的古厝、日式宿舍與日治時期留下的現代化公共建築與民間場域，一一變成了城鎮博物館不同主題的展區，文化場域的建構，朝向建立具有在地知識性、公共性、公益性的學習場所為目標。

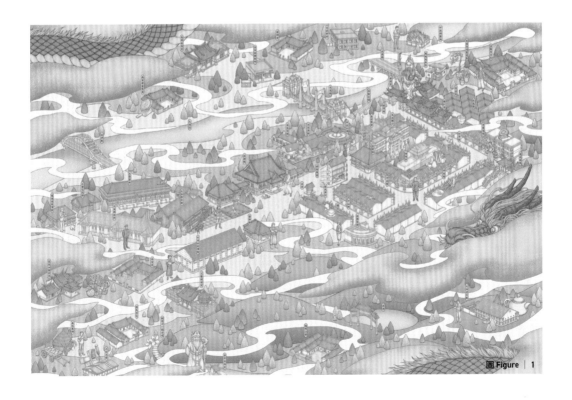

圖 **Figure** ｜ **1**

博物館的價值並不限於空間與藏品，源於其中，可以共享、傳承的知識才是核心。對於用「生態博物館」思維運作的木博館來說，「居民」與「在地生活」並不只是「採集」知識和故事的對象，而是能夠參與、有著自己詮釋的主體。所謂的自己詮釋，不單是將故事講出來，增加事物的多元觀點，而是在傳承推廣、轉譯創新方面，有著強大的主動權。

(2)│街角館計畫

「街角館」由木博館挹注資源，協助原有的城鎮中私有空間成為文化據點，強調培力街角館的經營者，具備博物館角度的思考能力，發展具自身特色，結合現地生活的展示及公共服務文化據點，數年來大溪城鎮中街角館數量逐漸增加，據點串聯形成文化網絡。這些空間場域，便是木博館理念的外延與彰顯。

所以，第二項重要策略，便是持續地培力人才、連結社群，擴大成為「博物館員」的認同感。博物館中除了行政工作者之外，博物館員也可以是參與進來博物館工作的志工、居民、社頭成員……等，讓越來越多人可以用博物館的目光，理解地方，跟博物館一起行動，改變地方。

最後，從公共文化場域的創造，到扶持城鎮博物館中社區社群，生態博物館還需要針對不同議題發展多元行動計畫，運用博物館方法（典藏、研究、展示及教育推廣），把知識傳遞給大眾，同時也累積更多知識。例如：街角館計畫 (2)、大溪的木藝產業文化、慶典文化的保存推廣等等行動計畫。

以上三種博物館經營地方的運作策略，使博物館不會限於單一觀點的象牙塔，也避免博物館片面決定詮釋的內容，進而踏實地串連起人際網絡與相應的空間、資源，落實生態博物館理念。而木博館這樣的工作本質與特性，也在建構「大溪大禧」的路途中，表現得淋漓盡致。

圖 Figure │ 2

木博館的館員深入參與大溪人的生活，一起設置香案桌迎接遶境隊伍。

While setting the incense table to greet the procession team, associates working in the Wood Art Ecomuseum are deeply involved in the lives of the Daxi people.

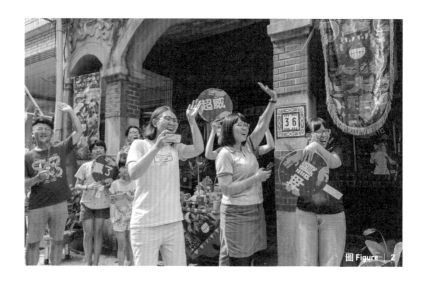

圖 Figure │ 2

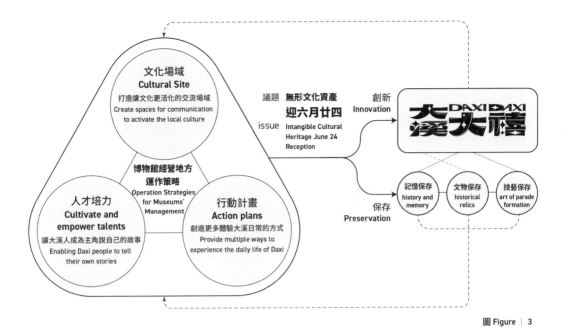

If you are a Daxi local, or an associate working in the museum, how do you get to know the Daxi Wood Art Ecomuseum? There might be more than one answer. On January 1, 2015, the museum's administrative organization was officially established. That being said, museum staff came to Daxi to co-learn and experience the workings of the town day in and day out, gradually picking up the momentum of sustainably preserving local cultural through various meaningful actions.

Have you ever imagined a museum where the collection is changing constantly? That the collection can engage in dialogue and dynamic exchange with the audience and exploring new ideas, that the audience's participation also reinterprets the collection? ... It sounds farcical, yet it may be the easiest way to understand the spirit of the "eco-museum" of Daxi Wood Art Ecomuseum.

Reinterpreting Daxi with the Locals

On March 28, 2015, the Daxi Wood Art Ecomuseum opened its doors to the public. The campaign poster was themed, "Daxi, the Birth of Our Museum," to fully illustrate the relationship between the Daxi Wood Art Ecomuseum and local residents. Furthermore, a purposefully designed map of the entire

museum area brought together the precious resources preserved in Daxi's landscape through centuries of development. The map shows the travel of the Dahan River, the mother river of Daxi, as well as the streets and buildings in the old city, and the humanities that thronged the three-layer river terrace. When the museum opened in 2015, the only two buildings restored and opened were Hall No.1 and the Martial Arts Dojo (Wude Hall), nonetheless, it still attracted slews of locals to study the map, and envision how the streets and landscapes of Daxi can be linked in the future. In so doing, it makes the whole of Daxi as a spatial community to be historically rewritten by the people of Daxi. This is how "WE" was chosen as the spirit of the Wood Art Ecomuseum.

The creation of the Daxi Wood Art Ecomuseum was formed through a bottom-up initiative with the locals. The ecomuseums originated in France, and the original founding precepts were quite complicated, with application challenges in the operation model. Taiwanese museologist Prof.Li-Cheng Lu once pointed out that "Since the ecomuseums originated in France have not been successfully developed into a widely accepted museum type after years of practice, one might as well consider ecomuseums as a way of thinking."

What is the museum's operational strategy in a local context?

The fundamental functions of a museum are generally defined as collection, research, exhibition, education and promotion, as well as public services and social connections, which have drawn more attention in recent years. Director Chen of the Wood Art Ecomuseum noted that the humanities, the natural environment, and the lifestyles derived from them are the "living collections " of a museum. Under this premise, what are the functions of the Wood Art Ecomuseum in Daxi?

First of all, the "cultural sites" are shaped as the foundation of Daxi's museum experience: the town's architectural clusters spanning the Qing Dynasty, Japanese colonial rule, and contemporary history are restored, organized, and opened, and they themselves encapsulate the development of the town and bear witness to traces of Taiwan's history in the town. The historic residences, Japanese-style dormitories, and modern public buildings and civic spaces left behind during the Japanese colonial period are transformed into different themed exhibits at the Wood Art Ecomuseum, and the cultural venues are established with the goal to foster a learning space for local knowledge, publicness, and public service.

圖 Figure | **4**

在大溪的每個人、每家店，只要願意分享故事，都是文化場域的一部份。

Every house or store in Daxi can be a part of the Cultural Site as long as they are willing to share stories.

The value of a museum is not limited to the space and its collections; rather, the sharable knowledge to be passed on is what makes museum as an establishment unique. For a museum that operates with an "ecomuseum" mindset, "residents" and "local life" are not just objects for "collecting" knowledge and stories, but rather, they are living organisms that actively participate in the experience with their own interpretations. The so-called self-interpretation is not only about telling stories and adding multiple perspectives to things, but also about the possession of a strong initiative in transmission, promotion, translation, and innovation.

Therefore, the second key strategy is to continue to cultivate and empower talents, connect communities to strengthen their sense of being part of the museum community. In addition to administrative work, museum staff are volunteers, residents, and community members who participate in the operations of the museum, so that more and more people can identify with the place through the perspective of the museum, and act concertedly with the museum to change the place for the better.

Finally, from creating public cultural spaces to supporting museum staff in urban museums, ecomuseums also need to develop diverse action plans to address different topics and issues. It does this by leveraging conventional museum methods (collection, research, display, and educational outreach) to transfer knowledge to the public and to accumulate more knowledge at the same time. Examples of this include the "Corner House Project" [1], the wood art industry culture in Daxi, and the preservation and promotion of festival and celebrations culture.

The aforesaid three place operation strategies for museums' management allow museums to be more than just an "ivory tower" of a singular point of view, preventing museums from unilaterally deciding on the contents of their interpretations, but rather, to connect interpersonal networks, their corresponding spaces and resources in a pragmatic approach to implement eco-museums. The nature and characteristics of the Museum's work are also manifested in the process of putting together "Daxidaxi" event.

圖 Figure | 4

「大溪大禧」原來是博物館學
"Daxidaxi " is museology in action

「博物館，不總是要保存事物的嗎？」木博館想改變些什麼呢？接著就讓我們用「迎六月廿四」文化的保存策略與「大溪大禧」所展現木博館的博物館方法學來訴說。

為地方慶典文化的保存再延續

一個延續了百年的大溪在地慶典「大溪普濟堂關聖帝君聖誕慶典」，是大溪人自小即參與的盛會。倚靠廟宇的管理單位，參與遶境的各「社頭」，齊心戮力傳承儀式、藝陣展演的內容。除了在農曆六月，依循著普濟堂籌備神明誕辰慶典的程序，廟方與相關單位進行開會、協調，信眾協助調度資源，志工參與洗廟（清潔整理廟宇）；男女老少能夠找到自己和慶典連結的角色。整個遶境慶典由 31 個社頭組成，而這些社頭組成來自大溪的某個地域、某個街坊，或是某種行業，於是大溪的每一個人或多或少，都與社頭有著關聯；再有一種記憶，則是兒時受社頭成員所託，走入隊伍舉旗子，和鄰里相似年紀的孩子互動，形成了專屬大溪人的童年。

縱使在現代，文化的延續力式微，但是「迎六月廿四」始終具有在地向心力。大溪在地的生態博物館，木博館希望對於慶典文化研究保存、傳承以及推廣，貢獻以博物館角度發揮的力量，過程以共學的精神呼應生態博物館精神，使慶典文化在生活中延續。

專業策展與博物館共同發展的方法論

木博館 2015 年創館後，承接了本來由大溪鎮公所已經主辦多年的「大溪文藝季」。2015~2017 年間，木博館先定調「大溪文藝季」的核心推廣主角即是「農曆六月廿四關聖帝君聖誕遶境」，規劃展演、教育活動，嘗試媒合專業表演團隊和在地社頭合作，不過當時的活動內容仍較為發散，尚未掀起對外的漣漪。

這三年來的「大溪文藝季」經驗，讓木博館產生一連串的疑問，在尋新挖舊之間尋求平衡，思考著如何一方面實踐地方節慶文化保存的同時，也大刀闊斧地創新連結現代性？回顧當時，臺灣些許城市開始導入策展思維，然而一個以慶典生活為主題，發生場域在城市，牽涉文化保存議題的作法，卻還未有可以參考借鑑的案例。

因此木博館希望有一個專業策展團隊，可以一起與博物館共同發展方法論，將傳統節慶文化結合創新方式推廣，也包容歷年累進呈現慶典文化的內涵，將慶典普及到不同地域、世代的人群中，還要能夠梳理出對國際溝通的表現和語言形式！這樣的艱鉅挑戰，使得身為主辦單位的木博館提出一個「總策展」計畫需求。

圖 Figure ｜ 1

木博館針對「迎六月廿四無形文化資產」的工作策略圖。

The diagram of museum strategy for the "June 24 Reception" Intangible Cultural Assets.

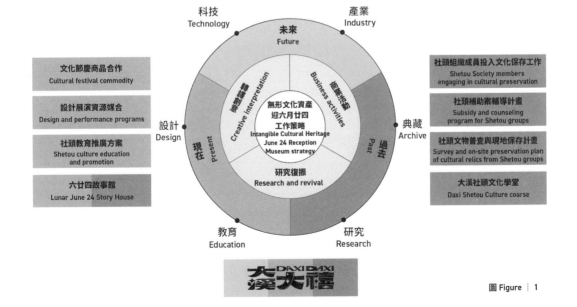

圖 Figure ｜ 1

(1) | **大溪大禧總策展架構**
請見第 123 頁。

2018 年參與總策展的衍序規劃設計提出「大溪大禧」論述與架構 **(1)**，不免要面對博物館內、外部的疑問。新出現的「大溪大禧」，其轉譯傳統再創新的想法，以及擴大觸及人群的目標，必須在籌辦過程中，滾動地和大溪人凝聚共識。面對參與人數眾多、不同群體的期待多元、密集時間的運作、協調介面複雜，應對起來並不容易。然而，當首年的「大溪大禧」便帶著清晰的意識，保持不介入傳統遶境兩日的內容，創造一個開幕遶境結合全社區，藉由大型表演、居民共演文化劇場、相關藝術作品產出、影像紀錄、創新展演、社區工作坊、國際交流等方式，透過每一項構思，讓居民能夠以不同方式參與到慶典文化之中，重新連結，產生保存與再發展的意識。

當大溪有了如此特別的新型態慶典，博物館、策展團隊、田野工作者在地方，日復一日地與居民共感、互動；年復一年的策劃與實踐，在大溪人身上誘發改變，總總匯聚成一股能量化作行動，促使文化節慶知名度提升，也深化了內部的文化保存意識。設計開發節慶多元參與體驗方式，並以傳統文化作為設計創作的豐厚養分，傳統文化與當代設計的相輔相成，使「大溪大禧」創造了有別於其他地方文化節慶的內容，人人都可以參與，可以分享，人人都是大溪文化的見證者，同時也一起與這座城市創造與延續文化，整個大溪都是文化展現的平台，整座城市打破界線，成為一座完整的博物館。能做出這樣的差異，也驗證了「大溪大禧」是一種博物館方式，也是一種成功且嶄新的城市行銷方法。

圖 Figure | **2**

2019 年「神嬉舞夜」，傳統將軍結合表演藝術走入人群，成為創新展演的一部分。

During the 2019 "Dancing with Gods" as a part of the innovative performance, the traditional generals fused with performing arts and entered the crowd.

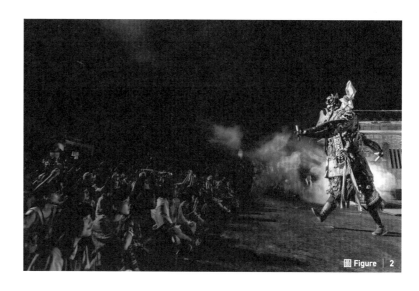

圖 Figure | **2**

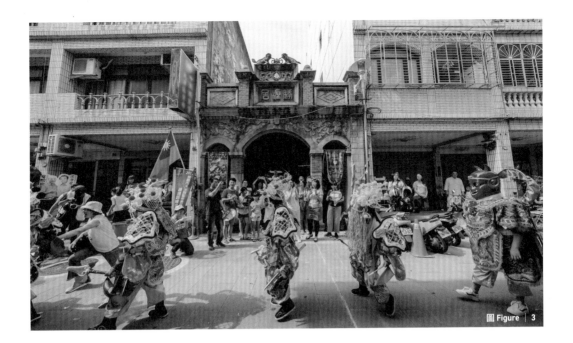

圖 Figure | 3

大溪國小學童穿戴由「給
孩子的遶境學」中訂製的
小將軍服裝，走在街頭跟
著社頭們一起參與遶境。

The children of Daxi
Elementary School wore
the costumes of little
generals, custom-made
during the education project
"Pilgrimage Course for
Children", and participated
in the procession along with
the Shetou groups.

"Isn't a museum always about collecting and preserving things? " What does
the Museum want to change? Now, let's dive into the cultural preservation
strategy of "June 24 Reception" and the museology approach of the Wood Art
Ecomuseum as demonstrated by Daxidaxi."

Preservation And Continuation of Local Festival Celebration Culture

As a local festival with over a century of history, the "Daxi Puji Temple
Guan Sheng Dijun Birthday Celebration Festival," is a local mainstay that
the people of Daxi have been participating in since they were young. The
organization of this event relies on the temple's management team and the
"Shetou" who participate in the procession together to pass on the rituals
and performances of the art formation. In addition to June on the Lunar
Calendar, following the procedures of Puji Temple in preparing for the
festival, the temple management team holds meetings and coordinates
with relevant organizations. The adherents help to allocate resources, and
volunteers participate in "temple washing" (cleaning and tidying up the
temple). People of all ages are able to find their own roles in connection
with this highly-anticipated festival. The whole parade celebration consists
of 31 Shetou organizations, who hail from all corners of Daxi, whether it's
from a certain community, a certain neighborhood, or a certain industry,
so everyone in Daxi is more or less inextricably linked to the Shetou

organizations. Locals also recall their childhood days of being encouraged by the Shetou to join the formations while waving flags, and interacting with children of similar age in the neighborhood, forming an exclusive fond childhood memory of the people of Daxi.

Even though these folk legacies are declining in modern times, " June 24 Reception" has always had the power to draw the local community together. As a local ecomuseum in Daxi, the Museum hopes to contribute to the preservation, dissemination, and promotion of the culture of celebration from the Museum's perspective, and to mirror the spirit of the ecomuseum with the dedication of co-learning, so that the culture of festival celebrations can continue in daily life.

Methodology of Professional Curatorial Methods and Ecomuseum Co-development

After the Daxi Wood Art Ecomuseum was established in 2015, it took over the "Daxi Cultural and Art Festival", which was hosted by the Daxi Township Office for many years. From 2015 to 2017, the Museum first focused on the "June 24th Guan Sheng Dijun Birthday Procession" as the highlight of the "Daxi Cultural and Art Festival," planning performances, exhibitions and educational activities, and attempting to collaborate with professional performance troupes and Shetou groups. Hover, the repertoire of the activities at that time lacked focused and had not yet caught the attention of greater society.

The experience garnered over the past three years from hosting "Daxi Cultural and Art Festival," made the Wood Art Ecomuseum raise a series of questions. Such as seeking to strike a balance between "exploring the new and digging up the old," and contemplating on how to preserve local festival culture while at the same time innovatively connecting with modernity. At that time, some cities in Taiwan started to introduce curatorial thinking, but there were no examples of cultural preservation in urban settings with the theme of festival and celebration culture.

The Museum wanted to form a professional curatorial team that could work with the Museum to develop a methodology that combined traditional festival culture with innovative methods of promotion, as well as embrace the cultural connotations of celebrations that have evolved over the years to reach people from different regions and generations. Furthermore, the Museum attempted to formulate effective expressions and language forms

for international communication. Such a daunting challenge compelled the Museum, as the organizer, to propose a "master curatorial" project [1].

In 2018, the BIAS Architects and Associates team, which was involved in the master curatorial process, and proposed the concept and structure of "Daxidaxi," was faced with questions from both the Museum and the general public. The new "Daxidaxi," with its bold idea of translating tradition and reinventing it, and its goal of expanding the audience, was to be executed in a rolling process through consensus-building with the people of Daxi. It was not easy to cope with the large number of participants, the diverse expectations of different groups, the ambitious and often a pressing deadline, and lots of moving parts. However, since its inception, the "Daxidaxi" event has a clear goal of not interfering with the two-day traditional procession with a creation of a new "prelude" procession that unites the entire community through large-scale performances, cultural theater performed by residents, production of related artworks, video documentation, innovative exhibitions, community workshops, international exchanges, etc. Through each of these ideas, residents are able to participate in the culture of the festival in different ways, reconnecting and creating a sense of preservation and redevelopment.

With Daxi having such an extraordinary new form of celebration event, museums, curatorial teams, and resident field workers share and interact with locals day after day and year after year, planning and putting into practice to induce changes in the people of Daxi. This converges into a force for change and action, contributing to the visibility of cultural festivals, and deepening the internalized awareness of cultural preservation. By designing and developing the festival's diverse experience, harnessing traditional culture as the rich nutrients for design creation, the complementarity of traditional culture and contemporary design is complemented. Thus "Daxidaxi" has created content different from other local cultural festivals, where everyone can participate and share, and bear witness to Daxi's unique culture, and together, they create and perpetuate this unique heritage. All of Daxi is a platform for cultural expression, breaking physical boundaries and becoming a complete ecomuseum. This difference is a testimony to "Daxidaxi" as a approach in museology and a successful and innovative way to market Daxi.

Chapter 3

歡迎來到「大溪大禧」
Welcome to Daxidaxi!

無論是各個社頭的藝陣輪番登場、三國將軍的豪華陣容、精彩萬千的酬神戲、紀錄特展、連結科技數位化……透過「大溪大禧」，讓傳承百年的「迎六月廿四」文化不只更有力量，全城共歡、共好、共創，將帝君的正氣能量分享給每一個人！

Whether it's a lineup of artists from various Shetou, a fancy formation of Holy Generals from the Three Kingdoms, theatre troupe performances paying homage to the gods , special documentary exhibitions, or the use of digitalization technology...Through "Daxidaxi," the culture of "June 24 Reception", which has been passed down for over a century, has not only become a profound show of strength, but allows the whole city to revel in joyous celebration, co-prosperity, and co-creation, thus spreading the positive energy of Guan sheng Dijun to all!

來自大溪，來自大禧
Proudly Hailed from Daxi

「大溪大禧」官方網站

2018 年夏天，「大溪大禧」這四個字橫空出世，社群上不時出現貼文分享，赤面青裝、手配青龍偃月刀的 Q 版神明圖像現身在大溪城區的各個角落，一眼便知是威風正氣的關公，老街店家貼滿歡喜關公的笑臉海報，而在記者的一篇「『大溪大禧』平安符萌到爆爆　網友留言：想要！」即時報導一出，正式掀起「大溪大禧」炫風，「大溪大禧」是什麼？大溪似乎有什麼好事即將發生了？「大溪大禧」要來了！

「大溪大禧」
2018-2022 年紀錄影片

這年首次的「大溪大禧」，帶來了年輕一代的新目光注視，也翻轉了在地居民對於慶典可能性的想像，了解到自己習以為常的生活和信仰，原來具有吸引人潮的魅力，而看見將慶典文化傳播出去、傳承下去的希望。在那時，「大溪大禧」以當代設計力轉譯傳統文化，所創造的城市文化慶典，讓木博館也收到許多關注，大家都希望了解大溪大禧的成功從何而來。

彷彿是大溪人對於關聖帝君的虔誠具有磁力，這一年木博館決定開啟一個推廣神明誕辰慶典的總策展計畫，磁吸到對於傳統民俗信仰、城鎮文化具有深厚興趣，願意克服重重溝通挑戰的策展團隊「衍序規劃設計」前來挑戰，團隊投入詮釋慶典文化與大溪人的信仰生活後，巧妙結合了在地觀點，設定「一場跨越當代設計與民俗信仰的城市祭典」，使活動本身不僅有炫目迷人的表現，更有穩定堅固的內核——來自木博館歷年梳理出，大溪人和信仰的故事，賦予節慶活動具有城鎮的自明性 **(1)**。

(1)｜自明性
都市或環境中令居民與空間使用者產生認同感與歸屬感，且具代表性的空間特質。

策展團隊發想出好記、好唸，又能突顯大溪地域與神的生日的「大溪大禧」。靈感來自地方田調說法，「迎六月廿四」家家戶戶會回鄉辦

(2)｜契孫

契孫，是給神明當義孫之意，是臺灣民間常見的習俗，希望藉神明力量保佑孩子順利長大。

(3)｜夜練

一到農曆六月，社頭們就會在下課下班後在城市中的廣場腹地集合，練習暖身、為遶境做準備。

桌招待親友，大拜拜就像是「大溪人的第二個過年」那樣的歡喜熱鬧。「大溪大禧」作為傳統聖誕慶典與遶境前的暖場活動，一邊告訴大家神明的生日快到了，一邊號召大眾一齊來大溪被招待，感受回家過節的氛圍。議題清楚，概念不只洗腦，更蘊含著尊重地方記憶的溫柔。

在過去總是熱鬧不已的農曆六月，從農曆六月初一開始，全大溪便像是設定了城市鬧鐘般，自動自發地進入關聖帝君的聖誕慶典籌備狀態，從初一由普濟堂召開的慶典籌備會宣告全面啟動，初六的契孫 (2) 返鄉參拜大會、六月中旬熱血的社頭夜練 (3) ，時序越接近聖誕日，越能感受到逐漸沸騰的城市氛圍，眾人引頸期盼著農曆六月廿四日慶典正日的到來。這是許多大溪人的兒時記憶，而這樣的傳統在大溪運行百年後，「大溪大禧」的出現，無疑是為這已被列為無形文化資產的宗教盛事，開啟一段全新的里程。

以「一場跨越當代設計和民俗信仰的城市祭典」定位的「大溪大禧」，從 2018 年初登場起，從地方宮廟與社頭的支持，到設計師、藝術家加入，各個領域的人從四面八方匯聚而來，一起研究、討論、籌備和歡慶。以生態博物館思維牽起「大溪大禧」，連動這些人際網絡與相應

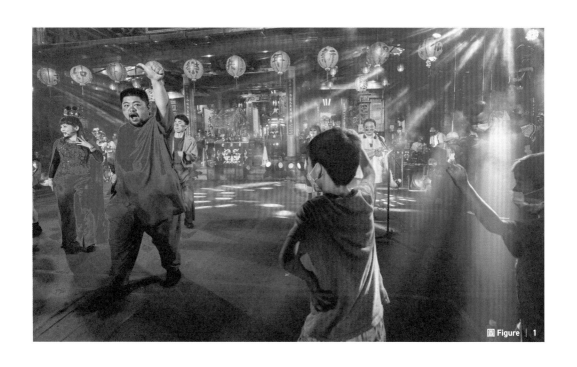

圖 Figure｜1

的空間、資源。在年年的號召與展演下，「大溪大禧」與「迎六月廿四」的時間軸逐漸貼合，將傳統慶典籌備期間的信仰生活，轉化成可以理解、可以體驗的展演內容，深入每個參與過的人心中，一起凝聚成具有在地特色的城市文化慶典。

"Daxidaxi"
Official Website

圖 Figure │ 1

「大溪大禧」是一個大人與小孩、儀式參與者與民眾、傳統與現代，人與神共歡的一場祭典。

"Daxidaxi" is a festival where adults and children, ceremony participants and the public, tradition and modernity, and people and gods can rejoice together.

In summer of 2018, the name of "Daxidaxi" was unveiled to the world. Social media immediately sprang to action by posting images of a cute figure of a red-faced god in green costume with a green dragon crescent sword appearing in all corners of Daxi. It's not hard to discern that the image is the depiction of the righteous god Emperor Guan. Posters of the smiling Emperor Guan were put up in the stores across the old street. A featured news article, titled, "The talisman of 'Daxidaxi' is so cute that netizens can't help wanting one too!" immediately set off a viral online buzz about "Daxidaxi"! So what exactly is Daxidaxi? It seems that something good is about to happen in Daxi? Daxidaxi is coming!

The first Daxidaxi has already attracted the attention of the younger generation, and transformed the local residents' perception about the possibilities of festival celebrations, with many coming to realize that the life and beliefs they had been accustomed to has the appeal of attracting people, and sensing the hope of spreading the culture of the festival and passing it on. At that time, Daxidaxi exemplified an urban cultural festival that translated traditional culture with contemporary design, and the Daxi Wood Art Ecomuseum received a lot of attention, with many people wanting to know how Daxidaxi's success came about.

It seemed that the devotion of the people of Daxi to Guan Sheng Dijun had itself become a powerful draw. That year, the Daxi Wood Art Ecomuseum decided to initiate a master curatorial project to promote the birthday celebration of Guan Shen Dijun, which attracted the curatorial team "BIAS Architects," which has a vested interest in traditional folk beliefs and town culture, and was willing to overcome many communication barriers, to come take on the challenge. After the team invested efforts in interpreting the culture of the festival and the devotion of the people of Daxi, they cleverly combined the local perspective and set up "a city festival that straddles contemporary design and folk beliefs", so that the event itself not only featured dazzling performances, but also most importantly had a stable and solid core - the story of the people of Daxi and their faith, which had been documented and compiled by the Wood Art Ecomuseum over the years, giving the festival a self-explanatory character.

The team came up with the name Daxidaxi, which is memorable, catchy, and it highlights the Daxi region and the birthday of God. The inspiration was derived from field research on a local maxim, "June 24 Reception", where every family will head back to the hometown to host a streetside banquet for their friends and relatives. This big worship ritual is a joyous and lively affair that is often regarded as "the second Lunar New Year of Daxi." As a traditional birthday celebration and a warm-up event precursor to the grand procession event, Daxidaxi proclaims to the world that Guan Sheng Dijun's birthday is coming and calls on everyone to come to Daxi to be entertained and immersed in the festive atmosphere of a second "homecoming". The theme is clear, and the concept is not only addictive, but it also gently pays respect to community memories and heritage.

(1) | Qishun

Devotees who regard Guan Sheng Dijun as their godfather.

(2) | Evening Practice

In June of the lunar year, the Shetou groups will gather in the plazas and squares after school and work to practice and prepare for the procession.

The sixth month of the lunar calendar is usually a time of lively religious events. Since day one, the entirety of Daxi automatically enters into the preparations for the birthday celebration of Guan Sheng Dijun (Holy Emperor Guan), as if an alarm clock has been set. From the first day of June, when the preparatory meeting for the festival is announced by Puji Temple, to the sixth day, when the Qishun **(1)** returns to Daxi to conduct worship rituals, to the mid-June evening practice **(2)** by Shetou groups, the closer we draw to the birthday, the more one can feel the buzz and excitement of the city gradually boiling over, with many people looking forward to the arrival of the festival on the 24th day of the 6th lunar month. This evokes a fond childhood memory for the people who grew up in Daxi, and after a hundred years of such a tradition, Daxidaxi undoubtedly marks a new milestone for this religious event, which has been classified as an intangible cultural heritage.

Daxidaxi is defined as "an urban festival that spans contemporary design and folklore beliefs." Since its debut in early 2018, people from various fields have gathered from all over the world to study, explore, prepare, and celebrate together, from the support of local temples and community leaders to designers and artists. Daxidaxi is built on the foundation of the ecomuseum concept, linking these interpersonal networks and the corresponding space and resources. With the annual calls and performances, Daxidaxi and the "June 24 Reception" timeline has gradually coincided, transforming the religious life during the preparation of traditional celebrations into an understandable and experienceable performance that takes root in the hearts of everyone who participates, and embedded into an urban cultural celebration with local characteristics.

31 社頭聯「走」，遶境開場主力陣容

31 Shetou organizations bolster the main lineup for the opening procession

2022 年，與神同巡

咚咚猜的鑼鈸聲，北管與大鼓聲此起彼落，陣頭隊伍依序穿過大溪普濟堂牌樓、朝向正殿內拜禮後尋找停留位置，視野遼闊的廟埕在此刻擠得水洩不通。跟著人龍隊伍一路擠進普濟堂廟埕，在地社頭們穿著設計師廖小子設計的桃色 T 恤非常醒目，清楚地分隔出觀光客與在地人；將軍們靜靜矗立路旁，與忙進忙出的工作人員形成動靜對比；現場熱度隨著震天鑼鼓快速升溫，看似熟悉的廟會風景，卻又帶著新鮮感以及濃濃令人振奮的氣息席捲而來，這是「大溪大禧」開幕日的新型態遶境——「與神同巡」。

與神同巡之前，必須先認識「六月廿四遶境」和關鍵角色「社頭」

(1) ｜墨斗陣

墨斗是以彈線方式畫直線的工具，協義社墨斗陣在拜禮時會由領隊拉出墨斗線，模仿木器師傅以墨斗畫線的動作，高喊「有準方？」組員回應「有哦！」是極具代表性的陣頭。

「遶境」是臺灣民間信仰常見的儀式，指的是神明巡視轄區，信徒相信神明出巡可以驅邪壓煞，祈求合境平安、風調雨順。

而大溪普濟堂的遶境傳統，百年來因不同時期成立的社頭組織與信眾來源而逐漸擴大。「社頭」一詞則是大溪人對參與六月廿四迎神遶境團體特有的稱呼，他們由在地各行各業或不同地區的民眾所組成，自發性地學習陣頭技藝、參與慶典，是大溪民俗文化的重要元素。這些社頭因其成員背景而各有特色，例如協義社因最初以木器業起家而發展出「墨斗陣 (1)」、興安社以生意人為主所以有「大算盤」，以及如月眉地區農民組成的「農作團」、「農友團」等，儼然在地歷史文化發展縮影。

(2) ｜將軍腳

大溪人所稱的「將軍」亦有人稱神將、大仙尪，是神明的駕前部將。「將軍腳」則是穿戴、迎請將軍的人。

而在每年「迎六月廿四」由各個社頭組成的遶境隊伍中，會見到各式表演藝陣與傳統工藝，有些人負責擔任將軍腳 (2) 成為聖帝公的護衛、

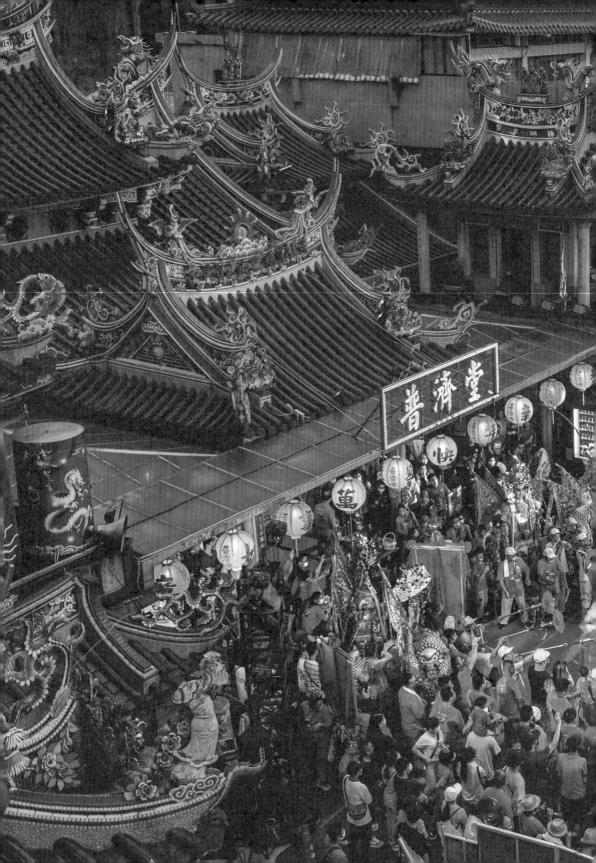

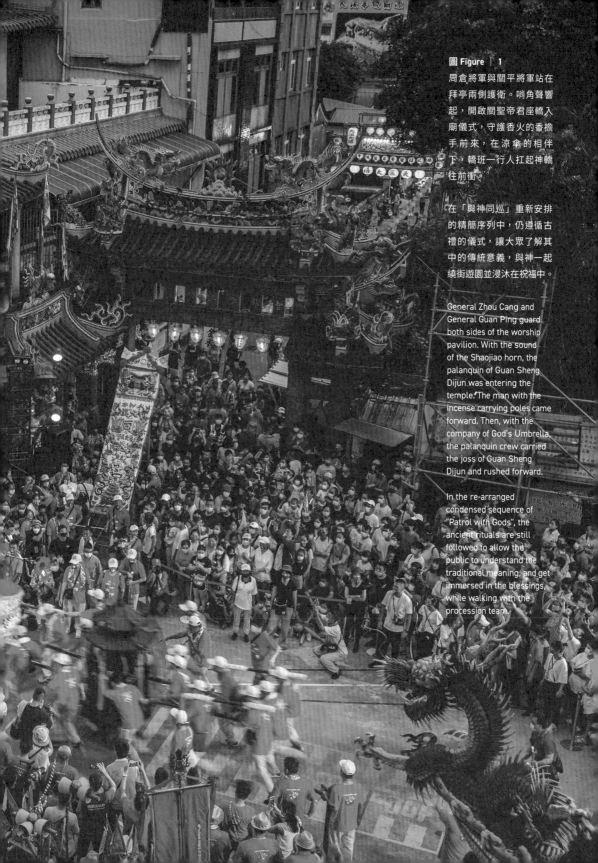

圖 Figure ｜ 1

周倉將軍與關平將軍站在拜亭兩側護衛。哨角聲響起，開啟關聖帝君座輦入廟儀式，守護香火的香擔手前來，在涼傘的相伴下，轎班一行人扛起神轎往前衝。

在「與神同巡」重新安排的精簡序列中，仍遵循古禮的儀式，讓大眾了解其中的傳統意義，與神一起繞街遊園並浸沐在祝福中。

General Zhou Cang and General Guan Ping guard both sides of the worship pavilion. With the sound of the Shaojiao horn, the palanquin of Guan Sheng Dijun was entering the temple. The man with the incense carrying poles came forward. Then, with the company of God's Umbrella, the palanquin crew carried the joss of Guan Sheng Dijun and rushed forward.

In the re-arranged condensed sequence of "Patrol with Gods", the ancient rituals are still followed to allow the public to understand the traditional meaning, and get immersed in the blessings, while walking with the procession team.

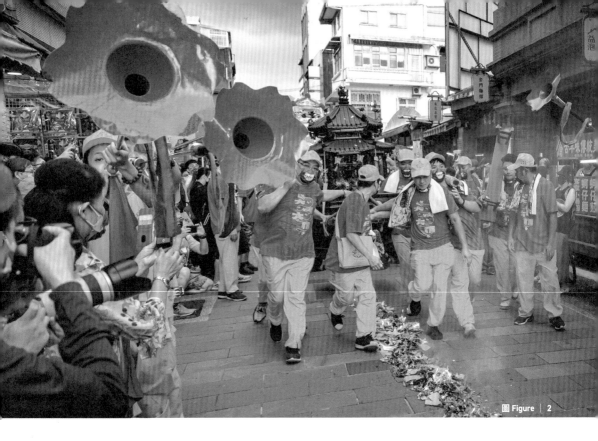

圖 Figure | 2

轎前哨角響起，「與神同巡」中即將入廟的最後一哩路，眾人合掌迎接衝刺過火而來的關聖帝君神轎。

With the sound of the Shaojiao horn, "Patrol with Gods" is on the last mile of the journey. All the people join hands to welcome the rapid arrival of the holy palanquin.

有些人負責扛神轎、有些人負責演奏音樂，逐漸形成分工合作的組織結構，一到農曆六月，大家就開始緊鑼密鼓地練習北管、舞龍、將軍步伐等，把整個大溪變成社頭的夜練場，只為在神明面前展現最精湛的技藝！

創新經典的與神同巡

「與神同巡」便是建立在這樣的文化底蘊上，依循著傳統遶境文化運作的核心，隊伍擷取「迎六月廿四」遶境精華、重新組合傳統序列，邀集 31 社招牌陣容、特色藝陣、三國將軍群以及最重要的——「關聖帝君」，組成一支精華版遶境隊伍，有如濃縮百年遶境文化的展演平台。

對不認識「迎六月廿四」的民眾來說，「與神同巡」就像可以快速通關的入門攻略，讓民俗慶典門外漢也能輕鬆飽覽遶境精華！當三聲起馬炮 (3) 轟隆巨聲響起，遶境隊伍便從普濟堂啟程出發，有些人選擇跟著大隊熱熱鬧鬧地前進、有些老玩家們則熟門熟路找到最佳看點等

(3)｜起馬炮

起馬炮就像是遶境前的信
號彈，號召大家集合，當
第三聲響起代表遶境正式
開始。

待隊伍到來，人手一支的祭典扇不僅在豔陽中提供搧風遮陽功能，更
有完整的隊伍排序介紹提供民眾對照，不想分心看圖說的民眾也沒關
係，因為廟埕的廣播系統正響起主持人的聲音，一一介紹進場拜廟的
隊伍是誰、特色是什麼，而這也成了「與神同巡」的一大特色，無所
不在的輔助介紹，想不認識他們也難呢！

而要組成一支從未出現過的隊伍陣容，在一開始便是「大溪大禧」團
隊難度頗高的考驗，從了解大溪傳統遶境的排序開始、再逐一認識 31
個社頭各自的特色與強項，在這樣龐大的宗教社群體系中慢慢搭起隊
伍的骨架，並挑選合適對應的陣頭放進適當的位置，從「開路先鋒」、
「表演藝陣」、「神明護衛」到「壓軸坐轎」，以一支濃縮遶境隊伍、
行動式的展演對大眾說大溪百年的信仰故事。而這樣精彩的企劃呈現，
難以想像一開始可是不被普濟堂和社頭組織認同的提案呢！

在眾人彼此協調、共同推動下，「與神同巡」在 2018 年華麗登場，漸
漸獲得在地社頭、社區的認同，成為在地人年年參與、觀眾年年必看
的新創經典，也形成農曆六月期間，「大溪大禧」開幕日與聖誕遶境
成為前後兩端的慶祝熱點。「大溪大禧」團隊相信，慶典本身最重要
的事必須發生在現場，保留最重要的精華與崇敬的核心，並以現代的
方式真實詮釋。

圖 Figure｜3

2020 年，嘉天宮同義堂的
神前護衛，帶領大眾從大
溪普濟堂廟埕出發，緊隨
其後的便是同人社關聖帝
君神轎。

In 2020, the Generals of
Chiatian Temple Tong Yi
Tang led the public to
set off from the Daxi Puji
Temple. The following is the
palanquin of Guan Sheng
Dijun carried by Tongren
Society.

圖 Figure｜3

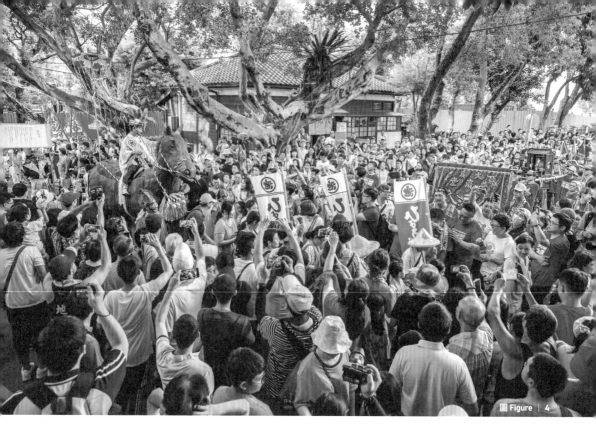

全方位的設計整合，每個角落都是教育現場

(4) | Hyoge 祭

「ひょうげ祭り」是日本香川縣高松市的民俗祭典，自江戶時代傳承至今，是當地農民向水神感謝恩賜、祈求豐收的民俗慶典。特色是參與者會利用各式在地農特產，製作遶境所需的各項道具服飾。

拿著扇子、小旗子等活動配件，沿著地圖標示的路線走，幾個廟埕、博物館前腹地成為遶境舞台，沿路串接著高掛的燈籠和火焰旗，跟著隊伍移動到好幾個擺有香案桌的店家前，這戶的香案桌典雅素淨、那家的新潮澎湃，案桌上充滿大溪遶境時節為了迎神和換香的人文風景，得以讓人細細端詳品味。

在建構「與神同巡」獨特的文化性展演中，「大溪大禧」也更進一步與其他國家或城市交流，不論是與日本香川縣 Hyoge 祭（ひょうげ祭り）**(4)** 交流演出，學習他們如何運用在地素材製作祭典所需的服裝道具以及與民眾互動橋段，抑或是 2022 年特別邀請到新竹都城隍廟來作客，讓兩組不同系統的遶境隊伍，來場前所未有的神級會面，兩個宮廟的委員會也相互交流，從如何祭拜、如何酬神、如何抬轎，將軍神轎與大眾在城市中近距離接觸，一切皆是因為有信仰核心、具備文化表現性，才能讓交流真實發生。

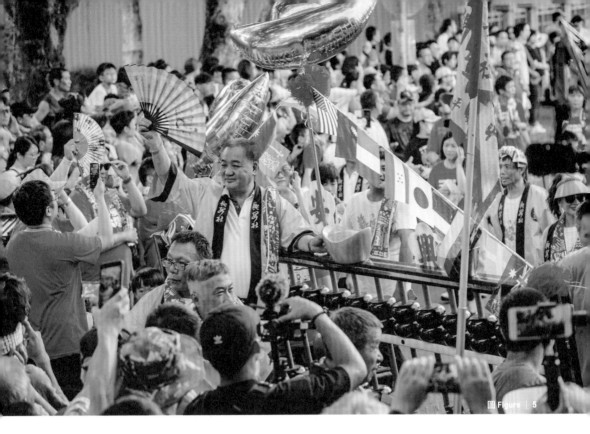

「與神同巡」不僅涵蓋了教育性，同時也被賦予了更多的文化性與藝術性，它不僅僅是一支濃縮版的遶境隊伍，更看見整個大溪老城區的空間串連，以及在移動性展演中如何與民眾互動，當設計成為「大溪大禧」品牌的拉力，在地文化與發展觀光的能量不斷增生，每個角落都是教育的現場。

圖 Figure | 4

「與神同巡」深化慶典的精神，並以現代的方式在呈現。圖為日本「Hyoge 祭」陣列與「與神同巡」陣列於馬路交會拼場的畫面，城市中的每一處頓時幻化成動態的展演場。

"Patrol with Gods" deepens the spirit of the festival and presents it in a modern way. The picture shows the intersection of the Japanese "Hyoge Festival" formation, and the "Patrol with Gods" formation on the road. Every place in the city is transformed into a dynamic performance venue.

圖 Figure | 5

畫面中間是興安社的特色藝陣「大算盤陣」，社頭成員大力展現與民眾互動相互交織在其中，無處不是歡樂慶典的氛圍。

The center of the figure is the characteristic art formation of Xing'an Society "Big Abacus Formation." The members of Shetou groups and the visitors are intertwined on the street, and the atmosphere of joy and festival is everywhere.

圖 Figure ｜ 6

孩子們穿戴手作的新竹都城隍范將軍、大溪關平將軍配件，一起在「大溪大禧」觀看「與神同巡」。

The children watch "Patrol with Gods" together at the "Daxidaxi" opening, within the handmade costumes which are the General Fan of Hsinchu City God and General Guan Ping of Daxi Guan Sheng Dijun.

圖Figure ｜ 6

(1) ｜ Mo Dou Formation

The Mou Dou is a tool used to flick a line to draw straight lines. The head of the Mo Dou Formation of the Xieyi Society will pull out the Mo Dou line during the worship service, mimicking the action of a master woodworker drawing a line with the Mo Dou and exclaiming, "Is it accurate?" "Yes!" will be the group members' response. It is a very representative formation.

Patrol with Gods, 2022

With the sound of cymbals, Beiguan and deafening drums, the procession passes through the paifang of Puji Temple in Daxi in order, and looks for a place to stay after a worship ritual inside the main shrine. At this moment, the vast temple grounds were crowded with onlookers. Following the queue of people all the way into the temple and spot the local Shetou members in peach-colored T-shirts created by designer Godkidlla, which clearly separates the visitors from the locals. The Holy Generals stand quietly by the side of the road, forming a contrast with the busy workers bustling about; the excitement of the scene picks up quickly with the loud gongs and drums. This is a seemingly familiar temple sight, but with a sense of refreshing ambience and an exciting atmosphere sweeping in. This is a new type of procession, "Patrol with Gods", on the opening day of "Daxidaxi."

The "June 24 Reception" and the key role of the "Shetou" You Should Know about Before "Patrol with the God"

"Temple Processions" are a common ritual in Taiwanese folk beliefs. It refers to the gods' visits to their "jurisdictions." The devout espousers believe that the gods' visits can expel or suppress evil spirits, and they pray for the safety of the territory and great tidings.

The Daxi Puji Temple Procession has gradually expanded over the centuries through the formation of Shetou organizations and the growing devotees at different times. The term "Shetou" is a unique name given by the people of Daxi to the groups that participate in the June 24 procession, which are composed of local people from all walks of life or different regions, who learn the art of parade formations and participate in the celebration, which is an important element

of Daxi folk culture. These Shetou have their own characteristics depending on the background of their members. For example, the Xieyi Society which started as a woodworking business, has developed the "Mo Dou Formation," [1] the Xing'an Society, which is dominated by businessmen, has the "Big Abacus Formation," and the "Nongzuo Tuan" and "Nongyou Tuan," which are formed by farmers in the Yuemei area, are like microcosms of local historical and cultural development.

(2) | Holy General

The "General" as the Daxi locals call it, refers to the Holy Generals (or Tōa-siang ang-á), who are guardians protecting the gods at the front.

In the annual "June 24 Reception" procession formed by various Shetou, various performing arts and traditional crafts will be performed, with some people acting as guards for the Holy Generals [2], others carrying the palanquin, and others playing music, gradually forming an organizational structure of division of labor and cooperation. As soon as the lunar month of June comes, everyone starts to practice the Beiguan (a traditional musical instrument), dragon dance, and the General's Stride, transforming all of Daxi into an evening training ground to showcase their best to the gods.

Creating an Iconic Patrol with the God

The "Patrol with Gods" is based on this cultural foundation. Following the core of the traditional procession culture, the team has taken the essence of the "June 24 Reception" parade and regroups the traditional sequence, inviting the signature lineup of 31 Shetou, special performing troupes, the Three Kingdoms Holy Generals and the most pivotal, the "Guan Sheng Dijun", to form a select procession team, which is like an exhibition platform for condensing the centuries-old temple procession culture.

(3) | Cannon

The sound of the cannon is the signal before the procession, calling for everyone to gather. The third sound represents the start of the procession.

For those who are not familiar with the "June 24 Reception," the "Patrol with Gods" is like a quick tutorial guide, allowing even laymen to easily enjoy the essence of the parade! When the three deafening roars of the cannon [3] are sounded, the procession sets off from Puji Temple, and some people choose to follow the large and lively formation. Some veterans are familiar with the best places to watch and wait for the processions to arrive, and the hand-held festival fans not only provide a way to cool off under the sun, but also provide a complete introduction of the processions for the public to see. It's okay if you don't want to be distracted by the illustrations, because the announcer's voice is playing on the temple's public announcement system, introducing one by one who the worshiping teams are and what their characteristics are. This has also become a major feature of "Patrol with Gods", with the helpful omnipresent introductions, it is difficult not to know about the process!

To form a team that had never been set up before was a challenge for the Daxidaxi organizing team, for starters. Starting from understanding the traditional order

of the Daxi temple procession, and then getting to know the characteristics and strengths of each of the 31 Shetou, the task force slowly yet steadily built the foundations of the team within an intricate religious community ecosystem, and selected the appropriate formation to place in the appropriate position and order. From the "Pioneers," "Performing Art Formation", "Divine Guardians" to the "Palanquin", the parade is an action-oriented performance that tells the story of Daxi's centuries-old faith to the public. It is hard to imagine that such a wonderful project was not approved by the Puji Temple and the community at the beginning.

With the coordination and joint promotion of all contributors, "Patrol with Gods" made its glorious debut in 2018 and gradually gained the recognition of local Shetou and communities, becoming a new classic that local people take pride in, and a must-see for the locals. It grew to be a highly-anticipated landmark event to mark the opening day of Daxidaxi and the birthday celebration procession in June. The Daxidaxi team believes that the most important thing about the celebration itself must happen on the spot, preserving the most important essence and the core of reverence of the faith, and interpreting it in a modern and authentic way.

Comprehensive Design Integration, Every Corner is an Educational Site

Hold fans, small banners and other activity accessories, follow the route marked on the map, and several temple squares and the open spaces in front of the Daxi Wood Art Ecomuseum become the stage for the parade. Along the route, the lanterns and flaming flags were hung high. Follow the procession to several stores with incense tables, one with an elegant and clean incense table, the other with a trendy design. The table is filled with the humanistic scenery of welcoming

圖 Figure | 7

香案桌前即成為動態的廣場，大眾看著孩童穿戴著「給孩子的遶境學」中設計的輕量石虎，在香案桌前展示舞獅拜禮的動作。

The space in front of the incense table becomes a dynamic square. The public watch the children wearing the lightweight costume of leopard cats, which is designed in the education program "Pilgrimage Course for Children," and showing the lion dance movements.

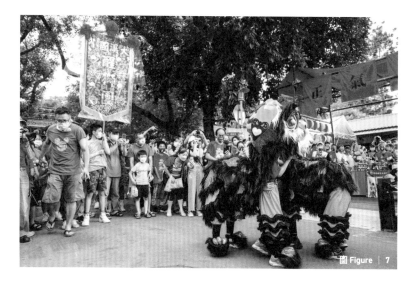

圖 Figure | 7

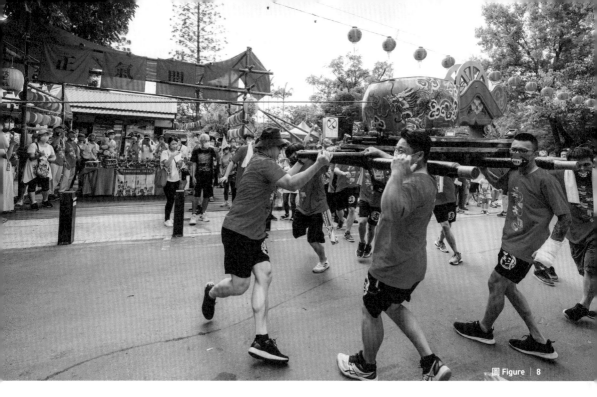

圖 Figure | 8

協義社的「墨斗陣」。在「大溪大禧」的香案桌前，扛起墨斗一起喊「嘿咻 逼逼 嘿咻」的口號，讓一行人舞出特色拜廟儀式。

In front of the demonstrative incense table of "Daxidaxi," the "Mo Dou Formation" from Xieyi Society carried the prop and showcased a unique temple worship ceremony.

(4) | Hyoge Festival

The folk festival in Japan passed down since the Edo period. Its origin is to thank the god of water and pray for a good harvest. The feature is that participants will use various local crops to make props and costumes for the procession.

the gods and changing incense at the time of the Daxi procession, which can be appreciated in detail.

In developing a unique cultural show called " Patrol with Gods," Daxidaxi has further fostered exchanges with other countries and cities, including the Hyoge Festival (ひょうげ祭り) **(4)** in Kagawa Prefecture, Japan, to learn how they adeptly used local materials to make costumes and props for the festival and interact with the public. Another highlight is a special invitation to the Hsinchu City God Temple in 2022, so that two different systems of procession parade teams can have an unprecedented meeting of the gods. The committee of the two temples also exchanged ideas on how to worship, how to devote to the gods, how to carry the palanquin chairs, and how to bring the gods into close contact with the public in the city, all because there is a core of faith and cultural expression that makes the exchange authentic and real.

"Patrol with the God" contains more than just educational value: it has also been given a more cultural and artistic dimension. The event is not only a condensed version of the procession, but also a spatial linkage of the entire old city of Daxi and how it interacts with the public in a mobile exhibition. When the design becomes the pull of the Daxidaxi brand, the momentum of local culture and tourism development grows, and every corner is a scene of education.

看酬神戲的各種變身

See the various transformations of
opera with divine powers

(1)｜李騰芳古宅
清領中期以後，臺灣一般在家族地位上昇後，為了光耀門楣，都會擴建住宅。精緻豪華的李騰芳古宅便是具有代表性的古蹟。

(2)｜定目劇
在固定地點長期性演出的固定劇目。

2019 年，神嬉舞夜

2022 年，神嬉舞夜

時序入夜，有別於日間鑼鼓喧天的藝陣喧囂，當日頭西落的魔幻霞光四射，「大溪大禧」另一場夜間大秀正在醞釀揭開序幕。

如果說「與神同巡」是以在地為主角的新型態精華版遶境，那麼「神嬉舞夜」便是透過表演藝術轉化酬神野台戲精神的演出製作。

臺灣閩南語俗諺說「誤戲誤三牲」，便是說沒有扮仙（酬神節目中重要的開場戲），所有的祭祀儀式都無法進行。在傳統廟宇慶典、神明誕辰中，常有信徒為酬謝神明而聘戲，因此，酬神戲的意義原在娛神、款待與答謝神祇，不僅神人同樂，人們把「貴賓席」留給神明、跟著看戲湊熱鬧。

不僅秉持著酬謝關聖帝君保佑的心意，更是要創造前所未見的新慶典演出製作，「大溪大禧」媒合傳統與當代表演藝術團隊，不僅以新的編制進行節目編排，更結合如李騰芳古宅 (1) 歷史場景或大溪普濟堂的廟埕場域設計，從一個個小創作，組成每一次上演的大製作，成就年年令人記憶深刻的新型態酬神戲：一種是運用各種創新元素融入傳統，將酬神戲的各種精彩與奇幻再放大，展現新潮的神、人共演之嶄新節目「神嬉舞夜」；另一種則是採集地方記憶與溫情，集結社區人們攜手真情共演的「定目劇 (2)」。這些不同以往的表演形式，也為「大溪大禧」建構出讓更多人認識大溪文化魅力的新途徑，用不一樣的方式，分享大溪的故事，也分享臺灣的故事。

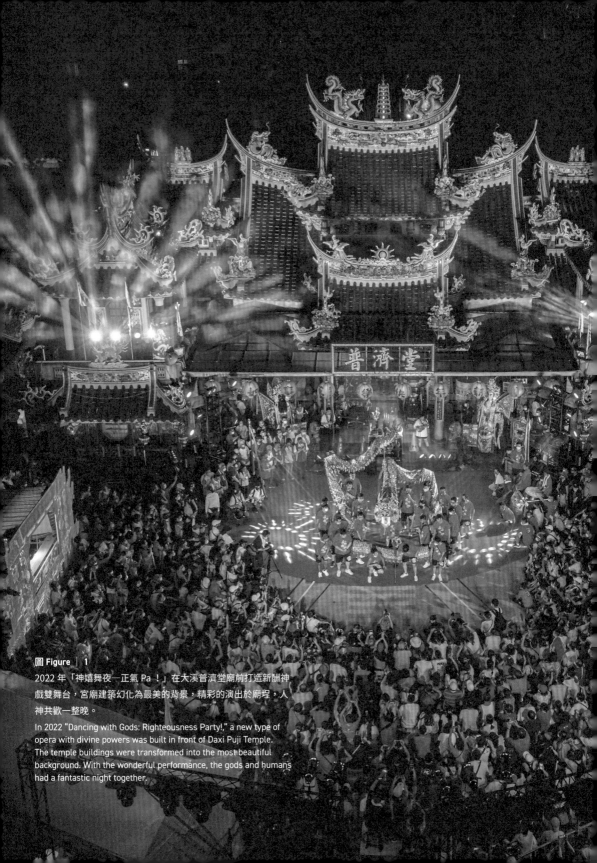

圖 Figure | 1

2022 年「神嬉舞夜—正氣 Pa！」在大溪普濟堂廟前打造新酬神戲雙舞台，宮廟建築幻化為最美的背景，精彩的演出於廟埕，人神共歡一整晚。

In 2022 "Dancing with Gods: Righteousness Party!," a new type of opera with divine powers was built in front of Daxi Puji Temple. The temple buildings were transformed into the most beautiful background. With the wonderful performance, the gods and humans had a fantastic night together.

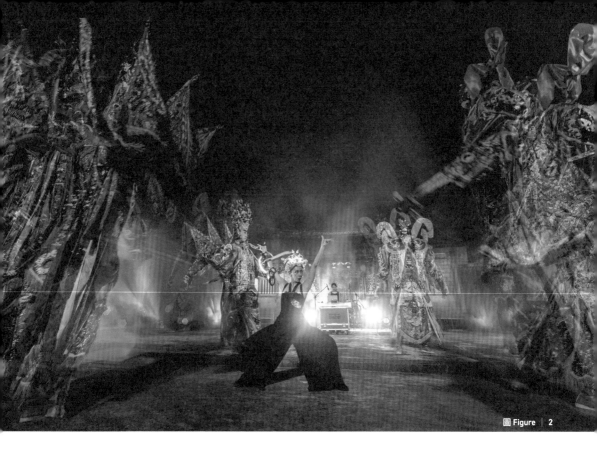

2019 年，藝術家廖苡晴、
許雁婷、與大溪在地嘉天
宮同義堂將軍跨界共創作，
在李騰芳古宅中共同帶來
震撼人心的演出。
In 2019, the heartshaking
performance brought by
artist Yi-Ching Liao, Yen-
Ting Hsu, and the Generals
from Daxi Chiatian Temple
Tong Yi Tang.

(3)│陳錫煌傳統掌中劇團
陳錫煌是傳統布袋戲師，
對各種角色的木偶表情動
作有精湛的詮釋，是獲得
國家雙授證的國寶級藝師。

酬神戲也是一場體現臺灣文化的秀

這夜，長長的排隊人龍湧入位在大溪月眉地區的「李騰芳古宅」，人
潮從外埕一路向半月池、外廣場蔓延至田園邊，從空中俯瞰，偌大的
平原暗夜，中間閃爍著絢麗燈光。

「大溪大禧」的前兩屆，「神嬉舞夜」得以在擁有百年歷史的國定古
蹟「李騰芳古宅」上演，結合古蹟場域、以跨越古今的電光搖滾向傳
統致敬，不論是由陳錫煌傳統掌中劇團 (3) feat. 拍謝少年的「國寶鬧
台」、以聲音和舞蹈藝術結合將軍共創的「與神共舞」，抑或是由燈
光設計師江佶洋為古宅創作的「炊煙騰雲」，皆是令人難以忘懷且感
到震撼的經典場景。

每當提及「神嬉舞夜」時，古宅前由將軍團包圍著電幻舞姬的奇幻畫
面總會浮現，這是由肢體藝術家廖苡晴、聲音藝術家許雁婷以及大溪

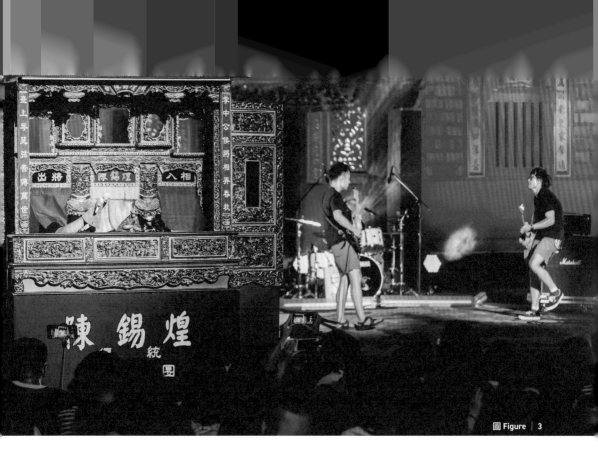

圖 Figure │ 3

2019 年，陳錫煌傳統掌中劇團與臺灣搖滾樂團拍謝少年，一同跨界創作合演掌中戲與搖鼓樂版的《巧遇姻緣》。

In 2019, Chen Hsi-Huang Traditional Puppet Theatre developed a new edition of the play "A Coincidence of Marriage" with Taiwanese rock band "Excuse the Youth".

(4) │ 屈禮

大溪將軍獨特的拜禮方式，以彎曲膝蓋的腳步，讓超過三公尺高的將軍呈現側身鞠躬的動作。

嘉天宮同義堂將軍團共同編製的「與神共舞」；許雁婷透過實際到大溪採樣，錄製大溪木匠、舞龍、北管夜練聲響，以聲景及電子聲響重新編曲，撞擊出傳統聲音新的可能；編舞暨表演者廖苡晴將大溪將軍獨特的「屈禮 (4)」動作轉化為當代舞蹈表演形式，在將軍團文化與視覺強烈的氣場中，舞者以並駕齊驅的舞動能量，周遊自若在四位將軍的能量場內，全場觀者無一不屏氣凝神，全神貫注在台上將軍與舞者一舉一動中，而這次的合作也成為參與藝術家創作 2021NTT-TIFA《靈蹤》(5) 的養分，大溪將軍團當時也成為《靈蹤》演出成員；而「與神共舞」製作於 2022 年又再次新編，在廖苡晴的編排下，將傳統的將軍與造型設計師李育昇所打造的「電氣將軍」匯合共舞，從媒材、演出編排皆結合傳統與創新，不僅賦予了作品新的生命力，也注入了專屬於大溪的靈魂。

另一個經典製作，便是由布袋戲國寶大師陳錫煌率領北管樂師對接拍謝少年的新世代臺味搖滾。

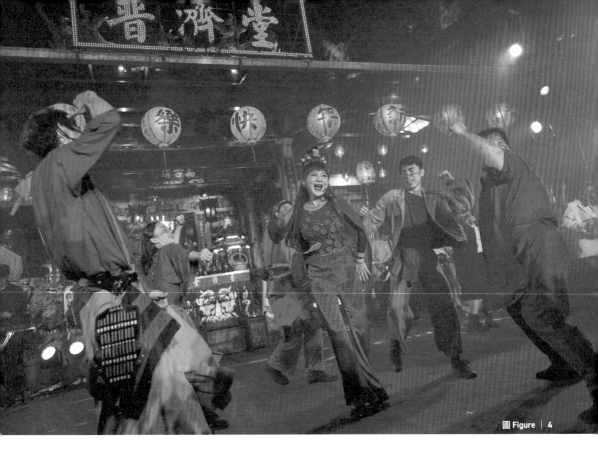

2022 年，由王彩樺、小事製作、同根生現場帶來讓大眾共唱共演的「大溪大禧」歌舞樂《紅紅 OnOn》。

In 2022, the "Daxidaxi" theme dance and song "OnOn" was performed live by Lotus Wang, Les Petites Choses Production, and A Root.

(5) |《靈蹤》

在互動演出中，舞者與操偶師開啟「人與神／人與偶」舞蹈對話，以現代角度書寫歷史。

(6) | 田都元帥

音樂界與戲劇界的守護神。

「聽 咱的歌聲 共阮的故事 唱予你聽……」當前奏響起，拍謝少年的歌聲讓氣氛搖滾起來，這是在 2019 年臺灣文博會與陳錫煌老師首次合作後，「大溪大禧」團隊當下便決定邀請陳錫煌老師和拍謝少年將演出搬到大溪現場，並透過重新設計的編排與橋段，以掌中戲混合搖滾樂，一起為關聖帝君祝壽。

陳錫煌老師帶著田都元帥 (6) 前來，加上掌中劇團弟子與後場音樂家，從白天在普濟堂廟埕為「與神同巡」遶境起頭、鬧台扮仙，到夜晚轉換舞台，與拍謝少年再度聯手，契孫契囝一起《骨力走傱》，配著《風入松》一起《巧遇姻緣》共創《未來就是我的安慰》。

而這一切都如同陳錫煌老師說的「照古早（慣例）來、意義很重要」、「來佮老人鬥相共 逐家做伙來佮這个文化傳承（來幫幫老人家 讓這個文化可以被傳承下去）」。

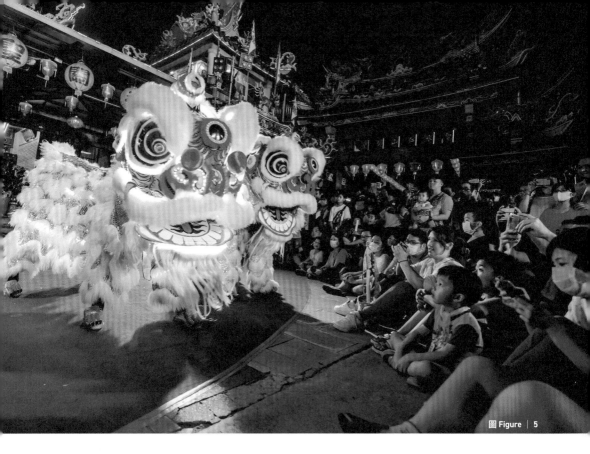

(7)｜拚場
大溪社頭間透過藝陣技藝相互較勁，稱為「拚場」。

連續兩年展演於李騰芳古宅的「神嬉舞夜」，在 2020 年轉移至大溪普濟堂的廟埕前，更貼近酬神戲的本質。不論是「神嬉舞夜」、「大溪霹靂夜」還是「正氣 Pa!」，這些為呼應當年度主題而有所變化的活動名稱，都展現了接地氣的熱鬧氛圍，而媒合當代表演藝術的本質更是年年變化與進化。以技藝拚場的「擂台秀」像是同根生樂團與新勝社飛龍團跨領域共演、臺灣雅典娜陳思妏與共義團三太子勁歌熱舞組合，抑或是當代舞團小事製作帶來「五虎將」與大溪金鴻慈惠堂醒獅團對尬技藝，巧妙地讓兩種不同的表演藝術像是拚場 (7) 又是共演的設計，慶典以酬神為號召，實則有凝聚眾人、同歡共樂的意義。

「如果能有一首曲子讓大家在慶典活動現場一起大聲唱、一起跳，那不是很有祈福意義嗎？」帶著這樣的想法，2022 年大溪大禧以一曲《紅紅 OnOn》不斷洗刷社群、音樂平台版面，看似洗腦無厘頭的主題曲，卻是為了融合宗教儀式、城市文化、慶典歌舞，由跨領域藝術家接力創作而成的入世歌曲。

挾著《紅紅 OnOn》初衷一路唱跳到了晚會現場，整個夜晚節目高潮迭起直至眾人期待的壓軸歌舞秀現身。演出集結了原班人馬「小事製作」、「同根生樂團」、「三牲獻藝」以及主唱「保庇女王王彩樺」帶領著大眾一起唱跳，「紅紅 紅紅紅紅 你最紅，紅面 紅衫 紅馬 紅紅紅 你最紅」副歌重複一遍又一遍，小朋友不怕生的站在第一排跳起來，現場零距離的舞碼輸出、高度即興力與無極限的表演張力，不僅讓表演藝術者玩得很過癮、觀眾看得也開心，賓主盡歡。

社區共演，詮釋在地的故事劇本

有別於「神嬉舞夜」中表演藝術拚場藝陣所碰撞的火花，2018 年由劇場專家「AMcreative 安徒生和莫札特」創意統籌策劃，與導演謝淑靖合作打造的「大溪文化劇場」則是向內挖掘，屬於大溪在地的歌舞定目劇。猶如細火熬燉的澎湃家宴，從採集屬於大溪豐富而溫暖的故事、加入社頭藝陣元素、與在地居民攜手共演、到現場本色出演，這是集結眾人力量譜寫出的臺語歌舞劇。

回到舞台劇準備開演的前一刻，正值盛暑的夏夜晚風徐徐，大溪的天幕籃球場上已架起五光十色、有著豪華佈景的野台劇場，居民從各個

圖 Figure │ 6

巷弄鑽出往現場湧入，觀眾席有吃飽飯後出來看戲的社區居民、也有玩一整天等待著劇場的遊客，大家交錯比鄰而坐。

當「有拜有保庇、有拜有保庇！六月廿四來迎神，大溪人的大過年，來喔！」音樂聲響起，台上出現了熟悉的身影、講述著台詞，分不清誰是專業演員誰是在地居民，大家一起又唱又跳，上演的劇情是大溪信仰的日常，台上台下自動融成了一遍，隨著演出手中搧著扇子大家一起歡笑、笑中帶淚，在最後一句「攏是為了關老爺！」樂聲奏閉，現場響起如雷的掌聲，老老少少爆滿的觀眾以掌聲和歡呼聲給予舞台劇最棒的肯定，這是大溪文化劇場、是「大溪大禧」期間限定的大溪定目劇。

在這樣的場景背後，是大溪文化劇場中幾個重要元素組成所創造出的劇場魅力，包含了在田調採集編寫、居民與專業演員共演、原創臺語歌舞、現地舞台，「大溪大禧」以打造大溪定目劇為目標，期望創造老少咸宜，讓大溪人演自己的故事、唱自己的歌的文化劇場。從2018 年《慶公生》到 2019 年《咱攏是社頭人》兩個年度的大戲，前者內容承載了大溪信仰與木藝文化的傳承，演繹大溪人世世代代以關聖帝君信仰為核心所發展出的動人故事；而《咱攏是社頭人》則是以新舊社頭的衝突及外來社頭的撞擊，讓大家重新思考參與大溪「迎六月廿四」的初衷，寄望共創大溪社頭多元展現與虔誠專一，傳承慶典的核心精神。

> 「身在大溪這塊土地上，和社頭團員、年輕學子及在地土生土長的人一起排演、述說屬於大溪的故事，讓我對這塊土地有了更多更深的連結，與人之間更是柔軟而感動著。」
>
> —— 共演居民 麗雲

導演謝淑靖也在臉書上寫下感想：每一次劇場圓滿落幕的成功與幕後的感動，皆與動輒內外至少 70-80 人，演出長達 70 分鐘，組成的分子包含了 16~70 歲年齡區間的素人演員、專業音樂劇演員跟來自各大門派的社頭、劇場技術團隊、攝影團隊、博物館等有關，大家各司其職在戲前戲後、台上台下，每個人都盡自己所能、做到最好。

在「大溪大禧」各種型態的新酬神戲中，可以看見藝術家來到大溪從傳統中汲取養分、創作後在大溪呈現，並在現場產生的巨大能量與回饋中又再次吸收養分，與在地的人和社群、空間場域、宗教儀式、事物彼此交融互動，互相吸收與給予，成為正向的文化能量循環，創造了不僅僅是以技藝酬謝神明，更是屬於「大溪大禧」新酬神戲的意義。

(1) | **Li Teng-Fang Ancient Residence**

After the mid-Qing Dynasty, Taiwanese families would expand their residences as their status rose. The exquisite and luxurious Li Teng-Fang Ancient Residence is one of the representative historic sites.

(2) | **Repertory theater**

A long-term specified repertoire in a theatre.

Dancing with Gods, 2019

Dancing with Gods, 2022

As the night progresses, unlike the hustle and bustle of the drums and gongs in the daytime, the magical haze of the sun sets in the west, and another night show is in the works for Daxidaxi.

If "Patrol with Gods" is a new type of parade with the Shetou as the main draw, then "Dancing with Gods" is a performance that transforms the spirit of "Opera with Divine Powers" through performing arts.

A Taiwanese Hokkien proverb advises "a mistake in performance is a mistake in sacrificial offerings", which means that all the rituals cannot be performed without the play of the immortals (the important opening act in the performance). In traditional temple celebrations and gods' birthdays, worshippers often hire an opera play to express appreciation to the gods. Not only are gods entertained like us mortals, but people leave "VIP seats" for the gods and follow the show to join in the fun.

In the spirit of expressing gratitude to Guan Sheng Dijun for his blessing, and in creating a new production of the festival that has never been seen before, Daxidaxi has combined the traditional and the contemporary performing arts team, while incorporating the historical scenes of Li Teng-Fang Ancient Residence **(1)** and the temple grounds of Daxi Puji Temple with new programming. From humble creations, each performance is a major production, resulting in a new type of memorable divine opera performance every year: one is a new show that incorporates various innovative elements into the tradition and amplifies the excitement and fantasy of temple opera performances, "Dancing with Gods ". The other is a "repertory theater" **(2)** that references local memories and warm sentiments and brings people from the community to perform together. These different forms of performances have created a new method for Daxidaxi to enable more people to experience the charm of Daxi culture, and to share the story of Daxi and the story of Taiwan in a novel format.

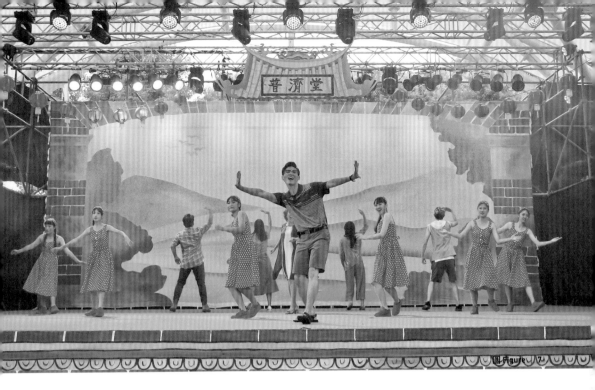

圖 Figure | 7

圖 Figure | 7

2018 年，大溪文化劇場《慶公生》劇照。由大溪人參與演出，共同演出屬於大溪的故事。

2018, the photo of the play "Celebrating Holy Emperor Guan's Birthday." People from Daxi participated in the performance and jointly performed the stories belonging to Daxi.

(3) | Chen Hsi-Huang Traditional Puppet Theatre

Chen Hsi-Huang is a Taiwanese glove puppeteer who has won the National Cultural Award. He has a superb interpretation of puppet expressions and movements.

Opera with Divine Powers =
A Cultural Show that Encapsulates Taiwanese Culture

On this night, a long line of people poured into the "Li Teng-Fang Ancient Residence" located in the Yuemei area of Daxi, and the crowd spread from the outer plaza to the Half-moon Pond and the outer square to the edge of the field. From a bird's eye view, the dark night of the vast plain is lit up with gorgeous lights in the middle.

For the first two years of Daxidaxi, "Dancing with God " was staged at the century-old national monument "Li Teng-Fang Ancient Residence." The "Smoke and Clouds" created by lighting designer Jiang Ji Yang for the old house are unforgettable and equally overwhelming, a tribute to tradition with a combination of monumental sites and electric rock that transcends the past and present. Whether it's the "National Treasure Prelude" by Chen Hsi-Huang Traditional Puppet Theatre **(3)** feat. "Excuse the Youth," the "Dance with the Gods", which combines the art of sound and dance with the gods, or the "Smoke and Clouds" created by lighting designer Chiang Chi-Yang for the old residence, they create a classic scene that is unforgettable and awe-inspiring.

Whenever "Dancing with God" is mentioned, the fantastical image of a troupe of Holy Generals surrounded by EDM dancers in front of the old residence

immediately springs to mind. This is "Dace with the Generals," a program put together by artist Liao Yi-Ching, sound artist Hsu Yen-Ting and the Daxi Chiatian Temple Tong Yi Tang Holy General Troupe.

Through actual field visits to Daxi, Hsu Yen-Ting recorded the sounds of Daxi carpenters, dragon dancers, and Beiguan bands in their night practice, and rearranged them with sound scenes and electronic sounds to create new possibilities for traditional sounds; choreographer and performance artist performer Liao Yi-Ching transformed the unique "curtsy" **(4)** posture of the Daxi Holy Generals into a contemporary dance performance form, in which the culture and visual intensity of the Holy Generals groups are strongly conveyed. The dancers unleashed the throbbing energy on stage with the aura of the four Holy Generals, and the audience held their breath and concentrated on every move of the gods and dancers on stage. This collaboration also became the nourishment for the participating artists in the creation of NTT-TIFA 2021 Lîng-tsong **(5)**, and the Daxi Holy Generals became a member of the performance of "Lîng-tsong" at that time. The choreography and production of "Dancing with the Gods" was revamped again in 2022. The choreography arrangement of Liao Yi-Ching, the traditional Holy Generals and the "electric gods" created by stylist Li Yu-Sheng were combined in the dance, incorporating tradition and innovation elements, from the medium to the performance choreography, not only endowing new life to the work, but also encapsulating the soul of Daxi.

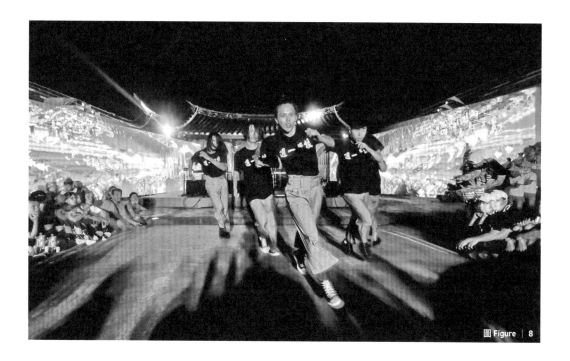

图 Figure | 8

Another classic production is the new generation of Taiwan-flavored rock by the national treasure of glove puppetry theatre, Chen Hsi-Huang, leading the Beiguan musicians, and the youthful flavors of the band Sorry Youth.

"Listen to our ballads, share our story, and I'll sing to you ..." When the prelude started, the song of the band "Excuse the Youth" immediately filled the site with the sound of rock. After working with Mr. Chen for the first time at the 2019 Taiwan Cultural Expo, the Daxidaxi team immediately decided to invite Chen and the "Excuse the Youth" to bring the performance to Daxi and celebrate the birthday of Guan Sheng Dijun with a redesigned choreography set, mixed with rock and roll music and glove puppetry.

Chen Hsi-Huang brought Marshal Tiandu **(6)** with him, together with the disciples of the Chen Hsi-Huang Traditional Puppet Theatre and the backstage musicians. From the beginning of the daytime procession at the Puji Temple Square in "Patrol with the God," to the nighttime dance stage, Chen Hsi-Huang joined forced with "Excuse the Youth" to perform "Running On," together with the devout offspring of Guan Sheng Dijun, as well as "Wind in the Pines" and "Chance of Marriage" to create "The Future is my Solace."

Mr. Chen Hsi-Huang commented so concisely: "it is important to practice tradition", "Come and work with the elderly to pass on this culture."

For two consecutive years, "Dancing with Gods" has been performed at the Li Teng-Fan Ancient Residence, and in 2020 it will be moved to the front of the Daxi Puji Temple, closer to the context of the performance. Whether it's "Dancing with God," "Daxi Pili Night" or "Righteousness Pa!," the names of these events, which echo the theme of the year, all exhibit a lively and authentic vibe, and the nature of the performance art that matches the local performance changes and evolves from year to year. The "showdowns" include a crossover performance between the A Root and the Xinshengshe Flying Dragon Troupe, a powerful song and dance combination between Athens Chen and the Gong Yi Santaizi Troupe, or a battle dance between Les Petites Choses Production's "Five Tiger Generals" and the Daxi Jinhong Cihuitang Lion Dance Troupe, which were cleverly designed to make the two different performing arts seem like a showdown **(7)** and a joint performance. The celebration is ostensibly a tribute to the gods, but it's also imbued with the meaning of uniting the people and sharing the joy.

"Wouldn't it be meaningful as a blessing if there was a song for everyone to sing and dance together at the celebration? " With this in mind, the 2022 Daxidaxi caused a sensation on social media and music streaming platforms with the song "OnOn," a seemingly nonsensical and catchy theme song; yet it is a song created by cross-disciplinary artists in order to integrate religious rituals, urban culture,

and celebration songs and dances.

With "OnOn" sung and danced all the way to the evening party, the whole evening program reached a climatic and much-anticipated finale song and dance show performance. "OnOn" brought together the original cast members "Les Petites Choses Production," "A-Root," "Sam-seng-hiàn-g" and the lead singer "Queen of Bobee Lotus Wang" to lead the public to sing and dance together. "Onon, Onononon…. You're the most On…" The chorus was repeated over and over, and the children were not afraid to stand in the first row and dance. The live dance performances, high improvisation and limitless tension of the performance not only climaxed to a high for the performers onstage, but also made for a lively engagement with the audience.

Community Joint Production: Interpreting Local Stories

"Celebrating Holy Emperor Guan's Birthday", 2018

"We Are All Shetou Members", 2019

Unlike the sparks of the performance art performance in " Dancing with Gods", the "Daxi Cultural Theatre" created by the theater experts "AMcreative" in 2018 is a collaboration with director Shu-Ching Hsieh to explore internally the local song and dance repertory theater of Daxi. Like a sumptuous family feast delicately prepared, from the collection of rich and heartwarming stories from Daxi, the inclusion of elements from the local community, the joint performance with local residents, and the live performance, this is a Taiwanese song and dance drama written with the power of the people.

Back to the moment before the play was ready to start, in the midst of the summer night breeze, a colorful and ornately decorated field stage theater was set up on the covered basketball court in Daxi. Audiences streamed in from all directions; residents showed up to watch the show after a full meal, plus as tourists who had been waiting for the theater all day, all sitting next to each other.

"When there is worship there is protection! When there is worship there is protection! June 24th is the New Year of the people of Daxi, come on!" As the music started, familiar figures appeared on stage, speaking their lines, and it was hard to tell who the professional actor was, and who was a local resident. Everyone sang and danced together, the drama was the daily life of faith in Daxi, the stage and offstage automatically blended into one. With fans in the hands, all the audience laughed with joy mixed in tears, and concluded with the line, "It's for the sake of Master Guan! " The audience, young and old, applauded and cheered to give the best support for the play, which is a limited repertory theater production of the Daxi Cultural Theater during Daxidaxi.

Behind such a scene is the charm of the theater created by the composition of several important elements in the Daxi Cultural Theatre, including the collection and writing of local field tunes, residents and professional actors who perform

together, original Taiwanese songs and dances, and local stages, etc. Daxidaxi aims to create a cultural theater where people of Daxi perform their own stories and sing their own songs for the enjoyment of all. From the key performances "Celebrating Holy Emperor Guan's Birthday" in 2018 to the "We Are All Shetou Members" in 2019, the former carries the heritage of Daxi's faith and wood art culture, and interprets the touching stories developed by the people of Daxi for generations, with the religious faith in Guan Sheng Dijun as the core; while "We Are All Shetou Members" highlights the conflict between the old and new Shetou and the impact of Shetou from outside Daxi to evoke the original purpose of participating in Daxi's "June 24 Reception," hoping to create a diversity of Daxi's Shetou groups and devotion to pass on the core spirit of the celebration.

> *"Being from Daxi, rehearsing and telling the story of Daxi together with the Shetou members, young pupils and the locals have gifted me with a deeper connection to the land and made the relationship with people even more tender and touching.*
> *--Li Yun, a local resident who performed in the play.*

Director Shu-Ching Hsieh also noted on Facebook: The success and behind-the-scenes stories of every successful theatrical performance is rooted in the fact that at least 70-80 people are credited for delivering the onstage and offstage performance, which lasts 70 minutes, with amateur actors from 16 to 70 of age, professional stage performers, Shetou groups, technical theater teams, film crews, and the Daxi Wood Art Ecomuseum. Everyone plays their part frontstage and backstage, onstage and offstage, and everyone tries to give their best!

In the wealth of performances devoted to the gods in Daxidaxi, one can see artists coming to Daxi to draw from the tradition, create and present their works in Daxi. The great energy and feedback generated on the spot will be referenced again, and the interaction with local people and communities, spatial sites, religious rituals, and other factors will blend with each other, absorbing and giving to each other, becoming a dynamic cycle of culture, creating a new meaning of Daxidaxi that not only honors the gods with outstanding performances, but that is also unique to Daxidaxi.

圖 Figure │ 9
同根生於「神嬉舞夜」現場教學傳統樂器與戲曲中常用的打擊樂記譜方法「鑼鼓經」。
In "Dancing with Gods," A Root taught the audience about the percussion music notation method that is commonly used in traditional musical instruments.

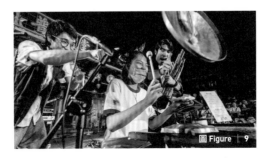

圖 Figure │ 9

將大溪人事物持續紀錄的力道
The momentum to continue documenting Daxi

每年的「大溪大禧」都會策劃一個實體紀錄特展,不只是年度設計過程的紀錄、有故事性的文化敘事,更是以多元手法、藝術性的層層轉化而打造的創新紀錄展,這也是每一年策展完整的主題性梳理,藉由設計觀點,切入城市的人事物,記錄時時刻刻在為信仰付出的人。

從「將軍與我」、「遶境事務所」到「舞德殿」,不難發現這些展覽的共通性皆圍繞在「迎六月廿四」信仰生活的精神與價值,將默默付出的在地人拉至鏡頭前成為被紀錄的主角,而每年的紀錄展也以不同的記錄手法和方式,導入藝術性和設計互動性,使之被保存,並保有其深度和張力,也讓每一位被紀錄者發現自身的生活即文化自覺,在此同時,「迎六月廿四」信仰生活的樣貌透過記錄進行數位建檔、不僅可永久保存、也使之成為展覽最重要的部分,每個人都可能是進到展覽殿堂中的關鍵角色。

2019 年的「將軍與我」紀錄展,以 11 幅影像看見人與信仰之間最真摯的連結與互動,2022 年的「舞德殿」紀錄展則以 12 幅動態記錄將軍的細膩腳步和儀式文化;而 2020 年的「遶境事務所」則盤點從過去到現在因「迎六月廿四」所衍伸出的慶典儀式、常民風俗以及遶境文化時序,挖掘、研究並復興逐漸消逝的珍貴信仰風俗,讓大眾、也讓在地看見大溪百年傳承的信仰生活學。

(1) │ 出巡
亦習稱「遶境」,指信徒自廟宇請出神尊或神聖物,並奉於神轎內,一起外出巡視整座城市。

每年的展覽都有信仰知識及在地文化的遞嬗性,將軟性內容有條理的收攏至展覽裡讓人細究設計意涵與實品對照,偶爾出現「展品出巡 **(1)** 中」的告示牌更是令人莞爾一笑,展覽成了為大溪「迎六月廿四」信仰生活的延伸、及「大溪大禧」對大眾說故事的最佳路徑。

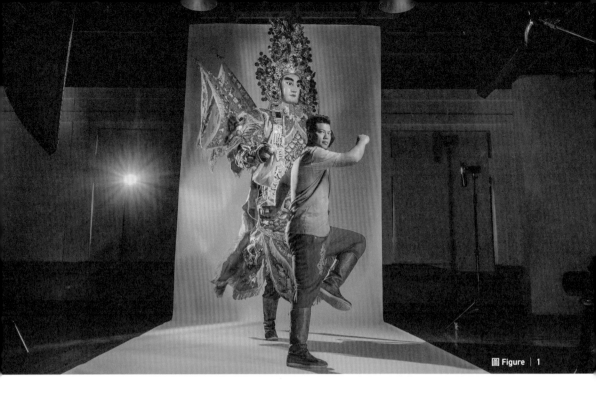

圖 Figure │ 1

2019 年，「將軍與我」紀錄展拍攝現場，嘉天宮同義堂的關平將軍（李晉德穿戴）與張書武展現將軍精神。

In 2019, while taking photos for the "General and I" exhibition, the General Guan Ping (carrying by Jin-De Lee) and Shu-Wu Chang from Chiatian Temple Tongyi Tang showcase the General's spirit.

用攝影記錄信仰，看見人與信仰之間最真摯的連結與互動

在《神之鄉》電視劇中，正在教男主角扛將軍的王大勇說「拿將軍最大的心法是把你自己藏起來，用你的腳步，就是將軍腳，去彰顯神明的風采，誠心為神明服務。」而這套扛將軍的心法，在真實的大溪或許並不需要特別傳授，因為將軍腳們藏匿凡間、處處皆是。

在大溪因關聖帝君信仰，而衍生出許多社頭以三國時代將領人物作為組裝將軍的原型。每年「迎六月廿四」時節，這些大溪的「將軍腳」便會紛紛現身，在信仰面前放下身段，用最大的敬意整裝，將一尊動輒三、四十公斤重的裝備穿戴在身上，一步、一步地踩踏前進。而為了進一步了解是什麼樣的強烈信念，讓這些人願意年復一年地承擔這樣的重擔？「將軍與我」攝影紀錄展於焉而生。

在攝影紀錄展中，是一趟深度挖掘、記錄將軍與其守護者的故事旅程，不論是關鳳將軍與大溪唯一女將軍腳團、為神明服務的一家人、背負強烈使命感的將軍腳傳人，抑或是因為扛將軍而交一輩子心的老朋友等，每個人都有各自對於信仰以及將軍的連結，11 組將軍威武神勇的

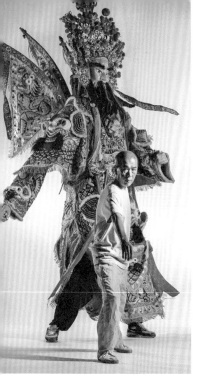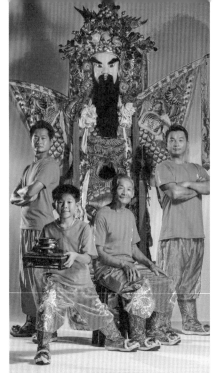

圖 Figure ┃ 2

2019 年「將軍與我」紀錄展：

（左）同義社黃忠將軍（楊孫忠穿戴）與黃俊祥。

（中）共義團廖化將軍與廖家三代：廖阿立、廖紀龍、廖紀宗、廖國翔。

（右）樂團社周倉將軍與賴銘偉。

"General and I" exhibition, 2019

(left) General Huang Zhong (carried by Sun-Zhong Yang) and Jun-Xiang Huang from Tongyi Society

(middie) General Liao Hua and A-Li Liao, Ji-Long Liao, Ji-Zong Liao, Guo-Xiang Liao from Gongyi Tuan

(right) General Chou Cang and Ming-Wei Lai from Le'bin Society

巨幅姿態，扛將軍的「將軍腳」們或坐或站直視鏡頭，神態自如，而共通的堅定意志是：他們扛起的並不只是將軍，還有世世代代傳承下來，對神明、對信仰以及對傳統文化的敬意。

不只在人間應援，更涵蓋天界將軍的「遶境事務所」

慶典的籌備不僅在人間，天界的神明與地上的扛轎者，兩者都是遶境不可或缺的主角！傳統關聖帝君誕辰慶典百年來如一日，神明沒有停止過對人間的應許，人們也感激關聖帝君的關照，代代相傳、年復一年的無私的準備各項慶典事務，才能讓這文化流傳，在神與人的依存連結下，宛若是一間運轉了百年的「遶境事務所」。

2020 年「大溪大禧」以「關公 online ！」為主題，強調無遠弗屆的祝福，特展以「遶境事務所」為題，展開「天界慶生會」及「人間應援團」兩個全新單元，除了延續以訪談及攝影展的方式記錄這段百年文化，更挑戰用場景創造的生動方式帶領大家一起進入異次元的世界裏。

2020 年「遠境事務所」紀錄展：

（左）糖塔：供桌上最厚工的珍貴風景——黃智弘。

（中）隨香：帶著祈願與感謝同行——黃林寶連。

（右）香案：為神明接風的民間重頭戲——謝阿森。

"The Office of the Temple Procession" exhibition, 2020 (left) Sugar pagodas: the most valuable sacrificial offering Chih-Hung Huang (middle) Follow the procession: walking with the god with prayers and gratitude Baolian Huang Lin (right) Incense table: a folk highlight to welcome the god A-Sen Xie

「大溪大禧」將無形概念以有形的方式呈現，位在普濟堂所屬建築二樓會議室的「天界慶生會」，會議室中央擺放了兩排整齊的長桌與份量感十足的木座椅，座位的主角則是桌面名牌上的各路神明，我們可以幻想關平太子、土地公、三太子等眾神明將軍齊聚一堂，不僅要受理人間的各項業務，也熱烈的討論如何幫關公慶生。最前方講台則是可以向關公祈願互動的「關公許願場」，整體互動的形式也很有趣，握住香許願後放開，籤詩就會從旁邊的小神獸吐出，展覽限定的籤詩表達著現代人需要的精神鼓勵與 10 位神祇一起給予現代人的祝福內容，期望在這個不安的年代能為大家帶來療癒的力量。

三樓的「人間應援團」展區，則採集 10 組籌備慶典的關鍵角色，串聯記錄大溪人如何盡一己之力、年復一年地扮演好自己的角色，堅持守護著遶境文化裡的每個細節，讓延續百年的「迎六月廿四」歷久彌新，也成為百年慶典組成裏堅強的靠山。無論是與神相隨 40 載的香擔手、年年推出遶境補給站的涼水攤、帶著祈願與感謝同行的隨香客等等，從文字與畫面中都可以感受到大溪遶境時節特有的人文風景，他們懷抱的不僅是對神明與土地的敬意，更是感恩與互助之心，是促成百年遶境文化與儀式的扛轎者。

大吉
── 第一首・萬事如意 ──

帝君主題
人喔，就是煩惱太多。你的人生根本沒什麼好擔心的，一切OK啦~

來自周倉關平的祝福
我老闆(關平：老爸)都這樣說了，日子過開心點。

來自太陽星君的溫馨提醒
風雨過後，撥雲見日(但還是要記得帶傘擦防曬喔)

來自土地公的關懷
你好，我就好

來自太子爺的療癒
擔心太多耶~ㄟ(´╭╮`)╯

來自千順將軍的問候
每件事都是最好的安排！

來自四海龍王的生活建議
宜：實踐你內心的idea
忌：負面思想迴圈

![圖公ONLINE DAXIDAXI]

中吉
── 第二首・愛自己 ──

帝君主題
所謂對自己的愛不只物質享受、慾望遷成。而是好好地照顧自己，順著內心真正的想望去做決定。

來自周倉關平的祝福
人生不長，不需要當濫好人。

來自太陽星君的溫馨提醒
很多事自有安排，不需要事事遷就。

來自土地公的關懷
不要捨得自己太累啊~

來自太子爺的療癒
跟我一起來罐多多 o(☆Φ∇Φ☆)o

來自千順將軍的問候
辛苦了、辛苦了~

來自四海龍王的生活建議
宜：適時說NO
忌：忍耐過頭

![圖公ONLINE DAXIDAXI]

上吉
── 第三首・耐心等待 ──

帝君主題
每件事都有因緣俱足的時候，凡事多給自己與世界一點耐心。

來自周倉關平的祝福
你有自己的tempo，不需要跟別人的速度。

來自太陽星君的溫馨提醒
無論天氣還是良人，等待都是值得。

來自土地公的關懷
你覺得蕃茄種下去隔天就會長出來嗎？不會喔~那就對啦！！

來自太子爺的療癒
皮卡丘讓我等了好久才出現，但我真的好喜歡喔(๑╹ω╹๑)

來自千順將軍的問候
慢慢來比較快~

來自四海龍王的生活建議
宜：練習深呼吸｜忌：貪快

![圖公ONLINE DAXIDAXI]

中吉
── 第四首・珍惜緣分 ──

帝君主題
你周遭的一切都不是理所當然的，好好善待眼前的人事物，不要只想著追求未來。

來自周倉關平的祝福
未來都是說不準的呀！兄Day~~

來自太陽星君的溫馨提醒
天氣多變化，記得帶水也帶傘

來自土地公的關懷
轟轟、綿份都由不得我們，而是取決於上的因與缺珍惜。請好好把握~

來自太子爺的療癒
看到有人送來我喜歡的點心，都會希望他留下一點 (๑•́ω•̀๑)

來自千順將軍的問候
以和為貴，吵架之前多想一下~

來自四海龍王的生活建議
宜：關心周遭的人｜忌：衝動行事

![圖公ONLINE DAXIDAXI]

上吉
── 第五首・誠實面對 ──

帝君主題
不事要理會別人的想法，也不用聽別人怎麼說，好好傾聽自己內心的聲音。

來自周倉關平的祝福
不要害怕接受真正的自己。

來自太陽星君的溫馨提醒
天氣太熱的時候別把自己累壞了。

來自土地公的關懷
自己在意的事，不需要刻意壓抑喔

來自太子爺的療癒
我的優點就是長得帥、缺點也是長得太帥，大家太~喜歡我了(*´∀`)~♥

來自千順將軍的問候
面對自己的缺點，但也要記得多看看自己的優點

來自四海龍王的生活建議
宜：寫出自己的十個優點
忌：人云亦云

![圖公ONLINE DAXIDAXI]

中吉
── 第六首・知足最有福 ──

帝君主題
事事過要求，其實也是一種貪。貪財、貪多、貪名聲、貪表現，都是無謂的追求，不會讓你的生活更快樂。

來自周倉關平的祝福
凡事求剛剛好，盡力而為。

來自太陽星君的溫馨提醒
台灣物產真的很豐饒，但不要因此浪費食物。

來自土地公的關懷
人生所需，夠用就好。

來自太子爺的療癒
多多喝一罐最好喝了，再喝一罐就會有點太胖 (>﹏<`)

來自千順將軍的問候
學習分享。

來自四海龍王的生活建議
宜：時時感謝｜忌：過度瘋狂購物

![圖公ONLINE DAXIDAXI]

大吉
── 第七首・勇者無懼 ──

帝君主題
擔心太多是沒有用的！與其太害怕失去或失敗，勇敢一點去嘗試看看所有的決定都在你手中。

來自周倉關平的祝福
把握機會，做自己真的想做的事。

來自太陽星君的溫馨提醒
行動力會帶你看見更多世界的樣貌。

來自土地公的關懷
要有信心，我們其實都在你身邊~

來自太子爺的療癒
勇敢的人最帥了！就跟帝君爺爺一樣帥！ฅ(=╹ω╹=)ฅ

來自千順將軍的問候
害怕面對的，終歸都要著正面迎擊！

來自四海龍王的生活建議
宜：有話直說
忌：過度依賴舒適圈

![圖公ONLINE DAXIDAXI]

上吉
── 第八首・真心對待 ──

帝君主題
很多人都不懂真心是什麼；真心是不介意回報、無條件地去付出。太期盼有所獲得，這就不是真心了。

來自周倉關平的祝福
真心跟虛誠是不太一樣的唷。

來自太陽星君的溫馨提醒
好好善待你生活的這片土地。

來自土地公的關懷
不用山一樣高的貢品，心意最重要。

來自太子爺的療癒
請好好對待小朋友，他們都是註生娘娘特別挑選送來的禮物！

來自千順將軍的問候
你平常的心意(和心聲)我們都有收到，也有傳達給媽祖婆了 ♥

來自四海龍王的生活建議
宜：多抱抱親近的人｜忌：吹毛求疵

![圖公ONLINE DAXIDAXI]

大吉
── 第九首・厭世有理 ──

帝君主題
不會因為做錯一件事，天就塌下來。也不會因為做得不夠好，就被雷劈。不需要一直往上爬，躺下來放空擺爛沒有關係。

來自周倉關平的祝福
你的生活真的不需要這麼累啦。

來自太陽星君的溫馨提醒
颱風下雨在所難免，但可以不出門~

來自土地公的關懷
不想做任何事時，也別責怪自己。

來自太子爺的療癒
我們一起來躺著發呆 _(:3」∠)_

來自千順將軍的問候
誠實面對「我就廢」，生活更快樂。

來自四海龍王的生活建議
宜：每日只有一件待辦事項
忌：口是心非

![圖公ONLINE DAXIDAXI]

大吉
── 第十首・相信自己 ──

帝君主題
對自己多點信心，你本來就和別人不一樣。為什麼要變得跟別人一樣？

來自周倉關平的祝福
我跟我老不一樣，也活出了特色啊！

來自太陽星君的溫馨提醒
無論面對喜歡、崇敬或是害怕的人，鼓起勇氣跨越心中的那個檻。

來自土地公的關懷
人生沒有標準答案，要為自己活啊

來自太子爺的療癒
我的肚子覺會告訴我想吃什麼，但也真的被它說中了耶！(๑•̀ㅂ•́)و

來自千順將軍的問候
重視直覺，那是人最寶貴的天賦喔

來自四海龍王的生活建議
宜：為自己實踐一個想完成的事
忌：用太多腦袋逼

![圖公ONLINE DAXIDAXI]

上吉
── 第十一首・平安健康 ──

帝君主題
無論多少榮華富貴，都沒有身心健康來得重要。

來自周倉關平的祝福
放寬心，好好善待自己。

來自太陽星君的溫馨提醒
遇到任何狀況時，不要心存僥倖。

來自土地公的關懷
每天出入平安，就是最大的福氣啊呵呵呵呵~

來自太子爺的療癒
其實攝小孩開心、乘乘長大就很好了，爸爸媽媽不要太過擔心(。・ω・。)

來自千順將軍的問候
好好吃飯！

來自四海龍王的生活建議
宜：睡眠至少八小時
忌：深夜吃重鹹

![圖公ONLINE DAXIDAXI]

中吉
── 第十二首・學習開心 ──

帝君主題
即便符合心裡想，但你開心嗎？人生不長，記得每天都要開心哦。

來自周倉關平的祝福
不時好好思考，來個人生自問自答？

來自太陽星君的溫馨提醒
無論什麼季節、什麼氣候、什麼生活、什麼挑戰，都學著順應應過。

來自土地公的關懷
看你愁眉苦臉，笑一個嘛~~~~~

來自太子爺的療癒
每天玩玩具、點心，以及跟虎爺一起玩，我都超級開心 ٩(๑´∀`๑)۶

來自千順將軍的問候
學習放輕鬆，肩膀就不會太緊繃

來自四海龍王的生活建議
宜：每天至少做一件讓自己開心的事
忌：壓力囤積不釋放

![圖公ONLINE DAXIDAXI]

中吉
——第十三首·心存善念——

帝君主題
事情不能只看表象，每件事情背後的心念，才是最重要的，要很清楚自己是為了什麼原因而做出選擇。

來自周倉關平的祝福
試著多幫助真正需要幫助的人。

來自太陰太陽星君的溫馨提醒
放颱風假請好好在家，確保安全。

來自土地公的關懷
在我們面前是怎樣的心，其實我們真的都知道喔。

來自太子爺的療癒
不給別人添麻煩，就棒棒(°ω°)人(°ω°)

來自千順將軍的問候
人與人的關係是練習，試著用柔軟一點的心去看待。

來自四海龍王的生活建議
宜：重視每個選擇｜忌：情緒勒索

關公ONLINE

中吉
——第十四首·有捨有得——

帝君主題
人與人之間購緣份，不適合自己的，也不要堅持忍耐。斷捨離是困難的，但該放下的也得要放下，面對現實。

來自周倉關平的祝福
人生是需要好好整理的。

來自太陰太陽星君的溫馨提醒
心境寬闊，怎樣都是海闊天空。

來自土地公的關懷
勇敢捨得，才是大人。

來自太子爺的療癒
生活要開心的話，不需要擁有太多東西呀！ヽ(◕‿◕)ﾉ

來自千順將軍的問候
不用為了或全別人，過度犧牲自己。

來自四海龍王的生活建議
宜：整理一下自己近期的生活狀態
忌：自顧不暇

關公ONLINE

上吉
帝君主題　第十五首·緊

不需要過度緊繃，活在世該的價值觀當中，學習放鬆是個重要的課題。

來自周倉關平的祝福
呼～～～～～～(深呼吸，一起來)

來自太陰太陽星君的溫馨提醒
世界如果太嚴謹，就不會那麼美啦

來自土地公的關懷
哎呀哎呀愁眉苦臉的，把眉頭鬆一鬆啦～！(笑)

來自太子爺的療癒
又不是天塌下來，不會怎樣啦！

來自千順將軍的問候
你可以學我們老闆(默娘)，吃個甜食就超開心。

來自四海龍王的生活建議
宜：預約頭皮舒壓療程
忌：在家足不出戶

關公ONLINE

…吉??
——第十六首·蛤——

帝君主題
在提問之前，要先整理好自己想問的是什麼喔？有明確的問題，才能獲得清楚的答案不是嗎？

來自周倉關平的祝福
不太懂你的問題耶～～

來自太陰太陽星君的溫馨提醒
？？？

來自土地公的關懷
阿你到底是想問什麼膩？

來自太子爺的療癒
欸…… (;´д`)。o0(‥‥)

來自千順將軍的問候
訊號是不是被干擾了？

來自四海龍王的生活建議
宜：請好好整理一下提問
忌：心神不定

關公ONLINE

大吉
—— 第十七首·給力 ——

帝君主題
會越來越好的！加油！！
(不好意思我話不多)

來自周倉關平的祝福
不要輕易放棄，fight！

來自太陰太陽星君的溫馨提醒
陽光普照，你還在等什麼？

來自土地公的關懷
動起來！！！

來自太子爺的療癒
多多加油～～～ (我是說多一點啦不是喝的 (ﾟωﾟ)

來自千順將軍的問候
向～前～走～

來自四海龍王的生活建議
宜：給自己精神喊話
忌：自我放棄

關公ONLINE

中吉
—— 第十八首·何須問 ——

帝君主題
你心裡都很清楚，不用特別來問我。

來自周倉關平的祝福
請好好面對內心的想法。

來自太陰太陽星君的溫馨提醒
你不是真的有疑問，對吧？

來自土地公的關懷
你可以的，就照自己想要的去做。

來自太子爺的療癒
不要一直問了喔…… (´-3·)

來自千順將軍的問候
……………？

來自四海龍王的生活建議
宜：自在生活
忌：臨內糾結

關公ONLINE

上吉
—— 第十九首·好好生活 ——

帝君主題
好好吃飯，好好睡覺，活在當下，生活就會好。

來自周倉關平的祝福
專注做好一件事，就好。

來自太陰太陽星君的溫馨提醒
找到自己適合的速度，是最重要的。

來自土地公的關懷
人如果只是追求青春不老，沒有意義啊，這樣只是著相。

來自太子爺的療癒
好好照顧自己的身體，因為塌了就沒了嘛。(·ω·)

來自千順將軍的問候
沒有好好生活，就什麼都不會好。

來自四海龍王的生活建議
宜：踏實度日
忌：盲目追求導致迷失

關公ONLINE

大吉
—— 第二十首·感謝感謝 ——

帝君主題
記得感謝的心念，對天地萬事萬物抱持感恩喔～！

來自周倉關平的祝福
感謝你對大溪大禧的肯定與支持！

來自太陰太陽星君的溫馨提醒
時時感謝，讓人如沐春風 ✿

來自土地公的關懷
感謝每逢初二、十六的熱情照顧。

來自太子爺的療癒
感謝大家總是陪我一起玩！
(∀´)人(´∀`)人(`∀`)人(´∀`)

來自千順將軍的問候
大家遶境辛苦了！

來自四海龍王的生活建議
宜：多喝水多休息
忌：過度勞動

關公ONLINE

圖 Figure | 4
2020 年「遶境事務所」紀錄展／天界
藉由互動裝置向關公許願，抽取來自關公和天上為遶境執勤的神仙將軍一起給予的現代祝福籤詩。

"The Office of the Temple Procession" exhibition, 2020
After making wishes to Guan Gong with the interactive device, visitors would receive the modern blessing poems given by Guan Gong and the Generals.

圖 Figure | 4

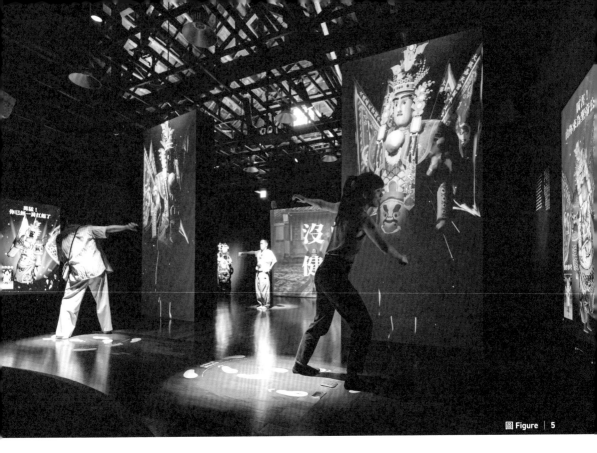

圖 Figure｜5

2022 年「舞德殿」紀錄展，在互動展區學習大溪將軍「屈禮」拜廟動作。

In the interactive area in the 2022 exhibition "Dancing Hall of Virtues," visitors could learn the unique saluting movement of Generals in Daxi.

「這些人成就了一個節慶、成就了一個文化，他們的堅持也是一種偉大；這些人對於地方這樣長年來的付出，才真的值得被感謝。而能為這樣的人們拍攝，比什麼都還有意思，亦是很重要的養分。」

——攝影師 林科呈

與眾神昂首前行，感受信仰的凝心正氣

穿越入口黑簾，踏入的神秘長廊，耳邊響陣陣悅耳的銀鈴聲，黑暗中只見兩側的一格格窗景，靈感取自化身將軍後、視野穿過將軍腹部窗景所看見的「迎六月廿四」風景，空氣中彌漫著香爐點起的裊裊輕煙，像是喚請眾神前來，從入口的場景設計，便猶如引人穿入將軍的世界中、進入一趟神聖的探索旅程。

(2)｜請神

在正式遶境前，會透過香爐執行請神儀式，邀請天上的將軍下凡。

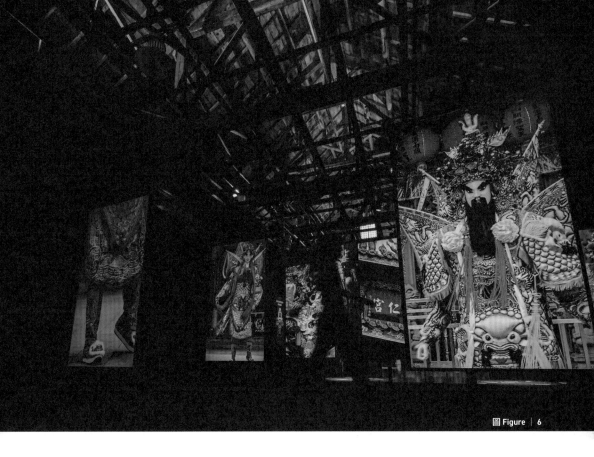

圖 Figure | 6

2022 年「舞德殿」紀錄展，以動態影像記錄 10 尊將軍，人與神的姿態。

In the 2022 exhibition "Dancing Hall of Virtues," there are videos recording the 10 Generals' movement and spirit.

「與眾神昂首前行，感受信仰的凝心正氣」是 2022 年「舞德殿」紀錄特展對大眾傳達的核心訊息。「將軍」為關聖帝君的行前護衛，守護著關聖帝君出巡，出巡的步伐與拜禮的儀態具有其特色和意義，代代相傳。繼「將軍與我」攝影紀錄展後，「大溪大禧」再次以將軍作為展覽策劃主題，透過動態影像記錄大溪 10 尊將軍的姿態特色，展現大溪社頭穿戴上將軍裝備時、化身將軍腳的動態表現與精神轉換。

「舞德殿」以將軍步伐為概念貫穿，循著「扛將軍」的三個重要儀式：請神 (2)、巡場、拜廟，分為三個展區認識大溪獨特的將軍文化。通過儀式感濃厚的第一個展區「神幸通廊」後，便進入由 8 組螢幕形塑出的將軍立體劇場。「一、二、三，屈！」從將軍步伐到特有的屈禮模式，站在交錯畫面的前方，可以感受到那醞釀已久的正氣之姿，不僅是畫面，以訪談方式記錄不同社頭將軍特色以及將軍腳經歷，更引人感受將軍與人之間的無形連結。

走過「將軍巡場」展區，觀者還能夠透過互動裝置，學習大溪將軍拜廟時特有的「屈禮」動作，隨地面數字指引試著踩「將軍步」，加入將軍文化傳承的行列；最後，再到下個展間跳一回關公慶生神曲《紅紅OnOn》，有別於前兩區的儀式空間，在這裡感受到的是置身現場的歡騰，跳完舞後，就能馬上掃描 QR code 下載自己的舞蹈片段，並上傳到牆上大型投影幕後，看自己與其他觀展者和王彩樺、小事製作一起跳舞的畫面，也象徵每個人都能夠將正心正念化為行動，用自己的方式感謝神明照顧。

連續兩年共同參與展覽策劃的包叔平說：「在『大溪大禧』看到的一切，其實也是信仰文化的經典一切，也是自古以來看到的廟會形式的一切。其實人一直以來都離不開這些，而神明也跟人其實很近。但凡事講求於最初的心念。」

Every year, a special physical exhibition is planned for "Daxidaxi". It is more than a documentation of each year's design process, a "storytelling" cultural narrative, but also an innovative documentary exhibition created by multiple methods and artistic transformations, which is also a complete thematic experience that examines each year's curatorial exhibition experience; it features everything about Daxi through design perspectives, and tracks the people who are devoted to their faith every moment of every year.

From "The General and I," "The Office of the Temple Procession" to "Dancing Hall of Virtues," it is obvious that the commonality of these exhibitions revolves around the spirit and value of the faith of "June 24 Reception" celebrations. The locals who have tirelessly contributed to this celebration are featured front and center in the exhibition. Every year, the exhibition uses different recording methods and approaches to introduce artistry and design interactivity, so that it is well-preserved to retains its depth and tension; it also allows each documented person to discover his or her own life as an epitome of cultural self-awareness. At the same time, the digital documentation of the faithful of "June 24 Reception" will not only be preserved forever, but also become the most important part of the exhibition, and each of them may be a key player in the exhibition hall. The "General and I" photo documentary exhibition in 2019 feature 11 images of the most sincere connection and interaction between people and their faith, while the "Dancing Hall of Virtues" special exhibition in 2022 featured 12 dynamic records of the delicate formations and ritual culture of the Holy

Generals. In 2020, the "The Office of the Temple Procession" took stock of the rituals, customs, and cultural sequences of the parade from the past to the present, so as to explore, study, and revitalize the precious beliefs and customs that are fading away, so that the public and the local community can witness the heritage of faith passed down in Daxi for over a century.

(1) | **On parade**

It is also known as "Procession", which means that believers invite gods or sacred objects from temples, enshrine them in palanquins, and go to inspect the entire city.

Every year, the exhibition conveys and passes on the knowledge of faith and local culture, and the soft contents are collected into the exhibition in an organized manner, so that people can examine the design context and contrast with the actual objects, and the occasional "exhibits on parade [1]" sign readily puts a smile on people's faces. The exhibition has become an extension of the faith life of "June 24 Reception," and the best approach to telling the story of Daxidaxi to the public.

Documenting Faith Through Photography, Witnessing the Sincerest Connection and Interaction Between People and Faith

In the TV series "The Summer Temple Fair," Wang Da Yong, who is teaching the main character to carry the Holy General, advises, "The greatest way to carry the Holy General is to hide yourself and use your steps. Make your feet that of the Holy General, to manifest the grace of the gods and to serve them sincerely." Here in Daxi, there may not be a need to teach this mental method of carrying the Holy General, because the men of the general are everywhere, living among us in the mortal world.

Because of the belief in Guan Sheng Dijun, many Shetou in Daxi have used famed Three Kingdoms era generals as the prototypes for their assembled generals. Every year, during the "June 24 Reception" festival, the "Holy General's Men" of Daxi will make an appearance, let down their guard, and dressing up with the utmost reverence, putting on a religious costume that weighs 30 to 40 kilograms before journeying forward, one step at a time. The "General and I" photo documentary exhibition was born out of a conviction that inspires these people to bear such a heavy burden year after year.

In the photo documentary exhibition, we embarked on a journey to dig deeper and documeng the stories of the Holy Generals and their guardians. Whether it is General Guanfeng and the only Holy General troupe made up of women, the family serving the gods, the heirs of the Holy Generals with a strong sense of mission, or the lifetime friendship formed from carrying the Holy Generals, everyone has their own connection to faith and the Holy Generals. The 11 Holy General troupes are awe-inspiring in their posture, and the "Holy General's Men" carrying the generals are sitting or standing looking straight at the camera, poised and calm, and the common determination is that they are carrying not only

the Holy Generals, but also the respect for the gods, for faith and for traditional culture, which has been passed down from generation to generation.

Not Only Supporting the Mortal World, But the Immortal as Well - "The Office of the Temple Procession"

The preparations for the festival are not only on the mortal world, but the gods in heaven and the palanquin bearers on earth, both of whom are indispensable protagonists of the parade! The traditional birthday of Guan Sheng Dijun has been celebrated the same way for over a hundred years. The gods have never stopped granting the wishes of the people, and the people are grateful for the care of Guan Sheng Dijun. The devout selflessly prepares for the various festivals from generation to generation, year after year, so that this culture can be passed on, and under the linkage between the gods and people, it is like an "Office of the Temple Procession" that has been running for a hundred years.

In 2020 "Guan Gong Online!" was chosen as the main theme for Daxidaxi that year, which emphasizes the infinite blessing of the god. The special exhibition is titled, "Office of the Temple Procession," and two new sections, "Divine Birthday Celebration" and "Mortal Support Group," were launched. In addition to continuing to document this centuries-old culture through interviews and photo exhibitions, we were also challenged to use scenes created in a vivid approach to lead people into an interdimensional world.

Daxidaxi attempts to present intangible concepts in a tangible medium. The "Divine Celebration" is located in the conference room on the second floor of the building where Puji Temple is located. Two rows of long, neatly arranged tables and weighty wooden seats are placed in the center of the conference room, and the main characters of the seats are the gods and goddesses as noted on the name plates on the table. We can imagine that Prince Guan Ping, the Earth God, Nezha (Third Lotus Prince) and other gods and goddesses are gathered together, not only to take care of various businesses of the mortal world, but also to enthusiastically discuss how to help Guan Sheng Dijun celebrate his birthday. The podium at the front of the exhibition is the "Guan Gong Wishing Field" where you can pray to Guan Gong, for an interactive experience. After holding the incense and making a wish, the divination poem will be spat out from the small divine creatures on the side. The divination poem, which is limited to the exhibition, expresses the spiritual encouragement needed by adherents and the blessings given by the 10 gods together, hoping to bring healing power to everyone in these troubled times.

The "Human Support Group" exhibit on the third-floor features 10 groups of key players in the preparation of the festival, documenting how Daxi locals have played their roles year after year, insisting on guarding every detail of the temple

procession culture, making the "June 24 Reception" last for over a century and serving as a steadfast support for the century-old celebration. Whether it is an incense bearer who have been with the gods for 40 years, the refreshments stalls that launch the supply station for the procession every year, or the devout faithful who travel on foot in gratitude, you can feel the unique cultural snapshot of the Daxi processional season from the words and images, and what they carry is more than just the respect for the gods and the land, but also the gratitude and the willingness to serve, which are the bearers of the centuries-old processional culture and rituals.

> *"These people have created a festival and a culture, and their perseverance is also inspiring. The contributions made by these people to their community is something to be acknowledged. To be able to photograph these adherents in action is more interesting than anything else, and it is also spiritually rewarding."*
>
> *- Photographer Lin Ke-Cheng*

Walking with the Gods and Feeling the Unifying Aura of Faith

Through the black curtain at the entrance, you step into a mysterious corridor, the sound of silver bells ringing in your ears, and in the darkness you can only spot window views from both sides. The inspiration is taken from the "June 24 Reception" scenery, seen through the window view of the Holy General's abdomen after incarnation into the Holy Generals. The air is filled with the swirling smoke from the incense burners, as if beckoning the gods to come, and from the design of the entrance, it is as if one is drawn into the world of the gods and enters a sacred journey of discovery.

The core message of the 2022 "Dancing Hall of Virtues" exhibition is to convey the spirit of "walk with the gods and feel the unifying aura of faith." The "Holy General" is the guardian of Guan Sheng Dijun on his holy procession, and the pace of the tour and the rituals of worship have their own characteristics and meanings, which have been handed down from generation to generation. Following the "The General and I" photo documentary exhibition, Daxidaxi once again focuses on Holy Generals as the theme of the exhibition, recording the various posture of the 10 Holy Generals in Daxi through video, showcasing the vivid facial expression and spiritual transformation of Shetou when putting on the Holy General's gear, and becoming a Jiangjunjiao (Holy General's Men).

"Dancing Hall of Virtues" is inspired by the choreographed strides of the Holy General, and the three important rituals of "Carrying the Holy General" are followed: invoking the gods [2] , the parade, and worshipping in the temple. The

program is divided into three exhibits to acknowledge the unique culture of the Holy Generals in Daxi. After passing through the first exhibition area, the "Hall of Gods," which is noted for its strong sense of ritual, you will enter the three-dimensional theater of the Holy General, which is created through 8 sets of screens. "One, two, three, curtsy!" From the general's posture to the unique bowing pattern, you can feel the long-established righteousness of the posture as you stand in front of the staggered screen; the interview is conducted to document the characteristics of different Holy Generals and the experience of the Holy General's men, which makes you feel the invisible connection between the gods and the people.

Walking through the "Holy Generals Parade" exhibition area, visitors can also learn the unique "bowing" curtsy posture of the Daxi Holy Generals during temple worship through an interactive device and try to step into the formations of the "Holy Generals Steps" as guided by numbers indicated on the ground, thus joining the passing of cultural heritage of Holy Generals culture. Finally, head to the next exhibition hall and dance to the song "OnOn," which is a celebration of Guan Sheng Dijun's birthday, and feel the joy of being part of the revelry, unlike the more austere ceremonial space in the first two areas. After the dance, you can immediately scan the QR code to download your own dance clip and upload it to the large projection screen on the wall to see yourself dancing with other visitors alongside singer Lotus Wang and Les Petites Choses Production, symbolizing that everyone can turn their positive thoughts into action and thank the gods for their care in their own way.

Bao Shu-Ping, who has participated in planning for the exhibition for two consecutive years, commented, "Everything that we see at "Daxidaxi" is actually everything that is classical to the culture of faith, and everything that we have seen in the form of temple events since ancient times. In fact, people have always been the integral element in the experiencer, and the gods are actually very close to the people. But everything depends on the original intent of the heart and mind.

圖 Figure | 7

2020 年「遠境事務所」
紀錄展的「天界」，關公
與為遠境執勤的神仙將軍
們上班中，同時提供許願
服務。

In 2020, at the "Divine
Birthday Celebration"
area of the exhibition
"The Office of the Temple
Procession", Guan Gong and
the Generals are working
on the preparation of the
procession and provide
wishing services.

圖 Figure | 7

3-5 ｜關公 around（Guan Gong around）

信念無遠弗屆，跨越時空的雲端現場
Transcending space and time,
expressing the far-reaching faith

在「大溪大禧」除了強調現場的重要性之外，如何讓非現場參與者以另一種方式參與、抑或是讓這趟文化之旅在非活動的當下延續、保持著探索熱度與文化故事的閱讀，各種線上與線下呼應的「行銷」設計變成了不可或缺的最佳途徑。從社群、線上體驗、網路直播至各種周邊聯名商品的設計都是「大溪大禧」的發聲管道。

同時開啟的 Facebook 與 Instagram 雙社群，是與群眾貼身溝通最重要的利器，「大溪大禧」總是在整個農曆六月開啟關公對話模式，把握每一次議題的傳送，打破同溫層與創造粉絲黏著度，讓在地故事帶動大眾情感，驅動想要在大溪大禧時刻前來朝聖的同屬感。

「遶境 Kit」的一系列周邊產品則是拆解遶境行為、配合年度主題，推出每一年來大溪必需收藏的珍品。鮮明的設計與有趣的產品，將民俗信仰知識與滿滿祝福包裹其中，成為「大溪大禧」最好的禮物。

(1) ｜關公 Online ！

除此之外，「大溪大禧」還加開一座永遠都在遶境的線上城「關公 Online ！」**(1)**，和用全新方式體驗大溪的實境遊戲「大溪 in LINE」，讓城市慶典跨越空間與時間的限制，隨時都能與大眾連線。

信念的力量是無遠弗屆的，時逢新冠肺炎（COVID-19）席捲而來的春季，人們保持社交距離、戒慎恐懼，社會氛圍近乎彈性疲乏直至入夏；正在大眾需要被療癒、振奮與鼓舞之時，大溪大禧以「關公 Online ！」作為年度主題，回到信仰本質的核心、傳遞無遠弗屆的祝福，同名主題網站「關公 Online ！」應運而生，以話題性和趣味性為沉寂一時的眾人注入一股新活水。

進入網站中，可以看到大溪老城區的風貌轉化成為各種圖像場景，高高掛起的燈籠串起大溪普濟堂、牌樓與老城屋舍，角色分明的各式藝陣、將軍組成遶境隊伍來回移動，而城區裡的居民則散落在各個角落忙裡忙外籌備中，網站細膩的刻畫大溪地景、人物、店家、景色，宛如一座線上博物館，因此，透過雲端社群的概念，無論人在何方，「關公 Online ！」猶如無形信仰世界中的有形入口，讓無法在真實世界中移動、觸碰的人們，隨時能跟大溪連上線、創造遊戲中的自我分身，成為遶境隊伍的一份子、也能向關聖帝君許願求籤，隨時都可以在此與帝君交流。

而若說「關公 Online ！」為跨越時間空間、世界各地的人們打開通往大溪「迎六月廿四」信仰世界的大門，那麼 2022 年推出的「大溪 in LINE」便是讓大溪人打開自己的家門，讓人們進入到真實的慶典生活中。

「大溪 in LINE」將「大溪大禧」長期調查蒐集大溪信仰風俗與知識性訊息轉化為遊戲關卡，打造含故事性、知識性以及趣味性的城市實境遊戲。透過常見的通訊 App 「LINE」為載體，拆解大溪百工百業共同參與慶典籌備的生活，轉化成指定任務與挑戰。遊客會收到來自將軍與關公的考驗，到豆干店習得大溪限定吉祥話 **(2)**，到糕餅店了解傳承百年的祭祀糕餅文化 **(3)**，進入大溪巷弄與宮廟，體驗在城市中迷路與問路。在地店家也紛紛化身遊戲關主共同參與，讓真實大溪場景與城市信仰生活融入線上遊戲機制中。

從「關公 Online ！」到「大溪 in LINE」，遊戲最大的共通特徵便是皆以關聖帝君為主角，在「Online」、「inline」等不同介面相互串接、創造「多重現場」的遊歷體驗，而不受空間限制的原鄉刻畫與再現，也讓信仰善念的傳遞跨時間空間、無遠弗屆，未來，這座線上博物館也將持續擴增與運作。

(2)｜豆干吉祥話
在大溪，豆干也是常見的供品之一，有「吃豆干，做大官」的祈福意味。

(3)｜祭祀糕餅文化
糖塔是供桌上最大亮點，大溪糕餅師傅的糖塔工藝已傳承至第四代。

圖 Figure ｜ 1

圖 Figure ｜ 1

在「關公 Online！」主題網站，線上刻畫一座大溪城，邀請大家一起線上遶境看直播。

There is a virtual town of Daxi on the website "Guan Gong Online!" to invite everyone to join the procession and watch the live broadcast online.

圖 Figure ｜ 2

帶著手機，在大溪老城區中隨時展開「大溪 in LINE」城市實境遊戲。

With the mobile phone, visitors could start the "Daxi in LINE" urban reality game in Daxi at any time.

圖 Figure ｜ 3

在「大溪 in LINE」遊戲中，透過扇子觸發 AR 遶境隊伍，輕鬆看懂遶境序列。

In the "Daxi in LINE" game, trigger the AR detour team through the fan, and easily understand the detour sequence.

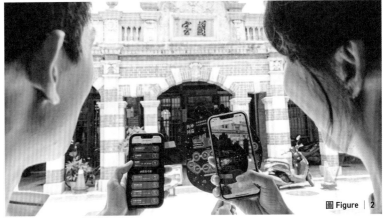

圖 Figure ｜ 2

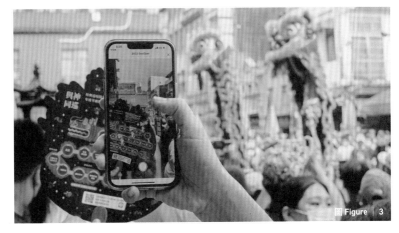

圖 Figure ｜ 3

在地店家成為城市實境遊
戲的關主，迎接前來挑戰
的所有遊客，深受親子遊
客的喜愛。

As the hosts of the city
reality game, the local
stores were tasked to
welcome all tourists who
come to clear the mission.
The game is deeply loved
by parents and children.

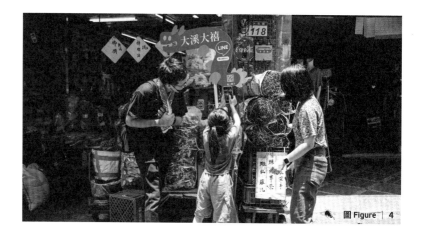

圖 Figure | 4

In addition to emphasis on the importance of being physically present at "Daxidaxi", being able to engage with off-site participants through online or similar strategies was absolutely vital; it kept the cultural journey going in the non-event context, and helped to maintain the enthusiasm for exploration and reading of the cultural background. Social media, online interactive experience, webcasting, and design of various original and co-branded products are all the channels of "Daxidaxi".

(1) | Guan Gong Online!

Facebook and Instagram are the main channels for 1on1 communication with the masses. "Daxidaxi" social media aims to drive a sense of belonging that makes people want to come back during the Daxidaxi time. Therefore, the strategy is to convey diverse issues, break the 'echo chambers,' create fan bonding, and let the local stories drive the public's emotions.

"Parade Kit" is a series of merchandise that comes out from the behavior of the procession and the annual theme. With distinctive and informative designs, the products become must-be-collected blessing gifts in Daxidaxi every year.

Besides, there are also two platforms in Daxidaxi, one is an online city "Guan Gong Online!," **(1)** that will always be in festival vibe, and the other is "Daxi in LINE," which provides a new way to experience Daxi by a game base. The two platforms allow urban celebrations to transcend the constraints of space and time, and connect with the public at any time.

The power of faith is far-reaching. In the spring when the COVID-19 epidemic was sweeping the nation, people carefully kept socially distanced from each other, and remained cautious and fearful. The overwhelming, irrational fear began to abate in summer. At a time when there was a dire need for healing, Daxidaxi adopted "Guan Gong Online!" as its annual theme, returning to the

core of the essence of faith and spreading the blessings of Guan Sheng Dijun throughout society. The eponymous website of the same name, "Guan Gong Online!" was created to inject a new breath of life into the community with excitement and fun themes.

In the website, you can marvel at the scenery of the old town of Daxi transformed into various graphic scenes, with lanterns hung high in the sky stringing Daxi Puji Temple, paifang (arched gate) and old town houses, and various troupe formations and Holy Generals in distinct roles forming procession teams moving back and forth, while the residents of the town were scattered in various corners busy with preparations. The website is like an online museum with its detailed portrayal of Daxi scenery, people, stores and attractions. Through the concept of cloud community, "Guan Gong Online!" served as a tangible entrance to the intangible world of faith, allowing people who cannot move or touch in the real world to connect with Daxi anytime and anywhere, creating their own in-game characters, becoming part of the procession team, and interacting, worshipping and asking for divinations from Guan Sheng Dijun anytime.

If "Guan Gong Online!" opens the door to the world of Daxi faith in "June 24 Reception" across time and space anywhere around the world, then "Daxi in LINE", launched in 2022, allowed the people of Daxi to open their own homes and enter into the real life of the festival.

(2) | Auspicious words of dried bean curd

In Daxi, dried bean curd is also one of the common offerings, with the blessing meaning of getting promoted.

(3) | Ritual cake culture

Sugar pagodas are the highlights of the sacrificial offering table, and the tradition of bakers making sugar pagodas in Daxi has been passed down to the fourth generation.

"Daxi in LINE" transformed Daxidaxi into a game level by collecting information about Daxi's beliefs and folk customs and knowledge over a long period of time, creating an urban reality game brimming with captivating stories, knowledge and fun. Through the widely-used communication app "LINE," the life of all the industries in Daxi who participated in the preparation of the festival was deconstructed and transformed into designated tasks and challenges. Visitors will receive tests and challenges from Holy Generals and Guan Sheng Dijun himself, learn about Daxi-exclusive auspicious words [1] at a dried bean curd store, learn about the centuries-old ritual cake culture [2] at a local bakery, and experience how it's like to get lost, and asking for directions in the city by entering the alleys and temples of Daxi. Local shopkeepers also take on the role of game, allowing authentic Daxi sites and scenes as well as urban faith life to be integrated into the online game.

From "Guan Gong Online!" to "Daxi in LINE", the most common feature of the games is that they all feature Guan Sheng Dijun as the main character, and they are interlinked in different interfaces such as "Online" and "inline" to create a "multi-locational" experience. Furthermore, the depiction and reproduction of Daxi is not limited by space, which also allows faith and goodwill to spread far and wide. In the future, this online museum will continue to expand and thrive.

我們眼中的「大溪大禧」
Daxidaxi in our eyes

在每年的「大溪大禧」城市慶典現場中，有一起加入創造的在地社區社群，也有宗教、設計、文化等跨領域的參加者，從每個人的角度都有不同的感受，都能看見不一樣的驚喜，邀請這五年來以不同身份參與的 10 個角色，分享他們眼裡的「大溪大禧」。

On the site of the annual Daxidaxi events are local community organizations who joined in the creation, as well as participants from various fields such as religion, design, culture, etc. Every participant brings a different perspective to the table. We have invited 10 characters who have participated in different capacities over the past five years to share their perspectives of Daxidaxi.

曾清憲 | **Albert Tseng**

大溪國小總務主任 | General Affairs Director of Daxi Elementary School

自從 2015 年接任大溪國小學務主任，也接下了學校推動 Q 版大仙尪的文化傳承任務，帶領舞蹈隊的學生穿戴不同將軍服裝跳舞。2019 年在鎮豐社洪社長的協助下參與「大溪大禧」，帶入傳統步伐教學與新設計的裝備。
我自己也是大溪的小孩，還記得小時候在廟埕看社頭夜練時崇拜的心情，很高興能透過「大溪大禧」，讓現代小孩也能感受傳統遶境文化的美好，扭轉社會對社頭、遶境不好的印象，以能夠穿上新設計的將軍服為傲。

Since taking over as director of general affairs at Daxi Elementary School in 2015, I have also taken on the task of promoting the cultural legacy of the cartoon version of Holy Generals at the school, leading the students of the dance team to dance in different Holy Generals costumes. In 2019, I participated in Daxidaxi at the behest of the president of Zhenfeng Society, Mr. Hong, and brought in the teaching of traditional Holy General strides with newly designed equipment. I also grew up in Daxi, and I still fondly recall the adoration I felt when I was a child watching the night practice of the Shetou at the temple square. I am glad that through Daxidaxi, I can help children revisit the beauty of the traditional temple procession culture and reverse the negative impressions of Shetou and temple processions, and I am proud to wear the newly designed Holy General's uniform.

江鳳兒 | Feng-Er Jiang

興安社前社長 | Former Head of Xing'an Society

我從 20 歲開始扛將軍扛到 50 歲，直到因為不忍心看到兩尊老將軍損壞，就讓祂們被收在普濟堂作為鎮殿將軍。直到現在 73 歲了，我去跟普濟堂阿祖（關聖帝君）說話的時候，還是會去看看祂們，常想著扛將軍時會穿的紅色褲子好久沒穿。因為「大溪大禧」，才有機會再把兩尊將軍請出來拍攝，也算是重溫回憶。我也很喜歡「大溪大禧」的所有內容都能上網看，可以分享給很多不方便出門、或是很遠的朋友，也讓「南媽祖、北關公」的大溪文化潛力可以傳得很遠很遠。

I carried the generals from the age of 20 until the age of 50, until I could no longer bear to see the wear and tear done to the two old Holy Generals. So, I let them be taken into the Puji Temple as the temple's resident generals. Even now, at the age of 73, I still visit them when I go to talk to A-Zo (Guan Sheng Dijun) of Puji Temple, and I often reminisce the years it has been since I wore the red pants I used to wear when I was carrying the Holy Generals. It was because of Daxidaxi that I had the opportunity to bring the two gods out again for a photo shoot, so I could relive my memories. I also like the fact that all the content of the Daxidaxi can be viewed online and shared with many of my friends, who are not able to head out or live far away, so that the cultural potential of Daxi, "Mazu in the South and Guan Gong in the North", can be spread far and wide.

余秀香 | Sally Yu

普濟堂幹事／關聖帝君庇佑的無敵廟婆 | Puji Temple Staff/ Temple Lady protected by Guan Sheng Dijun

我從 2019 年正式進入普濟堂工作，在那之前，大家都還常常問「大溪大禧」是什麼，後來我在普濟堂的時候，連外來的香客都慕名而來，問我「大溪大禧」什麼時候開始！接觸「大溪大禧」團隊的這幾年，從陌生到熟悉，每次大聲傳來的「廟婆！」都讓我覺得很溫暖，感覺一直有人持續在為大溪努力著，看著他們每年夏天從白雪公主變黑美人，雖有不捨，更多的是感謝。因為有「大溪大禧」，讓信仰變成可以和所有人分享的事情。

I started working at Puji Temple in 2019. Before that, people used to ask me what "Daxidaxi" was all about. Later, when I was at Puji Temple, worshippers from outside the town came to ask me when Daxidaxi would start. In the past few years since I began working with the Daxidaxi team, I have become familiar with the program. Every time I hear the loud acknowledgment of "Temple Lady," I always feel the warmth and pride swelling in my heart. The dedication of the people to the event never fails to fill me with gratitude. Because of Daxidaxi, faith has become something that can be shared with everyone.

黃裕凰

大溪唯一女木藝師

Yu-Huang Huang

The only female carpenter in Daxi

小時候對於「迎六月廿四」的記憶一般是在社團夜練開始就有點氣氛，但需要等到六月廿二日開始才會真正進入主力，而且也比較像是一個大溪自己的遶境，外縣市的人基本上知道的不多，而後慢慢的「大溪大禧」的活動展開，使得「迎六月廿四」的前哨戰提前了，而且也多了媒體行銷管道，讓大溪的「迎六月廿四」不再只是大溪人而已，讓外縣市的人、喜歡廟會文化的人得以了解，一個以在地人組成社頭遶境的廟會活動是個怎麼樣的過程，對大溪人的重要是什麼，我們土生土長的大溪人覺得，自己家鄉重要活動可以讓更多的人參與，讓關聖帝君給予庇佑，是一個很好的活動！

I still vividly recall that time when I was a child, that "June 24 Reception" already took on a certain mood during the evening practices by the Shetou groups, but it was not until June 22 that event experienced its true climax. It was also more like Daxi's own town procession, people outside the county knew very little about the event; but that changed after the Daxidaxi activities were launched. This has brought forward the momentum of "June 24 Reception", and has also added a versatile media marketing channel, so that the "June 24 Reception" is no longer just for the people of Daxi, but also for people from other counties and cities, who like temple fair culture to understand what a temple fair is like with local people forming Shetou organizations, and what is really important to the people of Daxi. We, the people of Daxi, feel that it is a good event for our hometown to allow more people to participate in important events and for Guan Sheng Dijun to give his blessings.

陳昭瑋

臺灣新生代綜藝新秀

Jeff Chen

Up-and-coming variety show host

在連續兩年受邀擔任典禮主持人的經驗中，深感「大溪大禧」是全臺灣以宗教慶典為主軸的活動中，最具有文化內涵與城市體驗結合度最高的大型活動，從每一個參與者的笑容中，讓我深深感受到這個活動把創造深植人心的環境做得絲絲入扣，也讓我在執行主持工作時，把眼睛所見、耳朵所聽到的一切美好事物，幻化成動力，為「大溪大禧」這個活動的成功喝采！

Having been invited to be the host of the Daxidaxi ceremony for two consecutive years, I am convinced that Daxidaxi is the most culturally significant event with the highest degree of integration with the city experience among all religious celebrations in Taiwan. This is self-evident from the smiles of each participant. This event has successfully created an environment that is deeply rooted in people's hearts, and I was able to transform all the beautiful things that I saw with my eyes and heard with my ears into an inspiration when I was hosting the event. Cheers to the continued success of Daxidaxi!

凱爾木木神旅行 | @mazulovers

感受相擁信仰傳承的旅行家 | A traveler who embraces the legacy of faith culture

六月廿四，原來是專屬大溪第二個過年的通關密語！每次講到「迎六月廿四」，當地朋友總是眼神發亮，一個地區要有能力舉辦地方盛典，聚落歷史、信仰文化的風華一定有著一代接一代的使命傳承。從類似於神明會的「社頭」組織百花齊放，到當地神明護衛標配的周倉、關平二將，由小學生擔當的小社頭聯盟，「傳承」是文化在當代是否能延續的重要關鍵，在「大溪大禧」我們發現了另一種回應當代的方法，推薦大家參與「大溪大禧」，沉浸在媲美過年的關公聖誕慶典。

June 24th is actually the second Lunar New Year celebrated exclusively in Daxi! Every time "June 24 Reception" comes up in a discussion, Daxi's locals invariably brighten at the chance to discuss this community event. If a community is capable of hosting a local festival that brings people together, the history of the community and the culture of faith have to undertake the mission to be passed down from generation to generation. From the blossoming of the Shetou organization, which is similar to a religious association, to the two generals, Zhou Cang and Guan Ping, who are the guardians of the local gods, and the small Shetou alliance, which is played by elementary school students, "inheritance" is an important key to the continuity of culture in the present day. We must also give an honorable mention of the Little Shetou Alliance, composed of elementary school students. "Heritage" is an important key to the continuity of culture in contemporary society, and we have found another way to respond to the present day in "Daxidaxi." I wholeheartedly recommend everyone to join "Daxidaxi" and indulge in the celebrations of Guan Gong Dijun's birthday, which is comparable to the Lunar New Year.

吉本梨惠 | Rie

愛上臺灣就飄海過來的臺灣中毒者 | A Japanese hopelessly in love with Taiwan

臺灣和日本民俗完全不同，臺灣廟會就是熱鬧。「大溪大禧」更不一樣！傳統技術令人感動！還有墨斗陣，果然是木職人所在的城市，很特別。在「大溪大禧」看到除了百年歷史的傳統表演以外，更增加高科技和藝術的概念。傳承不容易，融合新文化也一定更不容易吧！

Taiwan and Japanese folk customs are completely different, and Taiwan Temple Fairs are lively affairs. The Daxidaxi event is truly a spectacle that deserves a chapter in the history book! The traditional techniques are very impressive! The Mo Dou Formation is really special because it is the city renowned for its wood artisans. In addition to the century-old traditional performances, Daxidaxi has incorporated high-tech and artistic elements in its heritage. Legacy preservation isn't easy, and the integration of new culture must be equally challenging.

賴銘偉 | **Ming-Wei Lai**

同時是體育老師的社頭人 | Shetou member who is also a PE teacher

從看熱鬧、參與，到開始肩負傳承的任務，大溪「迎六月廿四」是我成長的記憶。小時候每年遶境時，看著高大威武的將軍，總是充滿了憧憬，直到高中時因緣際會之下加入樂豳社，正式成為社頭的一員。樂豳社裡年輕人比較多，大家也都很願意投入推廣，一起想方法讓更多人認識我們。當看到「大溪大禧」替社頭設計圖騰時，才驚喜地發覺原來可以用新的方式、新的形象去展現自己的特色。希望透過不同方式的深入體驗，能夠讓更多人有機會排除偏見、了解廟會，也認識大溪人引以為傲的「迎六月廿四」和社頭文化。

From watching and participating in the procession to taking on the task of passing the heritage on, the Daxi "June 24 Reception" is an embodiment of my growth. When I was a child, I was always filled with longing for the tall and mighty Holy Generals during the annual parade, until I joined the Le Bin Society in high school and became a member of the Shetou organization. There are more young people in the Le Bin Society compared to other Shetou, and we are all willing to work together to promote the club and find ways to let more people know about the program. When I saw the design of the emblem for Shetou by the Daxidaxi team, I was surprised to learn that we could use a new way and a new image to showcase our characteristics. I hope that through the in-depth experience in various formats, more people will have the opportunity to enjoy the temple fair without prejudice, and to get to know the "June 24 Reception" and the Shetou culture that the people of Daxi have taken great pride in.

邱懷萱 | **Elisa Chiu**

Anchor Taiwan 創辦人 | Founder, Anchor Taiwan

一個超過百年的宗教慶典，如何透過設計與策展，與城市展開對話，讓年輕人回家？關公、社頭、陣頭、將軍到工藝與北管，大溪的故事又如何轉譯為海外朋友認識臺灣的起點？每年的「大溪大禧」，熱鬧跨界，既當代、又傳統，重新定義了大溪的第二個過年，也帶來專屬於大溪人的集體記憶、團結與驕傲。

How can a religious festival, that has been celebrated year after year for over a century, open a dialogue with the city through design and curation, and draw young people home? How does the story of Daxi translate into a starting point for tourists overseas, to get to know more about Taiwan, from Guan Gong, Shetou, performance troupes, Holy Generals to crafts and Beiguan music? The annual Daxidaxi is a lively, contemporary and traditional repertoire that redefines Daxi's second Lunar New Year that fosters a community consensus, unity and pride exclusive to the people of Daxi.

（圖右者）

方敘潔 | **Janet Fang**

La Vie 全媒體主編 | Omnimedia Editor, La Vie

民俗信仰一向是臺灣最具有生命力和民間感染力的文資寶庫，從最顯而易見的紋樣色彩，逐步開展到道具物件、建築形制、陣頭樂音、信仰角色、服飾配搭、行為儀式等，都可以從其間萃出豐厚的文化養分，這一點在 2019 年我於《La Vie》策劃的專題〈信仰的設計〉時即深有所感。而自 2018 年起舉辦的「大溪大禧」更是近年來我認為最好的案例，也因此從第一屆起無論多忙，必定專程前往參加，也曾為了瞭解居民們的真實感受，與地方商家、社頭與普濟堂總幹事深度專訪，而在此間每年也都見證了「大溪大禧」的不斷進化。 以策展、設計為手法導入民俗信仰，最大的挑戰在於如何確保「神聖性」（sanctity）仍在？如何讓各有立場的在地「關係人」（stakeholders）願意參與？甚而，如何可能讓這原本即生命力蓬勃的信仰祭典持續保有自發的活力？在大溪木藝生態博物館獨特的定位以及衍序團隊的努力下，「大溪大禧」從無到有的歷程，絕對是值得借鏡的出色案例。

Folk beliefs have always been the most dynamic and appealing cultural treasure in Taiwan, from the most obvious patterns and colors, to props and objects, architectural forms, temple procession music, roles of beliefs, costumes and rituals, etc., all of which are rich cultural nutrients that keep the religious heirloom sustainable. This is something that I felt strongly about when I developed "The Design of Faith" at La Vie in 2019. In my opinion, Daxidaxi has been the best case-study of this in recent years. Since the first event was held in 2019, I'd always make a special trip to attend the event, no matter how busy I was. In order to understand the real sentiments of the residents, I also tried to include an in-depth interview with local businessmen, shetou leaders and the General Director of Puji Temple, and I have witnessed the continuous evolution of Daxidaxi every year since then. The biggest challenge in introducing folk beliefs through curatorial and design approaches is to ensure that the "sanctity" remains intact. How can we compel local "stakeholders" with different positions to participate? And how can we keep the spontaneous vitality of this already vibrant festival of faith? With the unique positioning of the Daxi Wood Art Ecomuseum and the tireless efforts of the team, the history of Daxidaxi, which started from scratch, is definitely an excellent example to be emulated.

新儀式主義：大溪大禧的現地策展
The New Ritualism:
The site-specific curatorial exhibition of "Daxidaxi"

文 —— 耿一偉｜國立臺北藝術大學戲劇系兼任助理教授

Yi-Wei Keng｜Adjunct Assistant Professor from the Department of Theatre Arts,
Taipei National University of the Arts

「大溪大禧」在過去五年來，拓展了臺灣地方節慶的新面貌。我認為有兩個重要的面相，可以在文章的一開始就點出來。一是這個活動讓傳統節慶的儀式，能與當代社會的活動嫁接，使得儀式有了新的生命力，我稱之為新儀式主義；二是策展團隊透過現地策展的方式，在不破壞大溪的關聖帝君慶典神聖性的情況下，創造出新的事件性。

不論是傳統的節慶或是當代的藝術節，最重要的核心關鍵，就是具有強烈的事件性。根據法國哲學家巴迪歐的看法，事件是改變生活或歷史軌道的開創性活動。衍序規劃設計顧問公司於2018年協助策劃「大溪大禧」之前，大溪的關聖帝君慶典雖然是在地的重要節慶，但名聲並沒有傳到桃園之外。衍序團隊設計了「大溪大禧」這樣的結構，在關聖帝君慶典的前三週，先舉辦一個名為「大溪大禧」的節慶活動，將設計元素導入這個藝術節當中。這個前所未見的前導活動，既打響新的「大溪大禧」名號，又因為新的活動與傳統慶典之間在內容與精神上，都有一貫的連續性，使得原本的慶典能在不受刻意干擾的情況，被灌入新的能量。在我看來，衍序所採用的策展方法，可被稱之為現地策展。

所謂的現地策展，是指在策展的過程中，對整體活動的規劃，不是從外來的概念或創意出發，而是以具體空間的存在為基礎，從這個現實的地基出發，經過研究與社區對話之後，所逐漸長出來的策展實踐。即使有當代設計元素的加入，衍序對「大溪大禧」的策畫，不會讓人有突兀感，就在於這個尊重各種空間意義(城市、社會與歷史)的策展過程，讓大溪這個特殊場域的諸多細節，被適當包裝並且放大，而不被策展理論或策展人品味所掩蓋。

一旦「大溪大禧」的策展結構被設定了，事件性就能在這個結構上被創造出來，比如每年不同的遊行表演變化，李騰芳古宅的電音派對每次可以有不同貴賓，武德殿的展覽手法能夠年年翻新，福袋的設計每年都有新巧思等等。如果沒有「大溪大禧」這樣一個具有現代策展精神的活動設計，就不可能在每一年都創造出新的事件性 —— 因為三週後的關聖帝君慶典，具有宗教的神聖性，任何修改或新的設計元素加入，都會造成傳統與現代的對立。但是「大溪大禧」的存在，彷彿是正式婚禮前一天的告別單身派對，讓人們可以不守規矩地慶祝，又不怕破壞到真正婚禮該有的慎重。

如果說告別單身派對也可以跟婚禮一樣，是一種儀式。「大溪大禧」所帶來新現象，不僅是創造事件性的策展架構，還有讓科技、設計與青年文化，可以融入傳統。傳統其實原本並不傳統，在進入現代社會之前，這些活動的內容以及舉辦活動所用到的各種技術，都是當時的當代文化。以前的人不會特別覺得這些慶典是傳統，因為活動的內容比如將軍服裝或是北管音樂，跟當時日常生活所流行的內容是一致的。但是當我們進入現代社會，生活方式隨著技術與社會在改變時，傳統慶典卻被儀式化固定下來，而與當代生活間有了一定的隔閡。「大溪大禧」的出現，找到一種解決之道，讓在社區生活中扮演重要角色的慶典儀式，可以有機會與時俱進。我們在「大溪大禧」中看到，新的元素像電音與設計美學，都讓這個慶典成為活的傳統。

不是我們活在傳統當中，而是傳統活在我們當中。傳統有了我們這個時代的印記，這就是新儀式主義的意義。

耿一偉
衛武營國家藝術文化中心戲劇顧問，國立臺北藝術大學兼任助理教授。曾任臺北藝術節藝術總監 (2012-17)。著有《文化領導力的 80 個關鍵字》等。譯有《劇場與城市》等。獲頒「德台友誼獎章」與「法國藝術與文學騎士勳章」。

Yi-Wei Keng
Yi-Wei Keng is the dramatic advisor of National Kaohsiung Center for the Arts-Weiwuying and was also the artistic director of Taipei Arts Festival (2012-17). He has written several books including "80 Keywords for Cultural leadership" and translated the book "Theatre & the City." Yi-Wei was awarded the Freundschaftsmedaille and Chevalier dans l'ordre des Arts et des Lettres.

"Daxidaxi" has made Taiwan's local festivals all the more colorful over the past five years. Two important perspectives deserve our immediate attention at the beginning of this article. The first is that the event gives the rituals of the festival a sense of modern relevance, revivifying the rituals with new energy, which I have coined as "new ritualism". Secondly, the curatorial team created a new event through site-specific curating, without compromising the sanctity of Daxi's Guan Sheng Dijun's ceremonies and celebrations.

Whether it is a traditional festival or a contemporary art festival, the key is to have a strong "event relevance." According to French philosopher Alain Badiou, events are groundbreaking activities that change the course of life or trajectory of history. Before BIAS Architects & Associates helped plan the "Daxidaxi" event in 2018, Daxi's annual Guan Sheng Dijun celebration was an important local festival, but its reputation did not spread beyond Taoyuan. The BIAS team put together the structure of "Daxidaxi" by organizing a festival called "Daxidaxi" three weeks before the actual Guan Sheng Dijun dedication rituals, to incorporate the design elements into the carnival. This unprecedented precursor event not only created the new "Daxidaxi" brand, but also ensured a continuity between the new event and the traditional ritual in content and spirit, allowing the original festival to be infused with new energy without deliberate interference. In my opinion, the curatorial approach adopted by BIAS epitomizes site-specific curation.

When it comes to site-specific curation, we have referenced the curatorial practice that gradually spawns from the existence of a specific space, based on a real existing site, after research and dialogue with the community, instead of starting from an external concept or idea for the general activity planning. Even with the addition of contemporary design elements, the curatorial process of "Daxidaxi" by the BIAS team does not give off an "out of place" affectation, as it respects various spatial contexts (urban, social and historical) and allows the many details of this special place of Daxi to be properly packaged and magnified, rather than being overshadowed by curatorial theories or curatorial preferences.

Once the curatorial structure of Daxidaxi is established, events can be created based on this foundation. For example, the performance of the procession changes every year, the EDM party at the Li Teng-Fang Mansion can invite different stars every time, the exhibition format of the Daxi Wude Hall can be revamped every year, the design of the "lucky bag" can take on new concepts and ideas every year. Without adopting a contemporary curatorial taste in the design of the Daxidaxi event, it would not be possible to create a new trending "event" every year because the celebration of Guang Sheng Dijun in three weeks in itself is inimitably sacred, and any modification, or additional design elements would result in a disconnect between tradition and modernity. But there are parallels between "Daxidaxi" and the bachelor party held the day before the official wedding, giving people a chance to celebrate with abandon, yet without fear of ruining the sanctity that a real wedding should have.

If a bachelor's party can be a ritual just like a wedding, then "Daxidaxi" brings a new phenomenon that not only creates a curatorial framework for events, but also allows technology, design and youth culture to be integrated with tradition. Tradition did not start out as tradition; the context of "traditional" events and the various approaches employed to organize them were considered contemporary culture at the time, before the advent of modern society. In the past, people did not particularly consider these celebrations as traditional because the highlights of the events, such as the costume of the deities or the Beiguan music, were consistent with what was trendy at that time. However, as we enter modern society and our lifestyles evolve

with technological and social progress, these traditional celebrations have become ritualized and fixed, and a certain gap between these tradition and contemporary life begins to widen. The emergence of Daxidaxi presents a solution for traditional rituals and ceremonies, which play an important role in the community, to evolve with the times. As we have seen with Daxidaxi, new elements such as EDM and design aesthetics have transformed this celebration into a "living tradition".

It is not that we live in the tradition, but that the tradition lives with us. Tradition has taken on the mark of our time, and conferred a new meaning to "New Ritualism".

「大溪大禧」指揮中心

"Daxidaxi" Command Center

以當代設計融合民俗信仰的準則，從一同回鄉為聖帝公慶生的心意，進而創造出代表大溪的城市祭典。「大溪大禧」不僅是鮮活的文化展現，兼具設計力、美感與創造性的特質，更豐厚了文化節慶呈現的層次。透過策展團隊衍序規劃設計的視角，拆解大溪大禧幕後每個工作方法模式，看見設計力如何推動地方文化記憶的價值與魅力。

This city festival, which symbolizes Daxi, was conceptualized from the idea of returning to one's hometown to celebrate the birthday of Holy Generals, which explains the integration of folk beliefs into its modern design. "Daxidaxi" is more than just a vibrant cultural exhibition: it's a celebration of design prowess, beauty, and creativity, all of which elevate the presentation level of the cultural festival. We break down each operational procedure used at "Daxidaxi" from the planning and design perspective of the curatorial team, demonstrating how the design force promotes the value and allure of regional culture.

幫神明慶生的總策展計畫？

A master curatorial project for God's Birthday celebration?

(1)｜文化治理
以文化進行政治與社會、經濟的調節，包括政府制定的文化政策、間接影響文化的政策，以及受社會倡議而影響的文化層面。

在 2017 年底時，木博館對外公告「2018 大溪文藝季展演藝術活動委託規劃執行案」，似乎是蓄勢待發已久，要從已登錄桃園市無形文化資產的「大溪普濟堂關聖帝君聖誕慶典」為基礎，尋找創新整合思維，欲對外發聲。計畫目標以在地文化整理、地方意識的凝聚至期望國際交流為目標，充滿遠大前景：

（一）以地方文化及生活、地域發展資源為基礎，發揚及推廣具地方特色的慶典及社頭文化。

（二）推動地方節慶文化國際化，促進國際交流。

（三）結合設計轉譯，凝聚居民連結與認同，並提供大眾共同參與創造，以促進傳統慶典文化傳承與延續。

（四）以傳統慶典文化為內涵，並提升大溪地域文化意象、美感及生活美學，打造亮點地方慶典文化品牌。

(2)｜白晝之夜
從法國發起城市夜間藝術節，於每年 10 月第一個週六晚上免費開放博物館、藝廊、文化機構等，讓城市變成藝術裝置與表演的舞台。2016 年臺北也加入白晝之夜行列。

很特別的是，2018 年大溪文藝季需求書的第一個執行項目是「總體策辦規劃」，需要提出年度策劃主題，聘請專業策展人，針對大溪文藝季論述整體策展策略及概念……等。在那個時間點，臺灣文化圈剛開啟總策展的思維，有文化治理 **(1)** 思維啟動總策展概念的活動非常的少。木博館有非常開放的思維，駐地在地方，開啟由下而上的在地文化研究與整合，實踐「生態博物館」（ecomuseum）的概念。針對「大溪普濟堂關聖帝君聖誕慶典」復興尋求新發展，徵求策展團隊與博物館一起為「大溪文藝季」重新定義與制定長期策略。

對於剛剛執行完兩年「白晝之夜 **(2)**」城市策展的衍序規劃設計（以下簡稱衍序）設計總監劉真蓉來說，木博館就像點了一盞引路至整理

(3)｜社區營造

「社區總體營造」一詞首
見於 1994 年，是以建立社
區文化、凝聚社區共識、
建構社區生命共同體的概
念，作為文化行政的新思
維與政策。

自身文化的燈，在看見法國能夠展現文化外交於各處，代表法國精神的藝術節慶「白晝之夜」推廣至全球，正在反思有沒有可以從臺灣文化出發，又具國際性的文化節慶時，看見了來自「大溪文藝季」的需求書。

但是，有總策展思維是一件事，為神明的祝壽辦的總策展倒是從來沒有想過的事。這是幫廟辦的策展？要文化研究，還是策展？整個需求書似乎有點像天書，出現太多衍序團隊看不懂的字，社頭？普濟堂？聖誕慶典？遶境？……專有名詞太多令人疑惑，於是決定親自前往大溪一探究竟。

當開車經過高速公路、田野、一條大河、進到環山的大溪，一幕幕的畫面牽動了真蓉兒時回外婆家的記憶；再走進大溪的街道，看著沿街百年的街屋、牌樓立面，廟口人來人往香火鼎盛，大溪這個地方的「人還在，故事也還在」，彷彿整個城市有神則靈，像回故里的悸動讓真蓉心裡開始刻畫「大溪大禧」的思維。

從命名開始

「文藝季」一詞在 1971 年左右出現，為政府方主辦的藝術文化相關活動，也會因地制宜而加上各種項目，推廣藝文活動至全國各個角落、鼓勵全民參與，而後在 1990 年代社區營造 (3) 興盛時期成為激發在地文化能量的推手。2007 年起由大溪鎮公所舉辦「大溪文藝季」，自 2015 年木博館開館後，本著文化治理的思維整理大溪地域性資料，接手「大溪文藝季」的辦理。2018 年開始，衍序接下總策展工作，儘管主辦單位木博館有著從在地到國際、從駐地工作到設計媒合百種需求，回到衍序，欲先了解事情本源再進行規劃，專注以設計思考帶出策展架構，讓意識上化繁為簡。

首先，衍序大膽提出「大溪大禧」為主題，取代「大溪文藝季」原本的定位，定名「大溪大禧——一場穿越當代設計與民俗信仰的城市祭典」。「大溪」加上「大禧」，使場所與關聖帝君神的生日同時展現，搭配上中文與英文同發音的共通性；副標上「當代設計」與「民俗信仰」並行闡述策展使命，「城市祭典」則定義是以整個城市一起設計、成為基地的慶典。

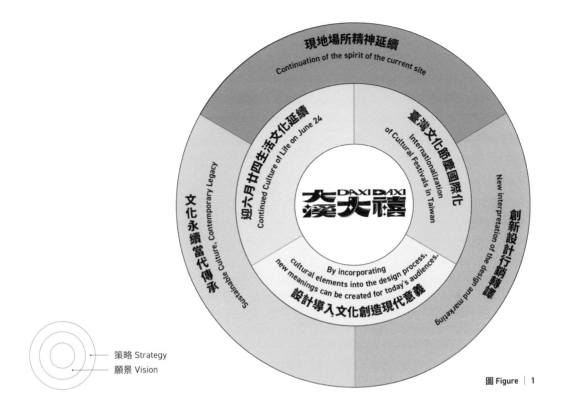

現地場所精神延續
Continuation of the spirit of the current site

迎六月廿四生活文化延續
Continued Culture of Life on June 24

臺灣文化節慶國際化
Internationalization of Cultural Festivals in Taiwan

文化永續當代傳承
Sustainable Culture, Contemporary Legacy

創新設計行銷詮釋
New interpretation of the design and marketing

By incorporating cultural elements into the design process, new meanings can be created for today's audiences.

設計導入文化創造現代意義

策略 Strategy
願景 Vision

圖 Figure │ 1

圖 Figure │ 1
「大溪大禧」發展願景與
工作策略圖。
The vision and work
strategy diagram of
"Daxidaxi"

建立品牌定位與發展策略後，延伸各種主題計畫與安排實踐的時序，這是一條木博館與衍序開啟的新路徑，「大溪大禧」重新命名時，代表將以成為臺灣的國際文化節慶品牌為願景，致力於設計導入文化，創造當代意義。

總策展是一種價值體現與多元設計的總和

「大溪大禧」有一個簇擁的傳統價值為「關聖帝君聖誕慶典暨遶境儀式」，但並不介入這個儀式的構成，僅扮演行銷推廣角色，由傳統遶境時序往前二週展開計畫內容，讓整體節慶時間從傳統二天時間延長為期一個月，所有創新計畫都視為「前祭」，舉辦在傳統遶境之前。

在「大溪大禧」中，總策展先制定一系列的設計思維產生主題計畫，構思一個節慶多元的組成畫面，再一一定義計畫概念，制定短期與長期操作方向，最後落實設計方法操作於各種展演、紀錄、製作、行銷

圖 Figure ｜ 2
「大溪大禧」總策展計畫
策略及執行架構圖
The master curatorial plan
and execution structure of
"Daxidaxi"

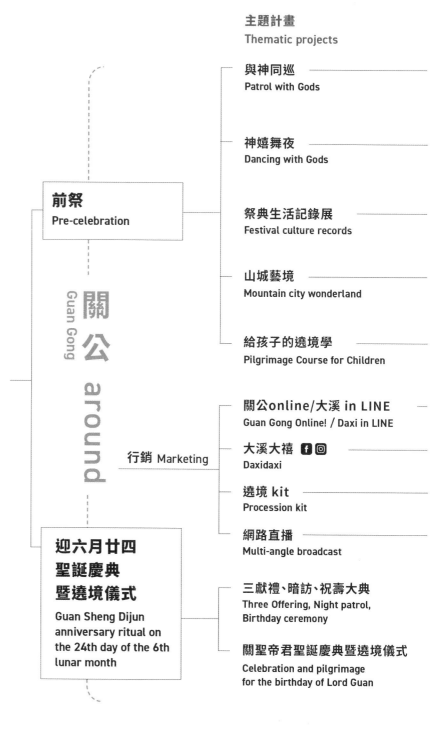

主題計畫
Thematic projects

與神同巡
Patrol with Gods

神嬉舞夜
Dancing with Gods

祭典生活記錄展
Festival culture records

山城藝境
Mountain city wonderland

給孩子的遶境學
Pilgrimage Course for Children

關公online/大溪 in LINE
Guan Gong Online! / Daxi in LINE

大溪大禧
Daxidaxi

遶境 kit
Procession kit

網路直播
Multi-angle broadcast

三獻禮、暗訪、祝壽大典
Three Offering, Night patrol,
Birthday ceremony

關聖帝君聖誕慶典暨遶境儀式
Celebration and pilgrimage
for the birthday of Lord Guan

前祭
Pre-celebration

行銷 Marketing

Guan Gong

關公 around

Guan Gong

迎六月廿四
聖誕慶典
暨遶境儀式
Guan Sheng Dijun
anniversary ritual on
the 24th day of the 6th
lunar month

大溪大禧 DAXI DAXI

一場跨越當代設計與
民俗信仰的城市祭典

A modern religious
Festival in which
contemporary design
joins folk beliefs.

定義 Definition	章節索引 Chapter	設計 Design category
600人重組的遶境陣列 New type pilgrimage sequence composed of 600 people	3-2, 4-4	儀式策展　Ceremony curation 物件設計　Object design
夜間訂製創作型晚會 Theatre and night performance customized for Daxi	3-3	展演規劃　Event scheduling 節目製作　Performance production 場域設計　Set design
以大溪生活為文本的紀錄展 Exhibition about how the festival impacts life in Daxi	3-4	展示設計　Display design 影像紀錄　Photography and video
城市氛圍策劃打造 Create the festival vibe in Daxi old town district	4-2, 4-5	工藝設計　Crafts design 場景設計　Scene design
設計帶入民俗教育 Design in Taiwanese folk education	4-4	工藝設計　Crafts design 儀式策展　Ceremony curation
線上城市體驗系統 Online city experience system	3-5	網頁設計　Website design 多媒體設計　Multi-media design 互動設計　Interactive design 遊戲設計　Game design 社群規劃　Marketing communications 產品設計　Product design 活動導播　Live broadcast
行銷與社群操作 Social media marketing	3-5, 4-6	
周邊聯名商品 Merchandise and co-branding product	4-4	
全城多角度影像紀錄 Video recording of the pilgrimage in whole town	3-5, 4-5	

等各種設計執行工作。計畫中設計操作的分項眾多，有儀式設計、工藝設計、影像紀錄創作、多媒體設計、產品設計、表演規劃、節目製作、展覽規劃設計、市集策劃、品牌行銷、教育及互動設計……等。總策展需要仔細思考最適切的方式導入設計，號召不同專業組成策展與設計團隊，創作出屬於「大溪大禧」以設計導入文化的方式。

讓所有參與設計的創作者瞭解在地文化，讓在地民眾接受設計思維，一同前往共同的目的地——「塑造『大溪大禧』成為臺灣節慶文化品牌」：讓臺灣文化形象從一場祭典、一場新遶境、一個月生活款待、一群人的百工生活，再到一個城市的風土歷史、一場場紀錄展演中，由大到小、由深至廣的清楚體現「一場穿越當代設計與民俗信仰的城市祭典」的意識，體現「大溪大禧」的策展規劃與設計方式。

讓人感受城市中交織的動能

「時間」在策展觀點是一種動能出現與消失的安排，隨意識時間表與人群聚集的量能，在整個城市中。前祭與「迎六月廿四」傳統慶典的關係，在「大溪大禧」裡，並非一前一後就結束，是一陣一陣，一個月間持續不斷的城市動態變化。

原本的大溪生活，宮廟與社頭，在農曆六月中，本是不斷地交織與堆疊。社頭社館整理裝備、安神準備遶境；宮廟舉辦契孫會、貼香條 (4)、搭牌樓、洗廟、各宮廟請神 (5)……而街頭巷尾則是忙著準備夜練、張羅祭祀牲禮供品等各種事宜。

經過總策展後，安排了一系列計畫，城市中的每個角色任務變得更多元了，大家時而被紀錄、時而在演出排練，可以見到遶境生活的點點滴滴逐項被打開，參與的角色從不同計畫的串連，也有了更多情感連結。再加上行銷的策劃，一直醞釀大溪人與回鄉人的情感連結，複習故鄉的點點滴滴，推出驚喜的品牌產品，讓參與節慶的熱度持續沸騰，活動越多元，最後慶祝的張力越強烈。

總策展像是調度城市中慶祝的能量，努力激發、在旁記錄、給予新觀點，幾年下來，「大溪大禧」充滿著城市中交織的動能，整個農曆六月，不論從哪一個時間看及參與，總有說不完的「六月廿四精神」與「大溪大禧」精彩畫面。

(4)│香條
在大溪，香條是請神的告示，會在友好的宮廟張貼，告知會在農曆六月廿二日前來迎神到大溪普濟堂作客數日。

(5)│各宮廟請神
普濟堂會備齊旌旗鼓樂至友好的宮廟迎請神喔，一起到大溪普濟堂參加祝壽儀式。

（下頁）「大溪大禧」主
題計畫強度和密度的動態
變化圖

Ｙ軸為所有的計畫與在地
社群，Ｘ軸為發生的時間
軸，大溪大禧加入大溪後，
讓原本只有傳統關聖帝君
聖誕慶典鬧熱的幾天，延
長為一個半月的城市擾動。

Dynamic flow in the
intensity and density of
the "Daxidaxi" thematic
projects:

The Y-axis is all the
thematic projects and local
communities, and the X-axis
is the timeline. This diagram
is to showcase how the flow
of time and people changed
after "Daxidaxi" in these
years. "Daxidaxi" extends
the celebration time from a
few days as per traditional
Guan sheng Dijun Birthday
celebrations, to one and a
half months.

人與生活，才是策展核心

最後一個重要的總策展想法為「因人制宜」，這個節慶的策展，主要溝通的對象有二大類別，一是設計創作者，二是大溪人，要以兩個全然不同的方式溝通與讓大家一起策展。

策展人堅持著整體性縱橫全貌的精神，與創作者討論每一個操作項目的精準程度，設計思維如何呈現？如何在「現場」發生？如何與群眾產生互動？如何與在地產生關聯？……給予策略、整合，「策展人」的角色與名字，只有對於設計創作相關工作者才有意義。之於在地人，或許注重的並非「策展人」這個角色，而是能不能在這個過程中，讓他感受到熱誠，讓他覺得你是「自己人」？

策展方式也許百百種，但是對大溪人只有一種，「用心對待」，如果你將每一位大溪人視為家人，就可以用對長輩的包容對待所有事，期待他們真心認同，策展人的角色就不重要了；反之，他們認為你是自己人時，才有大溪在地方法學，這也許是在地策展的唯一工作方式。

「大溪大禧」的策劃，完整的設計概念只佔了一半，另一半要靠大溪人內化了這個概念，共同演繹出大溪專屬的故事才算是完整。當大溪人很驕傲地大方接待所有客人，了解自身風土故事並講給下一代，積極參與創造性的慶典策劃，如此在「大溪大禧」期間，各種思維化為一種明顯可辨的狀態。

我們可以說，「大溪大禧」是一個總策展，是一個品牌，是一個內化到大溪人的精神，最後，每個前來共襄盛舉的人，也都是策展一部分。

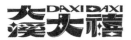

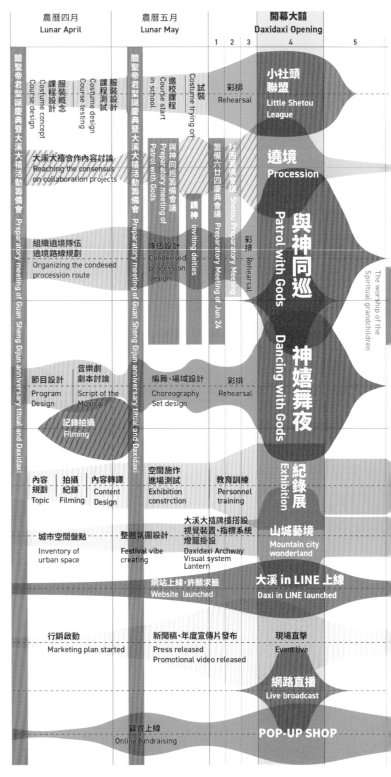

農曆六月
Lunar June

關聖帝君聖誕慶典
Guan Sheng Dijun Anniversary

農曆七月
Lunar July

農曆八月
Lunar August

9 10 11 12 13 14 15 16 17 18 19 20 21 22 23 24 25 26

整理裝備
Organizing equipment

夜練
Evening practice

Palanquin Cleaning
洗神轎

Build up the temporary
Shetou House
各社搭社館

請爐主神與爐主
Procession

遶境
Procession
Invite the deities
from incense
burner chief

擲明年度爐主·平安宴

送爐主神尊到新爐主家
Selection of the incense burner chief

After Banquet
Transfer the joss to the house of the next incense burner chief

貼香條
Post notices to invite the deities

搭牌樓
Set up the Archway

Temple Cleaning
洗廟

各宮廟請神
Inviting the deities from other temples

三獻禮　暗訪　祝壽大典
關聖帝君聖誕
Guan Sheng Dijun Birthday
Three offering, night visit and Birthday ceremony

平安宴 After Banquet

送神回各宮廟
Seeing the deities off

音樂劇
Musical

準備夜練點心
Snacks preparation

音樂劇
Musical

食物與祭祀用品採買
Offering purchasing

隨香·設香案
Walking with the procession
Set up the incense table

普濟堂拜拜
普濟堂志工點心攤
居民設涼水攤
Worship at Puji Temple
Volunteers in Puji Temple prepare the snacks
Residents providing cool drinks

線上直播
Broadcast on
Guan Gong Online

大溪 in LINE
Daxi in LINE

年度企劃介紹·參與者回饋
Annual projects introduction
Participant feedback

迎六月廿四行事曆
Daxi Calendar
in Lunar June

現場直擊
Event Live

經典回顧
Review

網路直播
Live broadcast

POP-UP SHOP

圖 Figure | 3

「大溪大禧」指揮中心 | 128

最難能可貴的是，在「大溪大禧」中我們看不到所謂「圈內人」
和「圈外人」的對立、「傳統」和「當代」的衝突，反而是地方
敞臂歡迎，策展人、設計師謙卑走進在地的身影，這是我們認為
在文化創新的路上，最美的一段風景。

—— 文化銀行 邵瓊婷

The most wonderful aspect of "Daxidaxi" is that there is no conflict between
"insiders" and "outsiders," "traditional" and "contemporary," but rather the
open arms of the local community and the humility of curators and designers
entering the community. This is the most beautiful element of the road to
cultural innovation, in our opinion.

— Aiting Shao, Bank Of Culture

The Museum unveiled the "2018 Daxi Cultural and Art Festival Exhibition and Artistic Activities Commissioning Project" at the end of 2017, which appears to be a long-awaited plan to source creative and integrated ideas from "Daxi Puji Temple Guan Sheng Dijun birthday celebration," which has been registered as an intangible cultural asset of Taoyuan City, to make a statement to the public. The goal of the project is to comb through the local culture, to unite the community, and to encourage international exchange, and the prospect is endless:

(1) To promote Shetou culture and its local flair, lifestyle and regional development.
(2) Promote the internationalization of local festivals and culture to facilitate international exchanges.
(3) Incorporating design reinterpretation, the project aims to strengthen the connection and identity of the locals, as well as provide the public with the opportunity to participate in the creation of the project, to promote the heritage of the traditional celebration culture.
(4) Refurbish Daxi's regional culture by promoting its imagery, aesthetics, and way of life in order to create a vibrant local celebration culture brand that draws inspiration from traditional festivities.

(1) | Cultural governance

Cultural governance includes cultural policy made by governments but extends also to cultural influence exerted by non-state actors and to policies which influence culture indirectly.

What makes the 2018 Daxi Cultural and Art Festival unique is that the first item executed is "master curatorial planning," which entails proposing an annual planning theme and hiring professional curators to explore the Daxi Cultural and Art Festival's overall curatorial strategy. At that time, Taiwan's cultural circle had just begun to consider the concept of chief curatorship, and there were very few activities that considered cultural governance **(1)** in order to initiate the concept. The museum is very open-minded, since it's a local establishment, and it supports a bottom-up approach to local cultural research and integration, putting the spirit of "ecomuseum" into practice. In response to the revival and search for new developments of the "Daxi Puji Temple Guan Sheng Dijun birthday celebration," the curatorial team is invited to collaborate with the museum to redefine and develop a long-term strategy for the "Daxi Cultural and Art Festival."

(2) | Nuit Blanche Taipei

Nuit Blanche is an annual all-night arts festival of a city. The museums, art galleries, and other cultural institutions would be open and free of charge on that night. The city itself is turned into a stage for art installations, performances, and other activities. In 2016, Taipei hosted the first Nuit Blanche.

Having just finished two years on curating the city of Nuit Blanche Taipei **(2)**, Tammy Liu, the design director of BIAS Architects & Associates (hereafter referred to as BIAS), regards the Wood Art Ecomuseum as a lamp that illuminates the path toward organizing her own culture. When she observed that France was able to demonstrate its cultural diplomacy everywhere and that the Festival Nuit Blanche, which embodies the spirit of France, was promoted globally, she pondered whether Taiwan had a cultural festival with an international vision. It was then that she came across the letter from the Daxi Cultural and Art Festival.

However, it is one thing to have a chief curatorial mind, but to have a chief curatorial mind for the birthday of a god is something else entirely. Is this a curatorial exhibition for the temple? Should this be a research into culture? Or a curatorial project? The request for proposal was filled with text the BIAS team does not understand, including Shetou, for example, so the whole thing reads like a decipherment. Puji Temple? Birthday celebration? Parade? She was perplexed by the sheer number of terms, so she made the decision to visit Daxi in person.

One after another, as she passed the highway, fields, a large river, and entered the mountainous Daxi, scenes brought back memories of her early trips to her grandmother's home. Taking a stroll through Daxi, one can observe the quaint facades of the city's century-old homes and shops, as well as the busy temple entrances where worshippers come and go. Tammy's return to her hometown, coupled with the comforting knowledge that "people are still here and so are the stories" (as if the entire city has a god), causes her to begin carving the concept of "Daxidaxi" into her mind.

Names are the place to start

(3) | **Community development**
Community development is a process where community members come together to take collective action and generate solutions to common problems. It is aiming to improve various aspects of communities and build stronger and more resilient local communities.

Around 1971, government-sponsored cultural events began to be referred to as "Cultural and Art Festivals." A wide range of initiatives, tailored to regional needs, would be added to disseminate arts and cultural opportunities throughout the country and inspire citizen engagement. Fast-forward to the '90s, when community building **(3)** was at its peak, it became a key factor in energizing local culture. The "Daxi Cultural and Art Festival" has been held annually by the Daxi Township Office since 2007. With the opening of the Wood Art Ecomuseum in 2015, we have taken over the festival's organization in the spirit of cultural governance and are organizing Daxi's regional information accordingly. The primary curatorial duties have been handled by BIAS since 2018. Even though there are hundreds of needs, ranging from local to international, from resident work to design matchmaking, BIAS wanted to study the origin of things prior to planning, and focus on design thinking to bring out the curatorial structure to streamline the experience.

First off, the name was changed to "Daxidaxi - an urban festival that spans contemporary design and folklore beliefs" and the theme "Daxidaxi" was boldly proposed to replace the original positioning of the "Daxi Cultural and Art Festival." The "Daxi plus the "Daxi" refers to the venue and the birthday of the deity Guansheng Dijun, since the Chinese and English pronunciations are identical. The curatorial goal is conveyed by "Contemporary Design" and "Folk Beliefs," as sub-topics, and "City Festival" is defined as a celebration of the entire city designing together.

Following the establishment of the brand positioning and development strategy, the various thematic projects were expanded, and the implementation timeline was set up. It's a fresh start made possible by Wood Art Ecomuseum and BIAS. When "Daxidaxi" was renamed, it represented the goal of becoming a brand for an international cultural festival in Taiwan and was dedicated to fusing culture with design and giving it a modern interpretation.

Master curatorship is the sum of a value embodiment and multi-dimensional design

The "Daxidaxi" congregates around the traditional value of "Guan Sheng Dijun Birthday Celebration and Parade," but it makes no change to the ceremony's structure and merely serves as a marketing and promotion tool. The project's events kick off two weeks before the customary parade schedule, extending the festival from its usual two days to a full month. All creative events that take place prior to the customary procession are referred to as "pre-festivals."

The chief curator of "Daxidaxi" first conceptualized the festival's composition, then developed a series of design concepts to generate a theme plan, and defined the plan's concept before creating the short- and long-term operation directions. The design methodology is finally put into practice in various exhibitions, documentation, production, marketing, and other design implementation processes. The project involves a wide range of design activities, such as

(4) | **Incense sticks**

The incense stick is the notice of inviting the Gods. It will be posted in the temples to inform that Puji Temple will visit again on the 22nd day of the 6th lunar month to invite these deities for being guests for a few days.

ceremony design, craft design, video documentation, multimedia design, product design, performance planning, program production, exhibition planning and design, market planning, brand marketing, educational design, and interactive design, among others. The chief curator must carefully consider the best way to introduce design and enlist the help of various professions to form curatorial and design teams in order to come up with a strategy for doing so at Daxi.

It is important that all designers have an appreciation for Taiwanese culture, that residents embrace the design process, and that everyone work toward a common goal: "to shape the 'Daxidaxi' as a cultural brand of Taiwan festivals." From a festival, a new procession, a month of living hospitality, a group of people's lives of all the industries, to a city's local customs and history, and a documentary exhibition, the cultural image of Taiwan is clearly realized from large to small, from deep to wide, in the spirit of "an urban festival that spans contemporary design and folklore beliefs," which embodies Daxidaxi's curatorial planning and design approach.

Expose the public to the city's pulsating, interdependent energy

(5) | **Invites the gods**

To invite the deities to join the ceremony, Puji Temple brings the flags and music performers to visit the friendly temples

From a curatorial vantage point, "time" is a stream of consciousness and the turnout of crowd gathering at various locations across the city. Rather than a linear progression from one phase of the Daxidaxi to the next, the connection between the pre-festival and the traditional celebration on June 24 is a kinetic urban landscape.

In the sixth month of the lunar calendar, the original Daxi life—the temple and the shetou - are layered upon one another. While the streets and alleys are busy preparing for the night practice and making offerings of sacrificial animals and other items, the shetou and sheguan organize equipment and prepare the gods for the procession. The temple holds a qisun meeting, puts up incense sticks **(4)**, builds an archway, cleans the temple, and invites the gods **(5)** at each temple.

Following the general curation, a number of projects were scheduled, and the responsibilities of each character in the city were expanded. We could see the little details of the procession's arrangement being revealed one by one while everyone was either being recorded or practicing for the performance. The connection between the various projects also helped the participating characters develop stronger emotional bonds. In order to maintain the fervor of festival participation, the marketing strategy has also encouraged an emotional bond between Daxians and returnees, reviewing every aspect of the hometown, and launching unexpected brand products. The greater the variety in the events leading up to the celebration, the more exciting it will be when it finally begins.

Like fine-tuning the celebratory energy of a city, the chief curator aims to inspire, document, and shed light on the festivities. Daxidaxi has become infused with the city's pulsating, interconnected energy over the years. The entire Lunar month of June is filled with wonderful "June 24 Spirit" and "Daxidaxi" scenes, regardless of when you look at them or take part in them.

The heart of curating is people and life

As a final key curatorial principle, consider how you can meet the demands of the public. There are two main groups of people to communicate with regarding the festival's curation: first, there are the designers, and second, there are the Daxi residents. It is important to communicate and bring people together in two completely different ways.

The curator is very adamant that a holistic perspective be maintained, and he or she has detailed discussions with the artists about the precision of every procedure. How can the design be presented? How does it happen "on the spot?" What are the various ways to engage the public? What connection does it have to the neighborhood? Only those involved in the creation of the designs will understand the significance of the strategies, integrations, roles, and name "curator." People in the area might care less about your official title as "curator" and more about whether or not they perceive you as genuinely invested in the project and accepting of their culture.

There are countless ways to curate, but for the Daxi people, there is only one that matters: "treating them with care." If you treat every Daxian as a member of your family, you can treat everything with the same tolerance that older adults have spent years to master, expecting their sincere appreciation, and the curator's position will become less crucial. On the other hand, there won't be a Daxi local methodology until they regard you as one of their own, and this might be the only way to engage in local curation.

The planning of "Daxidaxi" only involves half of the complete design concept; the other half must be internalized by the Daxi people and fully realized through their collective interpretation of Daxi's singular narrative. The various concepts are transformed into a distinctly recognizable state during the "Daxidaxi," when the folks receive all guests with generosity and pride. This is how they learn about their own local history and pass it on to the next generation, and actively participate in the creative planning of the festival.

We can say that "Daxidaxi" is a master curatorial exhibition, a brand, and a spirit that is internalized by the residents of Daxi, and everyone who attends the event contributes to the curation.

透過「場所記憶」，感受大溪限定的場景魅力

Experience the charm of Daxi through "site memories"

圖 Figure ｜ 1

從線上線下到行銷廣告，都在傳遞大溪場景畫面。

From online to offline, the marketing and advertising strategy of "Daxidaxi" is all about the image of Daxi.

圖 Figure ｜ 1

有點不好意思地說，大溪是個不太容易到達的城市，但的確是個很值得你親自造訪的地方。

每年「大溪大禧」舉辦時間，總有人會來信主辦單位詢問「大溪有火車站嗎？」、「捷運有到嗎？從高鐵到大溪要多久？」……等交通相關問題，可以感受到大部分想造訪大溪的遊客，對這裡的地理環境是毫無概念的。

大溪是北橫公路下山後會遇到的近山隘口城鎮，行經大溪老城區後經過武嶺橋渡過大漢溪，可以連接到桃園八德、中壢台地。而循著龍潭至大溪的內山公路（臺三線）進入大溪，可以沿著河谷快速下坡進入谷地，享受著遙望大溪老城的最佳視角，行經河谷底端的武嶺橋，從大橋兩側往外望，看見連接著遠方的寬廣河床與山崖上的老城區，不禁遙想過去大漢溪曾經的豐沛壯闊與河港繁榮的景象。前方山崖上，有坐擁絕佳美景的普濟堂熠熠生輝，這裡，即是「大溪大禧」故事發生的場景。

對我們來說，一趟旅程從路程中的風景便要開始計畫，即使翻山越嶺，途中經歷的風光，都會加深對終點的期待。這座城鎮裡的記憶與故事早已不勝數，但透過策展團隊對在地日常的觀察，融入策展的思考模式，讓延續百年的傳統遶境文化，有了重新與

圖 Figure │ 2

2022 年《紅紅 OnOn》MV
宣傳影片中，帶入大溪代
表性的場域畫面。

In 2022, the representative
scenes of Daxi were part of
the "OnOn" music video.

這座城鎮交織的機會，讓每個造訪大溪的人，都能透過這樣的企劃（也就是「大溪大禧」），感受這座城鎮獨有的魅力。

文化景觀中的現地策展

跨越大漢溪來到河東區域，一邊是翠綠稻田的月眉地區，一邊是連結老城區的石板階梯古道，走上古道連接到牌樓商行林立的和平老街……大溪老城區中場景資料庫非常多樣，每條老街、每個店家都充滿歷史感，街區仍然呈現生活與生產共生的樣貌；城鎮裡的廟宇興盛，有主祀關聖帝君、開漳聖王的普濟堂與福仁宮，仍然可見熙熙攘攘的信眾。

如何讓前來「大溪大禧」的所有人，都能夠感同身受這些場所與時代所交織的意義？

在「新遶境——與神同巡」與「古蹟中的搖滾——神嬉舞夜」等節目中，策展團隊嘗試讓大溪的歷史場景呈現出「生活現場感」與「嶄新的創造」兩種意義，前者是以遶境時街道全開的特色，參與其中，就像透過每個大溪人帶領朋友進入大溪生活似地；後者則是走進傳統宅

圖 Figure │ 3

「與神同巡」規劃遶境路
線、人流變化，與儀式發
生的空間。
上圖為老街中的遶境
下圖為大溪將軍在和平老
街接駕新竹都城隍爺

he plan of the procession
route, people flow, and
space where the ceremony
takes place for "Patrol with
Gods".
The figure above is the
procession in Heping Old
Street
The figure below is when
the General from Daxi
greets the City God from
Hsinchu at Heping Old
Street

院與廟埕，在歷史的最深處抑或信仰中心，看見傳統與當代激盪衍生出的新傳統。在大溪這個特殊基地中，執行只有這裡才會發生才能體驗的現地策展。

用一場遶境串連起所有人與整座城市

每年「大溪大禧」開幕「與神同巡」的下午，打開 Google map，大溪老城街區範圍，瞬間全部成為人流擁塞的紅線。從普濟堂拜廟出發的社頭隊伍，這個綿延一公里長、超過六百位在地居民重新組成約 20 陣的陣列組合，表現出遶境的精華：是線性的一列將軍隊伍、是花式的舞龍竄街，是一陣陣的音樂隊伍、還有莊嚴神聖的神轎轎班……隊伍一走過，讓街道處處成為展演場域、大大小小的廟埕與路口都成為舞台，家戶老宅即是香案桌祭拜的看台。每一組陣頭都有豐富的儀式表現性，走在街頭時，民眾會隨時加入、仔細端詳，熱烈詢問。

「大溪大禧」的重點，絕對不能不提到遶境，這可是這座城鎮慶典的重頭戲。因為人的流動，遶境可以瞬間讓街道擾動起來。在傳統的遶境裡，主體（神祇、神轎、轎班……等遶境陣列）與客體（隨香客、參與民眾）清楚，而「新型態遶境」中，我們試著操作街道空間與人流的動態變化，以「一個遶境、三座廟埕、五個香案桌、百戶人家一起來」的城市空間想像，讓主體與客體模糊，使之一起行動，帶著所有人在老城中經歷慶典的各種記憶，發展「與神同巡」這個新型態遶境。

(1) │ 香案桌拜禮
遶境陣列除了經過廟宇時
會拜廟，在香案桌前也會
進行行禮動作。

策展團隊依照城鎮空間安排事件，預設了人流的腳本。這一公里的隊伍是一陣陣能量的聚集，群眾跟著隊伍行走，演出者與觀者的力量像兩股浪頭，在大溪老城巷弄中交織著，時而是遶境隊伍的並進前進，時而是表演者與觀看者的彼此圍繞。將各個社頭想像成是流動性演出，隨著街道的容量隊伍陣列展開變形，香案桌就是事件發生場所，隨著香案桌拜禮 (1) 儀式進行，周圍的人流群眾像是以之為舞台似的圓形讓開，拜禮到哪，就像在城鎮中處處開出人流的花。遶境持續進行，最後城市中的所有人都在等待壓軸關聖帝君神轎轎班，隨著哨角聲響起，迎著衝刺而來的轎班，眾人一起合掌迎接坐轎中關聖帝君的到來。

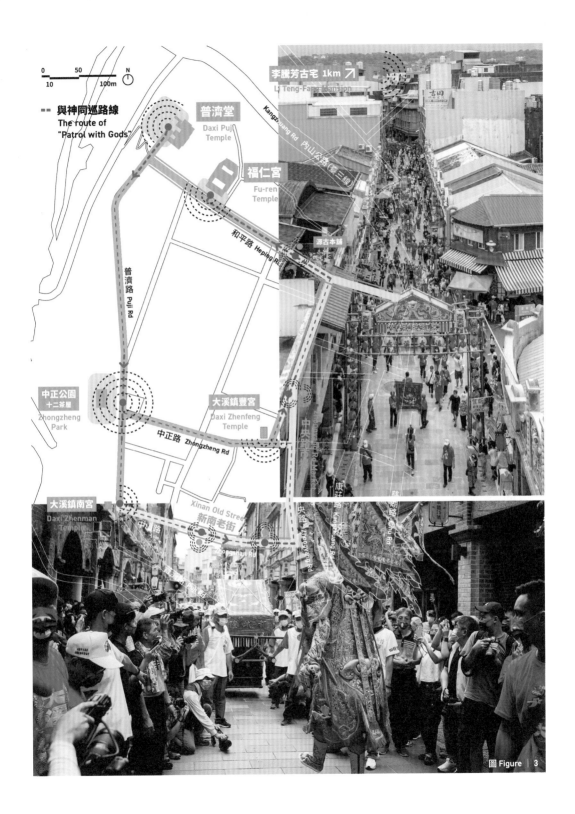

與神同巡路線
The route of
"Patrol with Gods"

普濟堂
Daxi Puji
Temple

福仁宮
Fu-ren
Temple

李騰芳古宅 1km ↗
Li Teng-Fang Mansion

Kangzhuang Rd 內山公路（臺三線）

源古本舖

和平路 Heping Rd

普濟路 Puji Rd

中正公園
十二茶屋
Zhongzheng
Park

大溪鎮豐宮
Daxi Zhenfeng
Temple

中正路 Zhongzheng Rd

大溪鎮南宮
Daxi Zhenman
Temple

Xinan Old Street
新南老街
Zhongshan Rd

圖 Figure | 3

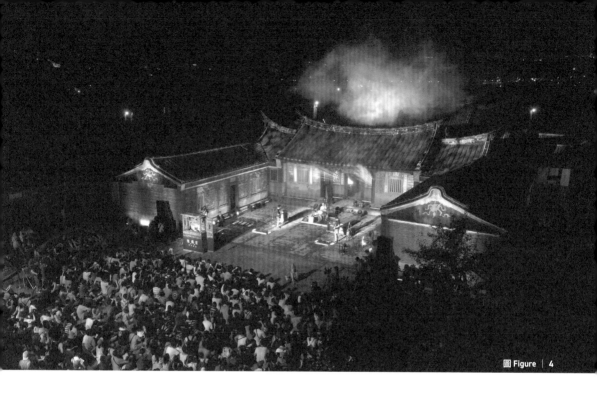

圖 Figure | 4

2019 年，點亮稻田中的李
騰芳古宅，作為「神嬉舞
夜」的表演舞台。
2019, Li Teng-fang Mansion
in the rice field was lit up as
part of "Dancing with Gods".

(2) |《巧遇姻緣》

為了讓聽不懂臺語口白的
觀眾也能領略掌中戲的美，
全劇不用口白，僅以細緻
的操偶動作表現故事中的
情感變化，是陳錫煌傳統
掌中劇團的看家戲碼。

老宅廟埕人如潮湧，新酬神戲金霞燦爛

相對於「與神同巡」是凝聚生活現場的慶典，「神嬉舞夜」則是激盪
出場所的歷史想像，演出現代版的傳統畫面。李騰芳古宅靜謐的環抱
下，是人與神共同欣賞演出的舞台。造煙機生出一朵朵祥雲入天邊，
陳錫煌老師親演《巧遇姻緣》(2)，老師一手操作小生的風流倜儻、
另一手主演小旦的嬌媚婉約，種種操偶細節呈現在戲台上，男女主角
為愛傾倒，全劇不用口白，搭配著拍謝少年唱著歌詞傳來「不願意一
陣風吹過來，一陣風吹過去愛你。」是搖滾？是掌中戲？陳錫煌老師
接過主持棒跟在場所有年輕人說：「你看過漢樂和西樂合作無？我請
後場跟拍謝少年一起演奏給你們聽，真好聽。」從來沒有想過在古宅
中的搖滾掌中戲，如此絲絲入扣、震撼人心。

另一場在普濟堂廟埕，層層燈光雕龍畫棟幻化成現代天宮，音樂由北
管與笙對著電吉他，三牲獻藝唱出「從此後我心無掛慮 竹籬茅舍獨安
居 歲月如梭匆匆去 轉眼又過三十年」，舞者廖苡晴帶著電氣將軍
與大溪嘉天宮將軍腳共同登場，舞姿頓點幻化周倉與關平，場域氛圍
使人忘我的慷慨激昂，瞬間讓觀眾彷彿身在不同時空。

當人與遶境的藝陣隊伍越靠近，藝術在環境體驗中呈現，留下的城市記憶就越深刻。現地策展的魔力，就這樣催化城鎮空間表現性，讓每一個參與的人身歷其境、沈浸在充滿祝福的氛圍中久久不散。

「大溪大禧」是無所不在的場所記憶

這座老城鎮的魅力俯拾即是，不只在打卡第一名的老街，在前進山林的內山公路上，在步行跨越大漢溪的大溪橋，在穿過一片綠油油田野中的李騰芳古宅，在民眾熙來攘往的大溪第一市場中，在一碗碗傳遞的油飯裡，還有每一個傳遞故事的笑容裡。

新型態遶境讓老城瞬間轉換氛圍，成為一個下午限定、節慶感濃厚的「大溪 LAND」，大家都一定要插上小旗幟、披著鮮豔的主題毛巾，一起走過市街參與遶境。期待現代與傳統共演碰撞的驚喜，就像是李騰芳古宅的「神嬉舞夜」，打開傳統空間最大想像性，當派對進入老宅，成為新舊蒙太奇的新潮畫面，閉上眼睛就可以感受老宅的前世今生。有時候一看到地標就讓人很想家，在主題曲《紅紅 OnOn》的 MV 播出後，山城俯瞰的畫面深植人心，讓許多觀眾紛紛留言「是大溪！」、「好想回大溪」……給予熱情響應。而在「大溪大禧」牌坊搭設後，許多人每天都守著牌坊開燈與街道合影，社群上每天都會出現早安、晚安的問候發文，提醒大家「大溪大禧」要來了……每個場景中人、事、時、地、物都引起大眾共鳴，甚至參與者會創造屬於自己與城鎮的連結，每個人都能在其中發掘新的收穫，探索到未曾發現過的大溪魅力，「大溪大禧」也漸漸創造了無所不在的場所記憶。

圖 Figure │ 5

圖 Figure │ 6

It's awkward for me to say that Daxi is not exactly an easy place to reach, but it's certainly a place you should visit.

Every year when Daxidaxi is held, people always write to the organizer asking, "Is there a train station in Daxi?" "Can I reach there by MRT?" "How long does it take to get there from the HSR Station"? These questions are telling indicators that most tourists who want to visit Daxi have no clue of the area's location.

Daxi is a town by the mountain pass that you will travel through after exiting the Northern Cross-Island Highway. After journeling through the old town of Daxi, you can cross the Dahan River via the Wuling Bridge and swing by Bade District and Zhongli Terrace. When you enter Daxi along the Inner Mountain Highway (Provincial Highway 3) from Longtan to Daxi, you can follow the river valley downhill into the valley, and get the best view of old town Daxi. When you pass the Wuling Bridge at the bottom of the river valley and look out from both sides of the bridge, marvel at the wide riverbed and the old town area on the cliff connecting the river in the distance. The experience will bring back memories of the magnificence of the river and the prosperity of the harbor town in a bygone era. On the cliff in front of us is the resplendent Puji Temple and the panorama. This is the site where the story of "Daxidaxi" begins.

For us, any journey begins with the planning of the itinerary, and even if we have to cross mountains and obstacles, the scenery we experience along the way will deepen the experience when we reach the final destination. This ancient town carries with it countless memories and stories. However, through the curatorial team's observation of the local daily life, the local daily life and even the traditional parade culture that has lasted for over hundred years are presented with the opportunity to intertwine with this town again, so that everyone who visits Daxi can enjoy the unique charm of this town through this program (that is, Daxidaxi).

"In Situ Curation" of the Cultural Landscape

Crossing the Dahan River to the eastern bank, you'll be greeted with Yuemei area with lush green rice paddies on one side and the old flagstone trails connecting the old city on the other side. Walk up the old trail to the historic Heping Street, which is lined with shophouses... The scenes in old town of Daxi is rich and diverse, each old street and store is imbued with history, and the area still harbors an air of coexistence of life and industry. The temples in the town, including Puji Temple and Furen Temple, attract many devout followers. The temples are dedicated to Guan Sheng Dijun and Kai Zhang Sheng Wang, and bustle with worshippers throughout the day.

How can everyone who comes to Daxidaxi experience the true essence of the intermixing of these sites and eras?

In the programs "Patrol with Gods" and "Rock in a Historic Monument - Dancing with Gods," the curatorial team seeks to present the historical scenes of Daxi that highlights "scene of life" and "brand-new creation." In the former, the streets are open during the parade, and it is like having a Daxi local as a tour guide; for the latter, one enters the traditional residences and temples and witnesses new traditions created by the juxtaposition of tradition and modernity, emerging from the deepest corners of history or the center of faith.

On-site curation is executed in Daxi, and it can only be experienced here.

Connecting everyone and the whole city with a parade

Every year, on the afternoon of the opening of Daxidaxi, when you launch google maps on your mobile phone, the whole area of Daxi Old Town instantly becomes a crimson red thoroughfare packed with people. The procession of the Shetou that started out from Puji Temple, which stretches on for one kilometer, with more than 600 local residents re-organized into 20 formations, demonstrates the essence of the procession. It is a linear procession of Holy Generals (Shenjiang), a fancy dragon dance, a procession of music, and a solemn and sacred palanquin... As soon as the processions pass by, the streets become exhibition sites, the temples, large and small, plus street entryways are turned into stages, and the old houses put out tables where the faithful can make offerings to the gods. Each parade formation is rich in ritual expressiveness, and as the procession moves along the streets, people are ready to join, carefully observing and asking questions.

The highlight of "Daxidaxi" is definitely the ritual procession, which is the centerpiece event of the town's celebration. The movement of the participants the parade can instantly enliven streets it passes by. In a traditional procession, the main body (the deity, the palanquin, the palanquin bearers, and other processional formations) and the believers (the worshippers and the participating people) are clearly defined. In the "new type of procession," the organizers try to manipulate the dynamic changes of the street space and the flow of people, using the urban space imagination of "one procession, three temples, five incense worship tables, and a hundred families coming together" to obscure the main body and the object and make them move in unison. Thus, a new type of parade, "Patrol with Gods," will be developed to bring back the memories of all the people who have experienced the celebration in the old town.

The curatorial team set up the event in accordance with the town space and preset the footprints of the human traffic. The kilometer-long procession bursts

with energy. As the crowd follows the procession, the delivery of the performers and the spectators is like two waves, intertwined in the lanes of the old town of Daxi. Sometimes the procession moves forward side by side, sometimes the performers and the spectators surround each other. When you imagine the Shetou to be mobile performances, as the sheer volume and formations of the procession moves and changes, the incense offering tables are the sites of the events. As the incense table worship **(1)** ceremony proceeds, the surrounding crowd make way as if encircling a stage. Wherever the worship ceremony takes place in town, it is like a blossoming of crowds. As the procession continues, everyone in the city awaits the grand finale, that of the passing of the palanquin carrying the Guan Sheng Dijun. With the sound of the Shaojiao horn, all the people join hands to welcome the rapid arrival of the holy palanquin.

(1) | **Incense table worship**

Besides worshiping temples when passing by temples, the formation of the procession will also perform salute actions in front of the incense table.

Crowds swarming in, opera tributes in resplendence

In contrast to "Patrol with Gods," which is a celebration of the actual living scene, "Dancing with Gods" is a modern iteration of a traditional tale that stimulates the historical imagination of the venue. Surrounded by the tranquil surroundings of the historic Li Tengfang Mansion is a stage where people and gods can enjoy the performance together. As the fog machine produces clouds of auspiciousness into the sky, Master Hsi-Huang Chen personally performed the glove puppetry "A Chance Encounter Leads to Marriage." **(2)** With one hand, Master Chen deftly manipulated the dashing male protagonist puppet, and with the other hand, a lovely and graceful female protagonist. The mastery is displayed in detail on stage, and the audience learns how the hero and heroine fell in love. The whole presentation was performed without oral narration, only accompanied by crooning voice of the Sorry Youth singing "reluctance to see the gust of wind blowing over, and when it blows your way, it leads me to love you." Is this a ballad? Is this glove puppetry? Master Hsi-Huang Chen took over the mic and said to all the young people in the audience, "Have you ever seen traditional Chinese music and Western music work together so well? Next, I'll invite Sorry Youth to perform together. It's very good." I could never have imagined a rock n' roll-inspired glove puppetry performance in an old mansion to be such an intriguing and profound experience.

(2) | **A Chance Encounter Leads to Marriage**

To allow audiences to enjoy the glove puppetry without understanding Taiwanese Hokkien, the entire play only uses meticulous puppet actions to express the emotion in the story. It is the signature play of Chen Hsi-Huang Traditional Puppet Theatre.

The other site was at Puji Temple, where layers of lights and carved dragons were transformed into a modern-day heavenly palace, and the music was performed by a Beiguan and a sheng against an electric guitar. The group Sam-seng-hiàn-gsang "From now on I have no worries, I live alone in an isolated hut, and the years go by like a flash, and thirty years have since passed." Dancer Liao Yi-Ching brought the electric Holy Generals and the holy generals of Jiatian Temple onto the stage together, and the dance was transfixed on the historical generals Zhou Cang and Guan Ping. The ambience in the venue was so impassioned that it

made the audience feel like they were transported to a different time and place. As onlookers close in on the processional art groups and art is brought into sharp focus, the more profound the urban memory will be. The magic of the local curatorial approach catalyzes the spatial expressiveness of Daxi, allowing each participant to experience and immerse themselves in the blessed atmosphere for a long time.

"Daxidaxi" is an omnipresent memory of the site

The charm of this old town can be experienced not only in its old streets, which is a popular check-in destination on social media, but also in the road leading into the inner mountains; in the Daxi Bridge crossing the Dahan River on foot; in the Li Tengfang Mansion, which passes through lush green paddies; in the Daxi 1st Public Market, bustling with foot traffic; in the bowls of savory Taiwanese Sticky Rice; and in the smiles of each and every story being passed around.

The new type of parade instantly transforms the atmosphere of the old town into an afternoon-only, festive "Daxiland," where everyone must put on small flags and brightly colored theme towels and walk together through the city streets to participate in the parade. There is an anticipation of the pleasant surprises of the collision of modern and traditional performances, just like the "Dancing with Gods" at the Li Tengfang Mansion. When one opens up the possibility for the wildest imaginations, when a night party takes place in an ancient residence, it becomes a new trendy montage of the old and the new, where you can fully experience the past and present of this ancient residence with your eyes closed. Sometimes the sight of landmarks makes people homesick. After the MV of the theme song "OnOn" was aired, the imagery overlooking this mountain town is imprinted in the audience, inspiring many viewers to leave the message "It's Daxi!" "I want to go back to Daxi"....and many more enthused responses. After the Daxidaxi paifang (a traditional style of Chinese gateway arch) was set up, many people took pictures of the landmark, shophouses, and the streets when the lights turned on every day, and social media chick-in's by way of good mornings and good nights were posted on social media every day. This serves as an apt reminder that Daxidaxi is approaching, and that the sights and sounds of the people, events, times, places, and things in each scene will resonate with the public, and even the participants will create their own connection experience with the town, in which everyone will be able to discover something new, and explore the allure of Daxi they have yet to know. Therefore, Daxidaxi has gradually created a site memory that remains omnipresent throughout.

「人」就是文化傳承的原力
"People" are the driving force of cultural transmission

「古早有句話『神明再怎麼興旺、再怎麼靈驗，還是要有人扛轎。』拜拜是一個傳一個，而活動能夠同時向很多人訴說，讓這份文化好好延續下去。」

——陳義春（大溪普濟堂前主委）

在 2022 年「大溪大禧－敦正氣」開幕前夕，全城眾志成城，每一個大溪人齊心盡力完成城市的驕傲給大家。民視記者這時前來，想要拍攝籌備的過程，希望捕捉社頭與策展單位衝突後合力的畫面，民俗技藝協會的江總幹事看著總策展人劉真蓉說：「現在溝通都順暢，沒有什麼衝突，就是一起解決、把事情做好。」劉真蓉此時卻回想起 2018 年第一次進入大溪時的情境，應該是相反的狀態：「每件事都是衝突，沒有任何突破點。」「你是木博館的廠商？不見。」普濟堂的主委知道了策展單位的身份後，立即明確拒絕。「你要自己去找要跟你們合作的社頭啊！」民俗技藝協會理事長如此回應。

以上是 2018 年時，策展團隊與「大溪大禧」最重要地方合作對象對話時的情景，當時才發現原來一心一意想像的與居民合作、設計與在地民俗的交流，並不如預期的那麼簡單順利。

與大溪人一起交陪、策劃與創造的長路

宮廟認為辦理民俗慶典是廟方自己的大事，政府不需要在這時間趁熱度舉辦「大溪文藝季」引入更多外來表演活動；民俗技藝協會認為團隊該先了解「社頭」再來談。策展團隊此時才發現，木博館、社頭代表（民俗技藝協會）、普濟堂，對「大溪文藝季」尚無交集和共識、

且有各自的期待想像，比較像是三方各自表述，因此策展單位想要將「大溪文藝季」轉型為新的節慶「大溪大禧」，期望與地方大眾合作溝通新的策畫內容在一開始並不順利。

策展團隊當時面臨到大抉擇：是要讓三方低度結合，使活動順利做好就好；還是要真正去擾動在地，讓三方共同合作。但多數的事無法掌控，案子可能無法達成預期效果。後來出自心中對原鄉執著的理想，選擇了前往與一整個城市的大溪人交陪的路。

第一關即是廟方本身，因此尋求跟普濟堂主委見面。經過非工作關係的請託，繞了很大的社交圈方能拜訪主委，主委一見到策展團隊，先是抱怨了三十分鐘與公部門的合作經歷，後來在策展團隊的細心說明之下，希望他了解這是為了大溪文化的傳承與發揚，並不是單純為了幫政府辦藝文活動。

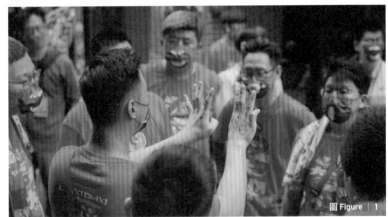

圖 Figure │ 1

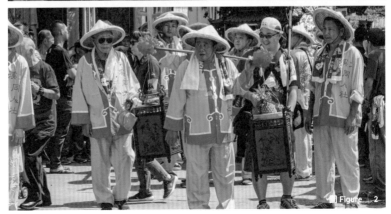

圖 Figure │ 2

普濟堂陳義春前主委先是耐著性子聽完，了解後一改嚴肅態度，看著策展人劉真蓉說「喔！有做功課喔！」、「這個你們問誰的？你們真的懂嗎？」

主委再三確認，讓我們明白原來他真正在意的只是有沒有尊重與了解大溪宮廟文化、有沒有了解其中人與人的關係，也許之前有再多的誤會，但是在一次次拜訪主委，也設身處地為普濟堂思考下，主委漸漸地不反對，並開始轉向支持「大溪大禧」。

第二關，「社頭即是核心」，想要大溪社頭一齊遶境，要能啟動所有社頭，就得尋求大溪民俗技藝協會的協助。策展團隊當時一週三天往返大溪，等待協會幹部們下班，帶著「大溪大禧」簡報到府討論開會，可是繞來繞去，始終無法觸碰到核心問題：到底可不可以結合 31 個社頭，各自派出特色藝陣，循傳統遶境排序重新組成跨社頭合作的新遶境隊伍？

協會江智誠總幹事說：「你們不能都用你們的想法，要了解社群的慣性，也有很多潛規則，溝通是藝術，要一步一步來。」

終於，協會安排策展團隊在協會舉辦的「關聖帝君聖誕慶典籌備會議」中簡報。與其說是會議，不如說是一個一百多人在大溪香滿園餐廳的辦桌，跟所有社頭大哥大姐介紹完自己後，試著說明這個全新計畫「大溪大禧」給大家，簡報完大家安靜略顯尷尬，總幹事一邊幫忙敬酒一邊緩頰幫忙地說「大家有沒有問題？我先敬一杯，沒有問題的話我們就拍手通過！」

就這樣，每年需要大家協助新策劃，或是各種相關議題，都和這些社頭人們在飯桌上解決了。並且於 2018 年後，協會在每年的籌備會議後，也會自動加上大溪大禧相關事項的討論，以尋求每個社頭的幫忙，這樣的轉變，也給策展團隊帶來很大的動力與鼓勵。

第三關，人事協調好後，再來則是最重要的「神的意願」。大溪普濟堂中的關聖帝君到底能不能加入遶境？同人社神轎組能不能扛著「聖帝公」神轎出動？於是同人社社長上香獻疏文 (1) 祭拜，詢問關聖帝君能不能執行「大溪大禧」中的「與神同巡」，**關聖帝君很給力地給出三個聖筊**；一路過了三大關，「與神同巡」概念到執行方向終於底定，轎班帶著哨角準備出動。

「與神同巡」前一天大家在廟前彩排，下過午後雷陣雨的普濟堂廟埕上，推出了一面佈告欄，上面貼出一張粉紅色公告，公告寫著「大溪文藝季之大溪大禧參與社頭配合事項」開幕大典與注意事項。看到民俗技藝協會幫忙調度 31 個社頭們，各社頭組織們自動有系統地加入參與，看著一字一句寫著交辦著明天大家要如何執行。那一天，策展人劉真蓉心裡想著，**「不管明天成功與否，我會一直記得這一張粉紅色公告。」**

秉持著讓大溪人與「大溪大禧」一起策劃的概念，策展團隊從最具代表性也最難協調的「與神同巡」開始，抱持著策展的概念與精神，協助木博館周旋於處理所有信仰儀式的宮廟、組織遶境陣列的 31 個社頭與民俗技藝協會，以及街道巷弄中收藏著不同城市記憶的居民及商家中。

(1)｜疏文
疏文指的是上奏給天庭的正式文件。

圖 Figure｜3

2018 年，民俗技藝協會以社頭參與宮廟活動的公告方式，將「大溪大禧」配合事項張貼在大溪普濟堂布告欄，請各社頭遵照指示。

In 2018, the Folk Art Association posted the cooperation announcement of "Daxidaxi" on the bulletin board of Daxi Puji Temple in the form of a traditional announcement, which is used to inform Shetou groups to participate in the activities of the Temple.

圖 Figure｜3

在媒體推波助瀾下，第一年便產生極大迴響：又潮又在地的形象與大溪鮮明的文化內涵，讓第一年舉辦即超過三萬年輕人湧入大溪這座城市。許多在地人提及在外唸書的孩子也紛紛帶著朋友一起回來。

「我女兒打電話說要帶大學同學回來參加『大溪大禧』，要兌換那個平安符！」、「她第一次關心爸爸做的事」社頭大哥鄭姚霖興奮地說。

直至活動當下，許多在地長輩才發現，原來他們一直細心守護的文化這麼具有吸引力。從那天起，「大溪大禧」也讓不同世代的大溪人，為了守護共同文化連結了起來。

「我是大溪人！」的氣魄與驕傲

大溪人一開始認為自己做的是參拜、儀式與遶境的日常，其實在木博館和策展團隊看來，每個角色都凝聚著信仰的力量，每個人的生活即是守護文化的表現。以人為本的策展思維呈現在每年的特展中，記錄大溪人年復一年承擔的責任，是遶境文化中的許多細節，是代代傳承的堅持，是大溪人傳承給下一代的知識與價值觀，人就是魅力所在。

「謝謝你們，我二十年沒有扛將軍了，沒想到還有機會被這樣記錄下來。」

七十三歲的興安社耆老江鳳兒爺爺與他六十四歲的好友陳世珍爺爺，兩人扛著普濟堂神殿旁，大溪的第一對將軍——周倉將軍、關平將軍，在「舞德殿」展覽中，動態展現神氣活現的將軍腳步伐。

在一旁幫忙的興安社將軍組組長吳岱鴻說「我從來沒有看過爺爺們扛將軍，這真是一代傳奇，『大溪大禧』記錄下的這些，每件事都是經典。」

「這是我們廖家的將軍與我們一家三代，代表我們廖家一起守護聖帝公的精神。」共義團的廖紀宗說。

拍攝當天，廖家大家長廖阿立、第二代廖紀宗與廖紀龍兄弟，以及下一輩的廖國翔，一家就像是許多大溪家庭的縮影，爺爺在神轎組、中生代在將軍組、新生代是廟會中最可愛的香爐手，在拍攝「將軍與我」特展的紀錄與影像時，廖阿立指導孫子如何擺出拿淨香爐姿勢，告訴兒子如何展示將軍，家族一同展現廖化將軍的守護風範。

> 「我相信信仰傳承不是只有一條路可以走，要尊重傳統工藝性，並讓傳統繼續進入現代生活。」

(2)｜香擔
當神轎上路遶境，會有人擔著香爐隨行，這就是「香擔」。香象徵著人與神明的溝通媒介，香擔就像移動式香案，也代表對神聖香火的守護。

同人社前神轎組組長余銘揚總是一邊忙著張羅同人社的衣服、斗笠、香擔 (2)、宮燈，一邊講解著香擔的工藝，與神連結的香煙裊裊……種種細節，也讓人感受到對信仰文化延續與守護的傾心全力。

除了關聖帝君聖誕當日參與遶境的各社頭藝陣，大溪人善用自己的實力與資源，在慶典籌畫及執行的過程中各自扮演好自己的角色。總是很會煮的普濟堂點心班長謝錦源，在慶典時刻不得閒地一直煮，不只是感謝帝君庇佑，更希望照顧前來進香的人們都能飽足，獲得滿滿體力；新勝社謝宏明年年陪著八十多歲的母親一同擺設香案桌，盡力延續謝家近百年的香案傳統。而大溪唯一的木藝女匠師黃裕凰，總是陪著高齡的外婆隨香遶境，帶著感恩的心緩緩地走，與神同行。

> 「我們在大溪所做的一切就像是立起一盞盞的聚光燈，把光投射在大溪人身上，讓他們為自己感到驕傲」，策展人劉真蓉說。

回想起在「舞德殿」的展場中，嘉天宮同義堂將軍組員邱顯青一人靜靜地在展場觀看展出的將軍動態紀錄，他的身影也被記錄在其中，

> 「我們沒有這樣看過自己被展出，原來我們是這樣走著，很驕傲，很感動。」

一旁的將軍步伐互動區前來一對父子，小男孩踩著熟練腳步，受到旁邊參觀者的讚嘆驚呼，他回過頭驕傲地說「我是大溪人阿！」那份驕傲的神情代表著，「大溪大禧」講的就是屬於大溪與大溪人們的故事。

信仰變成可以跟每個人分享的事

從一開始被視為由外來團隊規劃的活動，隨著幾年下來，「大溪大禧」嘗試連結了大溪社群、推廣「迎六月廿四」、訴說大溪故事，再加上討論度高的設計行銷，大溪人們在這幾年已經開始將「大溪大禧」視為地方上的大活動，木博館與策展團隊期許人們能對此感到認同與驕傲，並且擴大參與。

你會看見大溪人就像過去「迎六月廿四」要辦桌的年代，擔負起主人的身份，招待著前來的客人。從慶典籌備期間的宣傳活動開始，在社群的限時動態中，不斷向親友們預告「大溪大禧」的來臨，也有人成為街區中的應援站，擺出香案桌、發放活動文宣，加入介紹大溪的行列。

以大房豆干為例，不只有著街角館的身份，2022 年更成為「大溪大禧」專賣店的一員，也在活動期間成為最敬業的資訊站，每天都能看到街角館館長淑媛姐賣力向旅客們分享大溪的一切美好。

協盛木器行的姚慈盈也非常熱情：「你看！我特別把日治時期墨斗照片拿來，跟『與神同巡』文宣扇的遶境隊伍圖放在一起，這樣大家覺得好奇的時候，我們隨時都能跟大家說協義社的故事！」

(3)｜無牙糖
以古法製作的花生糖柔軟而不黏牙，沒有牙齒的老人家們都能享用，因此被稱作「無牙糖」。

而傳承百年的江家古早味花生糖，甚至有了更多機會將家族延續至今的做糖古法分享給大家，以及長輩們在六月廿四廟會賣「無牙糖 (3)」的歷史小故事，「我原本只有每週五、六、日營業，那活動期間週四也營業好了！」……分享的故事還有好多好多，等著每個來訪大溪的人慢慢蒐集體會。

而作為「迎六月廿四」慶典中心的大溪普濟堂，是連結宗教、文化的平台，從主委、總幹事、委員們到廟婆，都坐鎮廟中，始終真情接待所有來訪普濟堂的人們。

「謝謝大溪大禧，讓信仰成為可以跟每個人分享的事。」廟婆總帶著暖陽光似的微笑說著。

在 2022 年的開幕式前夕，普濟堂謝昌明主委製作了「感謝市長讓大溪大禧成為國際節慶品牌」的紅布條，興高采烈地分享屬於這個文化盛事的榮耀。委員們甚至說「我們今年特別幫每個社頭打一塊金牌匾額，大溪大禧開幕時，讓市長送給每一個社頭！」……「大溪大禧」已成為在地驕傲表現自己的舞台，自發輸出紅布條，大大掛起，自發打造「大溪大禧」匾額送給自己人，讓市長與社頭參與者合影，每個社頭帶著匾額一起「與神同巡」，這麼接地氣的舉動讓策展團隊哭笑不得，一開始雖想反對，最後發現這也是大溪耆老們對「大溪大禧」的認同，而欣然擁抱。

當新竹都城隍爺與其護衛將軍一同前來「大溪大禧」，兩個不同祭祀體系、代表不同城鎮的神祇，在大溪進行過去未曾有過的交流；從傳統接駕、參與新型態遶境「與神同巡」，到邀請都城隍爺與關聖帝君一起坐在拜亭，觀賞「神嬉舞夜——正氣 Pa！」的演出及兩邊將軍的交流示範……這一切的事務與禮俗，大溪人都鼎力相助。

「我們要在接駕都城隍時表現大溪精神，請大家一起配合。」大溪普濟堂謝昌明主委說。

「都城隍要來，我們社自願代表大溪迎接城隍爺。」共義團舉手說。

「兩位大神的接駕真的是一大挑戰，是在遶境上的一種創舉，也許有引起爭議，我們就當成是一種文化傳承跟教育，代表大溪，把禮俗做好，從善如流。」普濟堂委員黃智弘這樣說著。

新竹都城隍爺來訪的特殊機緣，不只讓人熱切感受到大溪人對於「大溪大禧」的支持，大溪人把這些事務看作自身事務般的認真態度，一起領著都城隍爺與六將會參與慶典，齊心表現家鄉文化的精神，這樣的層次早已超越「大溪大禧」本來的預期。

大溪的人們，讓我們在「大溪大禧」裡感受到臺灣文化的豐厚、地方社群的凝聚力、人際間的互助溫情。人與人一起扶持走下去，可以是個體，也可以化身群體，讓原生文化層次跨越信仰，讓「大溪大禧」持續保存原生文化的願力。

"There is an old adage that goes, 'No matter how prosperous and efficacious the gods are, someone has to carry the palanquin.' Worships are a tradition, and the event can speak to many people at the same time, so that this culture can continue on"

- Yi-Chun Chen (former Chairman of Daxi Puji Temple)

On the eve of the opening of the 2022 "Daxidaxi - Spirit of Righteousness," the whole city comes together and every Daxi local is contributing to showing the pride of the city to the world. A reporter from FTV came at this time and wanted to film the preparatory process, hoping to capture the picture of the conflict between a Shetou group and the curatorial organizer before finally working together. Director Chiang, the chief executive of the Folk Art Association, looked at Tammy Liu, the chief curator, and said, "Communication is now smooth, there is no conflict, we just work together to solve the problem and make things better." However, Liu instantly recalls a memory when she first entered Daxi in 2018, where the opposite was true: "Everything seemed to fuel conflict, and there is no breakthrough point. "*"Are you a vendor of the Ecomuseum? Then we're not interested."* When the chairman of Puji Temple found out the identity of the curatorial unit, he immediately rejected granting them an audience. *"You'll have to find Shetou willing to work with you!"* was the response of the President of the Folk Art Association.

This was what happened in 2018 when the curatorial team engaged with the most important local partners of Daxidaxi. It was then the team realized that the envisaged collaboration with residents and the exchange of design and local folklore that they had imagined was not as easy as expected.

The long journey of engagement, planning and creation with the people of Daxi

The temple believed that it is the temple's own cardinal responsibility organize folk festivals, and the government does not need to take advantage of the great public attention to organize the "Daxi Cultural Arts Season" to bring in more foreign performances at this time. The Folk Art Association believed that the curatorial team should first understand the Shetou culture in depth before any further engagements. The curatorial team realized at this time that the Ecomuseum, the Shetou representatives (Folk Art Association), and Puji Temple had not yet formed a consensus on the context of the "Daxi Cultural Arts Season" and each had their own expectations and imaginations. Therefore, the curatorial team wanted to transform the "Daxi Cultural Arts Season" into a new festival called "Daxidaxi" and hoped to engage with the local public to better communicate the new curatorial message.

The curatorial team faced a dilemma: whether to let the three parties form a low-intensity partnership and ensure the event went on smoothly, or to really upend local conventions and let the three parties work together closely. But when most things are out of your control, the desired result may not be achieved. Later, inspired by a strong resovel to transform the hometown, the team chose the path of engaging with all the people of Daxi.

The first hurdle was the temple itself, so a meeting was sought with the chairman of Puji Temple. Going through many hoops through connections unrelated to the project, the curatorial team was finally able to meet with the chairman. Upon meeting the curatorial team, the chairman first complained for 30 minutes about his experience with other public agencies. The curatorial team expressed sympathy with the chairman's previous grievances, and provided a careful explanation; they hoped to convey to the chairman that this was for the preservation and promotion of Daxi culture, and not simply for the purpose of helping the government organize art and cultural activities. After listening patiently, Yi-Chun Chen, the former chairman of Puji Temple, changed and looked at the chief curator Tammy Liu and remarked,

> *"Wow! You've done your homework!" "Who did you ask for this?" "Do you really get it?"*

The chairman's repeated inquiries confirmed the fact that he really cares about whether the team respected and truly understood the temple culture of Daxi, and whether the team understood the interpersonal relationships. Indeed, there were misunderstandings before, but after visiting the chairman again and again, and putting themselves in the shoes of Puji Temple, the chairman gradually let his guard down, and began to turn to support Daxidaxi.

The second hurdle is "the Shetou is at the core". If the team wanted the Shetou organizations of Daxi to join the Daxidaxi procession together, they must seek the assistance of the Daxi Folk Art Association to motivate other Shetou groups. The curatorial team went back and forth to Daxi three days a week, waiting for the association's officers to get off work and bring the "Daxidaxi" presentation on site to discuss, but progress went nowhere. The core question remains unanswered: Is it possible to combine the 31 Shetou groups, each sending out their own special art formations to re-form a new cross-Shetou parade team in the traditional parade sequence?

Director Chih-Cheng Chiang mentioned, *"You can't get stuck in your own ideas; you have to understand the practices of the Shetou and there are many unspoken rules, communication is an art, and you have to take it one step at a time."*

Finally, the Association arranged for the curatorial team to make a presentation at the "Preparatory Meeting for the Guan Sheng Dijun Birthday Celebration" organized by the Association. Rather than a meeting, it was more like a banquet for more than 100 people at Daxi Xiangmanyuan Restaurant. After introducing myself to all of the Shetou veterans, I tried to explain the brand-new project "Daxidaxi," After the briefing, everyone was quiet and seemed slightly embarrassed, so the director made the toast and asked helpfully *"Do you have any questions? I'll start with a toast, and if there are no questions, we'll clap our hands and approve of this proposal!"* In this way, every year, when we need help with new planning or various related issues, we work them out with these Shetou leaders through banquet meals. After 2018, the association will automatically add the discussion of Daxidaxi related issues after the annual preparatory meeting to seek help from the Shetou groups. This change has given the curatorial team a boost of energy and encouragement.

After the third hurdle, the coordination of personnel matters, comes the most important element: "God's will." Can Guan Sheng Dijun of Puji Temple join the procession or not? Will the palanquin crew be able to carry the "Holy Emperor Guan's" palanquin? In light of these considerations, the president of Trongren Society offered incense and worship, and asked Guan Sheng Dijun if he could perform the "Patrol with Gods" in the Daxidaxi. Guan Sheng provided the divine answer: three shengjiao (approval). After passing three major hurdles, the concept of "Patrol with Gods" finally was a "go," and the palanquin crew were ready to go out with their Shaojiao horns.

The day before the "Patrol with Gods," everyone rehearsed in front of the temple, and a bulletin board was put up in front of Puji Temple after an afternoon thunderstorm. A pink announcement was posted on the board, which reads "Notes on Cooperation for Shetou Groups Participating in Daxidaxi of the Daxi Cultural Art Season," It details the opening ceremony and notes. It was a moving sight to see the Folk Art Association helping to coordinate the 31 Shetou organizations, and each Shetou joined in automatically and systematically took note of how to cooperate with the ceremony to be held on the next day. On that day, curator Tammy Liu thought to herself, *"Whether we succeed tomorrow or not, I will always remember this pink announcement."*

With the concept of allowing Daxi locals to plan together with Daxidaxi, the curatorial team started with the most symbolic event, which as was also the most difficult to coordinate "Patrol with Gods". With the concept and spirit of curatorship, the curatorial team assisted the Eco-Museum coordinate with all participating temples, the 31 Shetou organizations, and Folk Art Association that organize the parade, and the residents and businesses throughout the Daxi that hold different memories of the city.

The first year was a great success, thanks to attention from the media: the trendy and local imagery and the distinctive culture of Daxi attracted more than 30,000 young people to the city in the first year of the event. Many locals mentioned that their children who were studying outside of Daxi also brought their friends back with them.

> *"My daughter called and said she wanted to bring her college friends back for the Daxidaxi, and to redeem the safety amulet!" "For the first time, she cares about what her father is doing."*

said an excited Yao-Lin Cheng, a member of a Shetou organization. It was only at the time of the event that many of the local elders realized how marvelous the culture they had been carefully guarding was. Since that day, the Daxidaxi has also connected different generations of Daxi to preserve their common culture.

Proudly proclaiming "I am from Daxi"

At first, Daxi locals thought they were doing the daily routine of worship, rituals and processions, but in fact, in the eyes of the Ecomuseum and the curatorial team, each role unites the power of faith, and each person's life is a manifestation of guarding the culture. The people-oriented curatorial concept and approach is epitomized in the annual special exhibition, which records the sacred duties that the people of Daxi have undertaken year after year, the many details in the culture of the procession, the persistence that has been passed down from generation to generation, the knowledge and values that the people of Daxi have passed down to the next generation. Simply put, the appeal of the event are the people of Daxi.

> *"Thank you. I haven't carried a Holy General for 20 years, but I never thought I'd have the chance to be remembered this way."*

Feng-Er Chiang, a 73-year-old elder of the Xing'an Society, and his 64-year-old friend, Shi-Chen Chen, carried the foremost pair of Holy Generals of Daxi, General Zhou Cang and General Guan Ping, next to the shrine of Puji Temple, in a kinetic display of the Holy General's stride in the "Hall of Dancing Virtue. Tai-Hung Wu, the leader of Xing'an Society's Holy General Group, who was helping out, said

> *"I've never seen the elders carrying the Holy Generals. They're really legendary. Luckily, everything is recorded in Daxidaxi, and everything is an instant classic."*

"This is the spirit of Liao clan's Holy General and our family for three generations, acknowledging that the Liao family has guarded the spirit of Holy Emperor Guan (Guan Sheng Dijun)," said Chi-Tsung Liao, of the Gongyi Society.

On the day of filming, the head of the Liao clan, Ah-Li Liao, the second-generation siblings, Chi-Tsung Liao and Chi-Lung Liao, as well as the third-generation member, Kuo-Hsiang Liao, were present. The family is like a microcosm of many local Daxi families, with the grandfather in the palanquin, the middle generation in the Holy General group, and the youth taking on the role as incense helpers in the temple event. During the filming of the "The Holy General and I" exhibition, Ah-Li Liao instructed his grandson on holding the incense burner and showed his son how to best showcase the posture of the Holy General, with the whole family demonstrating the best guardianship of Holy General Liao Hua.

"I believe that there is not just one way to pass on the faith, but to respect the craftsmanship of tradition and let it continue to enter modern life."

Ming-Yang Yu, the former chief of the holy palanquin group of the Tongren Society, was busy arranging the attire, hats, incense carrying poles [1], and temple lanterns of Tongren Society, while explaining the craftsmanship of the incense carrying poles and the swirling incense smoke connected to the gods...all these details best manifest the dedication to the continuation and protection of the culture of faith.

In addition to the various shetou who participated in the procession on Guan Sheng Dijun's birthday, Daxi locals also make good use of their own skillsets and resources to contribute to the planning and execution of the celebration. Chin-Yuan Hsieh, the head of the snacks team at Puji Temple, skilled at cooking, forked frenetically during the day of the celebration. Not only does he thank Guan Sheng Dijun for his blessings and protection, he also hopes that the god will protect the devout faithful who come to worship, and grant them enough energy. Hung-Ming Hsieh of Xingshen Society accompanies his mother, who is in her eighties, to set up the incense table year after year, and he tries his best to continue the Hsieh family's nearly century-old worship tradition. Yu-Huang Huang, the only female wood craftsman in Daxi, always accompanies her elderly grandmother to attend the annual procession, walking slowly with a grateful heart and with the gods.

"What we are doing in Daxi is like setting up a spotlight to acknowledge the people of Daxi and make them feel proud of what they have accomplished," said curator Tammy Liu.

In the "Dancing Hall of Virtues" exhibition, Hsien-Ching Chiu, a member of the Holy General group,under Tongyi Hall of Jiatian Temple, quietly watched the exhibits of the Holy Generals on display, and his figure was also recorded in it.

"We have never seen ourselves exhibited in this way, so that's how we walk and move! I am very proud and touched,"

he noted. A father and son came to the interactive area in front of the "Holy General's Stride" area. The little boy stepped skillfully and was surprised by the admiration he received. He turned around and proudly said, *"I'm from Daxi!"* That proud look means that "Daxidaxi" is the story of Daxi and its people.

Faith can be transformed into something that can be shared with all

"Daxidaxi" is an event that began with negativity of the townspeople as an intrusion has, over the years, and now, it's intimately ingrained in the Daxi community, such as by promoting "June 24 Reception," telling the story of Daxi, and through the viral and highly successful design and marketing campaigns. The people of Daxi have begun to see "Daxidaxi" as a major local event in the past few years, and the museum and the curatorial team hope that people will recognize and take pride in it and expand their participation.

You will see the people of Daxi taking on the role of hosts and entertaining the guests, just as they did in the old days when they had to host banquets to welcome June 24. From the promotion activities during the preparation of the festival, to informing friends on social media stories of the arrival of Daxidaxi, they have transformed themselves into the most compelling publicists, setting up incense tables and distributing event pamphlets to join in the introduction of Daxi to visitors.

For example, Da Fang Bean Curd is more than a corner store: in 2022 it became a member of Daxidaxi specialty store, and also the most dedicated information helpdesk during the event. Every day, you can see the store owner, Shu-Yuan, trying her best to spread the beauty of Daxi to visitors.

Chi-Ying Yao of Hsieh-Sheng Wood crafts is also very enthused: *"Look! I took the photo of the chalk line from the Japanese colonial era and put it together with the picture of the processional team featured on the "Parade with the Gods" promotional hand fan, so that when people ask questions, we can tell them the story of Hsieh Yi Society at any time!"*

The Chiang Family Peanut Candy Store, which has been passed down for a century, has even had more opportunities to share the ancient method of making candy that has been passed down through the generations to this day, as well as the story of the elders who sold "toothless candies" **(2)** at the June 24 temple fair, *"I used to only open for business on Fridays, Saturdays and Sundays, but I'll be open on Thursdays during that event!"* There are many more captivating stories to share, awaiting curious visitors to experience in Daxi.

(2) | **Toothless candie**

Peanut candies made in the traditional way are soft and not sticky, and even can be enjoyed by the elderly without teeth, so-called "toothless candies".

As the epicenter of the "June 24 Reception" celebration, Daxi Puji Temple is a platform to link religion and culture, from the chairman, director, committee members to temple ladies, they all sit in the temple and always welcome all who come to Puji Temple.

"Thank you, Daxidaxi, for making faith something you can share with everyone," said the temple lady with a warm smile.

On the eve of the opening ceremony of Daxidaxi in 2022, the Chairman of Puji Temple, Chang-Ming Hsieh, made a red banner "Thank you, Mayor, for making Daxidaxi an international festival brand" and happily shared the glory of belonging to this cultural event. The temple committee's members even said, "This year, we will award a gold plaque to each Shetou organization, and the mayor will give it to each Shetou organization representative during the opening ceremony of Daxidaxi!" Daxidaxi has become a stage for the local community to proudly express themselves, self-producing red banners, and hanging them up proudly, creating Daxidaxi plaques to recognize their own people's achievements, letting the mayor of Taoyuan to take a photo with the Shetou groups, and each Shetou to bring the plaque together to "Parade with the Gods". Although the curatorial team wanted to oppose this "local initiative" at first, they finally realized that it was also a recognition of the Daxidaxi by the elders of Daxi, and they gladly embraced it.

When Hsinchu City God and his guardian deities came to join Daxidaxi, the two faith systems, representing different ritual systems and cities, had an unprecedented exchange in Daxi. From the traditional palanquin ritual and participation in the new procession "Patrol with Gods" to inviting City God and Guan Sheng Dijun to sit together at the worship pavilion to watch the

performance of "Dancing with Gods- Righteous Party" and the demonstration of exchange between the two deities...the people of Daxi helped enthusiastically with all these affairs and rituals.

"We need to show the spirit of Daxi in the reception of the City God, and your cooperation is greatly appreciated." said the chairman of Puji Temple.

"Since the City God is coming, our society volunteered to welcome the City God on behalf of Daxi," said the head of Xing'an Society while raising his hand.

"It was a great challenge to hold palanquin rituals for the two gods, and it was a kind of innovation in the procession, which might have caused controversy.
We regarded it as a kind of cultural heritage and education, representing Daxi, doing the rituals well and going with the flow," Chih-Hung Huang, a committee member of Puji Temple, remarked.

The special opportunity of the visit of Hsinchu City God not only makes one deeply moved by the level of popular support of Daxidaxi from the locals, the people here have also taken these matters seriously as if they were their own affairs, and together they will lead the City God and the Six Holy Generals to participate in the celebration and express the spirit of their hometown culture together. Such a level has already surpassed the original expectation of Daxidaxi.

The people of Daxi have allowed us to profoundly understand the richness of Taiwanese culture, the solidarity of the local community, and the warmth of interpersonal support in the form of Daxidaxi. People can support each other, either as individuals or as a group, so that the local culture level can transcend beliefs and Daxidaxi continues to preserve the incredible legacy of native culture.

什麼是「價值先行」的設計思考？
What defines "value first" design conjecture?

所謂設計，是「設想」和「計劃」：設想是「目的」，計劃是「過程安排」，是一種有目的的創作行為。

所謂文化，廣泛來說，包含人類發展以來的語言、習俗、飲食、制度、知識、觀念、藝術⋯⋯等。大致上來說，「文化」代表著一群人的生活習慣，共同的習性與傾向。

大溪的「迎六月廿四」動員大溪各區域的人們一同參加，因為關聖帝君信仰文化所產生的祭祀行為，影響了這裡人們的生活日常，已然成為大溪具標誌性的在地文化。

「大溪大禧」的初衷，即是透過各種延續文化的設計思維，以設計延續「迎六月廿四」的樣貌，在當代社會真實體現「文化即生活」。但是設計如何導入文化？與傳統文化的差距是什麼？是形式，還是意識的表現？是短期功效，還是長期影響？要以在地為主，還是向外推廣？⋯⋯其實在每個計畫中，策展團隊都一定會面臨「復興傳統文化」與「開創性表現」的雙向考量，只是在於程度上的取捨。除了種種評估，同時也得在活動發生時間長短與感染力道上再三著墨，並針對議題擴散程度與溝通對象，判斷這些計畫是該著重「形式先行」還是「意識先行」，或是必須達成「平衡內聚在地情感交流」與「對外交流推廣」的目的⋯⋯而在衍生這些考量之前，從海量的在地資料與故事當中，找出值得延伸的重點與價值所在，進而策劃出適合在地的設計導入與執行方式，可說是策展團隊的大挑戰。

設計思維究竟如何運作，讓傳統文化能夠延續？我們試著以開幕式的「與神同巡」、行銷計畫中的「遶境 kit」與主題歌曲《紅紅 OnOn》的接力創作，來看到其中「設計帶入文化」的操作方式與層層影響。

與神同巡：新型態概念遶境

在臺灣文化當中，「遶境」是許多人都有的記憶。「神明乘坐神轎出來巡視」大概是多數人對遶境的主要印象，但對於遶境的儀式與陣容等細節，卻是記憶模糊。而隨著時代演進，對遶境文化的不解與誤解逐漸增多，這也讓策展團隊希望透過層層設計思考，用嶄新的方式，讓人們不再只是遶境儀式的旁觀者，更可以認識遶境裡的大小事，甚至成為遶境的參與者。

還記得第一年舉辦「大溪大禧」時，策展團隊用了一個月的時間，才搞清楚大溪當地人所說的「迎六月廿四」是什麼，「迎六月廿四」的遶境隊伍大概長什麼樣子。如果要進一步熟練地記住樂安社、同人社、興安社、協義社……等 31 個社頭的完整名稱，真的還有很大的努力空間。更何況要了解什麼是遶境的組成，什麼是每個社頭最具代表性的行頭……等繁複細節了。

也是因為如此，策展團隊最初只是單純想著，有沒有可能在「大溪大禧」的開幕，有一場號召 31 個社頭一起的「教學版濃縮遶境」：有陣列教學、大溪社頭示範、儀式禮俗展演，最重要的是還有關聖帝君神轎壓陣？只為了讓更多像策展單位一樣的遶境麻瓜，能夠得其門而入，將傳統遶境的邏輯記在心上，慢慢了解大溪每個社頭的特色，與關聖帝君遶境的禮俗，之後甚至能夠應用遶境的知識，在街頭巷尾都有廟宇的臺灣，隨時展開對周圍遶境隊伍的觀察，從中看見臺灣民間信仰文化之美。

關於「與神同巡」的組成，策展單位先列出一個「濃縮陣列原型」，**將傳統遶境陣列依照功能與位置，分類為「開路先鋒、表演藝陣、神明護衛、壓軸坐轎」四大主題**，帶領大家認識遶境。「大溪大禧精華版原型」前後依循傳統序列，前有普濟堂的頭旗與土地公，最後以大溪普濟堂關聖帝君壓陣。「表演藝陣」與「神明護衛」每一年則由不同社頭擔任不同的遶境位置，最終由 31 個社頭共同組成一支富有教育

性的隊伍，帶領大家藉由一起在濃縮成兩小時的精華隊伍時間當中，帶領大家看懂遶境，了解大溪社頭。

如果有因為文化交流而前來參與的神明，如同新竹都城隍爺的將軍與轎班陣列，也可以看見大溪尊重科儀地請出大溪的將軍 (1)，護衛著都城隍爺一起加入以關聖帝君為主的新型態遶境陣列。

(1) │ 迎接客神
當其他城市的神明來訪，由主神的護衛將軍到指定地點迎接，進行相互拜禮後，一路護衛神明回到主廟。

一切的排序，透過故事性與儀式性，連接與延續著傳統的精神，透過「與神同巡」一覽無遺。

給孩子的遶境學：將民俗生活結合設計的遶境教育計畫

無論是在「與神同巡」遶境現場，或是教育版說明圖中，其中的「小社頭聯盟」都非常引入注目。這支由兒童組成的遶境隊伍雖然不長，但是為了讓小孩接觸遶境文化得費盡心思。

「大溪大禧」結合文化傳承與設計，推出教育計畫「給孩子的遶境學」，希望大溪的孩子們能夠更認識自己家鄉的民俗與社頭文化。先是設計的轉換，設計師為了小孩特製三國將軍穿戴服裝與臺灣石虎版舞獅道具，以輕量化的材質運用在服裝設計上，降低兒童使用的負擔，以講究傳統卻時尚帥氣的造型，深得小孩們的心。另一方面是與社頭教練配合入校教學，在社團課傳授不同的藝陣技藝。在孩子們驕傲穿戴的將軍服裝、每週反覆練習之時，文化傳承就在其中。

農曆六月廿四日遶境時，「小社頭聯盟」隊伍與 31 個社頭的參與者，一起踏遍好幾公里的城市遶境，從行禮到拜廟都毫不馬乎。當孩子們隨著北管聲踏出腳步，一尊尊小將軍的威武，石虎的神情與靈巧，都演繹得生動無比。由孩子身體力行讓遶境文化持續，總是獲得滿堂彩，並深深感動著周邊所有的觀眾。

遶境 Kit：連結關公最近的距離

每逢初一十五，抑或各個年節與神明聖誕的祭拜儀式，是與臺灣生活最親近的信仰生活，但隨著時代演進，祭拜的方式也逐漸省略與簡化。

「遶境 kit」則希望聚焦於大眾都熟悉的「祭拜文化」，深入信仰知識並透過設計轉化的一系列物件。最特別的是，這個系列是「大溪大禧」實體內容中推廣對象最廣的；不僅能夠引起許多人的共鳴，還能夠以聯名方式與產業結合，成為大眾最容易入手與參與的方式。

其中就包含 2020 年炙手可熱的「平安福袋」：以「平安福袋，教你拜拜」為標語，將大溪人祭拜桌上特有的供品，重新設計變成一個禮物包。一打開，將裡面的長壽麵線、壽桃、蜜梅糕，與大溪特有的祭拜物——豆干擺上桌，再放上與關聖帝君聯繫情感的「平安符」，一個簡單的祈福拜桌就完成了。限量 500 個的「平安福袋」在送到大家手上之前，都會先在普濟堂裡過香爐，把祝福也一起包裝進去。提著「平安福袋」走在大溪街上，看著家家戶戶展示的香案桌，信仰生活的精神就在這之間持續傳遞。

而每年設計的限定款「大溪大禧平安符」，由普濟堂與木博館推廣使用。跨越宗教圈與設計圈，成為大家都想要的年度限定信物。普濟堂

圖 Figure │ 1
「遶境 Kit」行銷推廣層級圖
The marketing promotion hierarchy chart of the "Procession Kit"

平安福袋
Peace Amulet Mystery Bag

 × **500** 袋 bags

受眾 Target
大溪大禧粉絲
Fans of Daxidaxi

意義 Meaning
認識生活祭祀，了解拜桌上供品祈福意義
Transfer the worship culture from the blessing meaning of offerings on the worship table

平安符
Daxidaxi Peace Amulets

 × **5,000** 個 pices

大溪大禧粉絲
關公信眾
Fans of Daxidaxi,
Believers of
Guan Sheng Dijun

認識與神明結緣的臺灣民俗信仰
Transfer the knowledge of taiwan folk belief by the tokens with Gods

大溪大禧聯名維大力
Vitali-Daxidaxi edition

 × **480,000** 罐 cans

大溪大禧粉絲
關公信眾
大眾
Fans of Daxidaxi,
Believers of
Guan Sheng Dijun,
The Public

得知有一個信仰與設計結合的地方故事
Tell everyone that there is a regional story about design and belief

圖 Figure │ 1

大溪普濟堂關聖帝君聖誕遶境｜陣列簡圖

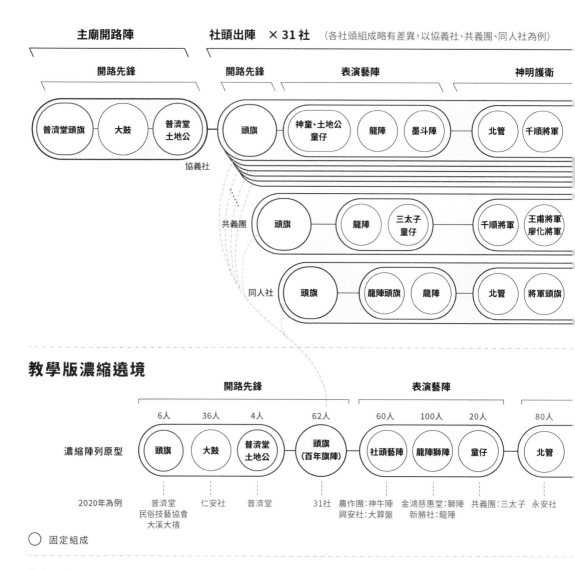

主廟開路陣

開路先鋒

| 普濟堂頭旗 | 大鼓 | 普濟堂土地公 |

社頭出陣 ×31 社 (各社頭組成略有差異，以協義社、共義團、同人社為例)

開路先鋒 ｜ 表演藝陣 ｜ 神明護衛

協義社
| 頭旗 | 神童、土地公童仔 | 龍陣 | 墨斗陣 | 北管 | 千順將軍 |

共義團
| 頭旗 | 龍陣 | 三太子童仔 | 千順將軍 | 王甫將軍廖化將軍 |

同人社
| 頭旗 | 龍陣頭旗 | 龍陣 | 北管 | 將軍頭旗 |

教學版濃縮遶境

開路先鋒 ｜ 表演藝陣

濃縮陣列原型

| 6人 | 36人 | 4人 | 62人 | 60人 | 100人 | 20人 | 80人 |
| 頭旗 | 大鼓 | 普濟堂土地公 | 頭旗(百年旗陣) | 社頭藝陣 | 龍陣獅陣 | 童仔 | 北管 |

2020年為例
普濟堂民俗技藝協會大溪大禧 ｜ 仁安社 ｜ 普濟堂 ｜ 31社 ｜ 農作團:神牛陣 興安社:大算盤 ｜ 金鴻慈惠堂:獅陣 新勝社:龍陣 ｜ 共義團:三太子 ｜ 永安社

◯ 固定組成

「與神同巡」陣列圖

2022年為例

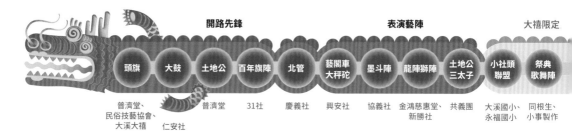

開路先鋒 ｜ 表演藝陣 ｜ 大禧限定

| 頭旗 | 大鼓 | 土地公 | 百年旗陣 | 北管 | 藝閣車大秤砣 | 墨斗陣 | 龍陣獅陣 | 土地公三太子 | 小社頭聯盟 | 祭典歌舞陣 |

普濟堂、民俗技藝協會、大溪大禧 ｜ 仁安社 ｜ 普濟堂 ｜ 31社 ｜ 慶義社 ｜ 興安社 ｜ 協義社 ｜ 金鴻慈惠堂、新勝社 ｜ 共義團 ｜ 大溪國小、永福國小 ｜ 同根生、小事製作

座轎

周倉將軍
關平將軍
——
巧聖先師
神轎
押帆

周倉將軍
關平將軍
關聖帝君
神轎

關刀
周倉將軍
關平將軍
同人社
神轎

壓軸座轎

普濟堂
香案車
普濟堂
壓帆
普濟堂
正副爐主子
哨角
香擔
普濟堂
關聖帝君
老祖神轎
押帆

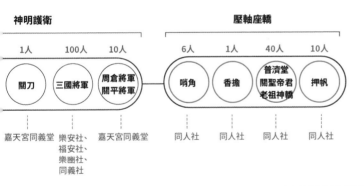

神明護衛

1人	100人	10人
關刀	**三國將軍**	**周倉將軍** **關平將軍**
嘉天宮同義堂	樂安社、 福安社、 樂豳社、 同義社	嘉天宮同義堂

壓軸座轎

6人	1人	40人	10人
哨角	**香擔**	**普濟堂** **關聖帝君** **老祖神轎**	**押帆**
同人社	同人社	同人社	同人社

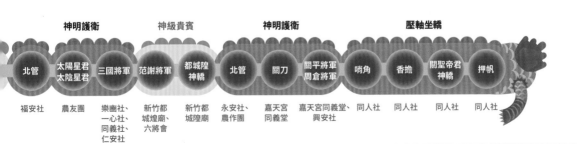

	神明護衛		神級貴賓		神明護衛			壓軸坐轎			
北管	**太陽星君** **太陰星君**	**三國將軍**	**范謝將軍**	**都城隍** **神轎**	**北管**	**關刀**	**關平將軍** **周倉將軍**	**哨角**	**香擔**	**關聖帝君** **神轎**	**押帆**
福安社	農友團	樂豳社、 一心社、 同義社、 仁安社	新竹都 城隍廟、 六將會	新竹都 城隍廟	永安社、 農作團	嘉天宮 同義堂	嘉天宮同義堂、 興安社	同人社	同人社	同人社	同人社

主委堅持手摺八卦符 (2) 與香灰 (3)，以最傳統的方式給予誠摯祝福，讓每個得到的人都感受到神明與整座城鎮的心意。

另一個知名的產品「大溪大禧維大力」，緣起於遶境隊伍喝涼水的習慣，策展團隊力求與桃園在地知名飲料公司「南亞食品」合作，推出聯名款維大力飲品，並與桃園市政府一起協助打開便利商店通路。結合「大溪大禧」宣傳力，全臺鋪貨 48 萬罐，期間限定，人人搶購。當關公與整座大溪城鎮都刻畫在瓶身上，一開罐就能喝到祝福，在盛夏感受與關公最接近的距離。

紅紅 OnOn：一首祭典樂的創作接力

「有沒有可能有一首主題曲代表『大溪大禧』，讓大家一起跳、一起唱，進而傳遞這裡的信仰與文化？」這個想法藏在策展團隊心中好幾年，直到 2020 年才正式開始收集文本、展開企劃、邀集創作者，展開為期超過一年的連續創作。但是創造一首慶典樂曲，需要動員的設計師與創作者，遠比當初策展團隊想像得要多很多。這次《紅紅OnOn》的創作，就由「大溪大禧」音樂總監——三牲獻藝 (4) 的柯智豪老師寫出對關聖帝君的奇想，與大溪嘉天宮同義堂張書武教練的「屈禮」步驟講解開始譜起，醞釀出歌曲的雛型：

　（將軍的屈禮步驟）
　正氣步 原地踏步 微笑弧線 一起搖擺
　正氣步 將軍起步 腳踩七星 左頓右抬
　（柯智豪老師最初寫下的詞）
　咱的關帝君 庇蔭大溪 四季如春
　咱的關帝君 大家大禧 日日安穩
　紅紅 紅紅紅紅 你最紅 紅面 紅衫 紅馬 紅紅紅 你最紅
　紅紅 紅紅紅紅 你最紅 風調 雨順 國泰 民安 沒煩沒惱 健康平安

接著參與的是創作型樂團同根生 (5)，他們聽著柯智豪老師詞曲創作的 demo 帶，跟策展團隊討論如何編寫一首祭典樂。身為樂團主唱、最知道如何帶動大家的楊智博說「一定要讓大家可以琅琅上口，能隨著韻律跳起來，可以傳達文化意象，又不會太過說教，有流行音樂的感官渲染力，但又不能太媚俗」，於是他加入韻律思考，與同根生

(2) | 八卦符
八卦摺形符令象徵神明所批的公文，若信徒遭遇危機且附近沒有神明時，八卦符就是神明的性物，能夠保佑信徒平安。

(3) | 香灰
代表著大溪普濟堂的香火保佑，有除煞鎮惡的效果。

(4) | 三牲獻藝
一個落實風土採集，並將電子音樂與臺灣廟宇音樂元素混種、融合的電子音樂跨界團體。

《紅紅 OnOn》MV

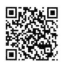

(5)｜同根生

結合民族樂器創作的融合樂團，宜蘭人組成。包含笙、月琴、柳琴、中阮、鋼琴、大提琴、貝斯、擊樂、人聲等。同根生以臺灣文化為基底，擅以環境與空間為創作靈感。

團員們嘗試以斯卡曲風 (6) 的律動為底，加入中西交融的鼓吹樂，建立獨特編曲風格。「即便是不懂中文的人聽到這首歌，還是可以跟著節拍律動一起跳，同時我們也試著把歌詞變得更趣味、簡單」，於是智博與同根生延續著柯智豪老師的精髓，做出了極為出色的歌樂舞整合，完成了這首《紅紅 OnOn》。

再來參與創作接力的，是在「大溪大禧」多次精湛演出的藝術表演團隊「小事製作 Les Petites Choses Production (7)」。他們接到音樂後，馬上展開舞蹈設計，同步發展一整套的當代舞蹈，以及一套讓大眾能入門的簡化版祭典舞。以成為流行性舞蹈為目標，小事製作與同根生一起不斷地調整、討論唱跳的韻律，把大溪的將軍步伐化為英氣十足的舞步，同時也兼顧了娛樂感。最後，代言人王彩樺壓軸加入，站在主位練舞練唱，歌舞樂的創作接力賽，一切的精彩彷彿渾然天成，十足地具有表演性。

圖｜2

《紅紅 OnOn》歌舞樂影音創作分工圖

圖 Figure｜2

圖 Figure｜3

2022 年「與神同巡」遠境隊伍插畫版，應用在擴增實境（AR）中。

The illustration of the procession formation of the 2022 version of "Patrol with Gods", which is applied in augmented reality (AR).

頭旗
Leading flag

大鼓
Drum

土地公
Puji Temple Tudigong
(Lord of the land)

在歌曲接力創作的同時，策展團隊也正在與影像團隊浪打影像與導演陳容寬熱切討論影像腳本。當導演看到大溪高大威武的將軍與祭典舞的雛形，便提出以傳統將軍步與現代正氣舞步，在大溪街頭進行動作比拼的概念：當人神在城鎮中穿梭、一起跳舞，將大溪所有經典場景帶入，一邊是由王彩樺帶領著舞者，召集音樂詞曲創作者一起加入；另一邊則由將軍們號招大溪人參與，最終全城鎮都在普濟堂廟埕集合。讓人看完 MV 立即朗朗上口，等不及來到大溪跟著一起唱跳。

從關聖帝君形象、將軍的正氣步口訣，再到大溪印象，一首歌的創造，不只是為了串起這些重要元素，而是從故事性、使用性到行銷面的各種考量，在創作接力開啟之前，已有縝密設計思考，層層疊加累積出的精彩成果。跨域設計者們接力創作，最終再以各種表演方式與線上傳播感染大眾，旋律與故事都將在大溪慶典持續《紅紅 OnOn》下去。

無論是「與神同巡」、「遠境 Kit」還是讓人聞之起舞哼唱的《紅紅 OnOn》，這些看似幽默風趣，輕鬆又親切的各種企劃形式，背後對應的即是臺灣人熟悉，卻已漸漸有生疏感的傳統民間信仰文化，但透過設計思考，創造了容易理解、而且讓人好奇的形式，為在地傳統文化的「延續」和「認識」找到更多傳達溝通的方式，加足了文化傳承的力道，讓信仰與這裡的故事可以繼續講下去。

Design involves "conception" and "planning": design also involves a "purpose" to plan for "an arrangement of the process," which is a purposeful creative behavior.

The so-called culture is actually includes the language, customs, food, social system, knowledge, way of thinking, art, etc. Generally speaking, "culture" represents the habits of a community of people's habits, common habits and tendencies.

Daxi's "June 24 Reception" mobilizes people from all regions of Daxi to participate, because the sacrificial behavior produced by Guan Shengdijun's belief culture has affected the daily life of people here, and has become a symbolic place in Daxi culture.

The "June 24 Reception" in Daxi mobilizes people from all areas to participate in the festival, because the rituals generated by the belief and culture of Guan Sheng Dijun have profoundly influenced the daily life of folks here as an iconic local culture in Daxi.

百年旗陣
Leading flag

墨斗陣
Mo Dou Formation

獅陣
Lion Dance

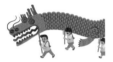

龍陣
Dragon Dance

三國將軍—張苞
Generals of Three Kingdoms -
Zhang Bao

三國將軍—關興
Generals of Three Kingdoms -
Guan Xing

三國將軍—王甫
Generals of Three Kingdoms -
Wang Fu

The intended plan for "Daxidaxi" is a continuation of "June 24 Reception" through various design ideas that perpetuate the culture, and to fully realize the concept of "culture is life" in contemporary society. But how can design be integrated into culture? What is the gap between design and traditional culture? Is it the form, or the expression of consciousness? Is it a short-term effect or a long-term impact? Should it be local or outward-looking? In fact, in every project, the curatorial team is faced with a two-way consideration of "reviving traditional culture" and "creative expression," but it is only a matter of degree of choice. In addition to these evaluations, we should also consider the duration of the event and its impact, and determine whether to focus on "form first" or "awareness first" for these programs, depending on the extent of the spread of the "issue" and the target audience. Furthermore, we must achieve the goal of "balancing local sentiments and exchange" with "external communication and promotion." Before pouring over these considerations, the curatorial team is challenged to identify the key points and values that are worth extending from the vast amount of local stories, and then to plan the appropriate design introduction and implementation methods that is suitable for the community.

How does design conjecture work to keep traditional culture alive? We attempted to see how the concept of "introducing contemporary design into traditional culture" would work, and how the different layers would interact and influence each other. Events such as "Parade with the Gods", the marketing plan of "Parade Kit" and the creation of the theme song "OnOn" served as prototypes and test grounds for the application of these ideas.

Parade with the Gods: A New Parade Concept

In Taiwanese culture, "procession parade" is a common fond memory for many people. Most people have the impression that "the gods come out on the palanquin to make their inspections", but the details of the procession, such as the rituals and the formations, do not easily come to mind. With the evolution of time, the misunderstanding and misconceptions about the processional parade culture are gradually increasing; this has compelled the curatorial team to hope that through layers of design conjecture, we can adopt a new way to let people not only be the spectators of the parade ceremony, but also recognize the events in the parade, and even become the participants of the procession.

I still remember the first year Daxidaxi was held. It took the curatorial team a month to figure out what the local people of Daxi called "June 24 Reception" and what the processional team for "June 24 Reception" looked like. There is still a lot to be done if we want to be more proficient in remembering the complete names of the 31 shetou, such as Le'an Society, Tongren Society, Xing'an Society, and Xieyi Society. Not to mention the complicated details of what constitutes a procession parade and what is the most representative costume of each shetou.

三國將軍—黃忠
Generals of Three Kingdoms -
Huang Zhong

三國將軍—趙雲
Generals of Three Kingdoms -
Zhao Yun

三國將軍—馬超
Generals of Three Kingdoms -
Ma Chao

哨角
Shaojiao horn

范謝將軍
General Xie and Fan

都城隍神轎
City God palanquin

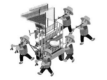

北管
Beiguan music

That's why the curatorial team initially simply wondered if it would be possible to have a "Teaching Version Condensed Procession" with 31 Shetou at the opening of Daxidaxi: teaching of formations, demonstration by Daxi Shetou organizations, an exhibition of ceremonial rituals, and most importantly, a palanquin of Guan Sheng Dijun. The purpose of the event is to allow more amateurs like the curatorial team to enter the event, to memorize the logic of the traditional processions, to learn the characteristics of each Shetou in Daxi and the rituals of the Guan Sheng Dijun procession, and to apply the knowledge of the processions to observe processions at any time throughout Taiwan, where there are temples everywhere, and to bear witness to the beauty of Taiwan's religious folk culture.

Regarding "Patrol with Gods," the curatorial team first listed a "prototype of condensed procession," which categorized the traditional parade into four main themes according to their functions and positions: "Pioneers, Performing Arts Formation, Divine Guardians, and Finale Palanquin," and inspired the audience to learn about procession parades. The "Daxidaxi Highlights Edition Prototype" follows the traditional sequence, with the leading flag of Puji Temple and the Earth God in front of it, and the Guan Sheng Dijun of Daxi Puji Temple at the end. Each year, different Shetou take up different positions in the parade for the "Performing Arts Formation" and "Divine Guardian." In the end, 31 Shetou groups form an educational team and leads the procession in a condensed two-hour event, helping people to understand processions and the Daxi community.

If there are gods who come to participate in the cultural exchange, just like the general and palanquin formation of Hsinchu City God, you will for sure see Daxi's Holy Generals guiding the formation from Hsinchu Chenghuang Temple **(1)** to join the new parade with Guan Sheng Dijun as the main deity.

Everything is sequenced, and the spirit of tradition is connected and continued through storytelling, which are all visible through the "Parade with the Gods".

Pilgrimage Course for Children
An education program that combines folk life with design

Whether in the "Patrol with Gods" or in the diagram of the teaching version of the procession, the "Little Shetou League" is the most eye-catching formation. Although there are not as many people as in other formations, the children's formation took a lot of effort.

The Little Shetou League is the result of the education program "Pilgrimage Course for Children," in which "Daxidaxi" combines cultural heritage and infuses design with cultural heritage. With this program, children in Daxi can better understand the folk customs and Shetou culture of their hometown. The designer

關刀
Green Dragon Crescent Blade

周倉將軍、關平將軍
General Zhou Cang and
Guan Ping

香擔
Xiandan

關聖帝君神轎
Puji Temple
Guan Sheng Dijun palanquin

(1) | Invite and Guide the guest of God

When there are gods coming to visit from other cities, the Generals of the god from the temple will go to greet them. After mutual worship, the Generals will escort the guest gods all the way to the main temple.

specially made the costumes for children, including the generals of the Three Kingdoms, and the Taiwan Leopard cat version of the lion dance props. With both traditional and stylish looking, made of lightweight materials, the costumes won the hearts of children. On the other hand, Daxidaxi cooperated with the school club coach to teach different choreography skills in the school. When children in the generals costume started to dance with with pride, and practice it over and over again, we know that cultural inheritance had started.

During the procession on the 24th day of Lunar June, the Little Shetou League formation traveled several kilometers around the city with the 31 Shetou groups. From curtsy to temple worship, the children took every movement seriously. When the Beiguan music came out, the little generals stepped forward firmly, and the Taiwan leopard cats danced dexterously. When the children practically provided continuity to the culture, the audience was deeply moved.

Procession Kit: The Closest Distance to Guan Sheng Dijun

The rituals of deity worships on the 15th day of the first lunar month, or on various festivals, are the form of faith that's an intimate part of life in Taiwan, but as the times evolve, the rituals are gradually omitted and streamlined.

"Procession Kit" hopes to focus on the familiar "worship culture" of the general public, and to deepen the knowledge of faith and transform it into a series of objects through design. What is special about this series is that it is the most widely promoted among the physical objects of "Daxidaxi;" not only does it resonate with many people, it can also be combined with the industry in a co-branded crossover format, making it the easiest way for the public to get involved and participate.

Among them is the popular "Peace Amulet Mystery Bag" in 2020: with the catchy slogan "Peace Amulet Mystery Bag, Teaching You How to Worship", the unique offerings on the Daxi worship table are redesigned into a gift bag. Once opened, the longevity noodles, longevity peaches, plum cake, and dried tofu, a unique worship item unique to Daxi, are placed on the table, along with the "peace amulet" that links you to Guan Sheng Dijun, and a simple worship table is completed. A limited number of 500 "Peace Amulet Mystery Bags" were first blessed at the incense burners of Puji Temple before packaged and delivered to lucky recipients. The spirit of faith in life continues to be passed on as we walk down the streets of Daxi with the "Peace Amulet Mystery Bags" and appreciate the incense tables displayed in each household.

Around 5,000 "Daxidaxi Peace Amulets" are produced each year and promoted by Puji Temple and the Wood Art EcoMuseum. It transcends the religious and

The simplified diagram of the procession in Daxi Puji Temple Guan Sheng Dijun anniversary ritual

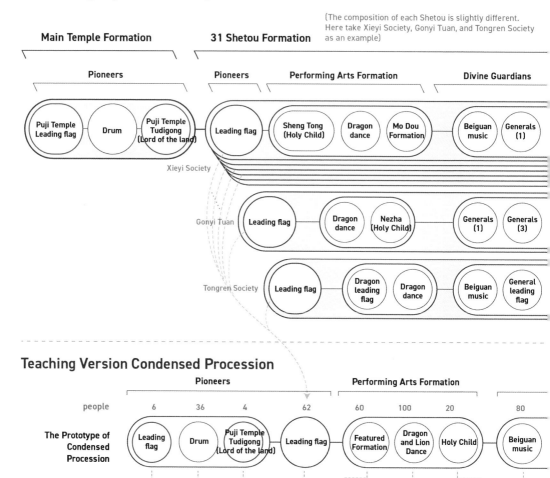

Main Temple Formation

31 Shetou Formation

(The composition of each Shetou is slightly different. Here take Xieyi Society, Gonyi Tuan, and Tongren Society as an example)

Pioneers

Pioneers | Performing Arts Formation | Divine Guardians

Puji Temple Leading flag | Drum | Puji Temple Tudigong (Lord of the land)

Leading flag | Sheng Tong (Holy Child) | Dragon dance | Mo Dou Formation | Beiguan music | Generals (1)

Xieyi Society

Gonyi Tuan — Leading flag | Dragon dance | Nezha (Holy Child) | Generals (1) | Generals (3)

Tongren Society — Leading flag | Dragon leading flag | Dragon dance | Beiguan music | General leading flag

Teaching Version Condensed Procession

Pioneers | Performing Arts Formation

people | 6 | 36 | 4 | 62 | 60 | 100 | 20 | 80

The Prototype of Condensed Procession

Leading flag | Drum | Puji Temple Tudigong (Lord of the land) | Leading flag | Featured Formation | Dragon and Lion Dance | Holy Child | Beiguan music

2020 version

Puji Temple, Folk Art Association, Daxidaxi | Ren'an Society | Puji Temple | 31 Shetou | Nongzuo Tuan: Cattle Formation, Xing'an Society: Big Abacus Formation | Jinhong Cihui Tangl: Lion Dance, Xinsheng Society: Dragon Dance | Gonyi Tuan: Nezha (Holy Child) | Yung'an Society

◯ Regular Formation

The procession of "Patrol with Gods"

2022 version

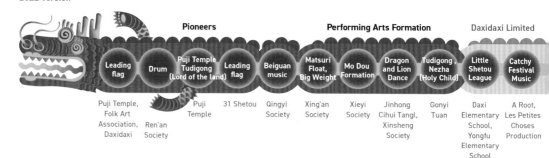

Pioneers | Performing Arts Formation | Daxidaxi Limited

Leading flag | Drum | Puji Temple Tudigong (Lord of the land) | Leading flag | Beiguan music | Matsuri Float, Big Weight | Mo Dou Formation | Dragon and Lion Dance | Tudigong , Nezha (Holy Child) | Little Shetou League | Catchy Festival Music

Puji Temple, Folk Art Association, Daxidaxi | Ren'an Society | Puji Temple | 31 Shetou | Qingyi Society | Xing'an Society | Xieyi Society | Jinhong Cihui Tangl, Xinsheng Society | Gonyi Tuan | Daxi Elementary School, Yongfu Elementary School | A Root, Les Petites Choses Production

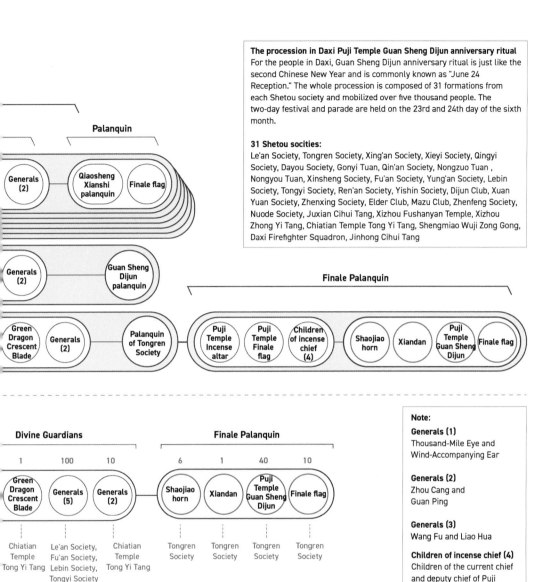

Palanquin

Generals (2) — Qiaosheng Xianshi palanquin — Finale flag

Generals (2) — Guan Sheng Dijun palanquin

Green Dragon Crescent Blade — Generals (2) — Palanquin of Tongren Society

Finale Palanquin

Puji Temple Incense altar — Puji Temple Finale flag — Children of incense chief (4) — Shaojiao horn — Xiandan — Puji Temple Guan Sheng Dijun — Finale flag

The procession in Daxi Puji Temple Guan Sheng Dijun anniversary ritual
For the people in Daxi, Guan Sheng Dijun anniversary ritual is just like the second Chinese New Year and is commonly known as "June 24 Reception." The whole procession is composed of 31 formations from each Shetou society and mobilized over five thousand people. The two-day festival and parade are held on the 23rd and 24th day of the sixth month.

31 Shetou socities:
Le'an Society, Tongren Society, Xing'an Society, Xieyi Society, Qingyi Society, Dayou Society, Gonyi Tuan, Qin'an Society, Nongzuo Tuan , Nongyou Tuan, Xinsheng Society, Fu'an Society, Yung'an Society, Lebin Society, Tongyi Society, Ren'an Society, Yishin Society, Dijun Club, Xuan Yuan Society, Zhenxing Society, Elder Club, Mazu Club, Zhenfeng Society, Nuode Society, Juxian Cihui Tang, Xizhou Fushanyan Temple, Xizhou Zhong Yi Tang, Chiatian Temple Tong Yi Tang, Shengmiao Wuji Zong Gong, Daxi Firefighter Squadron, Jinhong Cihui Tang

Divine Guardians

1	100	10
Green Dragon Crescent Blade	Generals (5)	Generals (2)
Chiatian Temple Tong Yi Tang	Le'an Society, Fu'an Society, Lebin Society, Tongyi Society	Chiatian Temple Tong Yi Tang

Finale Palanquin

6	1	40	10
Shaojiao horn	Xiandan	Puji Temple Guan Sheng Dijun	Finale flag
Tongren Society	Tongren Society	Tongren Society	Tongren Society

Note:

Generals (1)
Thousand-Mile Eye and Wind-Accompanying Ear

Generals (2)
Zhou Cang and Guan Ping

Generals (3)
Wang Fu and Liao Hua

Children of incense chief (4)
Children of the current chief and deputy chief of Puji Temple

Generals (5)
Generals of Three Kingdoms

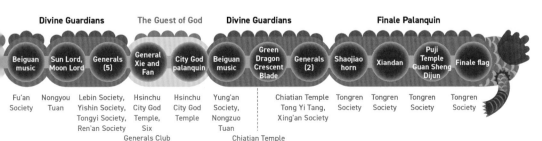

Divine Guardians

Beiguan music — Sun Lord, Moon Lord — Generals (5)
Fu'an Society — Nongyou Tuan — Lebin Society, Yishin Society, Tongyi Society, Ren'an Society

The Guest of God

General Xie and Fan — City God palanquin
Hsinchu City God Temple, Six Generals Club — Hsinchu City God Temple

Divine Guardians

Beiguan music — Green Dragon Crescent Blade — Generals (2)
Yung'an Society, Nongzuo Tuan — Chiatian Temple Tong Yi Tang — Chiatian Temple Tong Yi Tang, Xing'an Society

Finale Palanquin

Shaojiao horn — Xiandan — Puji Temple Guan Sheng Dijun — Finale flag
Tongren Society — Tongren Society — Tongren Society — Tongren Society

The Bagua amulet symbolizes the official documents approved by the gods. If believers are in danger and there are no gods nearby, the Bagua amulet is the pledge of the gods that can protect the believers.

(3) | **Incense ash**

With the effect of eliminating evil spirits, the Incense ash represents the blessing of Puji Temple.

(4) | **Sam-Seng-Hiàn-Ge**

An implementation of the terroir collection. They mix electronic music and elements of Taiwanese temples. It's a long project, but also a new form of electronic music performance groups.

design circles and becomes a limited annual token that everyone wants. The main committee of Puji Temple insists on hand-folding the bagua amulet **(2)** and incense ash **(3)** to give sincere blessings in the most traditional way, so that everyone who receives it can feel the bessling of the gods and the whole town.

Another famous product, "Daxidaxi Vitali," originated from the habit of drinking cold drinks for the parade. The curatorial team cooperated with the famous Taoyuan local beverage company "Nanya Foods" to launch a co-branded Vitali drink and helped open up the convenience store distribution channels together with the Taoyuan City Government. Combined with the publicity of "Daxidaxi," 480,000 cans were distributed throughout Taiwan, and only for a limited time, resulting in brisk sales. When Guan Sheng Dijun and the whole town of Daxi are engraved on the bottle, you can drink the blessing as soon as you open the can, and enjoy the closeness to Guan Gong in the summer.

OnOn: A Creative Relay of Catchy Festival Music

"Is it possible to have a theme song to represent "Daxidaxi" so that everyone can dance and sing together to, to further spread the faith and culture here? "The idea was implanted in the curatorial team's mind for several years; it came into fruition in 2020, when they began collecting texts, planning, and inviting creators for a year-long continuous creative process. But creating a festival track requires a lot more designers and creators than the curatorial team could have imagined at the time. The creation of "OnOn" was inspired by the music director of "Daxidaxi," Blaire Ko of Sam-Seng-Hiàn-Ge **(4)** , who wrote the lyrics on a whimsical imagination of Guan Sheng Dijun, and with the teaching of the "curtsy rites" by Shu-Wu Chang, the member of Jia Tian Temple Tong Yi Tang, resulting in the first draft of the song.

《紅紅 OnOn》 MV

(The curtsey steps of the Holy Generals)
General Move
Step and step Smiling curve Shake and shake
God leads the beat Step on the seven stars Left and right

(Lyrics originally created by Blaire Ko)
May the Lord Guan Bless Daxi always sunny
May the Lord Guan Bless people always fine
On On On On On On On a roll
Red face Red shirt Red horse OnOnOn On a roll
On On On On On On On a roll
On On On On On On On a roll
Fruitful Lucky Wealthy Peaceful Free and easy Safe and sound

(5) | **A Root**

A Root is a fusion
band featuring original
compositions for ethnic
instruments. The
instruments involved
are the sheng, yueqin,
liuqin, zhongruan, piano,
cello, bass, percussion,
and human voices.
A Root engages in
ideological destruction and
reconstruction relating to
Taiwanese culture.

(6) | **Ska rhythms**

Ska is a traditional music
genre from the Caribbean
island of Jamaica, which has
influenced many popular
music styles around the
world, featuring a joyful and
light-hearted rhythm.

(7) | **Les Petites Choses**
 Production

Taking "art with people"
as their motto, Les Petites
Choses Production not
only creates art for the
public but also emphasizes
"participatory art practice".
In the process of inviting
people to participate in
artistic creation, they
challenge the boundaries of
performing arts.

Next up is the creative band A Root **(5)**. They listened to the demo tape composed by Blaire Ko and discussed with the curatorial team on how to compose a ritual music. As the lead singer of the band, Jipo Yang, who knows how to bring out an infectious mood, said, "We must make it catchy, so that people will dance with the rhythm, and convey cultural imagery without being too preachy, with the sensual appeal of pop music, but not too kitschy." He incorporated rhythmic considerations, and worked with his fellow members to build a unique arrangement style by adding a blend of Chinese and Western drums and ska rhythms **(6)** . "Even when people who do not understand Chinese hear this song, they can still dance along to the rhythm, and we also try to make the lyrics more interesting and simpler." Therefore, Jipo and A Root continued the essence of Blaire's work and made an excellent integration of music and dance to complete the song "OnOn".

The team that took part in the creative relay was Les Petites Choses Production**(7)**, an artistic performance team that has performed many times at Daxidaxi. After receiving the music, they immediately began choreographing and developing a whole set of contemporary dances and a simplified version of the ritual dances for the general public. With the goal of becoming a popular dance, Les Petites Choses Production and A Root worked together to constantly modify and discuss the rhythm of the singing and dancing, transforming the Holy General's stances into a heroic dance step that is also entertaining. In the end, the popular singer Lotus Wang agreed to join in as the headliner, practicing dance and singing. The song and dance music creation relay race finally came to fruition, all the wonderment seems to come together for a fully spectacular performance.

While the songs were being created, the curatorial team was also discussing the music scripts with the video team, Lambda and director Jung-Kuan Chen. When the director saw the tall and imposing holy generals of Daxi and the prototype of the ritual dance, he suggested using the traditional General's Steps and the modern righteous steps to compete in the streets of Daxi: as the gods and men traveled through the town and danced together, all the classic scenes of Daxi were brought in to the video. On one side, Lotus Wang led the dancers and gathered music producers and creators to join in; on the other side, the Holy Generals called for the participation of the people of Daxi, and eventually the whole town gathered at Puji Temple square. The music video is so catchy that people can't wait to come to Daxi to sing and dance along with it.

From the image of Guan Sheng Dijun, to the Holy General's righteous step mantra, to the impression of Daxi, the creation of a song is more than linking these important Daxi stories, but also to consider various aspects from storytelling, usage, and marketing, and has been carefully designed and thought out before the creative relay process began, leading to layer after layer

of spectacular results. With the successive collaboration of designers, In the end, the public will be drawn in by various performance methods and online communication, so that the melody and story will continue to be "OnOn" at "Daxidaxi."

Whether it is "Patrol with Gods," "Procession Kit," or "OnOn," which inspires people to dance and hum, these ostensibly humorous, relaxed and friendly forms of projects actually echo the traditional folk culture that Taiwanese people are familiar with, but gradually feel alienated from today. Through design conjecture, we have created a form that is easy to understand and intriguing. We have found more ways to convey and communicate the "continuity" and "understanding" of the local traditional culture, so that the power of cultural transmission can be strengthened and the story of faith and this place can continue to be told.

Figure | 4

The co-created map of the thematic music video "OnOn"

📖 Figure | 4

注入當代設計，為傳統文化訴說新語

Traditional culture is given a new voice by incorporating contemporary design

想到「大溪大禧」，會想到什麼符號？

是關公露出牙齒自信的燦笑？是暈頭轉向的神龍眼睛？還是閃閃發光的標準字？

從臺灣民俗文化中採集元素再設計，「大溪大禧」在當代一片極簡的潮流下，以五光十色的美學風格包覆整座城市，每一項設計都像是帶著幽默語氣，展開城市與人、人與神之間的對話，把每個人一起拉進這場慶典中。

當設計是要為傳統說故事，設計師的加入，要解決的問題不只是形象上的美感。在「大溪大禧」，形象風格是最後一個階段才會討論的問題。一如本書的副標題「當代設計與民俗信仰一起策展」，當代設計的角色固然重要，更重要的卻是如何導入民俗信仰。臺灣民間信仰文化中，飽含著的原生的音樂性與工藝性，在轉化與保留之間取捨，提煉出傳統信仰裡最單純的善意祝福，帶給大眾振奮與鼓舞的力量，是設計師們在「大溪大禧」中，最重要的課題。

招募各方行家，共創專屬大溪的文化慶典

帶著對城市慶典的想像，就像畫好一張大溪的藏寶圖，策展團隊在每年冬去春來之際，揚起大帆，開始招募在各個領域中身懷絕技的設計師們登船，開啟每一年「大溪大禧」的探尋之旅，一起找尋展現這些寶物最適切的方式。

首先是定調每年度的重點顏色與設計元素的視覺總監廖小子，接著依照每年的主題計畫，邀請跨媒材的工藝設計師、跨界面的多媒體設計師、跨類型的影音創作者、文案影像工作者等等。

策展團隊邀請帶著一身功夫的設計師加入，希望他們能夠以各自專業的眼光看待大溪，深入傳統信仰民俗與宗教儀式，吸收在地文化給予的養分後，再一起對焦要重新轉化的內容與方式。

為了讓所有的設計和諧並存，共同呈現一場城市慶典，策展團隊必須持續與所有合作的設計團隊溝通，除了確認統一的設計風格調性、溝通語彙，更重要的是和每位設計師一起來回確認設計內容的可行性，讓最終結果能夠真實符合慶典現場的使用需求。為此創作過程總是在文化性、材料性與歷史脈絡上來回的考驗與挑戰，直到所有設計在祭典現場發生呈現，「大溪大禧」可以說是設計師的武場工作試煉場。

「大溪大禧」應該要長什麼樣子？

在最初思考「大溪大禧」的形象時，策展團隊就決定邀請擅長操作臺灣本土文化題材的視覺設計師——廖小子（以下簡稱小子）擔任視覺總監，要說小子的設計風格與準則是什麼？不如我們回頭來看大溪大禧主視覺設計的發展歷程。

由於「大溪大禧」是關聖帝君的生日，因此由關聖帝君代言自己的遶境文化，是最適合不過的。小子為了轉化關公嚴肅不苟言笑的形象，以親近的角色個性與鮮明的識別性，成為這個世代的故事傳話者等原則塑造關公形象，少女漫畫般閃亮亮的眼睛、露出牙齒燦笑的自信神

圖 Figure ｜ 1

2020 年，將 120 色主視覺精煉成 6 色版本的「維大力」聯名商品。

In 2020, the 120-color key visual was refined into a 6-color version to fit the limit of "Vitali" can printing.

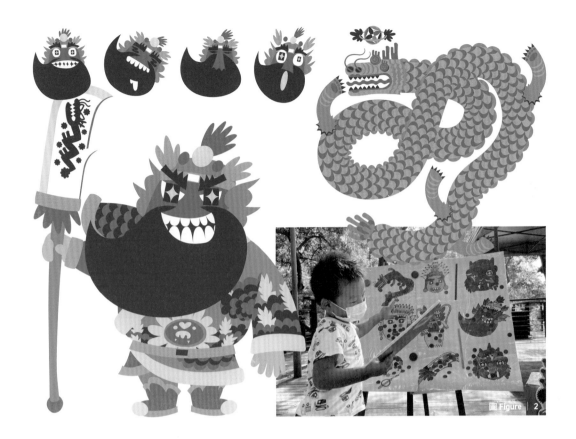

圖 Figure │ 2

「大溪大禧」視覺符號，
讓兒童也能自由疊加和辨
識，靈活運用與各種文化
教育中。

The visual symbol of
"Daxidaxi" allows children
to freely identify and even
draw it, so that it could be
flexibly used in various
cultural education.

(1) │ 執事牌

是民間信仰中神明出巡常
見的排場工具，模仿自古
代帝制的排場器物。

情，再搭配關公紅臉上歪一邊的大鬍子。這個具顛覆性的親近形象，
是角色關鍵細節（core detail）的打造，之後關公即成為大家對「大
溪大禧」最深刻的視覺印象。

關公角色設定後，小子接著建立出如執事牌 (1) 一般的「大溪大禧」
標準字，與宮廟的守護者「神龍」。「關公」、「神龍」與「大溪大
禧標準字」成為三個獨立的視覺元素，除了這三個元素之外，視覺構
成可以因應多元的議題，由小子自己或是大眾自由地疊加，保持與時
俱進的彈性樣貌，與大眾共同創造的空間，是開發出一個新的基底，
讓大家都可以自由發揮創造，就像是臺灣文化的視覺縮影一樣。

廖小子：

「我們該做的事情從來都不是把臺灣的某一部份刨掉，再重新
蓋一個東西。對我而言設計的基底與出發點，是認知到每一件
事情都是應該要存在的。」

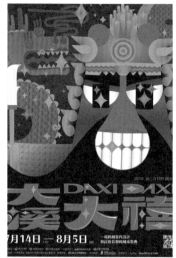

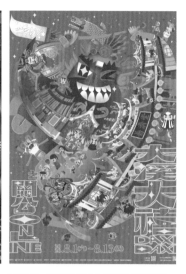

2018 年，以扁平視覺風格凸顯關公角色特徵。

2018 Guan Gong's character traits were highlighted with a flat visual style.

2019 年，強化關公、神龍的角色個性。

2019 The character of Guan Gong and the dragon god are strengthened.

2020 年，在關公形象中包覆全城市的建築與角色，強調大溪場域性。2020 Guan Gong's image encompasses the entire city's characters and architecture, highlighting the Daxi scene.

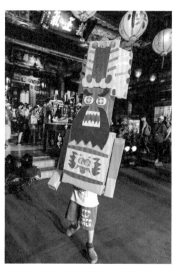

2021 年（未公開草圖）結合花鳥字與元宇宙概念重組視覺元素。

2021 (sketch) Rearranging visual components by fusing flower and bird characters with the idea of the metaverse.

2022 年，以神獸佈滿畫面，形塑慶典的熱鬧氛圍。

2022 The gods and animals are crammed onto the screen to create a festive atmosphere.

小孩將主視覺中的周倉將軍，製作成紙箱版將軍穿戴。

The child made the cardboard costume in the figure of General Zhou Cang in Daxidaxi edition.

(2) | **穿戴紙箱的小孩**
在「迎六月廿四」文化耳
濡目染之下，大溪孩子們
會套上挖洞的紙箱，模仿
將軍或童仔的動作。

小子進入大溪世界，持續延伸出關公的各種表情，也畫出關公身邊所有將軍好朋友們；進入大溪的城市地景，畫出廟宇建築、老街城市牌樓；活靈活現宮廟的守護者神龍與神獸夥伴們；連同城市中穿戴紙箱的小孩 **(2)**、帶著鴨舌帽參加遶境的居民角色都一一呈現，循序漸進的，建構出一個一百二十色的大溪世界，在 2020 年所有元素的累積來到巔峰，然而當年首次主視覺合作的維大力傳來一個製罐印刷的消息：「不好意思只能印製六色（而且還包含白色！）」小子只好點頭答應，硬生生將歷年來最複雜的主視覺，從一百二十種顏色縮減成六色。

有了小子設計的完整城市與角色設定，策展團隊展開《大溪大禧》立體繪本編輯計畫。由「工夫設計」擔任視覺統籌延伸出整座城市，並以立體書的紙張結構設計，將龐大的文史知識、歷史生活風俗、迎六月廿四文化等，精煉成為五個場景故事。

小子有時也會想做一些更大膽的嘗試，2021 年當臺灣面臨疫情最嚴峻的時刻，虛擬科技順勢而上，小子關在家裡苦思，最後居然以傳統花鳥字結合元宇宙的概念，發展出將既有的角色元素放進虛擬時空的主視覺草稿。正在遠距離上班的策展團隊一收到圖檔，馬上開視訊互相分享，看著突然被解構的關公，每個人都笑到一頭問號，超現實想像視覺拆解重組可以使用的極限。

小子純熟且具有高度彈性的視覺創造功力，五年來精煉出「大溪大禧」視覺應用規範，至今已發展成熟至足以包容慶典中形象尺度由大至小的塑造；從五公尺高的牌樓，到五公分寬的平安符都能靈活應用，5 歲到 95 歲的人都能辨識，歡喜參與，也吸引了設計師與粉絲們爭相收藏。「大溪大禧」的印象，從主視覺到所有應用商品與策展方向環環相扣，品牌清楚地建立在視覺形象之中。

傳統工藝的當代魅力

在臺灣遶境文化與廟宇建築，處處都能看到人們對神明心意，表現在各式各樣細緻的工藝中，如織品、木藝、紙藝、竹編、泥塑、剪黏、銅雕、石刻等。然而隨著時代的演進，許多繁複的工法也逐漸在簡化的過程中消逝。相較於記錄這些珍貴的技藝，「大溪大禧」是藉由一場城市慶典，讓這些傳統有機會在當代延續。這幾年邀請許多工藝師、

(3) ｜爐主

即是神明點選的年度信徒
祭祀活動代表。在大溪，
爐主經由每年向神明擲筊
決定，主要負責協助籌備
慶典相關事宜。

(4) ｜賞旗

每年大溪普濟堂管理委員會
及值年正、副爐主致贈給當
年度參與遶境之社頭的旗
幟，從日治時期使用印染技
術的平面布旗，到二戰後開
始出現繡莊製作的旗幟，從
製作技術和形式變化可以看
到時代的演進。

設計師加入，從大溪傳統信仰儀式中採集創作的素材，拆解物件中的符號性與背後代表的行為意義，再以當代的方式重新設計，最終提出延續傳統的各種可能性與實驗。

在大溪「迎六月廿四」文化中，有許多具有在地與社頭特色的物件。設計師徐景亭從社頭藝陣的道具中，選擇為協義社極具木器產業特色的大墨斗設計改造。在不破壞墨斗的原型下，用輕量化雲紋結構，凸顯傳統的精緻圖騰，同時設計燈光裝置，讓夜晚的大墨斗成為一座會發光粼粼的祥獸。設計師吳孝儒（Pili Wu）則是為大溪普濟堂與值年正、副爐主 (3) 犒賞社頭的「賞旗 (4)」，創造百年更替、屬於這個時代的樣貌。Pili 從各社的原生職業特色切入，以各社自豪的技藝及神明的笑顏組織旗面圖樣，最後考量現代為期兩天的傳統遶境，越到深夜越熱鬧的情境，以霓虹燈條為材質製作，在人神同慶與絢麗光線交織下，於當代留下全新的慶典符號。

圖 Figure ｜ 4

2018 年，吳孝儒以張力十足的「飛龍團」為概念，為新勝社設計霓虹賞旗。

In 2018, Pili Wu designed the banner of appreciation by neon light for Xinsheng Society with the concept of the full-bodied "flying dragon troupe".

圖 Figure ｜ 5

2019 年，徐景亭為協義社「大墨斗」設計會在夜間發光的新裝。

In 2019, Jingting Xu designed a new outfit that glows at night for the "Mo Dou Formation" of the Xieyi Society.

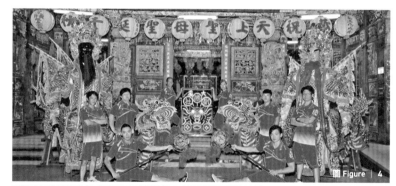

圖 Figure ｜ 4

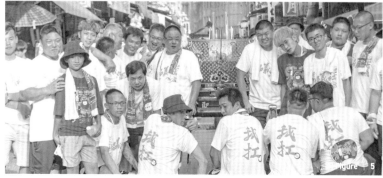

Figure ｜ 5

吳孝儒：

「信仰代表的是這片土地上最根本的連結、最原生的故事。每個時代都該有信仰該有的樣子，假如能夠慢慢進化，自然就能一直走在生活裡面。怎麼讓傳統回到現代，和現在所有年輕人做最直接的溝通和連結，我覺得就是設計師在此扮演的角色。只要還有人參與，這件事情就不會消失。」

在臺灣傳統宗教禮俗祭儀中，以竹與紙糊貼成人物、房子或器物的工藝。

傳統工藝在慶典之外，也展現在建築與空間中，當設計工作室「大象設計」肩負打造全城市慶典氛圍的任務，決定深入找尋大溪的工藝文化符號，也因此開啟了設計師潘岳麟的尋訪藝師之旅。在不同的藝師相互推薦介紹下，從紙糊 (5) 藝師的工藝中了解信仰常見圖騰的意義，並邀請霹靂戲團御用的賴登祥老師，以彩繪佈景 (6) 的方式參與牌樓元素，同時也請到集製燈、寫字、繪圖於一身的鄒弘義師傅製作竹編燈籠。最後以「宮廟慶典」與大溪「傳統建築體」不同的牌樓意義，以平頂和尖頂兩種形式，在大溪老城區中設置三座各有特色的「大溪大禧」牌樓。大眾在牌樓前拍下的每一張打卡照片，都展現著傳統於當代延續的可能性。

(6) | 彩繪佈景
在臺灣傳統布袋戲中，以寫實風格手繪的佈景與戲台，兼具搬運、使用、存放，以及滿足觀眾欣賞的需求。

潘岳麟：

「一直以來都對傳統工藝抱有很深的興趣，很榮幸有機會能夠與藝師們學習、合作、重新詮釋。最後以標誌性的牌樓呈現，希望帶給大家的是對城市慶典的期待，和一個重新認識傳統工藝的機會。」

為眾神設計現代新裝

(7) | 童仔
相較於超過三米高的「將軍」，「童仔」屬於中小型神偶，穿戴後的高度與一般人相仿，祂們的地位並不會隨著高度而減少。大溪社頭常見的童仔有三太子、濟公、土地公等。

從新型態遶境的形象轉換切入，想像人在遶境中穿戴的「將軍」與「童仔 (7)」，可以如何加入現代語彙，同時又保有能夠辨識的符號性，不失去原本精神的樣貌以及穿戴的便利性。2018 年，擅長結構拆解與非傳統材料運用的服裝設計師陳劭彥加入，為遶境角色設計新裝。最後選定與農友團合作，以用來象徵雷鳴電擊這兩種自然現象的雷神電母童仔進行設計，雷神童仔粗眉綠臉尖嘴，電母童仔粉臉秀眉頭上綁著包頭，別具造型特色。雷神電母就這麼跟著劭彥到臺北走了一圈，一起到設計工作室丈量設計、到工廠參與製衣測試，再到策展團隊衍序的辦公室最終調整確認。透過一層層拆解童仔服裝的布料結構，了解每一層與盔甲

對應的關係，最後再以現代感的漸層色與顯色布料重新設計，讓雷神電母的形象更鮮明的同時，也忠於既有的歷史文化脈絡。

陳劭彥：
「我覺得傳統文化最美的地方，就是經過時間考驗所遺留下來的故事跟痕跡，這是沒有辦法在一兩天內被取代的，也是這次合作中最大的收穫。」

2019 年隨著「給孩子的遶境學」教育計畫展開，邀請熟悉臺灣信仰文化的劇場造型設計師李育昇，從大溪的將軍文化中取材，設計給國小孩子的穿戴裝備。設計師李育昇從傳統戲曲的帽盔、靠甲、水袖、霞披的設計經驗中，不斷對應與大溪將軍服飾的共通語彙，設計出給孩子的穿戴裝備結構。在降低小朋友載重負擔之外，也兼顧傳統形象上各個將軍背後穿越時空所代表的意義：黃忠老當益壯、周倉忠肝義膽。從穿戴裝備形式的設計，凝聚教育傳承的意識，也讓傳承本身就充滿藝術行動力。

李育昇：
「身為傳承臺灣傳統文化的一份子是個榮幸，自己的創作能成為橋接下一代與傳統之間的媒介，就又是更特殊的榮幸。在『給孩子的遶境學』中為孩子設計的穿戴裝備成為了我之後『電氣神將』系列作品的雛形，就像是展開為眾神在當代臺灣尋找新軀殼新形象、續命續香火的創作過程。」

以鏡頭捕捉每一個堅持守護的身影

在「大溪大禧」所有合作的設計師、創作者中，把在地角色推到前面，讓自己的身份退到最後面的，就是攝影師們。在以大溪人為紀錄主角的年度特展中，攝影師林科呈會提前設計好幾種構圖，但是當面對全都是素人的在地人時，一切都要隨機應變。以扛將軍的人的背景故事為主題的「將軍與我」紀錄展，為了拍攝將軍，將挑高屋頂的武德殿變成大型攝影棚，超過三公尺高的將軍與將軍腳第一次同台呈現，光線、角度、畫面的張力都是考驗。第一天拍攝時從早到晚試了又試，終於在深晚一次拍攝後，真蓉、科呈看著相機的顯示幕，懸著的心才放下，畫面裡面的將軍與將軍腳都神采奕奕，完成了第一張照片的拍

圖 Figure | 6

圖 Figure | 7

圖 Figure | 6

設計進入文化的畫面－「大溪大禧」打造的關平小將軍，入列成為神前護將，護衛關聖帝君遠境。

Design fusing with the traditional culture: the little General Guan Ping created in "Daxidaxi" project was listed as a guardian of the god, Guan Sheng Dijun.

圖 Figure | 7

樂豳社的關索將軍大步跨過大溪大禧牌樓，牌樓設計與將軍傳統服飾相互呼應大溪大禧慶典的色系。

General Guan Suo from the Le'bin Society strode across the "Daxidaxi" arch gate. The design of the arch gate and the general's traditional costumes are in the same color system.

攝。以籌備慶典人物為主角的「遠境事務所」，則是要與緊張的爺爺奶奶們攀談聊天，讓他們放鬆下來，同時聚焦表現他們為信仰付出的行為與精神，透過鏡頭，點亮每個堅持守護百年文化的人們。

林科呈：

「平常參與遠境、廟會儀式的在地人們，可能從來沒有被這樣記錄過。對我而言拍攝的當下其實就已經產生意義，讓他們可以在傳統與攝影之間，透過新的方式看見自己不一樣的面相。」

劉伊倫（DC Films）：

從每一年的現場記錄，就能看到人的關係變化，從最初衍序與博物館、協會、社頭等各方相敬如賓、謹慎對話。到 2022 年大家什麼事都已經可以直接討論，在我們提出許多拍攝要求時，大溪人們更是永遠都是一句爽快的「好啊！」

在慶典活動中，所有的畫面都稍縱即逝。每年在現場滿滿的人潮中，總是可以看見動態與平面攝影師們，扛著設備努力穿梭奔馳，只為盡可能捕捉所有動人的瞬間。五年來持續記錄「大溪大禧」的影像團隊 DC Films，更是時常鑽進隊伍中，彷彿成為「大溪大禧」遠境陣列中每年必備的其中一個角色。累積幾年的情感，也投注在「舞德殿」特展的將軍動態影像中。在拍攝每一組將軍腳前，攝影師 Ellie 都會輕車熟路地示範起大溪將軍走步拜禮的步驟，讓社頭大哥們可以安心下來、自信表現。最終透過展覽中的將軍腳影像，把世代傳承下來對神明的心意繼續傳遞下去。

圖 Figure | 8

登入線上大溪城，感受信念無遠弗屆

「大溪大禧」建立在需要眾人齊聚的遶境文化上，發生最不可抗的阻力和挑戰便是 2020 年新冠肺炎疫情爆發。當全球士氣低迷，「大溪大禧」也面臨情況未明、無法決定是否要停辦的僵局，於是衍序只能且戰且走，思考如何回歸信仰本質精神，運用線上科技軟體，讓祝福無遠弗屆的傳遞。

2020 年以「關公 Online！」為年度主題，打造一個線上版的大溪慶典場景。插畫家廖國成以半立體插畫風格，如積木般一磚一瓦蓋出一整座大溪，從白天到夜晚，老城牌樓、山河稻田、廟宇與遶境隊伍通通刻畫出來，再加入不同身份角色的人，幻化出整個遶境場景，讓線上城市中也充滿故事與驚喜。黑洞創造與基本科技兩個團隊負責製作動態網頁，讓線上大溪城動起來，並透過互動式網頁介面，讓大眾可以選擇身份，加入線上排隊等遶境的行列，也可以看見大溪遶境路徑上的香案桌、涼水攤，還可以透過線上祈福與關公連線許願，在非常時刻常保心中的希望與信念。

> 插畫家 廖國成：
> 「為了承載遶境故事，最初以普濟堂為基礎單位，再依照比例把牌樓、街道、慶典中的人物一一蓋出來。當親身來到大溪、『與神同巡』陣列真實出現在眼前，就像進入筆下的插畫世界。」

> 黑洞創造 古健樺：
> 「每年遶境與衍序遠端連線，隨時準備在關聖帝君入廟時按下按鈕，在線上普濟堂放起煙火，整晚的守候只為了讓線上體驗與現場經驗扣合。當人們在線上也能感受到現場的熟悉感，這座線上城市就不僅是知識的傳遞，更有了保存記憶的意義。」

走進大溪 RPG（角色扮演遊戲）

如果整座城市是一個 RPG 遊戲，在臺灣人人都有的 LINE 通訊軟體上展開，只要打開手機就能觸發情境，走進大溪巷弄裡交朋友，深入認識慶典背後的生活文化，發覺文化原來就存在於這些盡心付出、熱情分享的在地人的身上。有了這樣的想像，策展團隊與擅長互動與體驗

圖 Figure | 8

「大溪 in LINE」透過 LINE
通訊軟體開啟 14 個關卡遊
戲，帶領大眾切換不同的
身份遊歷大溪。

With the communication
application LINE, "Daxi in
LINE" leads the visitors to
switch between different
identities when traveling in
Daxi and following the 14
missions.

設計的「叁式設計」合作，共同創造「大溪 in LINE」的城市闖關遊戲。為了讓真實場景中的遊戲體驗能夠順利，從行徑路線與距離、擲筊環節要控制的次數、店家與玩家的互動腳本，不斷測了又測，在大溪老城區來回奔波，最終讓店家廟婆們，成為實境遊戲中最有靈魂的NPC（非玩家角色）。然而這個體驗的真正目的從來都不是遊戲，而是帶領大眾遇見城市裡可愛的人、看見有趣的風景、認識有故事的信仰文化。

叁式設計：

「每次到大溪現場探勘，都能深入感受一小區的市民文化，看到當地人維持他們喜歡和擅長的事，而廟會和信仰文化也自然的融入其中。希望每個來玩的人都能和我們到現場探索時一樣，忍不住和老闆聊天、買一堆東西，一起因為變成關公金孫而有了歸屬感！」

5G 時代來了，全體集合！

在大溪農曆六月廿四日的傳統遶境中，有幾個經典必看的位置，大溪普濟堂是拜廟的壓軸、福仁宮有寬闊的廟埕讓社頭大展身手、遶境陣列最後面的關聖帝君坐轎，還有家家戶戶用心準備的香案桌。當大隊人馬穿梭在老城區中，超過兩公里的街道巷弄中，所有事情同時發生，每個人都只能選擇一個地方觀看。

(8) | 社館

大溪社頭會於「迎六月廿
四」期間設置「社館」，作
為慶典期間練習陣頭、整理
遶境用具及社員彼此聯繫的
臨時性基地，也會將社內的
神明神尊請入安置。

利用大溪佈建的 5G 網路環境，策展團隊在傳統遶境時，在城市中設置五台攝影機，在社群媒體和「關公 Online！」網站上直播，讓整個城市畫面同步展開。兩個主要廟埕的最佳視角可以隨時切換，木博館館員還擔任起主持人角色，帶著攝影師在城市跑動，帶領大眾看到社頭們在社館 (8) 整裝待發、涼水點心攤們招呼大家補充能量、沿街看熱鬧的居民與小孩，透過採訪深入看到遶境中的慶典百態。

記得直播時，地方耆老、社頭先進們通通擠在普濟堂辦公室，互相分享怎麼用手機看直播，興奮地說著可以看到關聖帝君到哪裡了，還可以同時看到外面廟埕拜廟的畫面。無論是初次認識大溪信仰文化的人，或是對大溪抱有故鄉情懷的人，也無論是在線上還是現場，所有人都能身歷其境，感受慶典中發生的每一個瞬間。

When you think of "Daxidaxi," what symbols come to mind?
Is it Guan Gong's toothy smile of confidence? Is it the dragon god's dazzling eyes? Or is it a shiny, standard text?

With its colorful aesthetic, "Daxidaxi," whose design draws inspiration from elements of Taiwanese folk culture and follows the modern minimalist trend, has engulfed the entire city. With a humorous tone, each design reads like a conversation between the city, people, and gods, bringing everyone into the celebration.

When a design must convey a narrative for a tradition, the designer collaborates to find a solution that goes beyond visual appeal. The topic of visual aesthetics is left until last in "Daxidaxi." The importance of incorporating folk beliefs outweighs the role of contemporary design, as the position of Daxidaxi, "A modern religious Festival in which contemporary design joins folk beliefs." Taiwan's religious culture is saturated with native musicianship and craftsmanship. The most crucial concern for the creators of "Daxidaxi" is to choose between conversion and preservation in order to choose the greatest blessings of traditional beliefs, and inspire the public.

Enlisting experts to develop a cultural celebration unique to Daxi

With the imagination of the city's celebration, just like drawing a treasure map of Daxi, the curatorial team sets sail every year at the turn of winter and spring and starts to recruit skilled designers in various fields to embark on the annual "Daxidaxi" journey to find the most appropriate way to present these treasures together.

The first is Godkidlla, the director of visuals, who is responsible for establishing the annual palette and other defining visual tropes. Then, in accordance with the annual theme plan, cross-media craft designers, cross-interface multimedia designers, cross-genre audio-visual creators, copywriters, and video artists, among others, are invited.
The curatorial team invites experienced designers to the exhibition in the hopes that they will be able to view Daxi with a professional perspective, explore the traditional beliefs, folklore, and religious rituals, and absorb the nutrients of the local culture before concentrating jointly on the contents and ways to reinterpret.

In order for all the designs to coexist harmoniously and to present an urban celebration, the curatorial team had to maintain constant communication with all the collaborators, not only to confirm a unified design style tone and communication vocabulary, but also to verify the feasibility of the design content with each designer, so that the final product could meet the requirements of the

celebration site. Due to this consideration, the creative process is constantly a test and challenge of cultural, material, and historical contexts until all of the designs are displayed at the festival site. It could be said that the designers' skills are put to the test in "Daxidaxi."

What should "Daxidaxi" look like?

When the curatorial team considers the image of "Daxidaxi" it decided to invite Chun-Yu Liao (Godkidlla, here in after referred to as L), a visual designer who specializes in local cultural themes in Taiwan, to be the visual director. Let's go back and review the development of Daxidaxi's main visual design.

Since "Daxidaxi" is the birthday of Guansheng Dijun, it is only fitting that Guansheng Dijun endorses the culture of his own procession. Guan Gong was portrayed by L as a storyteller of this generation with an intimate character personality and a clear identity, and with the shining eyes of a young girl in a comic book, the confident look of a toothy smile, and the large beard skewed on his red face. This was executed to highlight Guan Gong's somber and unflappable image. This subversive and intimate image-rebuilding is the creation of the core detail of the character, after which Guan Gong becomes the most impressive visual impression of "Daxidaxi".

(1) | Zhishi placard
The wood-carved placard imitating the objects that were held by ancient officials on patrol is commonly seen in temples.

After establishing the character of Guan Gong, L creates the standard characters of "Daxidaxi" to resemble those on a Zhishi placard **(1)** and the "dragon god" who serves as the temple's guardian. Guan Gong, the Dragon God, and the Daxidaxi standard characters are all rendered as independent graphic components. In addition to these three components, the visual composition can be superimposed freely by L or by the public according to a variety of issues, keeping a supple look that adapts to new circumstances. By involving the public in its design, a new platform for artistic expression has been established, serving as something of a visual microcosm of Taiwanese culture.

> *Godkidlla:*
> *"Never should we shed off a piece of Taiwan and replace it with something else. Knowing that everything should exist is, in my opinion, the first and most fundamental step in any design process. "*

(2) | Cardboard box costumes
Influenced by the culture of "June 24 Reception," children in Daxi will wear cardboard box costumes and imitate the movement of Holy Generals and Children.

L entered the Daxi universe and continued to expand Guan Gong's various expressions while also encircling Guan Gong with all of his general friends. He entered the Daxi cityscape and drew pagodas, historic streets, and temples. The temple's guardians, the dragon god, and his animal sidekicks looked like they could jump off the page. And one by one, the citizens of the city who are participating in the procession while donning cardboard box costumes **(2)** for

children and duck-tongue hats for residents are all unveiled, gradually creating the one-hundred-and-twenty-color Daxi world. Peak accumulation of all elements occurred in 2020, but Vitali, which had just begun cooperating on the main visual, informed everyone that they could only print in six colors (including white) on the cans L could only nod his agreement, and the most intricate main visual design of all time was shrunk from 120 to just six colors.

With the design guideline set by Godkidlla, the curatorial team launched the editing project for the pop-up picture book "DAXIDAXI". As the visual coordinator, Zishi studio developed the graphic of the entire city and designed the pop-up paper structure. Eventually, the knowledge and historical customs of "June 24 Reception" are included in the five-scene stories.

L sometimes wants to try something more daring. In 2021, when the pandemic in Taiwan was at its worst, virtual technology emerged. L was deliberating at home when he finally came up with the idea of fusing the metaverse with classic flower and bird characters. He then incorporated the preexisting character components into the main visual draft of the virtual time and space. The picture files were immediately shared by video message among the curatorial team members, who were working remotely, after they were received. Surreal imagination visual dismantling and restructuring can be pushed to their limits as witnesses watch Guan Gong disintegrate in front of their very eyes, prompting uncontrollable laughter and unanswered questions.

L is a skilled and highly and experienced creator. The "Daxidaxi" visual application standard has been improved over the past five years and is now developed enough to support large to small image scales in festivities. People of all ages can recognize and participate in the flexible application of everything, from a five-meter-tall pagoda to a five-centimeter-wide talisman, enticing designers and fans to compete to collect. The equity of the brand, "Daxidaxi," is clearly established in this visual image, from the main visual to all applied products and curatorial directions.

The Contemporary Appeal of Traditional Craftsmanship

People's devotion to the gods is evident throughout Taiwan's procession culture and temple architecture in a variety of delicate crafts, including weaving, woodworking, paperwork, bamboo weaving, clay sculpture, gluing, bronze carving, stone carving, etc. However, with the evolution of time, many complicated techniques have gradually been phased out in the process of simplification. "Daxidaxi" offers a chance for these cherished customs to live on in the present through an urban celebration, as opposed to simply documenting them. Therefore, we have invited many craftsmen and designers to join us in

(3) | Banner of appreciation

The "banners of appreciation" are the banners presented annually by the Puji Temple's Management Committee and the chief and deputy chief of the furnace to the shetou who participated in the procession. The evolution of the times can be seen in the changes in production methods and forms, which range from the flat cloth flags made during the Japanese rule period using printing and dyeing techniques to the flags manufacturered by embroiderers that started to appear after World War II.

(4) | Incense burner chief

The representative of the annual ritual activities selected by the gods. In Daxi, the incense burner chief is chosen by casting jiaobei (a divination tool, also known as "moon blocks") and is mainly responsible for the preparation of celebration-related matters.

(5) | Paper artists

In Taiwan's traditional religious rituals and ceremonies, people use bamboo and paper to make figures, houses, and objects.

(6) | Landscape painting

In Taiwan's traditional glove puppetry, the landscape in the background and stage are hand-painted in a realistic style, which can be easily transported, used, and stored, and is also artistically appealing.

the past few years to collect materials for creation from traditional Daxi rituals, deconstruct the symbolic nature of the objects and the behavioral meaning behind them, and then redesign them in a contemporary fashion, finally proposing various possibilities and experiments to continue the tradition.

Many objects with local and community characteristics can be found in Daxi's "June 24 Reception" culture. From the props of the shetou performance troupe, designer Jingting Xu chose to design and renovate the large Mo Dou, which is highly characteristic of the woodworking industry, for Xieyi Society. Without breaking the prototype of the Mo Dou, the lightweight cloud pattern structure is used to highlight the traditional delicate totem, and the lighting is designed to make the big Mo Dou a shimmering auspicious animal at night. The "banner of appreciation" [3] for Daxi Puji Temple and the current chief [4] and deputy chief of the furnace treating shetou was made by designer Pili Wu, who aimed to capture the appearance of the various historical periods through her work. Pili begins by examining the characteristics of each community's original professions. Each community's proud talents and the joyful faces of the gods are deployed in the flag pattern. Last but not least, the modern two-day traditional procession is taken into account; neon light bars are incorporated into the production, leaving behind a new symbol of celebration in the modern world, one that features the interplay of human and divine celebrations, as well as gorgeous light.

> *Pili Wu*
> *"Faith represents the most fundamental connection, the most original story of the land." Each era deserves its own set of beliefs, and as long as we keep moving forward slowly, life will continue to unfold naturally. To me, it's the designers' job to figure out how to bridge the gap between the old and the new, between tradition and the generation of today. We can expect this to continue so long as there are people involved."*

When the design studio "Elephant Design" was tasked with creating a city-wide celebration atmosphere, it decided to search for the cultural symbols of Daxi's craftsmanship, and that was how designer Yuelin Pan's began the journey to find artisans. With the recommendation of different artisans, we learned the meaning of the common totems of faith from the craftsmanship of paper artists [5]. Mr. Dengxiang Lai, the Pili troupe's private instructor, was invited to contribute to the pagoda's elements by painting the landscape [6] . Master Hongyi Zou, who is an expert in making lanterns, text design, and illustrations, was also invited to make bamboo lanterns. Finally, three Daxidaxi pagodas, each with its own characteristics, were set up in the old town of Daxi in the form of a flat roof and a spire, based on the different meanings of the "temple celebration" and the

"traditional architecture" of Daxi. Every photo taken by the public in front of the pagoda shows the possibility of continuing the tradition in the contemporary world.

> *Yuelin Pan:*
> *"I have always been interested in traditional craftsmanship, and I am honored to have the opportunity to learn, collaborate and reinterpret with the artisans. The last display is the distinctive pagoda, which we hope will heighten your enthusiasm for the city's celebration and provide you with an opportunity to familiarize yourself with traditional craftsmanship. "*

Designing new modern clothes for the gods

(7) | **Holy child**

Compared with the "Generals" who are more than three meters tall, the "Children" are the ones with the same proportions as humans. Some of the Children are common in procession, such as Tudigong (Lord of the land), Third Prince, General Fan, and so on.

Inspired by the new type of procession's visual representation, we speculate on how the traditional parade garb of "general" and "child" **(7)** might be updated to include contemporary vocabulary and concepts without sacrificing their iconic status or their pragmaticism. In order to create new costumes for the procession characters, costume designer Shaoyen Chen, who specializes in structural disassembly and the use of unconventional materials, joined the team in 2018. Finally, in collaboration with the Nongyou Tuan, the design was developed featuring Leishen and Dianmu, who stand for the two natural phenomena of thunder and lightning. Baby Leishen has thick eyebrows, a green face, and a sharp mouth, while Baby Dianmu has a pink face, thick eyebrows, and a bun on their head. Both of them have distinctive facial characteristics. Leishen and Dianmu accompanied Shaoyen throughout Taipei, taking measurements at the design studio, participating in garment testing at factories, and making final adjustments at the BIAS office of the curatorial team. By deconstructing the fabric structure of the children's costumes layer by layer and understanding the relationship between each layer and the armor, and then redesigning it with modern gradient colors and contrasting fabrics, the image of the Leishen and Dianmu was made more vivid while remaining faithful to the existing historical and cultural context.

> *Shao-Yen Chen:*
> *"I believe that the most beautiful aspect of traditional culture is the stories and traces sifted by the passage of time, which cannot be replicated in a day or two; this was the greatest benefit I received from this collaboration. "*

In 2019, with the start of the educational program "The Study of Procession for Children," the theater stylist Yusheng Lee, who is familiar with the culture of faith in Taiwan, was invited to take the material from the general culture of

Daxi and design wearable equipment for children in elementary schools. With the knowledge he picked up from designing the helmet, armor, water sleeves, and capes, designer Yusheng Lee adapted the Tahitian general's costume's vocabulary to structure of the equipment for children to wear. As an added bonus, it considers the traditional image of each general behind the meaning of time and space represented, such as how Zhong Huang is portrayed as old and strong and how Cang Zhou is portrayed as loyal and courageous. The design of the wearable apparatus combines the consciousness of education and heritage, and infuses the heritage with artistic action.

> *Yusheng Li:*
> *"It is a privilege to be included in the process of passing on Taiwan's cultural heritage to the next generation, but it is an even greater privilege to serve as a link between the younger generation and the older generation. The wearable apparatus I created for the kids in "The Study of Procession for Children" served as the model for "Electric Gods," a series of artwork to come, which functions as a creative process for finding new bodies and representations for the gods in modern Taiwan and giving them new meanings."*

Capturing every persistent guarding figure with the camera

Among all the designers and creators of "Daxidaxi" who collaborated with us, the ones who pushed local roles to the front and let their identities recede to the back are the photographers. Photographer Kecheng Lin plans a number of compositions in advance for the yearly special exhibition featuring the Daxians, but when working with the locals—all of whom are common folks —everything must be altered to account for unforeseen circumstances. In the documentary exhibition "The General and I," featuring the backstories of the men who carried the general. To better capture the general, the Wude Hall with its high roof was transformed into a large photo studio, and for the first time, the general and the general's feet, which are higher than 3 meters, were displayed on the same stage. All aspects of the photograph, including its lighting, composition, and emotional intensity, are put to the test. We made repeated shots from morning until night on the first day, and it wasn't until late that night that Tammy and Kecheng looked at the camera's display were we able to relax. Once it was established that both the general and the general's feet in the picture looked good, the first photo shoot was finished. The documentary "The Office of the Temple Procession," which depicts festival organizers, aims to talk to anxious seniors and help them relax while focusing on their acts and giving spirit, illuminating through the camera each individual who insists on preserving the centuries-old culture.

Ke-Cheng Lin:
"The local people who usually participate in the procession and temple rituals have probably never been documented in this manner." For me, the meaning is already created at the moment of shooting, which allows them to see their different faces in a new way between traditions and photography.

During the celebration, all the scenes were fleeting. Every year, in the crowded scene, you can always see the dynamic and graphic photographers running around with their equipment, trying to capture every thrilling moment as much as possible. The video crew that has been filming Daxidaxi for the past five years, DC Films, frequently snuck into the formations, as if they were playing a vital part in the procession formations each year. In the special exhibition "Dancing Hall of Virtues," the attachments that have developed over the years are also expressed through the general's moving images. Before photographing each group of the general's feet, photographer Ellie would easily demonstrate the steps of the Daxi general's walk to pay respects, so that the shetou's men could be put at ease and confident in their performance. Through the images of the generals' feet in the exhibition, we will continue to transmit the reverence for the gods that has been transmitted from generation to generation.

Log on to Daxi City online to feel the faith of the far and wide

The "Daxidaxi" is based on the culture of the procession, which necessitates the gathering of people, with the outbreak of COVID19 in 2020 posing the greatest resistance and challenge. "Daxidaxi" was stuck in an impasse because it was unsure of the circumstances and whether to put an end to the event at a time when morale around the world was low. For this reason, BIAS had no choice but to continue the fight, while also contemplating how to rediscover the true meaning of faith and employ modern computer programs to share this good news with the world.

In 2020, with the title "Guan Gong Online!" as the annual theme, we created an online version of the Daxi Festival. The entirety of Daxi was constructed piece by piece, block by block, by illustrator Kuo-Cheng Liao using a semi-stereoscopic illustration technique. From day to night, the old city and its pagodas, mountains, rivers, rice fields, temples, and procession formations are all carved out, and people with different identities are added to transform the whole procession scene, making the online city full of stories and surprises. Two teams, BlackHole Creative and Jiben Technology, are responsible for the production of dynamic web pages to make the online Tahitian City come alive. Through the interactive web interface, the public can choose their identity and join the online queue for the procession, as well as see the incense tables and refreshments stalls along

the procession route. You can also pray online and make a wish by linking to the Guan Gong to always keep hope and faith in your heart in extraordinary times.

Illustrator Kuo-Cheng Liao
To continue the story of the procession, Puji Temple was used as the base unit, and then pagodas, streets, and characters from the festival were constructed proportionally. When I arrived in Daxi and saw the "Patrol with the God" formation, it was as if I had entered the world of illustration.

Jianhua Gu, BlackHole Creative
To ensure that the online Puji Temple experience is on par with the in-person one, the procession is connected to the far end of BIAS each year and stands by, ready to press the button when Guansheng Dijun enters the temple and set off the fireworks. This virtual city serves as a means of memory preservation when users are able to experience a virtual version of a familiar physical environment.

Enter Daxi RPG (Role Playing Game)

If the whole city is an RPG game, playable on LINE, the most common communication softare in Taiwan, you can just turn on your cell phone and activate the scenario: walk into the alleyways of Daxi to make new friends, and learn more about the culture behind the celebration, and find out that the culture exists in these local people who are dedicated and passionate about sharing. With this vision in mind, the curatorial team collaborated with Ultra Combos, a company that specializes in interactive and experiential design, to create the "Daxi in LINE" urban level-passing game. We kept testing the route, the distance, the number of casting jiaobei (a divination tool, also known as "moon blocks") ritual session, and the interaction scripts between the shopkeepers and the players in order to make the game experience in the real scene smooth. Ultimately, we included the shopkeepers and temple maids as the most soulful NPCs in the City game. The true goal of this experience, however, has never been a game but rather, to introduce the public to the lovely folks in the city, fascinating scenery, and stories about the faith-based culture.

Ultra Combos:

"Every time I visit Daxi in person to explore, I can feel the culture of the people in small doses, and I can see that the local people operate and maintain what they like and are good at in their own way, and the temple and faith culture are naturally integrated into it. We hope that everyone who comes to play will feel as though they belong, just like we did when we first looked around, couldn't resist conversing with the boss, and couldn't resist buying a lot of stuff because we were made to feel like the golden grandchild of Guan Gong! "

5G era is coming. Time to rally!

There are a few well-known must-see locations in the traditional procession in Daxi on the 24th day of the sixth lunar month: Daxi Puji Temple is the culmination of the temple worship, Furen Temple has a large temple plaza for shetou to demonstrate their skills, Guansheng Dijun sits in a sedan chair at the rear of the procession, and each family prepares incense tables. When a large group of people traversed the old city's more than two kilometers of streets and alleys, everything occurred simultaneously, and each individual could only choose one location to observe.

Taking advantage of the 5G network infrastructure deployed in Daxi, the curatorial team set up five cameras throughout the city during the traditional procession and utilized social media and "Guan Gong Online! to livestream on the website, allowing the entire city's scenes to unfold simultaneously. Switching at any time will give you the best view of the two main temples. The staff of the Wood Art Ecomuseum also plays the part of the host, guiding the photographers around the city, taking the general public to see shetous dressed up in the sheguan [8] , the refreshment stalls beckoning travelers to stop by for something to tide them over, and the enthused bystanders and kids along the streets. Interviews allow for a detailed examination of the many phenomena that make up the procession celebration.

(8) | Sheguan

During the time of the "June 24 Reception," Shetou groups will set up Sheguan (Shetou houses) as temporary bases for practicing formations, sorting out equipment, and communicating with each other. The Gods in the groups will also be invited into the Sheguan in the meantime.

I remember that during the livestreaming, older adults and community leaders crowded into the Puji Temple office and taught each other how to watch the livestreaming on their cell phones, excitedly saying that they could see where Guansheng Dijun had gone and that they could also see the images of the temple worship outside at the same time. You can take part in the Daxi celebration both online and in person, regardless of your familiarity with Daxi culture or how much it reminds you of home.

充滿驚喜、讓人好想去大溪的最潮行銷學！

The trendiest marketing campaign that is full of surprises and makes you want to go to daxi!

不論你是從哪一個管道認識「大溪大禧」，都能感受到「大溪大禧」近幾年在不同群體中造成的討論風潮。策展團隊多年來擁有許多行銷策略，文化銀行也加入經營社群的行列，每年從「大溪大禧」Facebook 頭貼換上了關公的新表情開始，每天一起回應大眾如雪片般的留言到天亮，以下首次露出「我們」解析行銷背後的各種奇想。

我們絞盡腦汁向外延伸與大眾溝通的議題，從一顆壽桃到將軍選舉大號召；召喚大家對故鄉的情懷，讓大家奮不顧身前往；守住每一個跟大眾互動的媒介，直到傳統遶境線上直播的最高潮——關聖帝君進廟回到普濟堂後，行銷才大功告成。

將關公的角色應用到各種介面，從 LINE 到 Instagram 到 reels，從繪本到貼紙到所有城鎮指標，關公的視野始終與大家同在。創造持續進行，一首《紅紅 OnOn》，成為 Song of the Day，在「綜藝大熱門」節目上告訴大家「大溪大禧」要來了。

在「大溪大禧」中不分年紀、不分族群，多種視角切入，宣傳的目的不單是信仰，是打開各種體驗的概念，以及重新認識大溪的方式。

歡迎加入大溪隊！

大溪的故事很長，一時間說不完，社頭、將軍、老祖⋯⋯等，這些到底是什麼？為了讓大眾都可以進入大溪故事，我們決定先讓大家加入「大溪隊」。

成為社頭人

百年前大溪不同因相同的「職業」屬性的人各自集結，開始組成不同的「社頭」參與遶境，就是社頭的由來之一，也是形成大溪百工百業組成遶境隊伍一起在加入「迎農曆六月廿四日」為關聖帝君慶祝聖誕的起源基底。

因此，進入大溪先讓大家結黨成社。互動網站「關公 Online！」中，每個人進來都如同進入 RPG 遊戲中的角色扮演，先選擇你想要扮演的角色，如：礦工、有錢人、農夫⋯⋯時，同時間你已經經入了「社頭」，擁有鮮明的個性與故事，一起跟著關聖帝君遶境。社群上善用大家都愛做圖像心理測驗的習慣，幽默好笑地以「人生就像投資」形容大溪最精明商人的興安社，用「要怎麼收穫，先怎麼栽」的形容來代表農人背景的農友團，當你在笑怎麼「我的人生如同三太子時」，其實你已經進入哪德社，成為大溪社頭人，加入大溪隊了。

另一種則是偶像化「社頭」形象，讓你也一不小心就成為社頭的粉絲。我們用一個有如超級英雄聯盟畫面的社頭男孩聯盟組合，刻畫每一個個性鮮明的社頭人：肌肉爆棚的同人社轎班、身手矯健的新勝社舞龍好手、還有戴著斯文眼鏡的農友團北管樂手等。其實這些人物形象，都是漫畫家取材自真實在大溪見過的人。加上漫畫家的偶像濾鏡後，大溪各社頭粉絲頓時暴增，眾多人在開幕日，隨著「與神同巡」新型態遶境在街道穿梭，只為尋找各個社頭人火熱的身影。

圖 Figure ｜ **1**

以偶像般漫畫角色詮釋，帶領大眾認識大溪社頭特色。

By idolizing the characters, the public is familiarized with the Shetou groups' charm.

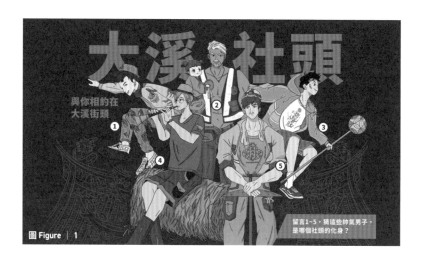

將軍守護神

大溪隊中最英勇剽悍的，莫過於「將軍」，也就是護衛神明的將軍們，扛起將軍便成為其化身，人神合一，帥氣爆棚。「二號關平，只有霸氣，沒有爸氣」、「七號謝必安、八號范無救，我們說得到、做得到」正逢選戰期間，我們將各路將軍化身候選人，以幽默的競選口號拉近將軍與我們的距離，讓大家選舉時也不忘選出一位人性化的守護神。各種守護神任你挑選的城鎮，怎能不愛呢？

圖 Figure │ 2

大溪將軍帥氣參選，帶出每一位將軍與關公的背景故事。同時加入當年前來交流的新竹謝范將軍。

By turning the various generals into candidates, we are trying to share the background stories of each general.

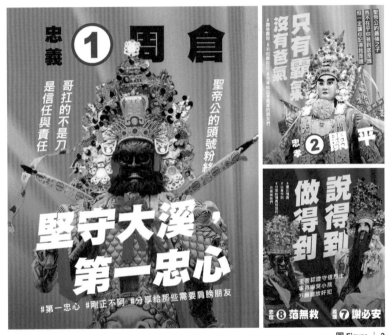

圖 Figure │ 2

關公小哥哥無遠弗屆！

一位通天聽的好朋友默默隱身在策展團隊中，有一天在普濟堂拜拜時，她突然對正在雙手合十祭拜的策展人劉真蓉說：「祂說叫祂小哥哥就好。」這句話對真蓉非常震撼，因為在這麼莊重的時刻，怎麼會說這麼出人意料的訊息？從此策展團隊就稱呼關聖帝君為「小哥哥」。我們也將這個奇遇，當成是關聖帝君精神無遠弗屆、不需拘泥形式的指點。

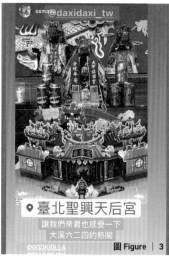

圖 Figure │ 3

農曆六月廿四日關聖帝君聖誕日，臺北聖興天后宮在 Instagram 的限時動態中，分享關聖帝君拜桌前的「大溪大禧」平安符、維大力，和立體繪本中的大溪普濟堂。
圖片來源：臺北聖興天后宮
On the 24th day of the 6th lunar month, Guan Sheng Dijun's Birthday, Sheng Sing Mazu Temple in Taipei put the "Daxidaxi" amulet, Vitali, and pop-up picture book on the incense table of Guan Sheng Dijun. They even displayed the page of the pop-up book showing Daxi Puji Temple and shared a story on Instagram.
Photo credit: Sheng Sing Mazu Temple

圖 Figure │ 4

打開 Instagram 濾鏡，每個人都能一秒變「大溪大禧」關公！
With the Instagram filter, everyone can immediately become Guan Gong in Daxidaxi version!

關公「小哥哥」其實是一個「關公就是我的好朋友」的角色形象，不是執著於信仰的表象，在意心念，與「大溪大禧」建立一道友誼的橋樑。

在「關公Online！」中有一個關公的房間，告訴大家祂頭戴綠色官帽、手持關刀，要準備去工作了，下一頁關公上工了，坐在辦公桌傾聽大家的願望，最後你可以跟祂請示一支靈籤。在大溪也有一個「遶境事務所」關公辦公室現場，不只關公，還有眾多天兵天將一起辦公，計畫著即將到來的遶境要怎麼安排各自的工作。大家看不見真正的祂，但是關公小哥哥似乎到處都在，前來「大溪大禧」的人們也透過扇子、旗幟、毛巾中到處都是無所不在的小哥哥的視覺圖案呈現下，感受到歡樂無比的氣氛。

關公小哥哥的角色形象活用於各種介面，有線上的「LINE 貼圖」、「Instagram 濾鏡」，更出擊各路產品，貼紙、鑰匙圈。角色形象穿透性極佳，成功跨越各種族群，代言起整個「大溪大禧」，人人都愛關公小哥哥。

跨同溫層不停出圈

「大溪大禧」的同溫層是大溪人？設計圈？關公信徒？還有呢？「大溪大禧」要講的故事太多，每說一個故事，就圈粉一次，一路上嘗試過很多的溝通方式，新的合作契機，總會有新的使用方法與火花，一路來累積了眾多粉絲等著跟「大溪大禧」的小編們與小哥哥對話。

由於欲教導大眾如何祭祀，於是推出平安福袋教大家拜拜，但是不只平安福袋上了供桌，「大溪大禧」的聯名維大力成為大溪人指定商品，家家戶戶香案桌上都出現了笑得開懷的小哥哥，於 2022 年「大溪大禧」維大力進入在跟全家便利商店銷售合作時，四處都傳來「大溪大禧」維大力上供桌的相片。更讓人感動的是，述說代表大溪「迎六月廿四」的故事的紀錄「大溪大禧」立體繪本，也受到宗教圈的歡迎，小編收到多處宮廟在祭祀時將「大溪大禧」立體繪本書放在宮廟供桌上分享翻開祭祀，如：臺北松山聖興天后宮的小編在關聖帝君生日當天標註「讓我們的帝君也感受到大溪六廿四的熱鬧」。

更多的是我們一直以大溪內容力嘗試各種新素材，讓許多領域提出討論，曾經一篇「揮汗吧！社頭少年」的社群貼文，讓多元性別族群社群熱議，指定前來大溪觀看故事內容。我們為了宣傳「大溪大禧」訂製一首《紅紅 OnOn》，上遍各種通告，在《百靈果 The KK SHOW》podcast 中大聊超時，《紅紅 OnOn》關公形象打歌打到「綜藝大熱門」。關公生日當天，線上音樂平台《街聲 Streetvoice》選出《紅紅 OnOn》成為 Song of the Day，「紅紅 紅紅紅紅 你最紅」著實傳遍各地。

也許都不是典型宣傳方式，但是基於故事性又開放幽默的溝通方式，讓「大溪大禧」每一出手，就多了好多好多朋友。

圖 Figure ｜ 5

「揮汗吧！社頭少年」取材自大溪人物情境，以短篇漫畫詮釋社頭的熱血夜練。插畫家：JOE

The story of "Sweat it out! Shetou Boy" is based on real people in Daxi and showcases the passionate evening training of the Shetou groups.
Illustrator: JOE

圖 Figure ｜ 5

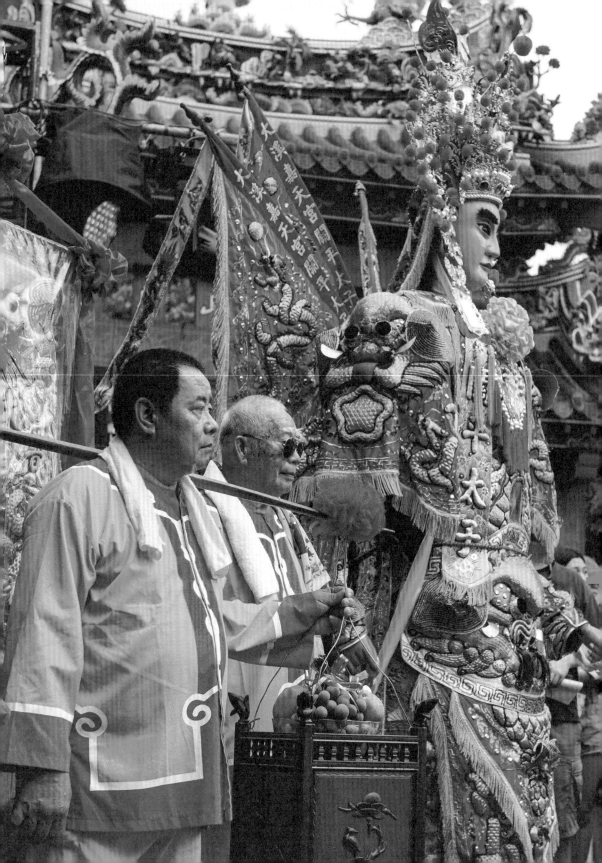

大溪就是你家，故鄉感催你回家

我們真的很感情用事，很愛「大溪大禧」，也想邀請更多人認識，
其實，我們在社群裡寫了一封又一封大溪給大家的情書，
用故鄉感、用信仰、用真心，號召大家。

大溪，
不怕你來了又走，
不怕你逛了熱鬧歡唱的廟會，
拍了幾張生機盎然的街景，
錄了幾段社頭出陣，便走；

不怕你吸取了沒有保留的燦亮日照，
重溫了人情的純粹，
沐浴了信仰的勁頭，
享受了一天大溪人百年來守護的傳統最初之美，便走。

因為結束了今年，
廟埕一樣會有我們的夜練；
街巷仍有我們虔誠的香案；
我們一樣一代牽著一代，
明明地去、暗暗地歸，
為守護這座山城；
為答謝浩蕩神恩；
更因為，當你離開後，
你帶走的，不僅有熱鬧與飽腹，
還找回了，
藏在心底深處，根的來處。

最後，讓我們多說一句：
「歡迎你來大溪。」

I wish there was a "Daxidaxi" in my hometown too!

Let's go to "Daxidaxi" together!

Designers, remember to come check out "Daxidaxi"!

The trendiest parade "Daxidaxi"

I heard that "Daxidaxi" is fun

The marketing of "Daxidaxi" is simply awesome!

Regardless of the channel through which you learned about "Daxidaxi," you can feel the viral buzz "Daxidaxi" has created among different groups in recent years. The curatorial team and the Bank of Culture have been working together for many years to create a community, starting with a new emoji of Holy Emperor Guan on the "Daxidaxi" Facebook post every year, and responding to the thousands of comments, creating a viral buzz around the event. We have been working hard to extend our communication channel with the public, from a longevity peach to a call for the election of a general, we have helped people recall what they remember about their hometown and prompted them to head to Daxi. We guarded every medium of interaction with the public until the livestream of the traditional procession of Guan Sheng Dijun into the temple was completed.

We applied the role of Holy Emperor Guan to various interfaces, from LINE to Instagram to reels, from illustration books to stickers to all town indicators, and Guan Gong's vision was always with everyone; our creation continued, and the song "OnOn" became Song of the Day, letting everyone know that "Daxidaxi" was coming on the variety show "Hot Door Night".

In Daxidaxi, regardless of age or ethnicity, the aim of the promotion is not just about faith, but also the concept of opening up various experiences and a way to get to know Daxi again.

The following is a rundown of the various ideas behind the "we" analysis of marketing.

Welcome to Team Daxi!

The history of Daxi is so long that we don't know where to begin. To guide the people along to enjoy the Daxi experience, we decided to have you on the Daxi Team first.

Becoming a Shetou Member

Hundred years ago, Shetou organizations formed due to a shared profession/ trade, and is the foundation behind why people from all walks of life join the "June 24 Reception" procession and celebrations.

Therefore, the introduction to Daxi involves helping people to form subgroups. In the interactive website "Guangsheng Online!" everyone enters the site as if they were role-playing in an RPG game, first choosing the character you want to play, such as a miner, a tycoon, a farmer... At the same time, you have already joined the "Shetou" and have a distinct personality and story to follow along with the Holy Emperor Guangsheng Dijun. On social media, it is popular for people to use images and avatars for psychological tests; it's like saying "my life is like an investment" with a comedic spin. In fact, you have already entered the Xing'an Society, known to have members who are smart traders and businesspeople. When you think "you reap what you sow", you make a great member of the Agricultural Society. When you are laughing how "my life is like the Nezha," , you have already entered the Nuode Society, becoming a Shetou member in Daxi, and joining Team Daxi.

The other is to idolize the "Shetou" image, so that you also accidentally become a fan of the Shetou. We use a League of Legends-like group of Shetou boys to portray each distinctive Shetou: the muscular palanquin crew, the agile dragon dancer of the Xingshen Soceity, and the Beiguan musicians of the Agricultural Society wearing elegant eyeglasses. In fact, these characters are taken from people the comic artist has actually met in Daxi. After adding the cartoonist's idolized filters, the number of fans of each Shetou in Daxi suddenly increased exponentially, and many people went through the streets on the opening day to the new "Parade with the Gods," just to track the whereabouts of each Shetou.

Divine Guardians - the Holy Generals of Daxi

The title of the most heroic and formidable of Team Daxi goes to Holy Generals. Their roles are to protect the gods; those who carry the Holy Generals will become their incarnation, forming a unity of man and god. "No. 2, Guan Ping, no one can beat him in domineering style" "No. 7, Xie Bi'an, No. 8, Fan Wu Jiu, we practice what we preach" just in time for the election season, we turned the various generals into candidates, with comedy-laced campaign slogans to draw the Holy Generals closer to us, so that we do not forget to elect a humanized divine guardian during the election. How can you not love a town where you can choose from a variety of Holy Generals?

The "Xiao Ge Ge" is Omnipresent!

One day, when a friend who was more spiritually sensitive was worshipping at the Puji Temple, and suddenly said to curator Tammy Liu, who was worshipping with her hands in a namaste pose, "He said to call him Xiao Ge Ge." (Xiao Ge Ge: an endearing term of address for a young man) This shocked Tammy, how could she say something so surprising at such a solemn moment? The curatorial team

打開《大溪大禧》立體繪本，整座大溪普濟堂躍然紙上。

Open the pop-up picture book "DAXIDAXI", and the whole Daxi Puji Temple appears vividly on the paper.

Guan Gong Online! – Room of Holy Emperor Guan

has been calling Guan Sheng Dijun "Xiao Ge Ge" ever since. We also took this strange encounter as a sign that the spirit of Guan Sheng Dijun is far-reaching and does not need to be formalized.

Holy Emperor Guan "Xiao Ge Ge" is actually an affectionate character image of "Holy Emperor Guan is my good friend", not stubbornly clinging to the austere appearances of faith, but caring about the heart and mind, and building a bridge of friendship with "Daxidaxi".

In "Guan Gong Online! " you'll see a room of Holy Emperor Guan, telling you that he is wearing a green official hat and holding a Guan Gong sword, and is ready to go to work. On the next page, the Holy Emperor Guan is at work, sitting at his desk listening to everyone's wishes, and finally you can ask him for a divination stick. In Daxi, there is also a "Procession Office" where not only Holy Emperor Guan, but also many heavenly soldiers and generals are working together, to figure out how to systemize their work for the upcoming procession. While we can't see the real personification of Holy Emperor Guan, but Xiao Ge Ge seems to be everywhere! The people who joined the "Daxidaxi" also felt the joyful ambience with the visual presentation of Xiao Ge Ge on fans, flags and towels.

The character of Xiao Ge Ge Holy Emperor Guan is used in various interfaces, such as LINE stickers and Instagram filters, and also in various products, such as stickers and key rings. The character's image is loved widely, and appeals to various demographic groups as the spokesperson for the whole of "Daxidaxi," and where everyone loves Xiao Ge Ge Holy Emperor Guan.

Holy Emperor Guan for All: Transcending Echo Chambers

Is the echo chamber of "Daxidaxi" the people of Daxi? Is it the design community? Is it the faithful who believe in Holy Emperor Guan? Is there more? There are too many stories to tell when it comes to Daxidaxi, and we attract new

fans with every attempt. We have tried many ways of communication and new opportunities for cooperation, and there are always new ways of use and sparks, and we have accumulated many fans waiting to talk to our editors and to Xiao Ge Ge Holy Emperor Guan.

In order to teach the public about the worship ritual, we launched a Peace Amulet Mystery Bag. The bag not only made its way to the offering table, but the co-branded "Daxidaxi" Vitali became a designated product for the people of Daxi, and a smiling Xiao Ge Ge appeared on the incense table in every household. In 2022, when "Daxidaxi" cooperated with the convenience store chain FamilyMart, photos of Daxidaxi Vitali on the offering table became a viral sensation. What is more touching is that the "Daxidaxi" pop-up picture book, which represents the story of "June 24 Reception" in Daxi, has also been welcomed by the religious circle, and many temples even put the "Daxidaxi" pop-up picture book on the incense table during the ritual. For example, the editor of Song Shan Sheng Xing Mazu Temple in Taipei posted this: "Let our Holy Emperor feel the hustle and bustle of Daxi on June 24" of the official fan page on the birthday of Guan Sheng Dijun.

More than that, we have been trying out various new materials with our Daxi content, which has brought up many fields for discussion. A "Sweat it out! Shetou Boy" posted on social media had generated a lot of interest from the LGTBQ community, who have come to Daxi to learn about the story. We made a song "OnOn" to promote "Daxidaxi" and it was on all kinds of announcements, and we talked about it on the "The KK Show" podcast hosted by Bailingguo, and "OnOn" was a hit song with the image of Holy Emperor Guan and featured on the variety show "Hot Door Night" On the day of Holy Emperor Guan's birthday, the online music platform "Streetvoice" selected "OnOn" as the Theme of the Day, spreading the track far and wide.

圖 Figure ｜ 6

2022 年 7 月 1 日，在當年「大溪大禧」開幕前夕，《紅紅 OnOn》登上獨立音樂平台 StreetVoice 的「Song of the Day」。

On July 1, 2022, on the eve of the opening of "Daxidaxi," the thematic song "OnOn" was selected as the "Song of the Day" by the independent music platform StreetVoice.

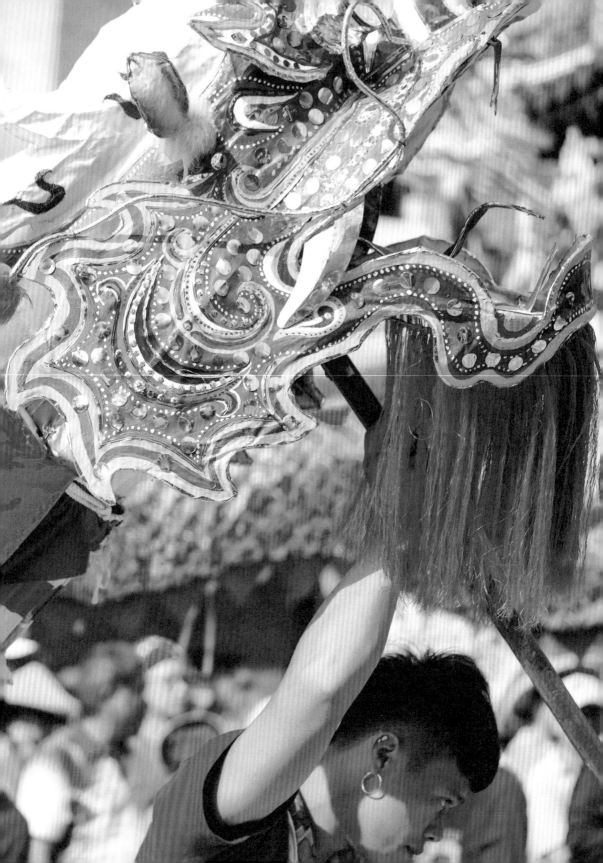

It may not be a typical promotion strategy, but the storytelling and open and comedic way of communication has made "Daxidaxi" gain a lot of fans every time the event is held.

Daxi Is Your Home, Your Hometown Urges You to Come Home

We are sentimental, really love "Daxidaxi" and would like to invite more people to get to know it.
In fact
we have written love letters from Daxi to everyone on social, using our sense of hometown, our faith, and our heart to call everyone.

Daxi
is not afraid that you will come and go,
is not worried that you will visit the lively and joyful temple fair.
take a few pictures of the vibrant street scenes,
record a few videos of the Shetou performances,
and then leave.

I am not worried that you have absorbed the bright sunlight and attention, that you rediscover the purity of hospitality,
and that you have bathed in the energy of faith,
enjoyed the original beauty of the tradition that the Daxi people have been preserving for a hundred years,
and then leave.

Because after this year is over,
there will still be our night practice at the temple square,
the streets and alleys will still be filled with incense,
we still teach and mentor each other from generation to generation.
We will head out in brightness, and return in the dark,
we shall protect this mountain city,
and thank God for His grace.
And because, when you leave
you take with you not only the memory of the event, stomach full;
you will have also rediscovered, hidden deep in your heart,
the place where your roots come from.

Finally, let us say one more thing.
Welcome to Daxi. Welcome.

「大溪大禧」之外，關於祭典的雜思
Beyond "Daxidaxi:"
Musings on rituals and ceremonies

文 —— 李取中｜《大誌雜誌》《週刊編集》 創辦人

Fines Lee｜Founder of "The Big Issue Taiwan" and "The Affairs" magazine

作為一個編集人，與祭典相關的主題或多或少會碰觸到，隨著內容主題的切入點不同，每次對於祭典的思考角度也有所差異，底下的文字試圖從三個方向談及，而我從大溪大禧看到了這些的可能。

個人與創作的參與，所有的生物妝扮好了準備祭典

「祭典開始了。這是野獸之國，這是妖怪之島。這是遠古人類與自然界的溝通，我們畏懼、崇敬那些看得到的與看不到的力量，於是透過儀式趨吉避凶、透過吟唱降妖伏魔，我們裝扮成想像中的生靈，我們假想著災厄的到來與驅離。直到詩人以詩句探照穿透這一切。我是你腳下的小草，亦是那全知的生靈。我是最先來的，比你先，先於你，不需你歌頌，我也能生存。祭典是需要的，時間是凌晨四點鐘，這一次讓我們吟唱詩人的字句，在那被統領的野地。」

許多祭典的進行，人們總會裝扮成未知的神靈或生靈，不管是東正教新年祈福儀式裡的樹人（Survakari），保加利亞山城的毛怪巴布格里（Babugeri），薩丁尼亞島上戴著黑面具的Mamuthones，阿爾卑斯山區的怪獸坎卜斯（Krampus）、察格塔（Tschäggättä）、追捕人（Schnappviecher）等......。這些用想像裝扮起來生靈，將未知的事物具體化，並透過儀式的進行來象徵著神祇亦或災厄的到來與驅離，同時，更重要的是，人們可以藉由這樣的裝扮形式參與祭典儀式中，並進一步透過創造力與想像力重新與自然溝通，仿若碰觸到那不可見的萬物生靈。

重拾人與地方的連結，祭典的可能與設計師的介入

> 「看著本書，一方面想起自己還保有多少小時候對於生長地方的記憶，是春明時節才出現的凌晨（或黃昏）時分的潤餅皮小攤、是戲院亦或田埂旁的灌溉溝渠、是幾年一度的廟會建醮活動、是走在鄉間小路上望去那些不知名的遠山、是暗暝時抬頭仰看的星空，這些場景輕易地走過我們的歲月，卻沒能讓我們紮根，沒能讓我們記住季節的味道、水的源處、神的顏色、山的名字，以及星星的方向，於是當我們失去生活的能力與本質時，我們也找不到那條回家的路。或許，不造物的設計師，喚起的是人們重拾生活的能力，也是重拾人與地方、自然相處的能力。」

由於一本關於社區設計的推薦邀約，想起了一些成長時期的事，寫下了一些雜感。對許多離開家鄉到外地工作的人來說，廟會活動往往是印象最深刻，同時也是最能把人跟生長的土地連結起來的事物，但隨著年紀的增長，那條透過廟會祭典活動接繫起來的羈絆卻似乎越來越遠、越來越淡薄，不再能帶來內心那股興奮莫名的悸動，我想或許是因為這些祭典活動沒能進一步隨著儀式的進行將地方上的自然環境與文化脈絡內化到內心的理解與感動，那不是把廟會辦得多盛大、廟宇蓋得多堂皇所能到達的，「不造物的設計師，喚起的是人們重拾生活的能力，也是重拾人與地方、自然相處的能力。」這段文字也是我對設計師介入地方祭典活動的期待。祭典應該是帶領人們去深入參與並真正認識地方的起點與終點。

越傳統越現代，把傳統祭典的意義尋回並重新建立新的儀式

> 「我們何其幸運，生活在一個未知的世界。一個無法用巫術、科學、宗教解釋的世界。信仰可以給你一切的答案，唯一的要求是拋棄你心中的疑惑。未知帶給了我們極大的恐懼，但未知也給予了我們極大的喜悅。2015 年，是對人類才有意義的概念。就像各式的節慶與祭典儀式一般。當我們處身其中時，總會勾動我們心中潛伏的情緒，那是兒童時期晦暗未明的主要徵象，總是夾雜著歡愉、肅穆與紛擾雜沓的人群，在不知其所以的儀式下進行著與未知世界的溝通。而隨著年紀的增長，我們仿如失去了與那個未知世界連結的能力，同樣的儀式，或許歡愉的氣氛還在，但那一抹似有若無的隱晦感卻已難尋。或許，現實的力量將我們拉得太遠了。我們想要借由這次的主題，試圖找回一些與未知世界的連結，或許，也試圖找回一些遠古人們與自然萬物的相處之道。」

詩人說「我們何其幸運 / 無法確知 / 我們生活在怎麼樣的世界。」對未知事物的恐懼、崇拜、好奇與探索是人類的本能甚或是人類存在的目的，但當我們自以為了解並不斷盲目拓展自身生存領域時往往是災難的開始，祭典的形式不應隨著時間僵化而不知所以、不應隨著政體更易而被挪用曲解，祭典的存在應在於提醒人們那未知事物的存有，是心靈的南方，在人們迷失或忘卻自己也是自然萬物的一員之時。

As a compiler, I have touched upon topics related to rituals and celebrations more or less, and with the different takes on theme content, my perspectives on rituals varies each time. Therefore, I attempt to share my thoughts below from three perspectives, and I recognize these possibilities in "Daxidaxi."

Personal and creative participation, all the creatures are costumed and ready for the festival

"The festival has begun. This is the land of beasts, the island of monsters. This is the communication between the forefathers and nature. We fear and revere what is visible and invisible, so we ward off evil through rituals, subdue demons through dharmic chants, we dress up as envisioned spirits, we imagine the arrival and expulsion of misfortune. Until the poet ingeniously verbalizes all of this in a message. I am the grass at your feet, and the all-knowing spirit. I was the first to come, long before you, and I can continue without your adoration. The rituals are necessary; the time is 4:00 a.m. Let us recite the words of the poet, in the wild land that is our dominion."

People would dress up as unknown supernatural beings or spirits in many of the rituals, be it the Survakari in the Orthodox Church's New Year's blessing ceremony, the Babugeri in the Bulgarian mountain towns, the Mamuthones in black masks on Sardinia, the Krampus, the Tschäggättä, or the Schnappviecher in the Alps. These imaginary beings begin to materialize and embody the unknown after they're costumed, symbolizing the arrival, and ritualistic expulsion of disasters. More importantly, people can participate in the rituals in costumes, and transcend into a communicative experience with nature with creativity and imagination to engage with the invisible spirits.

Re-attesting to the connection between people and place, the possibility of rituals and the intervention of designers

"While reading this book, I recalled the treasure trove of memories I still have of the place I grew up in, such as the stalls selling spring rolls at dawn (or dusk) during the Lunar New Year, the local theater, or the irrigation ditches of the fields, the temple fairs and dedication ceremonies once every few years. The memories encompass the strolls along a country road, sweeping the eyes to the unknown distant mountains afar, stargazing when slumbering in the dark. These snapshots flit through the years, not giving us a chance to take root, to remember the taste of the seasons, the fountainhead of water, the color of the gods, the names of the mountains, and the direction of the stars; in the process, we lose our grasp of the essence of life, we cannot find our way home. Perhaps, the designer who doesn't create things, evokes people's ability to regain their life skills, and their ability to coexist with place and nature."

The invitation to write a book about placemaking jogs my memory of my formative years, and I couldn't help but jot down some of my thoughts. For many people who have left their hometowns to elsewhere for better employment prospects, temple activities are often the events that left the most impression, and an experience that can most connect people with the land they grew up in. However, as I advance with age, the firm bond that had been established through the temple rituals and festivals seemed to drift farther and farther away, and no longer brought about the stirring of excitement in my heart. I think perhaps it is because these rituals have not been able to help the people internalize the natural environment and cultural contexts of the community, which is not something that can be achieved by making the temple fair as grand as possible, or

the temple as majestic as they could. "The designer who does not create materialistic objects is the one who evokes in people the ability to regain their life skills, and the ability to coexist with places and nature." This passage also outlines my expectation of designers' involvement in local festivals. Rituals should be the starting and terminal points to engage people in truly understanding the community.

The more traditional, the more modern: Recovering the significance of traditional rituals and re-establishing new rituals

"How fortunate we are to live in a world of unknowns. A world that cannot be explained by witchcraft, science, or religion. Faith can give you all the answers, the only requirement is to transcend your doubts. The unknown terrifies us, but it also gives us great joy. The year 2015 is a concept that only makes sense to human beings. It is akin to rituals and festivals; when we are in its midst, it awakens the simmering emotions in us, which are the primary symbols of a childhood yet to be enlightened. It mixes joy, solemnity, and a huge crowd of revelers, communicating with the unknown world in a ritual of unknown origins. As we grow older, we seem to lose the ability to connect with the unknown and the unchartered. The same rituals are held, the joy is still palpable, but the wisp of the profound becomes more elusive. Perhaps, the power of reality has pulled us too far away. We want to take full advantage of this theme, and try to discover the connection with the unknown, and perhaps the semblance of a harmonious coexistence with nature, just as our ancient forefathers did."

"We're extremely fortunate not to know precisely the kind of world we live in," once wrote the famed poet Wislawa Szymborska. Fear, worship, curiosity and exploration of the unknown are human instincts, or even the purpose of human existence, but when we think we know and keep blindly expanding the realm of our existence, it is often the onset of a disaster. The practice of rituals should not be misinterpreted with the passage of time, or the change of political rules. Rather, rituals should exist as a reminder to people of the existence of the unknown, the home of the heart, lest people should become lost or forget that they are also part of the natural world.

李取中

1970 年生，東海大學物理系畢。2010 年將社會企業型雜誌《The Big Issue 大誌雜誌》引進臺灣，2017 年成為國際街報組織 INSP 支持型會員、2018 年獲頒國際街報獎最佳設計獎、金鼎獎優良刊物推薦。2016 年創辦編集者新聞社，2017 年發行《The Affairs 週刊編集》，獲得 2018 年金點設計獎年度最佳設計獎、 2018 年日本 Good Design Award Best 100、2019 年金鼎獎最佳新雜誌獎、2021 年人文藝術類金鼎獎。

Fines Lee

Born in 1970, Fines Lee holds a bachelor's degree in Physics from Tunghai University. He introduced the social enterprise magazine "The Big Issue" to Taiwan. Therefore, Lee became a member of the International Network of Street Papers (INSP) In 2017 and won the Best Design Award at the Global Street Paper Summit and the Excellent Publication Recommendation of the Golden Tripod Award in 2018. He also founded The Affairs Medium in 2016 and published "The Affairs" monthly newspaper in next year, which won the Best Design of the Year at the 2018 Golden Pin Design Award, the 2018 Japan Good Design Award Best 100, Best New Magazine at 2019 Golden Tripod Award, and 2021 Annual Golden Tripod Award in Humanities and Arts.

後記
Epilogue

「大溪大禧」是一個個感受性的總和、相信的力量累積出的果實。「信仰」這件事就像長久不換的「友情」，即便世上有多少悲歡離合、物換星移，這份精神依然靜靜地陪伴著你我，在有人在的地方持續演進、傳延香火，保佑眾生。所有發生在大溪的事都是文化的一部分，擷取轉化出讓現代世人可以「感受」的事物，也更進一步地連結至我們的文化記憶。

「大溪大禧」成功交織了「一個城鎮的尺度、城鎮凝聚的大眾精神、擁有的文化記憶」：尺度、精神與記憶，三維交叉營造出鮮明的「大溪大禧」印象，製造出再看見「現在仍保有的美好」的難得機緣，讓每一個人都有機會重新加入「文化繁衍的可能」。 **(1)**

透過這些年的「大溪大禧」，共創的文化敘事，共享的文化文本，讓「祝福」成為最好的設計。

"Daxidaxi" is the fruit of the sum of all emotions and the power of belief. "Faith" is like a long-lasting "friendship," even if there are many sorrows and joys in the world. Even though things change, and people move on, this spirit is still quietly accompanying you and me. Where there are people, there would be heritage to uphold, and we shall continue the legacy and bless all beings. Everything that happens in Daxi is but one small part of our culture, and it is extracted and transformed into something that the modern world can "resonate with" and further connects to our cultural memory.

"Daxidaxi" successfully intertwines "the scale of a town, the converging spirit of the town, and the cultural memory it possesses": scale, spirit, and memory, all three dimensions intersect to create a clear impression of "Daxidaxi", creating a rare opportunity to see "the beauty that still remains" and giving everyone the chance to rejoin "the possibility of cultural reproduction".**(1)**

Through these years of Daxidaxi, the jointly created cultural narrative and shared cultural contexts make "blessing" the best design.

(1) 此段為台新銀行文化藝術基金會 鄭家鐘 董事長為「大溪大禧」註解。
The comment of Daxidaxi by Simon Cheng, the chairman of Taishin Bank Foundation for Art and Culture

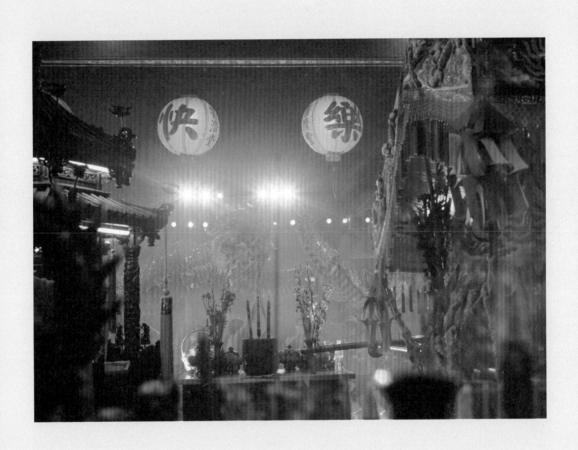

大溪大禧 感謝名單
Special Thanks

主辦單位
桃園市立大溪木藝生態博物館
陳倩慧、郭俊麟、陳佩歆、枋彩蓉、陳淑妃、溫欣琳、詹雅如、孫祺竣、余相君、梁芸齊、及全體同仁

總體策展
BIAS 衍序規劃設計
總策展人：劉真蓉
總策展團隊：陳漢儒、Alessandro Martinelli、楊婷崴、方心汶、余咨穎、張芷瑄、劉子翔、包叔平
歷年參與：劉育純、蔡政哲、林容靚、楊婕、謝君竹、張蓉蓉、劉真怡、許文相、劉芳綺、滕孟哲、王思匀、劉育純、潘旻真、陳涵文、江東晉

視覺總監
廖俊裕（廖小子）

社群行銷
衍序規劃設計、文化銀行、吳家睿

感謝曾經幫助、參與「大溪大禧」以及本書的所有人。

大溪普濟堂
關聖帝君、謝昌明主委、邱益興總幹事、陳義春前主委、藍倍敏前總幹事，以及傾力相助的所有大溪普濟堂幹事及委員們

大溪社頭
樂安社、同人社、興安社、協義社、慶義社、大有社、共義團、慶安社、農作團、農友團、新勝社、福安社、永safe社、樂廟社、同義社、仁安社、一心社、帝君會、玄元社、振興社、老人會、聖母會、鎮豐社、哪德社、聚賢慈惠堂、溪洲福山巖、溪洲忠義堂、嘉天宮同義社、聖廟無極總宮、大溪義消中隊、金鴻慈惠堂、桃園市大溪區社團民俗技藝協會

2018 大溪大禧

與神同巡
儀式設計：衍序規劃設計
主力協辦：大溪普濟堂、民俗技藝協會
組織參與：大溪社頭
主持人：陳明珠
國際交流：日本香川縣 Hyoge 祭
交流單位：月眉社區、南興社區、至善高中

神嬉舞夜
企劃整合：衍序規劃設計
主持人：DJ 小樹（陳弘樹）
演出團隊：三牲獻藝、銀河藝廊、大溪畫老李後喜和徒弟林宜杰、小事製作、嘉天宮同義社、拍謝少年
硬體技術：聖地音響

設計師媒合計畫
▍大禧霓虹旗
道具設計：吳孝儒
媒合社頭：嘉天宮同義社、農友團、哪德社、新勝社、興安社
▍雷電霓裳
服裝設計：陳劭彥
媒合社頭：農友團
▍視覺改造
平面設計：廖小子
媒合社頭：新勝社、嘉天宮同義社
▍大溪大戲
音樂創作：柯智豪
媒合社頭：大溪北管 李後喜

主題特展 五社五師創新紀錄展
展覽設計：衍序規劃設計

大溪文化劇場 慶公生
製作團隊：安徒生和莫札特的創意劇場
製作人：林奕君
導演：謝淑靖
編劇：林政勳
音樂設計：許哲綸
演出人員：AMcreative 安徒生和莫札特的創意＆大溪居民
在地社團：協義社、哪德社

山城藝境
工藝設計：銀河藝廊、葫蘆剪工作室

創意性展演計畫
▍創意大偶－社區踩街共演
創作團隊：無獨有偶
創意製偶工作坊：樂旗隊、扯鈴隊、民俗舞蹈團、舞龍醒獅團、笛鼓隊
▍神前獻藝－演出製作
演出團隊：小事製作、虎劇團、中興國小扯鈴隊、沙盒製作、鼓兒・鼓聚坊、女爵騎士、畸零地創造、至善高中、TC 舞團

市集
合作團隊：三手微市集
參與品牌：Bear&bag 熊與袋、JuMi 啾咪手作玩意兒、Green fields 綠蔭花草、愛麗絲愛手作、Hsin Hsin 手作、貓咪愛種花、既飾感、纖維革編所、潔與她的鹿、CC. BEAR、蔓蒂藝術、寶貝時光、疏樓凜閣、たまたま、偶爾手作、鯨魚陶藝工作室、樂玩兒 deedee soap、C house 溪房子手作、有木木工房、淨心園藝工坊、木藝工坊、S and K、堂和神桌、TAMU TAMU、林北釀造、Mars coffee、LittleThings、楓手作、兜兜共和國。掌櫃瘋手作、Velina 手作．靴下．雜貨、綠兔子工作室、手作木藝工坊、Enjoy henna 幸福手繪、路人甲咖啡、DB Brewer 德意精釀、魯小小手作、因為心情好。Handmad、Abbraccio 柏拉丘

宣傳影片
導演：劉伊倫
拍攝團隊：DC Films 影像

影像紀錄
紀錄影片：DC Films 影像
平面攝影：董昱、徐志豪、羅富暘、楊佳穎、滕孟哲

2019 大溪大禧

與神同巡
儀式設計：衍序規劃設計
主力協辦：大溪普濟堂、民俗技藝協會
組織參與：大溪社頭
主持人：詹秉軒
國際交流：馬來西亞檳州政府旅遊文化部舞獅團
硬體技術：捷韻實業

神嬉舞夜
企劃整合：衍序規劃設計
主持人：許騎凱
演出團隊：陳錫煌傳統掌中劇團、許雁婷、廖苡晴、嘉天宮同義堂、哈管幫、拍謝少年
舞台執行：王靖元
燈光設計：江佶洋
硬體技術：捷韻實業、生活方程式

設計師媒合計畫
▍扛得起的大墨斗
工藝設計：徐景亭
媒合社頭：協義社
▍龍柱平安符扭蛋機
工藝設計：李育昇
參與單位：大溪普濟堂

主題特展 將軍與我
展覽設計：衍序規劃設計
人物攝影：林科呈
文字採訪：胡士恩
參與拍攝：吳岱鴻、李健維、李信發、呂建德、林鴻斌、林偉祺、林育揚、廖阿立、廖紀龍、廖紀宗、廖國翔、陳安榆、簡佳俞、賴銘偉、廖朝舟、邱文俊、簡勝輝、王淳權、林錫安、謝源平、劉正智、李汪振、黃俊祥、楊添忠、李昭銘、盧欣農、黃國豪、黃教壽

給孩子的邊境學
服裝道具設計：李育昇
教材編輯：衍序規劃設計
動作指導：張書武
參與團隊：鎮豐社、農作團、共義團淨爐手、大溪國小

大溪文化劇場 咱攏是社頭人
製作團隊：安徒生和莫札特的創意劇場
製作人：林奕君
導演：謝淑靖
編劇暨副導：林政勳
音樂設計：許哲綸
演出人員：AMcreative 安徒生和莫札特的創意＆大溪居民
在地社團：嘉天宮同義社、同人社、金鴻慈惠堂醒獅團、大溪高中

六廿四大百貨－商家聯名
企劃整合：衍序規劃設計
參與店家：堂和木器行、木村一棟、伊格森企業有限公司、大易國際藝

術有限公司、花森早午餐、杏芳食品、大溪茶屋、溪友綠、磅咖啡、藝享茶、大房豆干

宣傳影片
導演：劉伊倫
拍攝團隊：DC Films 影像

影像紀錄
紀錄影片：DC Films 影像
平面攝影：董昱、安竹本、陳子正、楊佳穎、康志豪

2020 大溪大禧

與神同巡
儀式設計：衍序規劃設計
主力協辦：大溪普濟堂、民俗技藝協會
組織參與：大溪社頭
主持人：陳昭瑋
硬體技術：捷韻實業

大溪霹靂夜（神嬉舞夜）
企劃整合：衍序規劃設計
節目監製：柯智豪
舞台執行：王靖元
演出團隊：新勝社飛龍團、金鴻慈惠堂醒獅團、大溪共義團將軍組、嘉天宮同義堂、三牲獻藝、同根生、小事製作、臺灣雅典娜 - 陳思妏、安徒生和莫札特的創意
硬體技術：捷韻實業、生活方程式

主題特展 遶境事務所
展覽設計：衍序規劃設計、包叔平
人物攝影：林科呈
裝置設計：李育昇
攝影人物：黃朝枝、謝錦源、邱玉梅、李美雪、李葉、簡阿招、王阿滿、謝阿森、余銘揚、李蔡蘇、江鳳兒、鄭敏男、余秀香、黃林寶蓮、徐枝堂、黃智弘、藍倍敏、林秀蘭
工程協力：黃裕凰、利銘實業社

遶境 Kit －商家聯名
商品企劃：衍序規劃設計

▌《大溪大禧》立體繪本
藝術總監：廖小子
視覺統籌：工夫設計
文字編輯：衍序規劃設計、包叔平

▌平安福袋
包裝設計：田修銓
媒合單位：大房豆干、大溪普濟堂

▌聯名合作
維大力、曖曖內含光、禾餘麥酒

山城藝境
整體設計：米力
協力執行：洄游創生

金喜大廟市
市集統籌：米力
協力執行：洄游創生
參與品牌：大房豆干、愛地球木工、森³ sunsun-museum、禾沐 Homu、慢手、古蹟燒、小滿食堂、包・手作羊毛氈、offoff theatre by gu siaoyin、法朋烘焙甜點坊、胡家涼麵、週末炸雞俱樂部、迪茶 DEAR TEA、印花樂、溫事、嬤嬤murmur、李亭香 Li Ting Xiang、津美妙、或者風旅、Pinkoi、奉茶、MUCAO、烏樹林精釀啤酒、打包 DABOA、三樂雞蛋糕、旺達減糖手作貝果、阿美米干、圖圖咖啡、局外人、藝享茶、忠貞眷村麻辣香滷、佳樂雞蛋糕、洄游創生風格採集、日日田職物所、高原祈艾、桂竹協會、NAE 插畫工作室、去哪裡都行

關公 online! －互動網站
網站企劃：衍序規劃設計
網站製作：黑洞創造、基本科技
插畫設計：廖國成
籤詩設計：田修銓

大溪大禧 官方網站
網站企劃：衍序規劃設計
網站製作：山川久也

宣傳影片
監製：李政道
導演：姚吉慧
拍攝團隊：人生知道創意有限公司

影像紀錄
紀錄影片：DC Films 影像
平面攝影：董昱、張育維、黃聖凱、安竹本

2022 大溪大禧

與神同巡
儀式設計：衍序規劃設計
主力協辦：大溪普濟堂、民俗技藝協會
組織參與：大溪社頭

主持人：陳昭瑋、陳孟賢
文化交流：新竹都城隍廟
香案設置：源古本舖、旭文堂鐘錶、永珍香餅店、大料崁故事館、福仁公、余銘揚
硬體技術：必應創造
現場協力：張詠晶、張舜雅、董岳鑶

正氣 Pa！（神嬉舞夜）
企劃整合：衍序規劃設計
節目監製：柯智豪
節目設計：楊智博
舞台監製、燈光設計：必應創造
演出團隊：大溪普濟堂、新竹都城隍廟、王彩樺、新勝景掌中劇團、金鴻慈惠堂醒獅團、新勝社、嘉天宮同義堂、廖苡晴 X 拚場電氣將軍、A Root 同根生、樂無社、小事製作、三牲獻藝
舞台執行：王靖元
轉播團隊：生活方程式

主題特展 舞德殿
展覽設計：衍序規劃設計
文案設計：包叔平
互動影像裝置設計：叁式設計
紀錄影片製作：DC Films 影像
音樂設計：三牲獻藝、同根生
頭旗設計：李育昇
參與拍攝：張書武、邱顯青、江鳳兒、陳世珍、余明政、吳岱鴻、田祐嘉、呂建德、李信發、邱俊堯、廖建成、簡長華、林志祥、黃慶賓、簡敏哲、陳俊男、賴銘偉、簡佳俞、黃俊祥、黃智偉、許源吉、許仁杰、陸邦雯、吳軒名
工程單位：利銘企業社、木 A 空間美學
水電整合協力：鋐燁水電
視訊整合協力贊助：冠嘉系統科技有限公司

給孩子遶境學 2.0
服裝道具設計：李育昇
合作對象：大溪國小、永福國小、鎮安社、嘉天宮同義堂、金鴻慈惠堂醒獅團

紅紅 OnOn －主題歌舞樂創作
企劃整合：衍序規劃設計
音樂總監：柯智豪
音樂製作：同根生
舞蹈設計：小事製作
MV 導演：陳容寬

MV 監製：戴妏伊
拍攝團隊：浪打影像
合作代言：王彩樺

大溪 in LINE －城市實際遊戲
企劃整合：衍序規劃設計
遊戲設計：叁式設計
合作廟宇：大溪普濟堂、福仁宮
合作店家：大房豆干、永珍香餅店、江家古早味花生糖、協盛木器行、大易藝術、第一商行

山城藝境
工藝設計：大象設計、好家在台灣
合作藝師：賴登祥、鄒弘義

遶境 Kit －商家聯名
商品企劃：衍序規劃設計
產品設計：廖小子、衍序規劃設計、呂國維
合作店家：達文西瓜藝文館、協盛木器行、新南 12 文創商行、木博館物產小舖
聯名合作：維大力

市集
市集統籌：好家在台灣
參與品牌：維大力、Draft Land、Keya Jam、錦茂行。百年茶貿易公司、作息尚好、嬤嬤 murmur、糸島織物 mee.textile、法朋 Le Ruban Pâtisserie、或者、Omake Taiwan、麒麟山告解室本家、庫魯不塔人、軌室、糸赤 mee.tsu 鴨寶 where is hazel？、游記百年油飯、日日田職物所、烏樹林從前從前、雙口呂文化廚房、大溪小石、蕎。點子、花疫室、西城、艸文子

故事體驗課程
企劃整合：衍序規劃設計
教學指導：小人小學
將軍面具設計：李育昇
現場教學：小人小學、桃媽田野工作室、嘉天宮同義堂、共義團、樂團社

影像紀錄
紀錄影片：DC Films 影像
平面攝影：李建霖、林祐任、張國耀、楊佳穎（嘟嘟嘟）、黃聖凱（黃毛）、葉峻瑪、黃煜維、黃暐翔
傳統遶境直播：生活方程式、中華電信、洋洋實業

VERSE Books Local oo2

大溪大禧：當代設計與民俗信仰一起策展
Curating Daxi: The Development of Daxidaxi Festival

指導單位 | 桃園市政府、桃園市政府文化局

出版單位 | 桃園市立大溪木藝生態博物館

地址 | 桃園市大溪區普濟路 11 號後棟 2 樓
網站 | https://wem.tycg.gov.tw
電話 | 03-388-8600

一頁文化制作股份有限公司

地址 | 臺北市大安區建國南路一段 177 號 2 樓
網站 | www.verse.com.tw
電話 | 02-2550-0065
信箱 | hi@verse.com.tw

編輯策劃 | 衍序規劃設計顧問有限公司

總編輯 | 陳倩慧、劉真蓉

主編 | 包叔平

封面設計 | 廖俊裕（廖小子）

美術設計 | 衍序規劃設計顧問有限公司

文字編輯 | 張芷瑄、余咨穎、楊婷嵐、陳佩歆

編排設計 | 余咨穎、張芷瑄

行政編輯 | 溫欣琳、吳玲育、游佳軒、林依靜

英文翻譯 | 統一數位翻譯

英文審校 | 胡怡敏、Alessandro Martinelli
Florian Scheucher

攝影 | DC Films、董昱、楊佳穎、黃聖凱、林祐任、
林科呈、葉峻瑀、李建霖、鄭崴文、黃煜維、
安竹本、徐志豪、康志豪、陳子正、羅富暘、
張國耀

印刷 | 通南彩色印刷有限公司

總經銷 | 時報文化出版股份有限公司

地址 | 桃園市龜山區萬壽路 2 段 351 號
電話 | 02-2306-6842

GPN 1011102210

ISBN 978-626-7264-00-3

定價 新台幣 580 元

初版一刷 2023 年 1 月

國家圖書館出版品預行編目（CIP）資料

大溪大禧：當代設計與民俗信仰一起策展 = Curating Daxi : the
development of Daxidaxi Festival / 大溪木藝生態博物館作. --
初版 . -- 桃園市：桃園市立大溪木藝生態博物館；臺北市：一頁
文化制作股份有限公司 , 2022.12
面； 公分
ISBN 978-626-7264-00-3(平裝)

1. 博物館學 2. 藝術展覽 3. 設計 4. 民俗

906.6 　　　　　　　　　　　　　　　111020840

Superviced by

Taoyuan City Government

Department of Cultural Affairs, Taoyuan

Published by

Daxi Wood Art Ecomuseum, Taoyuan

Address | 2nd floor, No.11, Puji Road, Daxi District,Taoyuan City
Website | https://wem.tycg.gov.tw/
Telephone | 03-388-8600

Onepage Culture Production Company

Address | 2nd floor, No. 177, Section 1, Jianguo South Road,
Da'an District, Taipei City
Website | www.verse.com.tw
Telephone | 02-2550-0065
Email | hi@verse.com.tw

Developmental Editor

BIAS Architects & Associates

Editor-in-chief

Chien-Hui Chen, Tammy Liu

Editor

Shu-Ping Pao

Book cover design

Chun-Yu Liao (Godkidlla)

Art Design

BIAS Architects & Associates

Text Editor

Chih-Hsuan Chang, Peter Yu,
Ting-Lan Yang, Pei-Hsin Chen

Layout Design

Peter Yu, Chih-Hsuan Chang

Administrative Editor

Hsin-Lin Wen, Ling-Yu Wu, Jia-Xuan You, I-Ching Lin

English Translation

PTSGI.com

English Proofreading

Yi-Min Hu, Florian Scheucher

Photagrapher

DC Films, Doane Don, Chia-Ying Yang, Sheng-Kai
Huang, You-Ren Lin, James Lin, Chun-Yu Yeh, Jian-
Lin Li, Bear Cheng, Yu-Wei Huang, Peng-Tai Hong,
Zhi-Hao Xu, Kris Kang, Zi-Zheng Chen, Rock Burger
Photography, Kok-Yew Chong

Printing

Ton Nan Color Print Company

Distributor

China Times Publishing Company

Address | No. 351, Section 2, Wanshou Road, Guishan District,
Taoyuan City
Telephone | 02-2306-6842

GPN | 1011102210
ISBN | 978-626-7264-00-3
Publishing Date | January 2023
580 NTD

大溪大禧 DAXI DAXI